Aegean Faience
of the Bronze Age

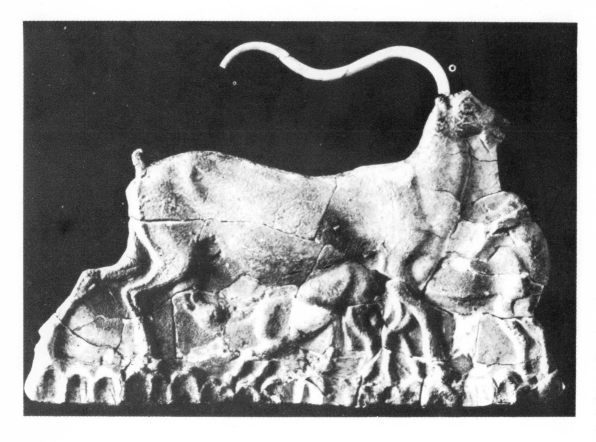

Wild goat or antelope and kids plaque, Temple Repository, Knossos.
Scale: $\frac{2}{3}$ actual size.
Cliché Cahiers d'Art, Paris

Aegean Faience of the Bronze Age

Karen Polinger Foster

New Haven and London
Yale University Press
1979

*Published with assistance from the Ludwig Vogelstein Foundation in memory
of Julie Braun-Vogelstein (1883–1971).*

*Plates 5 and 15 reprinted from Zakros: The Discovery of a Lost Palace of
Ancient Crete by Nicholas Platon with the permission of Charles Scribner's
Sons, copyright © 1971 Nicholas Platon.*
*Designed by Thos. Whitridge
and set in Monophoto Bembo type
by Asco Trade Typesetting Limited, Hong Kong.
Printed in the United States of America by
Murray Printing Company, Westford, Mass.*

*Published in Great Britain, Europe, Africa, and Asia (except Japan) by Yale
University Press, Ltd., London. Distributed in Australia and New Zealand by
Book & Film Services, Artarmon, N.S.W., Australia; and in Japan by
Harper & Row, Publishers, Tokyo Office.*

Library of Congress Cataloging in Publication Data

Foster, Karen Polinger, 1950-
 Aegean faience of the Bronze Age.

 *"Revised version of my doctoral dissertation,
done for Yale University in 1976."*
 Bibliography: p.
 Includes index.
 *1. Faience—Aegean Sea region. 2. Bronze age
—Aegean Sea region. 3. Aegean Sea region—
Antiquities. I. Title.*
NK4305.5.A35F67 1979 738'.0938 79-4132
ISBN 0-300-02316-2

Contents

Plates

Figures

Diagrams

Maps

Preface

THIS STUDY is the revised version of my doctoral dissertation, done for Yale University in 1976. I am grateful to many for their encouragement and suggestions throughout the preparation of this book. The generosity of the Harriet Pomerance Fellowship of the Archaeological Institute of America enabled me to examine faience in museums in Greece and England during the winter of 1975. A handsome grant from the American Philosophical Society made possible another trip to Greek museums in May of 1977, as well as the acquisition of photographs. A grant from the American Council of Learned Societies supported the final preparation of the manuscript. The Ludwig Vogelstein Foundation in memory of Julie Braun-Vogelstein (1883–1971) provided a liberal subvention for publication.

For their willingness to make objects and photographs available for study, I owe special thanks to S. Alexiou and the staff of the Heraklion Museum; C. Davaras of the Haghios Nicolaos Museum; J. Sakellarakis of the National Museum, Athens; D. E. L. Haynes of the British Museum; and P. R. S. Moorey, A. C. Brown, and M. Vickers of the Ashmolean Museum. D. von Bothmer of the Metropolitan Museum of Art allowed me free access to the Cypriote faience in the Cesnola Collection. S. Hood and G. Cadogan kindly permitted me to see the Royal Road faience in the Stratigraphical Museum, Knossos. I am grateful to N. Platon for allowing me to treat the faience from Zakros. J. V. Canby made available files on Egyptian faience in the Walters Art Gallery.

This book has profited considerably from conversations and correspondence about faience with G. Cadogan, S. Heim, A. Kaczmarczyk, A. Milward, N. Platon, and E. J. Peltenburg. V. L. Davis has provided Egyptological guidance; B. R. Foster has aided with Assyriological questions. C. W. Gates, M.-H. Gates, C. Mee, and J. D. Muhly have suggested stylistic parallels and discussed Bronze Age historical problems with me. J.-C. Poursat encouraged me to undertake a study of Aegean Bronze Age faience as a dissertation subject. He also allowed me to examine the manuscript of his now-published work on Mycenaean ivories.

I am particularly grateful to J. J. Pollitt, my dissertation supervisor, for having given freely of his time to advise me on numerous matters concerning the focus, organization, and conclusions of this study. On my behalf he also made notes on several objects in the National Museum, Athens, in June of 1976.

At every stage of the work, from its initial proposal to the completion of the book, I have benefited immeasurably from the suggestions and support offered by B. R. Foster.

K. J. F.
June 1978

Abbreviations

AAA	*Annals of Archaeology and Anthropology, University of Liverpool.*
AJA	*American Journal of Archaeology.*
AJSemL	*American Journal of Semitic Languages and Literatures.*
ASAtene	*Annuario della R. Scuola Archeologica di Atene.*
AthMitt	*Mitteilungen des deutschen Archäologischen Instituts, Athenische Abteilung.*
BASOR	*Bulletin of the American Schools of Oriental Research.*
BCH	*Bulletin de Correspondance Hellénique.*
BMFA	*Bulletin of the Museum of Fine Arts, Boston.*
BSA	*British School at Athens, Annual.*
CAD	*The Assyrian Dictionary of the Oriental Institute of the University of Chicago,* Glückstadt, 1956–77.
*CAH*³	*The Cambridge Ancient History,* third revised edition of volumes I and II, Cambridge, 1970–75.
COWA	*Chronologies in Old World Archaeology,* edited by Robert W. Ehrich, Chicago, 1965.
EphArch	*Archaioligike Ephemeris.*
FuF	*Forschungen und Fortschritte.*
GRBS	*Greek, Roman and Byzantine Studies.*
IEJ	*Israel Exploration Journal.*
ILN	*Illustrated London News.*
JAOS	*Journal of the American Oriental Society.*
JCS	*Journal of Cuneiform Studies.*
JdI	*Jahrbuch des k. deutschen archäologischen Instituts.*
JEA	*Journal of Egyptian Archaeology.*
JESHO	*Journal of the Economic and Social History of the Orient.*
JHS	*Journal of Hellenic Studies.*
JNES	*Journal of Near Eastern Studies.*
JRGZM	*Römisch-Germanisches Zentralmuseum, Mainz, Jahrbuch.*
KrChr	*Kritika Chronika.*
MDP	*Mémoires de la Délégation en Perse.*
*MMR*²	Martin P. Nilsson, *The Minoan-Mycenaean Religion and its Survival in Greek Religion,* second revised edition, Lund, 1950.
OIC	*Oriental Institute Communications.*
OIP	*Oriental Institute Publications.*
PEQ	*Palestine Exploration Quarterly.*

PM	Arthur J. Evans, *The Palace of Minos at Knossos*, London, 1921–35.
PPS	*Proceedings of the Prehistoric Society.*
ProcBritAc	*Proceedings of the British Academy.*
QDAP	*Quarterly of the Department of Antiquities in Palestine.*
RA	*Revue Archéologique.*
RAssyr	*Revue d'Assyriologie et d'Archéologie Orientale.*
RHA	*Revue Hittite et Asianique.*
RStO	*Rivista degli Studi Orientali.*
SciAm	*Scientific American.*
SIMA	*Studies in Mediterranean Archaeology.*
SMEA	*Studi Micenei ed Egeo-Anatolici.*
Wb	Adolph Erman and Hermann Grapow, *Wörterbuch der ägyptischen Sprache*, Berlin, 1926–31.
WVDOG	*Wissenschaftliche Veröffentlichungen der deutschen Orient-Gesellschaft.*
WZKM	*Wiener Zeitschrift für die Kunde des Morgenlandes.*
ZÄS	*Zeitschrift für ägyptische Sprache und Altertumskunde.*

Introduction

THIS BOOK treats the corpus of Aegean Bronze Age faience as an integral group of objects and places this material within the context of the Bronze Age faience industry as a whole. The inquiry progresses from definitions of faience to discussion of modern and Bronze Age terminology for faience and related products. It then surveys the chronological and geographical distribution of faience, with particular attention paid to second millennium material. A detailed examination is made of Minoan, Greek mainland, and Aegean island faience. The objects are grouped typologically, and each set is considered in turn. Finally, these sets are rearranged into chronological units in order to describe the general characteristics and historical development of Aegean faience and to define its role in Aegean foreign relations.

The emphasis throughout is on the economic conditions under which faience was produced or acquired. My thesis is that Aegean and other Bronze Age faience manufacture was closely linked to the availability and use made of luxury goods, especially lapis lazuli. On the one hand, centers of faience production with ready access to semiprecious materials, or the profit derived from their export, experimented with the possibilities of faience and developed new forms and methods. On the other hand, centers with little means of obtaining luxury goods tended to exploit faience for the sake of its imitative properties.

This study is also concerned with the problem of identifying centers of faience production. On the basis of archaeological, textual, and stylistic evidence, the locations of original, principal, and subsidiary centers are suggested. These were nearly always established where political, cultic, or mercantile interests were concentrated. Increasingly sophisticated technical analysis is a potentially useful source of information about the provenance and local characteristics of faience. Egyptian, Cypriote, and Iranian faience is currently being analyzed using several techniques; the author hopes to undertake analysis of Aegean pieces in the future.

I

Faience Technology
and Terminology

Section 1 FAIENCE TECHNOLOGY

FAIENCE IS A COMPLEX COMPOSITE MATERIAL whose technical
description is the first topic of this study.[1] The two essential constituents of
Bronze Age faience were silicates, generally in the form of powdered
quartz, sandstone, flint, or sand,[2] and sodium carbonate binding agents,
usually natron.[3]

Of the variety of Bronze Age faience manufacturing techniques, the
simplest involved combining these two materials and heating them to
approximately 870°C.[4] At this temperature some of the carbonate migrated
to the surface of the object and there formed a powdery deposit that fused
with quartz grains under increasing heat. The result was self-glazed faience
with a smooth, white, lustrous surface. To produce blue self-glazed ob-
jects, fired pieces were coated with a solution of copper oxide or copper
carbonate, sodium carbonate, and powdered quartz[5] and refired.

An alternative method was to apply a glazing compound of powdered
quartz, natron, copper, and traces of potassium and other minerals directly
to prefired faience pieces. Black geometric and representational decoration
was achieved by painting fired objects with a solution of magnesium

1. For detailed descriptions of faience composition, as well as further references, see
J. F. S. Stone and L. C. Thomas, "The Use and Distribution of Faience in the Ancient
East and Prehistoric Europe," *PPS* 22 (1956): 37–39; A. Lucas and J. R. Harris, *Ancient
Egyptian Materials and Industries* (London, 1962), pp. 155–78; R. H. Brill, "Ancient
Glass, " *SciAm* 209 (1963): 120–30; E. Riefstahl, *Ancient Egyptian Glass and Glazes in the
Brooklyn Museum* [= *Wilbour Monographs* 1] (Brooklyn, 1968); R. J. Forbes, *Studies in
Ancient Technology* 5 (Leiden, 1966), pp. 112–13.

2. Lucas and Harris, *Materials*, pp. 158, 162–64.

3. Lucas and Harris, *Materials*, pp. 174–78.

4. According to Brill, the presence of alpha quartz crystals in ancient faience indicates
that its firing temperature could have been no higher than 870°C. ("Ancient Glass,"
SciAm 209 [1963]: 123). In work on Egyptian faience, J. V. Noble found 950°C. the best
firing temperature ("The Technique of Egyptian Faience," *AJA* 72 [1968]: 169). C. Kiefer
and A. Allibert, on the other hand, place the firing temperature of Egyptian faience near
the point quartz changes to cristobalite, that is, 870° to 920°C. ("Pharaonic Blue Ceram-
ics: The Process of Self-Glazing," *Archaeology* 24 [1971], table I p. 112).

5. Noble, "Technique," *AJA* 72 (1968): 169.

dioxide and then refiring the pieces.[6] Polychrome faience was the result of building up as many as four successive layers of colored glazes or of filling incised areas with color in a technique related to cloisonné work.[7]

In the proper proportions, the prefired synthesis of quartz and natron was sufficiently elastic and malleable to be worked in a number of ways.[8] One-piece clay molds were used for making the fronts of figurines, inlays, plaques, and other ornaments. The backs were then finished by hand. Animal and human figures, furniture pieces, fruit, flowers, bracelets, and the like were modeled by hand. Vessels and containers were either thrown on a potter's wheel, formed in molds, or built by hand.[9] Beads were generally manufactured using a combustible core method.[10] Moist faience was rolled around axes of plant stems or thin wooden sticks, then cut into desired bead lengths and allowed to dry. When fired, the cores disintegrated, leaving a string hole. Barrel, globular, and incised beads and miniature vessels were also made in this way, with shaping and decoration done after cutting.[11]

Yet another manufacturing technique was used to produce the brilliant turquoise material which is the hallmark of much of Egyptian faience. The mechanics of this technique have been recently elucidated on the basis of ethnographic and laboratory observations. The former were carried out in the Iranian ceramic workshops at Qom, which produce blue donkey beads nearly identical in color and glossiness to Egyptian faience.[12] The method used at Qom is to form a mixture of finely powdered quartz pebbles and gum tragacanth into beads and to allow them to dry in the sun. The beads are then packed in containers surrounded by layers of a crumbly white material, fired in a kiln for twelve hours, and cooled for another twelve. The result is a set of perfectly glazed, bright blue beads.

Laboratory analysis has shown that self-glazing results when a core composed in part of soluble salts is enveloped in a substance that has enough alkaline ions to form a vitreous flux on the surface, yet not enough to induce a fusion.[13] Copper is primarily responsible for the blue color, as well as for increasing the fusibility of the materials and aiding in the reac-

6. Prior to the Old Kingdom, Egyptian black decoration was produced by the reduction of feric oxide, a principle refined by Classical Greek potters. Difficulties in maintaining proper kiln temperature led to the adoption of magnesium dioxide as the sole material for black in the New Kingdom (personal communication, A. Kaczmarczyk).

7. Lucas and Harris, *Materials*, p. 160.

8. For more extensive discussion of manufacturing techniques, see Kiefer and Allibert, "Pharaonic Blue Ceramics," *Archaeology* 24 (1971): 110–11; also G. A. Reisner, *Excavations at Kerma* (Cambridge, Mass., 1923), pp. 134–43 for production methods.

9. F. W. von Bissing, *Fayencegefässe* (Vienna, 1902), pp. xxiii–xxiv, with references to his catalogued pieces.

10. See Lucas and Harris, *Materials*, pp. 44–46 for faience bead technology. Also useful is Reisner's section in *Kerma* on faience beads and amulets (pp. 90–92).

11. Reisner, *Kerma*, p. 137.

12. For a full report, see H. C. Wulff, H. S. Wulff, and L. Koch, "Egyptian Faience: A Possible Survival in Iran," *Archaeology* 21 (1968): 98–107.

13. See Kiefer and Allibert, "Pharaonic Blue Ceramics," *Archaeology* 24 (1971): 112–17, especially Table I, p. 112, "The mineralogical nature of the silica in the bodies and glazed surfaces...," and Table II, p. 115, "Chart of the results of self-glazing experi-

tions of the siliceous components. Hue and brightness[14] are functions of the types of coating, body composition, and soluble salts used. The intensity of the blue has been found to decrease when the particles of coloring agents are more finely ground.[15] It is interesting to note that blue beads encased in a white lining were discovered at the Islamic Fustat site in Egypt,[16] affording another example of the continuity of manufacturing techniques.

The following circumstances have been suggested[17] for the invention and development of faience, which J. F. S. Stone has termed "man's first conscious essay in the production of a synthetic material."[18] The initial stage may have taken place in rock-lined fire pits. There siliceous stones, such as steatite, the ashes of alkaline-rich saltwater plants, and some copper, perhaps fragments of freshly ground malachite, were fortuitously combined and heated. After evening fires it was discovered that several rocks had turned bright blue. The resemblance these accidentally glazed stones bore to the coveted materials of turquoise and lapis lazuli was probably the major reason for beginning deliberate production.[19]

In the second stage, steatite was sculptured into beads, small figurines, and other objects, then glazed with liquid mixed with finely ground blue powder scraped from previously glazed stones, and finally fired. Though steatite was soft enough to carve easily and hard enough after intensive heating to resist damage, the repertoire of objects was somewhat restricted. This may well have been the impetus for the third and last stage: the substitution of a man-made siliceous substance for steatite and the refinement of the glazing process.

There has been considerable discussion as to whether the sequence outlined above could have occurred independently in different areas.[20] The following factors figure in the resolution of this problem: evidence

ments." See also the summaries of unpublished B.S. theses on ancient glaze composition given by W. O. Williamson in "The Scientific Challenge of Ancient Glazing Techniques," *Earth and Mineral Sciences* 44 (1974): 17, 21–22. Preliminary work on body and glaze composition of this type of Egyptian faience is tabulated in Lucas and Harris, *Materials*, pp. 474–75.

14. The finding of pans of colored glazes at El-Amarna attests to the deliberate effort of faience makers to produce wares with a wide range of carefully controlled colors (W. M. F. Petrie, *Arts and Crafts of Ancient Egypt* [Chicago, 1910], p. 117).

15. C. L. Peterson, "Egyptian Blue and Related Compounds," M.A. thesis, Ohio State University, 1950; results summarized by E. R. Caley and J. C. Richards in *Theophrastos: On Stones* (Columbus, 1956), p. 186.

16. Kiefer and Allibert, "Pharaonic Blue Ceramics," *Archaeology* 24 (1971): 109.

17. A concise statement of prevailing theories, from which this account has been adapted, appears in Riefstahl, *Ancient Egyptian Glass*, pp. 1–2.

18. Stone, "Use and Distribution," *PPS* 22 (1956): 37.

19. E. J. Peltenburg has pointed out that the earliest development of faience as an imitation of semiprecious stones depended more on its resemblance to turquoise than lapis, because of the latter's rarity in fifth millennium Egypt and Mesopotamia ("Some Early Developments of Vitreous Materials," *World Archaeology* 3 [1971]: 6–12).

20. The prevailing opinion is, as Lucas and Harris have written, "Neither the glazing of stone nor the making of such an extraordinarily complex material as faience is likely to have been invented in more than one place" (*Materials*, p. 464).

for related pyrotechnological skills, such as sophisticated metallurgical techniques; concentration and nature of the faience recovered from a given site or region; economic considerations, including patterns of trade, distribution of wealth, and availability of craftsmen; and stylistic analyses of the faience. This problem is treated more fully below and in chapters 2 and 4, especially in connection with Egyptian and European faience.

Technical analysis has helped to elucidate variations in the chemical compositions of faience from different sites. In an early and extensive spectrochemical project, J. F. S. Stone and L. C. Thomas examined trace element content and qualitative attributes of specimens from many locations in the Near East, Aegean, and Europe.[21] Unfortunately, their results failed to show trends or correlations between groups because of the large percentage of dependent variables.

One of the most interesting projects of faience analysis is the recent reconsideration of J. F. S. Stone and L. C. Thomas's data for British beads.[22] New statistical approaches were used, designed to analyze data with closely linked variables. On the basis of trace element analysis, bead shape, the nature of overseas trade connections, and a revised date for the Wessex culture, it has been postulated that some beads were locally manufactured.[23]

Neutron activation analysis of faience has also been used to advantage[24] because of the high copper and sodium content of Bronze Age faience. After removal from the reactor, these elements are sources of activity for several days. A major advantage of both neutron activation and X-ray fluorescence over spectrochemical procedures is that it is unnecessary to pulverize the faience objects. Future projects of this type promise to yield important results.[25]

In the manufacture of glass paste, the reactions described above between heated sodium carbonate and powdered quartz proceeded further than they did in faience, because of a higher percentage of sodium carbonate,

21. Stone, "Use and Distribution," *PPS* 22 (1956): pp. 68–77.

22. R. G. Newton and C. Renfrew, "British Faience Beads Reconsidered," *Antiquity* 44 (1970): 199–206.

23. A summary of Newton and Renfrew's results is plotted in their fig. 1, based on a ratio between the magnesium/tin and aluminum content of the beads ("British Faience Beads Reconsidered," *Antiquity* 44 [1970]: 205). This conclusion has been disputed in yet another reexamination of this material, which upholds the view that East Mediterranean faience was introduced to Britain about 1450 B.C. (H. McKerrell, "On the Origins of British Faience Beads," *PPS* 38 [1972]: 286–301). It is difficult to support this last in the light of additional evidence bearing on the Wessex culture, discussed below in chapter 2.

24. For a preliminary report with explanations of methodology, see A. Aspinall et al., "Neutron Activation Analysis of Faience Beads," *Archaeometry* 14 (1972): 27–40.

25. X-ray fluorescence analysis of Egyptian faience of all periods is currently being done by A. Kaczmarczyk. Preliminary compilation of the results shows, for example, that certain elements (tin, chromium, nickel, cobalt, antimony, and lead) were rare in pre-Amenhotep III faience and suggests a correlation between the technical and artistic innovations of the Amarna period. Other discoveries show, for instance, that the level of potassium in faience is related to the use of freshwater (high K) or saltwater (low K) plant ashes (personal communication).

a higher firing temperature, a longer firing time, additional stages of repowdering and refiring, or any combination of these.[26] The result was an incomplete fusion of components, which could be molded or cast as readily as faience but which at the same time was more lustrous, richly colored, and gemlike than faience.

These characteristics made glass paste an even better artificial substitute for lapis lazuli than faience. Real lapis was costly and difficult to obtain, since its most likely ancient source was the Kerano-Munjan Valley in Badakhshan.[27] From there lapis seems to have been exported southward to the Indus Valley and westward to southern Turkmenistan, Elam, southern and then northern Mesopotamia, and from there overland to Egypt, Anatolia, and eventually to the Aegean.[28] Scarcity of lapis at one point along the route resulted in a shortage at points farther from the source, as was the case, for example, in Early Dynastic II–III Mesopotamia and in Egypt during the same time period.[29]

Though glass paste was manufactured throughout the Near East in the late Bronze Age, its most extensive use seems to have been in Mycenaean Greece.[30] There the dark cobalt blue, semitranslucent substance was effectively combined with gold and other materials to make a wide variety of ornaments. Several Late Helladic workshops well supplied with quantities of glass paste, gold wire and inlays, ivory, and lapis lazuli along with other semiprecious stones have been recently found at Thebes.[31] The finished glass paste jewelry usually is of standard Late Helladic design: rosettes, spirals, stylized shells and leaves, and lily buds.[32] Occasionally

26. The transition from faience to glass, with the intermediate stage of glass paste, is described in detail by Brill in "Ancient Glass," *SciAm* 209 (1963): 123.

27. For an extensive discussion of the sources, distribution, and uses for lapis in the ancient Near East, see G. Herrmann, "Lapis Lazuli: the Early Phases of its Trade," *Iraq* 30 (1968): 21–57. The evidence for lapis sources in Badakhshan, Persia, Lake Baikal, and the Pamirs is considered. Though Badakhshan is the most probable site of ancient mines and mining villages, "the occasional use of the Baikal source for poor quality material cannot be altogether ignored" (p. 28).

28. These trade routes have been mapped primarily on the basis of find-spots in the regions enumerated. See the map pp. 12–13 and the information that follows in V. I. Sarianidi, "The Lapis Lazuli Route in the Ancient East," *Archaeology* 24 (1971): 12–15.

29. J. C. Payne, "Lapis Lazuli in Early Egypt," *Iraq* 30 (1968): 58–61; and Herrmann, "Lapis," *Iraq* 30 (1968): 53–54.

30. For a survey of the Mycenaean industry, see T. E. Haevernick, "Mycenaean Glass," *Archaeology* 16 (1963): 190–93. The recent discovery that many Tutankhamun treasures are inlaid with glass paste and glass instead of gems suggests that Egypt had a larger glass paste industry than hitherto suspected (E. Pace, "Some 'Gems' in Tut Tomb are Glass," *New York Times*, 21 July 1976, p. 36).

31. S. Symeonoglou, *Kadmeia* I [= *SIMA* 35] (1973), pp. 63–71 and fig. 271. E. Vermeule has commented on the abundance of lapis there: "Such a dazzling collection could be afforded only by connoisseur aristocrats actively engaged in overseas trade, where Mycenaean ships could pick up small quantities of the stone brought to Syrian harbors at the end of the long caravan routes from Afghanistan" ("A Mycenaean Jeweler's Mold," *BMFA* 65 [1967]: 30). See also K. Demacopoulou, "Mycenaean Jewellery Workshop in Thebes," *Athens Annals of Archaeology* 7 (1974): 172–73.

32. It has been suggested that the small glass paste plaques decorated with a single spiral were occasionally used as diadems or headdresses, for they are sometimes found in circlets

a more remarkable piece has been recovered, such as the intricate ivory wing inlaid with blue glass paste from Mycenae.[33] The Linear B furniture descriptions suggest that glass paste was also used with great skill and imagination for inlay work on tables and chairs.[34]

Of special interest are the steatite molds used for casting glass paste jewelry.[35] These usually lack the pouring channels of molds for metal jewelry, and the designs are particularly deep so that the cooling beads could be extracted easily. There were also small grooves next to the design negatives in which wires were laid to form the beads' string holes. An elaborate mold from the Citadel House at Mycenae contains negatives for lily buds, cockleshells, and a composite design of leaves and spirals.[36] Another from Cyprus has space for pendants and beads of standard shapes as well as crescent-shaped depressions, perhaps for hammering sheet gold.[37] An unusual red steatite mold from Mycenae has pictorial and syllabic versions of the double axe in addition to rosettes, spirals, and winged bees.[38]

Brief mention should be made of the Early Bronze trinket molds, similar in design to the glass paste molds.[39] These generally have places for a number of negatives, including geometric and representational pendants, animals, rosettes, earring patterns, and small figurines. The wide variety of patterns and styles may indicate that itinerant craftsmen carried them through the Near East, endeavoring to cater to local taste.[40]

Towards the end of the sixteenth century B.C., variations in the techniques used to combine the basic constituents of faience and glass paste

around skulls and may have represented ringlets of hair. See N. Yalouris, "An Unreported Use for some Mycenaean Glass Paste Beads," *Journal of Glass Studies* 10 (1968): 9–16.

33. From the tholos of the tomb of Clytemnestra, #2890, A. J. B. Wace, "Mycenae," *BSA* 25 (1923), fig. 81 a. This report of the Mycenae excavations contains a number of illustrations of the best-preserved kyanos; see, for example, figs. 14e, f; 75a–n; 81; 86a, b; 88; 89.

34. See the next section below.

35. For a list of East Mediterranean molds, see Vermeule, "A Mycenaean Jeweler's Mold," *BMFA* 65 (1967), n. 4; and "Graffito on a Steatite Jewelry Mold from Mycenae," *Kadmos* 5 (1966), n. 7 and p. 145; L. Åström, *Studies on the Arts and Crafts of the Late Cypriote Bronze Age* (Lund, 1967), p. 129, nn. 1 and 2.

36. A. H. S. Megaw, "British Archaeology Abroad, 1966," *Antiquity* 41 (1967), p. 126 and pl. X (b).

37. Åström, *Arts and Crafts*, fig. 73, and discussion on p. 129. Apparently it was not uncommon for a workshop to use the same mold for both glass paste and gold jewelry making, as a mold from Tell Fakariya also shows (Vermeule, "Jeweler's Mold," *BMFA* 65 [1967], figs. 3a, 3b, and p. 25).

38. As Vermeule has noted, "The signs were never meant to appear on any part of the finished jeweler's product ... perhaps we should regard them as marks of identification, either for the craftsmen who made the mold and worked with it, or as a means to distinguish one mold from the others in the workshop" ("Graffito," *Kadmos* 5 [1966]: 145; see fig. 2 and pl. II).

39. J. V. Canby, "Early Bronze 'Trinket' Moulds," *Iraq* 27 (1965): 42–61.

40. A close study of several molds might "confirm the general picture of merchants travelling from Mesopotamia across Anatolia to the coast at the end of the Third Millennium B.C." (Canby, "Trinket Moulds," *Iraq* 27 [1965]: 59).

resulted in the production of true glass.[41] These changes involved increasing the proportion of calcium, as well as heating all elements to a temperature of about 1060°C. so that a completely fused, viscous substance was formed.[42] This was then poured over or into molds to make a variety of objects, especially vessels, small figurines, and jewelry.[43] Decoration was often achieved by pulling out threads of cooling glass to create festoons, twists, and geometric patterns on the surface of the glass object.

The basis for the sophisticated technology of glass making is certainly to be found in the preceding centuries of experimentation with faience, glass paste, and other materials involving firing and casting.[44] Its development prior to the Late Bronze Age was perhaps only retarded by the lack of furnaces capable of maintaining and controlling such high temperatures.[45] A few examples of third millennium glass attest to limited early success in glass making.[46] It has been suggested that the first manufacture of glass was in northern Syria, whence it quickly spread to northern Mesopotamia and then to Egypt.[47] Though the earliest datable Egyptian

41. Glass has been defined as "a fourth state of matter that combines the rigidity of a crystal with the largely random molecular structure of a liquid" (Brill, "Ancient Glass," *SciAm* 209 [1963]: 120). Bronze Age glass conforms to this definition.

42. Brill, "Ancient Glass," *SciAm* 209 (1963): 126–27, especially the diagram on p. 126 of the probable evolution of glass. See my note 4 above to compare the firing temperatures suggested for faience. For another exposition of the evolution of glass, see K. Kühne, *Zur Kenntnis silikatischer Werkstoffe und der Technologie ihrer Herstellung* (Berlin, 1969), pp. 21–22 and fig. 14.

43. For discussions of ancient glass in general, see Forbes, *Ancient Technology* 5, pp. 112–236; for basic studies of Egyptian glass, see Lucas and Harris, *Materials*, pp. 179–94; Riefstahl, *Ancient Glass*, passim.

44. F. Schuler has charted the evolution of Egyptian glass making from the earliest pottery, faience, and core vessels to the blown ware of the Roman period in his study "Ancient Glass-making Techniques," *Archaeology* 15 (1962): 32–37. Mesopotamian glass has been treated in detail by H. Kühne in "Glas nach archäologischem Material," *Reallexikon der Assyriologie*, III, pp. 410–17.

45. References in cuneiform sources to furnace types for glass, metal, and ceramics have been collected by A. Salonen in "Die Öfen der alten Mesopotamier," *Baghdader Mitteilungen* 3 (1964), especially pp. 114–24.

46. These have been discussed by H. C. Beck in "Glass before 1500 B.C.," *Ancient Egypt and the East*, 1934, pp. 7–21. Of particular interest is a lump of preworked glass from Eridu, which suggests the presence of a glass works there during the Akkadian period. Furthermore, it is one of the earliest pieces to have been colored with cobalt, according to H. Garner ("An Early Piece of Glass from Eridu," *Iraq* 18 [1956]: 147–49).

47. The north Syrian origin of Egyptian glass making has been proposed by J. D. Cooney, among others, in his "Glass Sculpture in Ancient Egypt," *Journal of Glass Studies* 2 (1960): 11–44. A. L. Oppenheim has recently set forth philological material bearing on this theory in "Towards a History of Glass," *JAOS* 93 (1973): 259–66. Mekku, probably a West Semitic word meaning "stone," and eḫlipakku, another West Semitic word, denoting "precious stone," occur in texts from Qatna, Ugarit, and in the Amarna letters, indicating that the materials they represented were of some importance for the Levantine/Egyptian trade of the late Eighteenth Dynasty. According to Oppenheim, both are terms for glass paste made in north Syria as an imitation gemstone material and exported as such to Egypt. Ehlipakku, however, is not mentioned in the glass texts (see below, n. 49), and its components therefore are difficult to determine; mekku, most likely a quartzite element in faience and glass paste, is discussed more fully below.

glass admittedly shows some Mesopotamian influence in form and decoration, pieces of purely Egyptian type were made in quantity soon thereafter.[48] It seem likely that independent work in glass making began in several centers around 1600 B.C. and was an outgrowth of increasingly sophisticated faience techniques.

Of particular interest is the cuneiform glass text material,[49] discussed at greater length in section 2 below. These texts are the work of seventh century B.C. scribes, who presumably were copying much earlier material. Despite the wealth of lexical and other information in the texts, it is important to note that the scribes' primary intention was to maintain literary traditions rather than to preserve highly technical instructions for glass production.[50] In doing so, however, they collected unusual vocabulary and specific directions which enable a partial reconstruction of actual procedures.

One of the special features of glass was that it could be poured in a hot, viscous state over a metal core, removable once the glass had cooled sufficiently. Vessels made in this way, with their colorful thread designs and elegant bottle and goblet shapes, were popular in Mesopotamia and Egypt.[51] The few core-formed vessels from Cyprus are probably of Egyptian derivation, as are those from Syria and Palestine.[52] In the Aegean there was little core-vessel production, but instead a continuation of the traditional mold-casting methods, perhaps stimulated by the northern Mesopotamian glass-casting industry.[53] Cast or molded glass objects had a wide distribution, especially star-disc pendants, small plaques of nude females, and blue spacer beads.[54]

The development of the faience, glass paste, and glass industries is but one of many Bronze Age pyrotechnical advances. Others were achieved in such industries as glazing, plastering, and all types of metallurgical work.

48. T. E. Haevernick, "Assyrisches Millefioriglas," *Forschungen und Berichte, Archaeologische Beiträge* 10 (1968): 67.

49. A recent comprehensive edition of this corpus has been prepared by Oppenheim in his section "The Cuneiform Texts," in *Glass and Glassmaking in Ancient Mesopotamia* (Corning, 1970), pp. 4–101. See also his "More Fragments with Instructions for Glassmaking," *JNES* 32 (1973): 188–93. The terminology relating to faience and glass paste is discussed below in section 2.

50. J. D. Muhly has called attention to the relevant cautionary points in his review of Oppenheim's *Glass and Glassmaking* in *JCS* 24 (1972): 178–82. In his opinion, glass making "was to be seen as a craft for artisans, not as a source of knowledge to be recorded by scribes" (p. 181). Oppenheim, on the other hand, views the preservation of this technological information as the result of a "concerted effort of the Assyrian royal court to promote crafts considered at that time essential for royal prestige" ("Towards a History," *JAOS* 93 [1973]: 265). For amplification, see his remarks in *Glass and Glassmaking*, p. 6.

51. Extensive research on core-formed vessels has been done by D. Barag in "Mesopotamian Core-Formed Glass Vessels 1500–500 B.C.," in Oppenheim, *Glass and Glassmaking*, pp. 131–97 with complete catalogue and bibliography and "Mesopotamian Glass Vessels of the Second Millennium B.C.," *Journal of Glass Studies* 4 (1962): 9–27.

52. Åström, *Arts and Crafts*, p. 126.

53. Barag, "Core-Formed Vessels," in Oppenheim, *Glass and Glassmaking*, p. 193.

54. Barag, "Core-Formed Vessels," in Oppenheim, *Glass and Glassmaking*, pp. 188–93.

The development and products of each industry merit individual study. The interrelationships among these pyrotechnical industries pose complicated problems that also require special attention. Other topics deserving full treatment include possible technological relationships among the pyrotechnic al industries of different regions, such as the Aegean faience industry and the Egyptian glass industry. Investigations of this breadth, however, are beyond the scope of the present inquiry.

Section 2 FAIENCE TERMINOLOGY

Initial uncertainty as to the precise nature of Bronze Age faience, glass paste, and glass has led to some ambiguity in the modern terminology for these materials. The English word *faience* is derived from the name of the Italian town Faenza, which has produced a type of tin-glazed earthenware since the sixteenth century A.D.[55] *Faience* and its cognates in other languages[56] were first used for those ancient objects whose lustrous surfaces and colorful decoration were thought to resemble Faenza ware. Other words borrowed from terms for modern ceramics have been used to describe faience and glass paste. These include *porcelain*, *glaze*, *glazed ware*, and *glazed paste*. The first properly refers to a class of fine nonporous ware of kaolin, quartz, and feldspar, while glaze denotes any substance producing a smooth glassy coating on another surface after firing.[57] Paste is a soft plastic mixture, such as any of the moist clays used in making pottery, or it can denote the artificial gems made from glass and lead.

In an effort to be more specific, the terms *glazed siliceous ware* and *fritted siliceous ware* have sometimes been used. Siliceous ware, however, can describe a number of materials with a high silica content, encompassing most ceramics as well as glass and faience. Frit, on the other hand, properly refers to glass that has been melted and ground to a powder for addition to glazes or enamels.[58] This term has come to be identified with a dark blue, compact material also known as *Egyptian blue* and should be restricted to this usage.

Egyptian blue is an artificially made, crystalline silicate of copper and calcium with the chemical formula $CuO.CaO.4SiO_2$.[59] Like faience, its components were powdered, mixed with a binding agent, molded, and fired, with the difference that additional powdering and firing steps were added to the beginning of the procedure.[60] Egyptian blue closely resembles the Late Egyptian material often referred to as *glassy faience*,

55. A concise discussion of the development of Faenza ware appears in B. S. Myers, ed., *McGraw-Hill Dictionary of Art* (New York, 1969), vol. 2, p. 379; see also D.Whitehouse, "The Origins of Italian Maiolica," *Archaeology* 31 (1978): 42–49.

56. For instance, in German: *fayence*; French: *faïence*; Italian: *faenza*; Russian: *fajans* (фаянс); modern Greek: *phaventianon* (φαβεντιανόν).

57. For further references, see the entries under "Porcelain," (vol. 4, pp. 411–12) and "Ceramics," (vol. 1, pp. 529–31) in the *McGraw-Hill Dictionary*. Also see D. Rhodes, *Clay and Glazes for the Potter* (Philadelphia, 1973), part II, devoted to a study of glazes.

58. Rhodes, *Clay and Glazes*, pp. 196–200.

59. Brill, "Ancient Glass," *SciAm* 209 (1963): 123.

60. Forbes, *Ancient Technology* 5, pp. 112–14.

or *glassy frit*.[61] This seems to have been introduced during the Twenty-second Dynasty, coinciding with a decline in Egyptian glass manufacture.[62] The two materials are quite similar in appearance and were both used for pigments and jewelry. The chief distinguishing feature is that Egyptian blue crystals are pleochroic; when light rays vibrate parallel to their axes, they are a pale rose color, and when they vibrate perpendicular to their axes, the light rays are an intense blue.[63] Also, the composition of glassy faience, unlike that of Egyptian blue, cannot be expressed by a precise chemical formula.

Evidence for the Bronze Age terminology for faience, glass paste, and glass is afforded by textual material in Linear B, Egyptian, Sumerian, and Akkadian. Exact translations are often elusive and distinctions unclear, yet the identifiable Bronze Age words yield much information as to the contemporary descriptions of these materials' components, characteristics, uses, and special features.

The ku-wa-no of the Linear B records refers to glass paste and is the precursor of the later Greek word kyanos (κύανος). Ku-wa-no appears in two tablets belonging to the Pylos furniture series.[64] In Ta 642 is mentioned a nine-foot-long table "inlaid with aquamarines and kyanos and silver and gold."[65] An opulently decorated chair and matching footstool are described in Ta 714: "One chair of rock crystal, inlaid with kyanos and silver and gold on the back [which is] inlaid with men's figures in gold and with a pair of gold finials and with golden griffins and with griffins of kyanos. One footstool inlaid with kyanos and silver and gold and with golden bars."[66]

In the Citadel House at Mycenae were found five tablets listing ku-wa-no-wo-ko-i, "glass paste workers," among other craftsmen and workers.[67] The texts probably deal with disbursements of foodstuffs, either as regular rations or for specific occasions. Associated with these texts were various furnishings of the Citadel House platform shrine, most of which seem to reflect Minoan religious traditions.[68] This perhaps affords archaeological

61. Variant E of Lucas and Harris, *Materials*, pp. 164–65.

62. For examples of glassy faience, especially sculptures, and discussion of its characteristics, see Cooney, "Glass Sculpture in Ancient Egypt," *Journal of Glass Studies* 2 (1960): 32–39.

63. W. T. Chase, "Egyptian Blue as a Pigment and Ceramic Material," in R. H. Brill, ed., *Science and Archaeology* (Cambridge, Mass., 1968), p. 80.

64. Controversy has arisen over the purpose of the Ta furniture series, that is, whether it records the contents of a reception room or royal gifts or whether it lists the grave goods of a nobleman. M. Lindgren has presented the arguments in her study "Two Linear B Problems Reconsidered from a Methodological Point of View," *Opuscula Atheniensia* 8 (1968): 61–72, and has concluded, "There is nothing to prevent these objects existing without any connection at all with a tomb" (p. 72).

65. J. Chadwick, *Documents*² (Cambridge, 1973), pp. 339–40 (#239).

66. Chadwick, *Documents*², p. 344 (#244) and p. 502.

67. Chadwick, *Documents*², pp. 506–7 (#321).

68. For a report on the area of the platform shrine, see W. D. Taylour, "Mycenae," *Antiquity* 43 (1969): 91–97 and "New Light on Mycenaean Religion," *Antiquity* 44 (1970): 270–80.

evidence that some guilds of Minoan craftsmen may have set up workshops on the Greek mainland, bringing their native skills and cults with them.[69]

The Greek kyanos with the meaning "glass paste" occurs in several Homeric passages, particularly in descriptions of inlaid objects, such as Nestor's table (*Iliad* xi 629) and Atreides's cuirass, with its parallel strips of kyanos, gold, and tin (*Iliad* xi 15). The same combination of materials was used for the new armor of Achilles, which showed among other scenes a golden vineyard with grapes surrounded by a kyanos irrigation channel and a tin fence (*Iliad* xviii 548). Other Homeric references to the use of kyanos include the description of Alcinous's palace, which had high walls of bronze topped with kyanos tiles (*Odyssey* vii 84).

Considerable information about kyanos as lapis and glass paste is collected by Theophrastos in *De Lapidibus*.[70] The characteristics of lapis lazuli and its manufactured imitation are set forth in some detail, with special attention paid to the Egyptian product. Theophrastos notes: "Those who write the history of the kings of Egypt state which king it was who first made fused kyanos in imitation of the natural kind; and they add that kyanos was sent as tribute from Phoenicia and as gifts from other quarters."[71] In other Greek texts kyanos referred also to lustrous dark blue materials, such as azurite and niello and even seawater and cornflowers.[72]

The Mycenaean ku-wa-no is a cognate of the Hittite ku(wa)nnan.[73] Like kyanos, the Hittite word was used for dark blue materials, particularly beads, ornaments, and Hittite copper, which was probably derived from azurite ore.[74] Other cognates of ku-wa-no are the Akkadian uqnû, the Ugaritic iqni and the Sumerian ZA.GÌN.[75] This group of cognates probably stemmed from a common *Kulturwort* for lapis lazuli,[76] just as the English word faience and its cognates stem from the place name

69. Chadwick, *Documents²*, p. 507.

70. Sections 31 and 37 deal with genuine lapis lazuli; sections 39, 40, 51, and 55 are concerned with its artificial substitute. For translation and commentary, see Caley and Richards, *Theophrastos: On Stones*.

71. Theophrastos, section 55 (Caley and Richards translation). Unfortunately, his compilations preserve little more of the historical traditions about the manufacture and trade of faience and glass paste.

72. The important references have been collected and discussed by R. Halleux in "Lapis-lazuli, azurite ou pâte de verre?" *SMEA* 9 (1969): 47–66. See also the Greek lexica for kyanos as "blue corn-flower," "sea water," and "blue wall-creeper bird."

73. The basic study of the word and its occurrences is by A. Goetze, "Contributions to Hittite Lexicography," *JCS* 1 (1947): 307–11, with more recent remarks by E. Laroche, "Études de linguistique anatolienne," *RHA* 24 (1966): 180. See also J. D. Muhly, *Copper and Tin* (Hamden, Conn., 1973), p. 358, n. 57 for a suggested emendation of one of Goetze's examples from "a stick with copper fittings" to "a scepter (decorated) with blue glass paste."

74. Muhly, *Copper and Tin*, p. 176.

75. For a discussion of the Akkadian and Sumerian terms, see Oppenheim, "Texts," in *Glass and Glassmaking*, pp. 9–15. For the Ugaritic, see M. Dietrich and O. Loretz, "Der Vertrag zwischen Šuppululiuma und Niqmandu," *Welt des Orients* 3 (1966), p. 231 and n. 110.

76. Oppenheim, "Texts," in *Glass and Glassmaking*, p. 10, n. 14.

Faenza. In general, uqnû kūri (literally, "lapis from the kiln") denoted imitation lapis, while uqnû šadî (literally, "lapis from the mountain") referred to genuine lapis.[77] In several contexts ZA.GÌN was used to describe imitation lapis, such as in a Neo-Babylonian price text listing ZA.GÌN at a cost too inexpensive for it to be genuine,[78] and to denote Egyptian blue, such as on a Persian peg of that material with the inscription "peg of na4ZA.GÌN."[79] Occasionally the Sumerian KÙ.AN is linked with this group on the basis of interpreting its literal meaning, "metal of heaven," as "sky-blue metal."[80] Recent inquiry, however, has presented strong evidence that KÙ.AN usually refers to meteoritic iron.[81]

Other cognates include the Latin cyaneus, "dark blue, sea blue," and cyanus, "blue cornflower, blue-bottle," and "a precious stone, a type of lapis lazuli."[82] The Sanskrit çyânas, "smoke," and çyâmas, "dark," may also be cognates.[83]

Information about Egyptian terminology for faience, glass paste, and glass may be gleaned from a sizeable number of texts. The best documented of these terms, ṯḥnt, is generally written syllabically followed by the determinative 𝍇.[84] This sign represents a beaded pendant of a type presented to the new pharaoh, according to the Middle Kingdom coronation procedures set forth in the Ramesseum dramatic text.[85]

In one important context, ṯḥnt clearly denotes faience. This is the hieratic inscription on a large gold-rimmed faience vase from Tell el Yahudijeh. The text reads in part ". . . the gift of a vase of ṯḥnt and gold to the great Isis. . . ."[86] Elsewhere ṯḥnt seems to be used less specifically and may mean faience, glass paste, or glass.

Precious objects made of ṯḥnt appear frequently in the Harris Papyrus, a detailed statement of Rameses III's benefactions to the temples.[87] These

77. Oppenheim, "Texts," in Glass and Glassmaking, pp. 10–13.

78. Oppenheim, "Texts," in Glass and Glassmaking, p. 13.

79. Oppenheim, "Texts," in Glass and Glassmaking, p. 14.

80. Halleux, "Lapis-lazuli, azurite ou pâte de verre?" SMEA 9 (1969): 66.

81. J. K. Bjorkman, Meteors and Meteorites in the Ancient Near East (Tempe, 1973), pp. 110–14.

82. C. T. Lewis and C. Short, A Latin Dictionary (1966).

83. H. G. Liddell and R. Scott, A Greek-English Lexicon (1883). Also noted in Muhly, Copper and Tin, p. 357 n. 52.

84. For variant writings and the major occurrences, see the entries in A. Erman and H. Grapow, Wb V: 390–91, with the appropriate source references. In A. Gardiner's Sign List (Grammer, [Oxford, 1969]), the forms of the determinative are S15, 16, and 17. It was first identified by H. Schafer in "Altes und Neues zur Kunst und Religion von Tell el-Amarna," ZÄS 55 (1918), p. 26 n. 2.

85. K. Sethe, Dramatische Texte zur Altaegyptischen Mysterienspielen [= Untersuchungen X] (1928), sections 76–79, scene 24, discussion pp. 185–89. See also Wb V: 390 (9).

86. E. Naville, The Mound of the Jew and the City of Onas (London, 1890), pl. 8 and description pp. 29–30. It is difficult to date the vase precisely; Naville places it tentatively in the time of Piankhi (751–716 B.C.) and certainly later than the Twenty-second Dynasty. See Wb V: 390 (12); 391 (7).

87. W. Erichsen, Papyrus Harris I [= Bibliotheca Aegyptiaca V] (1933) (hereafter cited as Harris).

include seals,[88] beaded collars,[89] tassels serving as counterweights for collars,[90] and various sorts of beads, finger rings, and amulets.[91] Also listed are ṯḥnt šʿd hnw,[92] perhaps incised ṯḥnt vessels, or alternatively, vessels filled with cut or coarsely ground ṯḥnt.[93] If psḏt, "shiny," is read instead of šʿd, "cut," the phrase may indicate vessels of especially lustrous ṯḥnt.

Evidence that ṯḥnt was green or blue green is afforded by texts describing fields and leaves as ṯḥnt color.[94] Other information about ṯḥnt comes from a passage in the Salt Papyrus 825.[95] This discusses how magicians and priests are to model an Osiris figurine of îm by hand, and then to glaze it with ṯḥnt. Im has been tentatively identified as a generic term for plastic material;[96] ṯḥnt may refer to the solution of powdered quartz, natron, and copper compounds applied to the faience core before firing. The Ebers medical papyrus notes that ṯḥnt could be combined with additional natron[97] or used in its liquid state.[98]

The profession of ṯḥnt manufacturer is attested twice. A stela of the Thirteenth or Fourteenth Dynasty records the offerings made by Aba on behalf of his brother Mesu, îmy-r ṯḥnt, "overseer of ṯḥnt."[99] An Old Kingdom mastaba was built by an official whose titles included sḥm ḥwt ṯḥnt, "controller of the ṯḥnt workshop."[100] In several lists of stones the term ṯḥnt mꜣʿ, "real, genuine ṯḥnt," appears, which may indicate a type of mineral glass that occurs in the western desert.[101]

With the word ḥsbḏ "lapis lazuli," it is important to determine whether the real stone or its imitation is meant. In instances where ḥsbḏ is a pigment, the word must refer to finely ground glass paste, since lapis was not used as a coloring agent.[102] Archaeological evidence indicates that the ḥsbḏ window frames, hallways, and walls described in several New Kingdom texts denoted faience and not genuine lapis inlays.[103]

88. *Wb* V: 391 (6) = *Harris* 15b, 7; 34a, 5; 53b, 3.

89. *Wb* V: 391 (7) = *Harris* 62b, 8.

90. *Wb* V: 391 (7) = *Harris* 62b, 9.

91. *Wb* V: 391 (7) = *Harris* 15b, 8; 34a, 7; 53b, 1; 64b, 1–7.

92. *Wb* V: 391 (9) = *Harris* 15b, 8; 34a, 6; 53b, 2.

93. J. R. Harris, *Lexicographical Studies in Ancient Egyptian Minerals* (Berlin, 1961), p. 233. For a complete survey of the literature on ṯḥnt, see pp. 135–38. This work is comprehensive and particularly useful for its coverage of obscure, difficult, or unpublished texts. Much of the material that follows has been culled from its sections on semiprecious stones and pigments.

94. For a list of these contexts, see Harris, *Minerals*, p. 136, n. 9–13.

95. E. A. W. Budge, *Facsimiles of Egyptian Hieratic Papyri in the British Museum, Second Series* (London, 1923), pls. 31–40. See also *Wb* V: 390 (13).

96. *Wb* I: 78 (2), (3), with this definition suggested by Harris, *Minerals*, p. 200.

97. W. Wreszinski, *Der Papyrus Ebers* (Leipzig, 1913) 105, 15. See *Wb* V: 391 (18).

98. Wreszinski, *Ebers* 49, 21. Harris wonders if this was to be taken internally (*Minerals*, p. 137).

99. W. M. F. Petrie, *Tombs of the Courtiers and Oxyrhynkhos* (London, 1925), pl. 29 (7).

100. Harris, *Minerals*, p. 136.

101. Harris, *Minerals*, p. 137 nn. 10–11.

102. Harris, *Minerals*, pp. 148–49.

103. Harris, *Minerals*, pp. 128–29.

It is possible to identify ḥsbḏ as imitation lapis in several other cases. Ḥsbḏ wḏḥ, "molten lapis," clearly refers to a substance produced during one of the manufacturing stages of glass, glass paste, or faience.[104] In the same context is mentioned mfkȝt wḏḥ, "molten turquoise,"[105] probably a faience or glass paste imitation of that semiprecious stone.[106] Among the tribute lists compiled together with the records of Thutmosis III's campaigns is an enumeration of ḥsbḏ mȝʿ, "genuine lapis"; ḥsbḏ nfr n bbr, "beautiful lapis from Babylon"; and ḥsbḏ iryt, "manufactured lapis."[107]

There are two attestations of the craftsman's title irw ḥsbḏ, "maker of lapis."[108] One of these, Edinburgh 449, was written on a small piece of good-quality blue glass paste. Perhaps this was a sample of the workshop's output intended to encourage patronage.

As seen above, wḏḥ, "molten," in conjunction with the names of stones and minerals, can indicate that a manufactured imitation was meant. This is probably the case with the inrw ʿšȝw n wḏḥ, "many stones of molten material," which are listed among Thutmosis III's Asiatic tribute.[109] J. R. Harris has pointed out that perhaps "the reference is to some type of artificial gem produced in Syria which the Egyptians did not recognize as faience."[110] One entry in the Harris Papyrus distinguishes between ʿȝt wḏḥ, "molten stones," and ʿȝt nbt, "genuine stones."[111] The contrasting phrases provide still another example of Egyptian terminology attempting to differentiate between artificial and natural materials.

Wȝḏ, a general term for green pigment whose color is usually due to the presence of malachite, should perhaps be added to the list of terms concerned with faience, glass paste, and glass. Ḥsb n wȝḏ, "crushed material of green [malachite]," occurs in the Book of the Dead as a substance, possibly faience, from which a barque is to be made.[112] The same phrase appears in the Edfu mineral lists, where the substance seems to have served as a coloring agent for faience.[113] As yet there is insufficient textual evidence to include ššyt nt wȝḏ, "green pigment of malachite," in this group.[114]

Imyt and ḥmt should also be mentioned here. The former occurs in an obscure context as "a form of decoration the virtue of which lay in its resistance to heat and damp. . . ."[115] Though a special type of faience or glass paste might be indicated, imyt plausibly refers to a technique of

104. *Wb* III: 334 (11) = *Harris* 64b, 8.

105. *Wb* II: 56 (7) = *Harris* 64b, 9.

106. According to Harris (*Minerals*, p. 110), this should perhaps be identified with Lucas's Variant D, faience with a hard blue or green body (*Materials*, pp. 163–64).

107. S. Steindorff, *Urkunden des ägyptischen Altertums* IV: 701 (33rd year, 8th campaign).

108. *Wb* III: 334 (7). Both Cairo WB #110 and Edinburgh 449 are published in the *Wb Belegstellen* III, p. 99.

109. *Wb* I: 98 (5) = S. Steindorff, *Urkunden* IV: 695 (31st year, 7th campaign).

110. Harris, *Minerals*, p. 99.

111. *Wb* I: 165 (21) = *Harris* 73, 13.

112. Harris, *Minerals*, p. 144 n. 19.

113. Harris, *Minerals*, p. 144 nn. 17 and 18.

114. Harris, *Minerals*, p. 143 n. 17, and pp. 152–53.

115. Harris, *Minerals*, p. 98.

relief or inlay work. A third possibility is that the word is related to im, which, as noted above, is a generic term for plastic material. A few occurrences of ḥmt, "copper," have been tentatively identified as references to green glass paste or faience, based primarily on its use in granular form for seals and pigments.[116]

Before considering the cuneiform glass texts, brief note should be made of the Ugaritic and Hebrew word spsg, "glaze." In the Ugaritic myth of Anath and Aqhat, the hero Aqhat cries out: "Glaze will be poured on my head," perhaps referring to hot molten faience, glass paste, or glass.[117] The word also occurs in Proverbs 26:23: "Like glaze crusted over pottery are smooth lips and an evil heart."[118] The Hittite zapzagai- is based on the same root. This word appears in a ritual text dealing with the setting forth of various types of vessels.[119] The Akkadian zabzabgû appears in an Akkadian pseudoscholarly text, a so-called Silbenvokabular.[120] In W. F. Albright's discussion of spsg, he has drawn attention to the next line of the Anath myth, "and ḥrṣ poured on my head," and has pointed out that perhaps ḥrṣ shares a common root with the Arabic ḥuruḍ, "alkali plant, potash made from its ash."[121] Since this is a necessary component of faience, glass paste, and glass, Albright has proposed that ḥrṣ be translated as "molten glass," though there is no reason to exclude molten faience or glass paste.

The cuneiform tablets known as the glass texts provide a rich source of information for the terminology and methodology used in production of several Mesopotamian materials.[122] There are difficulties, however, that impede their elucidation. In addition to the large percentage of rare or unique words, the obscure references to ritual and chemical procedures, and the lack of clearly defined typological sequences, there is also the underlying problem of interpretation. As A. L. Oppenheim has pointed out:

> These texts cannot be taken simply as technical instructions and studied as such ... their wording and their literary form were historically conditioned, and their evaluation in this context is of critical importance to the understanding of the texts.[123]

116. *Wb* III: 86 (15), (17); 87 (1). See also the discussion in Harris, *Minerals*, p. 117 nn. 10–17.

117. H. L. Ginsberg, "The North Canaanite Myth of Anath and Aqhat," *BASOR* 98 (1945), p. 21 n. 55. He was also the first to propose the meaning "glaze" for the difficult passage in Prov. 26:23.

118. W. F. Albright, "A New Hebrew Word for 'Glaze' in Proverbs 26:23," *BASOR* 98 (1945): 24.

119. *Keilschrifturkunden aus Boghazköi* VII: 48 obv. 9–13.

120. *CAD Z*, p. 10.

121. Albright, "Word for 'Glaze'," *BASOR* 98 (1945): 24–25.

122. The entire corpus has been recently organized and edited by Oppenheim in "Texts" in *Glass and Glassmaking*. The section that follows here is based on this detailed and comprehensive work, with text references given as they appear there.

123. Oppenheim, "Texts," in *Glass and Glassmaking*, p. 4. See also notes 49 and 50 above.

The following discussion should be considered with these cautions in mind.

The majority of the glass texts seems to deal with the manufacturing of completely fused and homogeneous true glass, as it has been defined in section I. The texts mention consistently high temperatures, which are to be maintained over an extended period. They note how the air should whistle when it escapes from the red-hot kiln. They describe how the foaming, boiling glass is to be tested for viscosity by means of tongs and pincers, and how the material should be reground and refired several times, with other ingredients added in intermediate stages.

The intent of this discussion of the glass texts is to focus on the ingredients and methods connected with faience and glass paste manufacture. Oppenheim singled out the terms anzaḫḫu, būṣu, zukû, and tuzkû and labeled them "primary, alkali-silicate glasses." His choice was based chiefly on the occurrence of these terms in a lexical list of the seventeenth/eighteenth century B.C., attesting to a preglass knowledge of these words.[124] As the names for Oppenheim's categories imply, he understood these substances occupied intermediate positions and were neither raw materials nor finished glass. A close examination of these terms' interrelationships, in conjunction with the accompanying diagrams, may serve to identify these terms more precisely with faience, glass paste, and their principal components.

Recipes for the manufacture of būṣu, zukû, tuzkû, and dušû involve grinding, combining, and firing several sets of five ingredients. These are NAGA, immanakku, Ú.BABBAR, namrūtu, and anzaḫḫu. The first of these components, NAGA, has been identified with an alkaline plant also attested in connection with whitening linen and soap production.[125] NAGA plant ashes and Egyptian natron served the same purpose in faience manufacture, both furnishing the requisite sodium carbonate. Immanakku is described in a first millennium lexical series as being "like river silt dotted with pebbles" and is mentioned elsewhere as a hard conglomerate stone used for cylinder seals.[126] It seems likely, as Oppenheim has suggested, that this should be taken as a general term for silicate stones,[127] perhaps coarse sand.

Ú.BABBAR, literally "white plant," is defined in a medical text as "the name of the sap of the poplar tree."[128] The composition of poplar sap, especially in the spring, is such that it could have been readily made into a paste or adhesive substance.[129] This would have been ideal as a binding agent, just as gum tragacanth is used today for the blue beads made in Qom, Iran. Namrūtu, a white calcinated material made from

124. Oppenheim, "Texts," in *Glass and Glassmaking*, pp. 18–21, 84–85.

125. J.-P. Grégoire, *Archives Administratives Sumériennes* (Paris, 1970), p. 63; W. Ph. Römer, *Sumerische "Königshymnen" der Isin-Zeit* (Leiden, 1965), p. 191.

126. *CAD I*, pp. 127.

127. Oppenheim, "Texts," in *Glass and Glassmaking*, p. 74.

128. Oppenheim, "Texts," in *Glass and Glassmaking*, p. 75 n. 91.

129. Personal communication, F. Mergen, Yale School of Forestry, who kindly explained some of the chemical properties of poplar trees.

red coral, provided a good alternative for alkalies because of its high calcium content.[130]

The meaning of anzaḫḫu is more difficult to define. In the glass texts it seems to appear in place of immanakku with two exceptions, Alpha Group B§14 and Beta Group D§P. This suggests that it might be a type of quartzite, perhaps coarser than immanakku. Occurrences in other cuneiform texts indicate that it was used to make bowls and ornaments as early as the Ur III period; adjectives associated with it are "unwashed, washed" and, curiously, "male, female."[131] The gender distinction may reflect the Aegean and Egyptian color convention for painted art works in which females are white and males red. Female anzaḫḫu might mean white quartzite, and male anzaḫḫu, red or pink quartzite.[132]

According to the glass texts, būṣu (diagram 1) was made either by combining, grinding, and firing namrūtu and anzaḫḫu (Alpha Group B§20) or NAGA, namrūtu, anzaḫḫu, and immanakku (Alpha Group B§14 and Beta Group D§P). Būṣu, therefore, probably denotes faience, a meaning supported by its contexts elsewhere. In the Middle Assyrian period, būṣu appears in texts describing tableware, inlaid statues, and containers for oil.[133]

Two derived products were made from būṣu: reddish lapis lazuli glass and zagindurû, "lapis-colored glass." The former was produced by combining būṣu with tersītu and immanakku (Alpha Group §12). Tersītu is probably glass paste and was manufactured by combining zukû and copper coloring compounds. This will be discussed further in connection with the zukû group (diagram 2). Zagindurû, "lapis-colored glass," was produced in several ways. Būṣu and tersītu were combined (Alpha Group §15) or būṣu, tersītu, NAGA, and namrūtu (Alpha Group §6). A third way was to mix būṣu, tersītu, namrūtu, and immanakku (Alpha Group §7). To būṣu, namrūtu, tersītu, and Ú.BABBAR were sometimes added coloring material and anzaḫḫu (Alpha Group §8). Still another combination involves būṣu, tersītu, NAGA, namrūtu, and anzaḫḫu (Alpha Group §3).

The second major set of formulae is the zukû group (diagram 2). As was the case with būṣu, zukû was made from a combination of immanakku and NAGA (Alpha Group §4), with Ú.BABBAR sometimes added (Alpha Group §1). It thus seems probable that zukû was likewise a term for faience.

Zukû's derived product was principally tersītu. This was made by regrinding zukû and by adding this to URUDU.HI.A nēḫu (Alpha Group §2 and §5). The term URUDU.HI.A nēḫu, literally "slow" copper, has been discussed at length.[134] Its function here was to introduce a blue

130. Oppenheim, "Texts," in *Glass and Glassmaking*, p. 79.

131. For further references, see *CAD A/2*, p. 151.

132. There is evidence from Greek sources to support this view. Theophrastos (section 31) states: "One kind of kyanos is called male and the other female, and the male is the darker of the two." Other examples of classical authors' sex distinctions of stones are given by Caley and Richards in *Theophrastos*, pp. 124–26.

133. *CAD B*, pp. 348–49.

134. Oppenheim, "Texts," in *Glass and Glassmaking*, pp. 76–77.

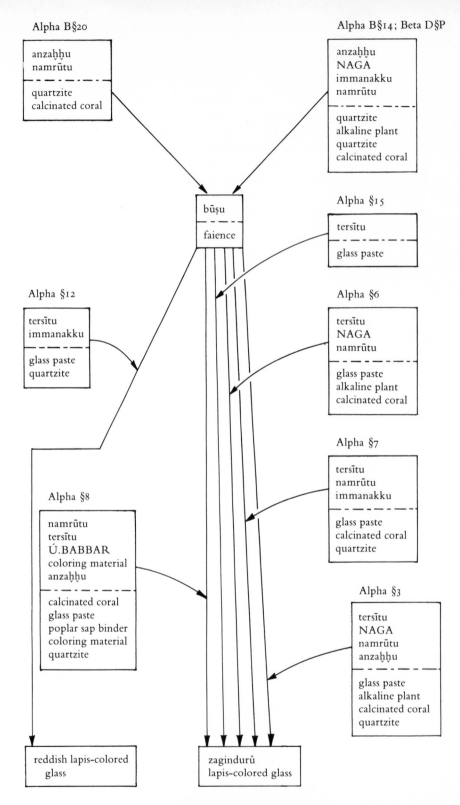

Alpha B§20

anzaḫḫu
namrūtu
- - - - - - -
quartzite
calcinated coral

Alpha B§14; Beta D§P

anzaḫḫu
NAGA
immanakku
namrūtu
- - - - - - -
quartzite
alkaline plant
quartzite
calcinated coral

būṣu
faience

Alpha §15

tersītu
- - - - - - -
glass paste

Alpha §12

tersītu
immanakku
- - - - - - -
glass paste
quartzite

Alpha §6

tersītu
NAGA
namrūtu
- - - - - - -
glass paste
alkaline plant
calcinated coral

Alpha §7

tersītu
namrūtu
immanakku
- - - - - - -
glass paste
calcinated coral
quartzite

Alpha §8

namrūtu
tersītu
Ú.BABBAR
coloring material
anzaḫḫu
- - - - - - -
calcinated coral
glass paste
poplar sap binder
coloring material
quartzite

Alpha §3

tersītu
NAGA
namrūtu
anzaḫḫu
- - - - - - -
glass paste
alkaline plant
calcinated coral
quartzite

reddish lapis-colored
glass

zagindurû
lapis-colored glass

DIAGRAM 1 Būṣu Group

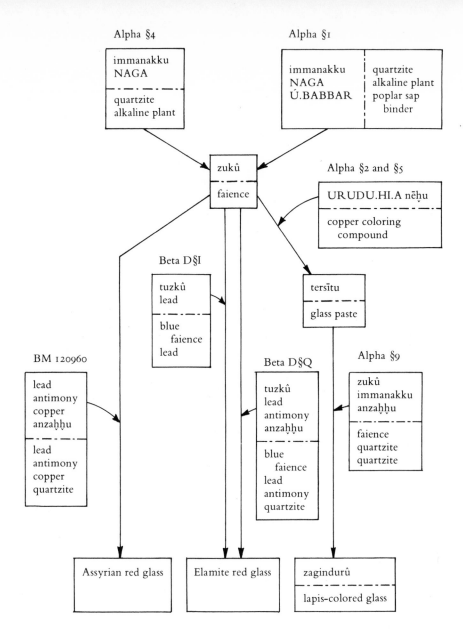

Alpha §4

immanakku
NAGA
- - - - - - - - -
quartzite
alkaline plant

Alpha §1

immanakku | quartzite
NAGA | alkaline plant
Ú.BABBAR | poplar sap
| binder

zukû
faience

Alpha §2 and §5

URUDU.HI.A nēḫu
- - - - - - - - -
copper coloring
compound

Beta D§I

tuzkû
lead
- - - - - -
blue
faience
lead

tersītu
- - - - - -
glass paste

BM 120960

lead
antimony
copper
anzaḫḫu
- - - - - -
lead
antimony
copper
quartzite

Beta D§Q

tuzkû
lead
antimony
anzaḫḫu
- - - - - -
blue
faience
lead
antimony
quartzite

Alpha §9

zukû
immanakku
anzaḫḫu
- - - - - -
faience
quartzite
quartzite

Assyrian red glass

Elamite red glass

zagindurû
- - - - - -
lapis-colored glass

DIAGRAM 2 Zukû Group

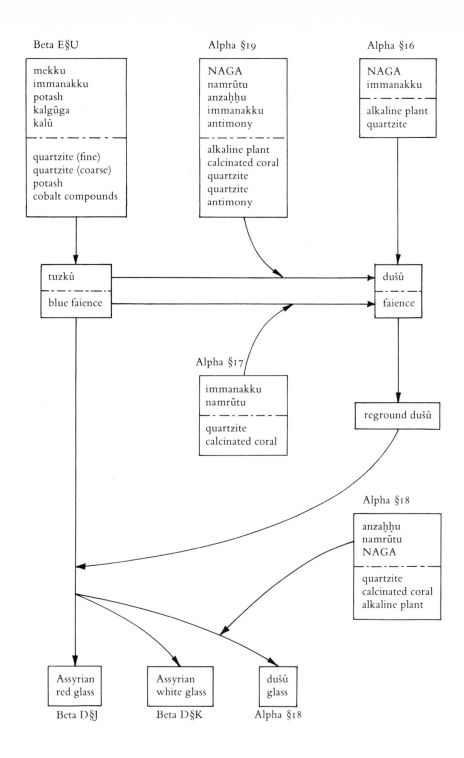

Beta E§U

mekku
immanakku
potash
kalgūga
kalû
- - - - - - - - -
quartzite (fine)
quartzite (coarse)
potash
cobalt compounds

Alpha §19

NAGA
namrūtu
anzaḫḫu
immanakku
antimony
- - - - - - - - -
alkaline plant
calcinated coral
quartzite
quartzite
antimony

Alpha §16

NAGA
immanakku
- - - - - - - - -
alkaline plant
quartzite

tuzkû
- - - - - - - - -
blue faience

dušû
- - - - - - - - -
faience

Alpha §17

immanakku
namrūtu
- - - - - - - - -
quartzite
calcinated coral

reground dušû

Alpha §18

anzaḫḫu
namrūtu
NAGA
- - - - - - - - -
quartzite
calcinated coral
alkaline plant

Assyrian
red glass

Beta D§J

Assyrian
white glass

Beta D§K

dušû
glass

Alpha §18

DIAGRAM 3 Tuzkû/Dušû Group

coloring material. Tersītu, therefore, should probably be identified as blue glass paste.

When tersītu was reground and refired with zukû, immanakku, and anzaḫḫu, the lapis-colored glass zagindurû resulted (Alpha Group §9). Another true glass, Elamite red, was the product of zukû, tuzkû, and lead (Beta Group D§I) or zukû, tuzkû, lead, anzaḫḫu, and antimony (Beta Group D§Q). Assyrian red, a third true glass of the zukû group, was manufactured by combining zukû with lead, antimony, copper, and anzaḫḫu (BM 120960 §i, ii).

The ingredients and interrelated products of tuzkû and dušû form a third major group (diagram 3). The components of tuzkû were mekku, immanakku, potash in mineral form, kalgūga, and kalû (Beta Group E§U). There is some evidence to suggest that mekku was made from milḫu, probably a type of stone that, according to a Neo-Babylonian commentary, was equated with anzaḫḫu.[135] If anzaḫḫu is quartzite, then mekku might well be a more finely powdered quartzite. Kalgūga and kalû have been identified with cobalt compounds,[136] rendering the meaning of tuzkû, blue faience.

According to one recipe, NAGA and immanakku were the constituents of dušû (Alpha Group §16), which therefore is another term for faience. Dušû could also be made by combining immanakku, namrūtu, and tuzkû (Alpha Group §17) or by mixing namrūtu, NAGA, tuzkû, anzaḫḫu, immanakku, and antimony (Alpha Group §19).

Three derived true glasses resulted from a mixture of dušû and tuzkû: Assyrian red (Beta Group D§J); Assyrian white (Beta Group D§K); and dušû-glass, which is composed additionally of anzaḫḫu, namrūtu, and NAGA (Alpha Group §18).

The following is a tentative glossary of the cuneiform words relevant to this study of faience:

anzaḫḫu:	quartzite, perhaps finely ground
būṣu:	faience
dušû:	faience
dušû (reground):	faience or glass paste
immanakku:	quartzite, perhaps sand
kalgūga:	potash
kalû:	cobalt compounds
mekku:	quartzite, perhaps finely powdered
NAGA:	alkaline plant
namrūtu:	calcinated coral
tersītu:	blue glass paste
tuzkû:	blue faience
Ú.BABBAR:	poplar sap binder
URUDU.ḪI.A nēḫu:	copper coloring compound
zukû:	faience

135. Oppenheim, "Texts," in *Glass and Glassmaking*, p. 57. See also my note 47 above.
136. *CAD K*, p. 95.

2

Chronological
and Geographical Survey
of Faience Distribution

THE SURVEY OF FAIENCE manufacture and distribution begins at the end of the fifth millennium and concludes at the end of the Bronze Age in the second millennium.[1] Its geographical scope is equally wide, for faience has been found not only in the Near East and Aegean, but as far east as the Indus Valley and northern India, as far west as Scandinavia and the British Isles, as far north as Siberia, and as far south as East Africa.

What were the principal centers of faience production in each millennium? What geographical patterns of faience manufacture can be elucidated? What reasons can be suggested for intensive production in one area and scarcity or lack of faience in another? Can distinctions be drawn between locally made faience and imported objects? Is there evidence for workshops or itinerant craftsmen?

The earliest known faience has been recovered from late fifth millennium levels at two northern Mesopotamian sites, Tepe Gawra and Tell Arpachiyah. At Tepe Gawra, faience, glazed steatite, obsidian, carnelian, and marble beads were found in levels XIX to XVI, dated 4300 to 3900 B.C.[2] A faience discoid pendant as well as faience beads were found in contemporaneous levels at the nearby site of Tell Arpachiyah.[3] On the basis of the proximity of the two sites and in the absence of faience antedating these finds, one can conclude that faience was first invented in this area of northern Mesopotamia. The finding of this early faience together with glazed steatite jewelry and ornaments supports the theory outlined in

1. This section owes much to J. F. S. Stone, "The Use and Distribution of Faience in the Ancient East and Prehistoric Europe," *PPS* 22 (1956):39–61. I have adopted his method of presenting the material millennium by millennium. It has not been possible to see firsthand much of the faience discussed in this chapter. Specialists in the regions and periods involved will wish to emend the list of faience pieces, adding new ones and perhaps categorizing others as nonfaience.

2. A. J. Tobler, *Excavations at Tepe Gawra* II (Philadelphia, 1950), p. 192. For the dating of these levels, see E. Porada, "The Relative Chronology of Mesopotamia," in *COWA*, pp. 176–77.

3. M. E. L. Mallowan and J. C. Rose, "Excavations at Tall Arpachiya," *Iraq* 2 (1935): 92, 97.

chapter 1, section 1 that faience developed from the manufacture of glazed steatite objects.[4]

During the fourth millennium, the faience industry flourished and expanded in northern Mesopotamia. Throughout the period a variety of beads, inlays, seals with geometric designs, and pendants was produced at Tepe Gawra.[5] The presence of a few faience beads in Ninevite burials indicates gradual dissemination from the original centers of faience production.[6] Toward the end of the fourth millennium, many thousands of faience beads were deposited in thick layers at Nineveh,[7] Tell Brak,[8] and Tepe Gawra.[9] At that time a center of production was established at Nineveh, evidenced by the unworked faience found there together with finished products. In addition to the standard repertory of spherical and hexagonal shapes, several new bead types were made at Nineveh. Among these were inverted drop pendants, imitation tooth pendants, and the so-called crumb beads made of small aggregates of faience.[10]

At Tell Brak an enormous number of faience beads, amulets, and figurines was deposited beneath the platform of the Grey Eye Temple, along with alabaster "eye-idols" and other small stone amulets. The find is remarkable not only for the quantity but also for the great diversity of the faience objects. Many animal figurines were found, such as hedgehogs, hares, ducks, bears, and monkeys, as well as skillfully molded rosettes, trees, and models of kidneys.[11] There were elaborate fluted, double conoid, and segmented beads.[12] This collection of precious objects is one of the earliest of a class of foundation deposits laid down for ceremonial reasons or to enhance the value of the building.[13] The extensive use of faience as part of foundation procedures provides further evidence of the well-established faience industry in northern Mesopotamia.[14]

4. For further discussion of the glazed steatite industry, see H. C. Beck, "Notes on Glazed Stones," *Ancient Egypt and the East*, 1934, part I, pp. 69–83; 1935, part II, pp. 19–37.

5. Tobler, *Tepe Gawra* II, pp. 87, 89, 192–93, 178, 195.

6. R. C. Thompson and M. E. L. Mallowan, "The British Museum Excavations at Nineveh 1931–1932," *AAA* 20 (1933), pl. 79.

7. H. C. Beck, "Beads from Nineveh," *Antiquity* 5 (1931):427–37.

8. M. E. L. Mallowan, "Excavations at Brak and Chagar Bazar," *Iraq* 9 (1947):33, 254–56.

9. E. A. Speiser, *Excavations at Tepe Gawra* I (Philadelphia, 1935), pp. 133–35; and A. L. Perkins, *The Comparative Archaeology of Early Mesopotamia* (Chicago, 1949), p. 187.

10. Drawings of some of the more unusual types appear in Beck, "Beads from Nineveh," *Antiquity* 5 (1931):429, 433.

11. Mallowan, "Excavations at Brak," *Iraq* 9 (1947), pls. 10, 14, 16, 17.

12. Mallowan, "Excavations at Brak," *Iraq* 9 (1947), pls. 27, 28, 84.

13. R. S. Ellis has studied the subject in detail in *Foundation Deposits in Ancient Mesopotamia* (New Haven, 1968), esp. pp. 131–40. In other periods there were often complicated arrangements of beads and other objects, as at the late thirteenth century Ishtar Temple at Assur (pp. 98, 138), or standardized numbers of beads to be placed in the offering boxes, as at late third millennium Uruk and Nippur (p. 68).

14. This contradicts Perkins's statement that the Brak faience pieces were "imports from the South or made by Southern craftsmen in the North" (*Comparative Archaeology*, p. 188). Faience appeared in the north more than a millennium earlier than it did in the south; it seems to have been the north, in fact, which encouraged southern Mesopotamian faience production.

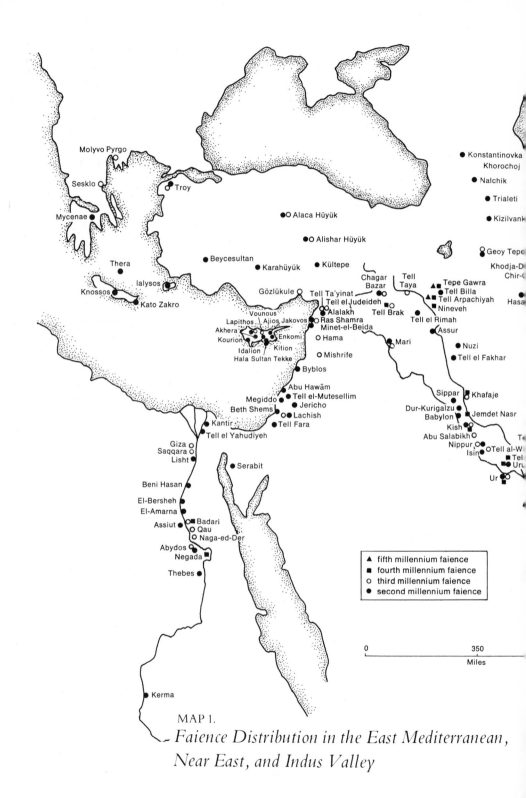

MAP 1.

*Faience Distribution in the East Mediterranean,
Near East, and Indus Valley*

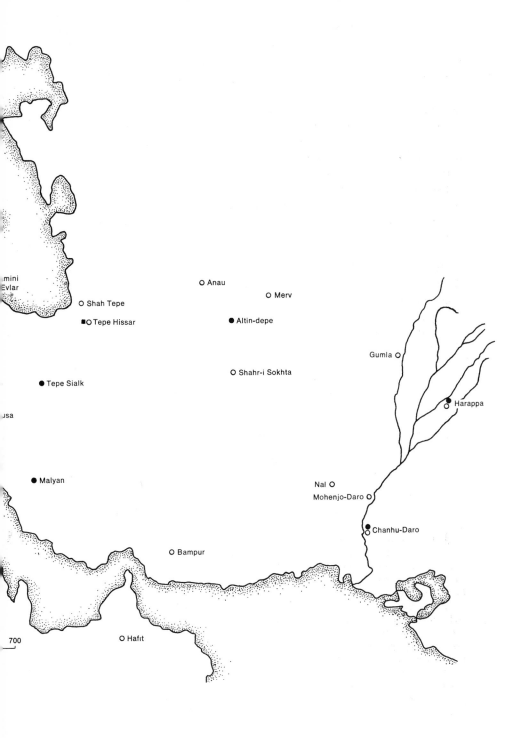

mini
Evlar

O Anau

O Merv

O Shah Tepe

■O Tepe Hissar ● Altin-depe

Gumla O

● Tepe Sialk O Shahr-i Sokhta

usa

 ● Harappa

● Malyan

 Nal O
 Mohenjo-Daro O

 ● Chanhu-Daro

O Bampur

700 O Hafit

Another center of production developed in southern Mesopotamia at the end of the fourth millennium, certainly stimulated by the north. The beads, amulets, bracelets, anklets, and other ornaments from Jemdet Nasr,[15] Kish,[16] and Ur[17] closely resemble northern products. Some new forms evolved, such as the vasiform pendant.[18] From the Eanna IV levels at Uruk was recovered an unusual group of long, thin faience seals with geometric patterns.[19] The chief innovation of the southern industry was the production of miniature faience vases. Two of these have been found at Khafaje,[20] and one example from Ur has an impressed chevron pattern in a band around its shoulder.[21] Faience seals and beads have been found in Iran in fourth millennium levels at Susa[22] and Tepe Hissar.[23] By the end of the fourth millennium, faience had been widely distributed to the south and east of its place of origin in northern Mesopotamia.

Whether or not the technique of faience manufacture spread southwest from Mesopotamia to Egypt is a difficult question to resolve. On the one hand, the appearance of faience in fourth millennium Upper Egyptian Predynastic contexts[24] coincides with the appearance there of other Mesopotamian techniques, artifacts, and styles. These include pottery types and designs, agricultural implements, glyptic, recurring motifs on slate palettes, and architectural features.[25] In addition, there is some evidence for mapping fourth millennium sea and land routes connecting Mesopotamia and Egypt.[26] On the other hand, reassessment of Egyptian

15. E. Mackay, *Report on Excavations at Jemdet Nasr* (Chicago, 1931), pp. 272–76.

16. For a complete guide to the grave goods from the A Cemetery, see P. R. S. Moorey, "Cemetery A at Kish: Grave Groups and Chronology," *Iraq* 32 (1970): 105–28.

17. C. L. Woolley, *Ur Excavations* IV (London, 1955), pp. 66–68.

18. Vasiform pendants were found at Khafaje, Telloh, and Jemdet Nasr in the south and in the north only at Tepe Gawra (Perkins, *Comparative Archaeology*, pp. 33, 147).

19. Perkins, *Comparative Archaeology*, p. 141.

20. Perkins, *Comparative Archaeology*, p. 153.

21. Woolley, *Ur Excavations* IV, pp. 30, 63.

22. J. de Morgan, "Observations sur les couches profondes de l'acropole à Suse," *MDP* 13 (1912), figs. 22–23.

23. E. F. Schmidt, *Excavations at Tepe Hissar Damghan* (Philadelphia, 1937), pp. 61, 118; and "Tepe Hissar: Excavations of 1931," *The Museum Journal* 23 (1933): 355, 362.

24. G. Brunton and G. Caton-Thompson, *The Badarian Civilisation and Predynastic Remains near Badari* (London, 1928), p. 56 and pls. 49, 50; W. M. F. Petrie, *Prehistoric Egypt* (London, 1920), p. 42.

25. Detailed studies of this material have been done by P. Amiet, "Glyptique Susienne archaïque," *RAssyr* 51 (1957): 126–29; E. J. Baumgartel, *The Cultures of Prehistoric Egypt* I (Oxford, 1947), passim; H. J. Kantor, "Further Evidence for Early Mesopotamian Relations with Egypt," *JNES* 11 (1952): 239–50; and "Egypt and Its Foreign Correlations," in *COWA*, pp. 6–14 and fig. 3, p. 27; J. Kaplan, "The Connections of the Palestinian Chalcolithic Culture with Prehistoric Egypt," *IEJ* 9 (1959): 134–36; S. Yeivin, "Early Contacts between Canaan and Egypt," *IEJ* 10 (1960): 193–203.

26. A direct sea route from Mesopotamia to Upper Egypt has been suggested by Kantor in "Further Evidence," *JNES* 11 (1952): 250, and by G. A. Wainwright, "Early Magan," *Antiquity* 37 (1947): 307–9, among others. W. Helck has proposed an overland route in his volume *Die Beziehungen Ägyptens zu Vorderasien im 3. und 2. Jahrtausend v. Chr.* (Wiesbaden, 1962), pp. 6–9. Recent investigations have pointed to a land route through southern Sinai (A. Ben-Tor, "Palestine and Egypt at the Dawn of the Bronze Age," paper presented at the American Oriental Society meetings, 17 March 1976).

material has indicated that Mesopotamia exerted far less influence than hitherto surmised.[27] Much of this material has demonstrable Egyptian antecedents for style and characteristics. The same might well be true of the earliest Egyptian faience. Its development may have been indigenous and independent, arising from successful experiments with glazed steatite and improved firing capabilities, as in northern Mesopotamia.

By the end of the fourth millennium, there were two major centers of faience production, one in northern Mesopotamia and one in Upper Egypt. A subsidiary center had been established in southern Mesopotamia. This pattern continued in the third millennium, with the addition of an important eastern center of production in the Indus Valley. The wide distribution of faience from these four centers resulted from the expanding network of third millennium commercial connections.[28]

A variety of beads, buttons, pendants, and seals was produced in third millennium northern Mesopotamia and Syria. This material comes chiefly from Tell Taya,[29] Chagar Bazar,[30] Tell Brak,[31] and Hama.[32] The Akkadian levels at Tell Taya also yielded several well-made faience bowls, a jar lid, and a container with a rim perforated for suspension.[33] From the same levels came a fragment of a blue beard,[34] similar in design and workmanship to the lapis beards on the animal-headed lyres and harps from Ur. The substitution of faience for lapis lazuli and other valuable materials became increasingly common in the north as a means of providing imitation luxury goods at relatively little cost. This combination of economic and aesthetic considerations is the principal reason for the type and quantity of faience objects produced in northern Mesopotamia.

In the last third of the third millennium, a class of beads known as "duck beads" appeared at Tell Brak,[35] Chagar Bazar,[36] Tell Taya,[37] Mishrife (Qatna),[38] and Lachish.[39] Texts from this period mention small stone or

27. See A. J. Arkell and P. J. Ucko, "Review of Predynastic Development in the Nile Valley," *Current Anthropology* 6 (1965): 145–66; Kantor, "Egypt and its Foreign Correlations," in *COWA*, pp. 13–14.

28. For a comprehensive survey of Mesopotamian trade in the third millennium, see G. Pettinato, "Il commercio con l'estero della Mesopotamia Meridionale nel 3. millennio av. Cr.," *Mesopotamia* 7 (1972): 43–166. See also A. L. Oppenheim, "Trade in the Ancient Near East," *Fifth International Congress of Economic History* (Moscow, 1970): 1–37.

29. J. E. Reade, "Tell Taya (1972–73): Summary Report," *Iraq* 35 (1973), pl. 67b.

30. M. E. L. Mallowan, "The Excavations at Tall Chagar Bazar and an Archaeological Survey of the Ḥabur Region," *Iraq* 3 (1936): 56–57.

31. M. E. L. Mallowan, "Revelations of Brilliant Art in North-East Syria over 4000 Years Ago," *ILN*, 15 October 1938, pp. 697–701.

32. C. F. A. Schaeffer, *Stratigraphie Comparée* (London, 1948), p. 109. For the faience cylinder seals found at Hama, see H. Ingholt, *Sept Campagnes de Fouilles à Hama en Syrie* (Copenhagen, 1940), p. 23 and pl. VI 8, 10.

33. Reade, "Tell Taya," *Iraq* 35 (1973), pl. 75 d. One of these vessels retained the marks of the tripod on which it had rested in the kiln; another had fragments of coarsely ground copper on its surface, perhaps the work of apprentice or inferior craftsmen (p. 184).

34. Reade, "Tell Taya," *Iraq* 35 (1973), pl. 68 b.

35. Mallowan, "Revelations," *ILN*, 15 October 1938, pp. 698–99.

36. Mallowan, "Chagar Bazar," *Iraq* 3 (1936), fig. 7, nos. 27, 29.

37. Reade, "Tell Taya," *Iraq* 35 (1973), pl. 67 b.

38. Schaeffer, *Stratigraphie Comparée*, p. 116 and fig. 99.

39. O. Tufnell, *Lachish IV and V: The Bronze Age* (Oxford 1958), p. 74.

ivory bird-shaped objects called DAR.me-luh-ha [mušen], literally "colored bird of Meluhha," among the products of lapidary and other workshops.[40] I suggest that this name refers also to the faience "duck beads" and that the ornaments represent hens, not ducks.

This suggestion is made for several reasons. The land of Meluhha was almost certainly located in the area of Afghanistan and the Indus Valley.[41] Native to that region is the red jungle fowl, which was domesticated first in the Indus in the third millennium.[42] By the end of that period, domesticated fowl had been introduced to Mesopotamia; the earliest Egyptian reference to hens dates from the mid-second millennium.[43] It seems likely, therefore, that the "colored bird of Meluhha" referred to a domesticated species of fowl and that its name reflected the bird's origin.[44] Moreover, faience, stone, terra-cotta, and ivory representations of these birds are common in the Indus and bear a strong resemblance to the "duck beads."[45] The popularity of hen-shaped objects in Mesopotamia, Syria, and Palestine may have been because of the somewhat exotic nature of these birds, or because of some special significance attached to them. Most of the beads show hens with flat undersides and are perhaps meant to represent nesting or brooding fowl.

From north Mesopotamia, faience was distributed to third millennium sites in central Anatolia, the southern Caucasus, and the plain of Antioch. Segmented, disc, and spherical beads were found in the mid-third millen-

40. L. Legrain, *Ur Excavations, Texts* III (London, 1947), 1498. i. 6; 757.5; 761.3; 768.7; 776.5.

41. For recent studies on the location of Meluhha, see I. J. Gelb, "Makkan and Meluḥḥa in Early Mesopotamian Sources," *RAssyr* 64 (1970): 1–8; R. Thapar, "A Possible Identification of Meluḥḥa, Dilmun and Makan," *JESHO* 18 (1975): 1–42; K. Jaritz, "Tilmun-Makan-Meluḥḥa," *JNES* 27 (1968): 209–13.

42. F. E. Zeuner, *A History of Domesticated Animals* (London, 1963), pp. 443–45. More recent study also shows that "chickens ... were not present as domesticates in the late prehistoric of the Near East" (C. A. Reed, "Animal Domestication in the Prehistoric Near East," in S. Streuver, ed., *Prehistoric Agriculture* [Garden City, N.Y., 1971], pp. 435–36.

43. Zeuner, *Domesticated Animals*, pp. 444–45. An unusual New Kingdom spoon has a carved hen and rooster at opposite ends of the handle (G. D. Hornblower, "The Barndoor Fowl in Egyptian Art," *Ancient Egypt and the East*, 1934–35, p. 82). A late Eighteenth or early Nineteenth Dynasty ostracon bears an accurately drawn rooster (H. Carter, "An Ostracon Depicting a Red Jungle Fowl," *JEA* 9 [1923]: 1–4).

44. The meaning "peacock" has been suggested by W. F. Leemans in *Foreign Trade in the Old Babylonian Period* (Leiden, 1960), pp. 161–64, 165; and by M. E. L. Mallowan, "The Mechanics of Ancient Trade in Western Asia," *Iran* 3 (1965): 5. "Francolin" or "black partridge" has been proposed by B. Landsberger in "Einige unerkannt gebliebene oder verkannte nomina des Akkadischen," *Welt des Orients* 3 (1966): 247. "Hen" has been in fact put forward by A. Salonen in *Vögel und Vögelfang im alten Mesopotamien* (Helsinki, 1973), pp. 155–56, but without a satisfactory explanation for the bird's connection with Meluhha.

45. Among many examples, see E. Mackay, *Further Excavations at Mohenjo Daro* (Delhi, 1937), pls. 74 #5, 9, 10; 77 #12; 81 #17; 125 #19; J. Marshall, *Mohenjo-Daro and the Indus Civilization* (London, 1931), p. 349; M. S. Vats, *Excavations at Harappa* (Delhi, 1940) pp. 300–309; pl. 78 #1, 4, 13, 16, 18, 19. Indus Valley faience is discussed at greater length below.

nium royal tombs at Alaca Hüyük.[46] Contemporaneous levels at Alishar Hüyük yielded disc beads, incised pendants, and a small vessel with two perforated knob handles.[47] Among the grave goods at Geoy Tepe in Azerbaijan were faience barrel, discoid, and tubular beads, and an unusual hub-shaped bead.[48] Faience beads were found at several sites in the plain of Antioch, mainly from the Early Bronze levels of Tell el Judeideh and Tell Ta'yinat,[49] and to the northwest at Gözlükule (Tarsus).[50] From the Ishtar Temple levels at Mari were recovered a few faience beads and a bowl similar to those mentioned above from Tell Taya.[51]

In quantity of objects manufactured, southern Mesopotamia continued as a subsidiary center of faience production in the third millennium. The explanation for this must be that precious and semiprecious stones, gold, and silver were readily available to southern craftsmen owing to the active trade carried on by the southern cities.[52] Demand for luxury goods such as lapis could be met more easily than in the north, and the need for faience imitations was correspondingly less acute.

As a result, the special and unique characteristics of faience, in particular its color variations, surface luster, and malleability, were explored more fully in the south. Sophisticated lapidary and goldsmith techniques were applied to faience manufacture, and technically difficult and innovative pieces were produced. In the Early Dynastic cemeteries at Kish, for instance, were found elaborate faience cylinders with spiral inlays of bitumen, perhaps intended as handles to be fitted on metal tangs.[53] Also recovered at Kish were faience cylinder seals, beads, spindle whorls, and heads of hairpins.[54] The private houses in the scribal quarter at Nippur yielded ninety-six unusual faience inlays in the shapes of triangles and also a faience cone.[55] Small groups of well-made faience beads have been found beneath

46. Stone, "Use and Distribution," *PPS* 22 (1956):45.

47. E. F. Schmidt, *The Alishar Hüyük* (Chicago, 1932), figs. 101, 197.

48. T. B. Brown, *Excavations in Azarbaijan* (London, 1951), pp. 111–13, 118–19, 128–29, 130, and pl. 22. The tombs have been dated to the middle of the third millennium.

49. R. J. and L. S. Braidwood, *Excavations in the Plain of Antioch* I (Chicago, 1960), pp. 341–42; 394–95; 426–27.

50. Schaeffer, *Stratigraphie Comparée*, pp. 272, 275. The Gözlükule finds have been dated to 2300–2100 B.C.

51. A. Parrot, *Les Temples d'Ishtarat et de Ninni-Zaza* (Paris, 1967), pp. 279–80 and pl. 52 #1047.

52. See M. Lambert, "Le destin d'Ur et les routes commerciales," *RStO* 39 (1964): 90–91 for an assessment of southern trade, particularly the importance of Ur in the third millennium. Archaeological and textual evidence for trade in grain, cloth, leather, perfumes, and the like has been collected by H. E. W. Crawford, "Mesopotamia's Invisible Exports in the Third Millennium," *World Archaeology* 5 (1973):232–41, with emphasis on the role of the southern cities. For a study of the artifacts, texts, and theories of Near Eastern trade in this period, see P. L. Kohl, "The Balance of Trade in Southwestern Asia in the Mid-Third Millennium B.C.," *Current Anthropology* 19 (1978):463–92.

53. E. Mackay, *The "A" Cemetery at Kish* II (Chicago, 1929), p. 134 and pl. 43, fig. 2.

54. Mackay, *"A" Cemetery* II, pp. 133–34; *"A" Cemetery* I (Chicago, 1925), p. 55. Early Dynastic III graves at the nearby site of Abu Salabikh yielded amygdaloid and cylindrical faience beads (J. N. Postgate and P. R. S. Moorey, "Abu Salabikh," *Iraq* 38 [1976], pp. 167, 159; pl. 27 c).

55. D. E. McCown, R. C. Haines, D. P. Hansen, *Nippur* I (Chicago, 1967), p. 105 and pl. 153:21. See also pp. 97–98 for Nippur faience beads.

the ziggurat terrace at Ur[56] and in the Akkadian levels at Tell al-Wilayah.[57]

An important center of faience production was established in the Indus Valley in the third millennium. The appearance of faience there coincided with the development of the mature Indus civilization.[58] Part of the impetus for this development came from Mesopotamia[59] by way of an overland route across Iran, southern Turkmenistan, northern Afghanistan, and into the Upper Indus Valley,[60] and a sea route through the Arab/Persian Gulf and along the southern coast of Iran and Pakistan.[61]

The discovery of faience at third millennium sites in Iran and Afghanistan has made it possible to trace its overland spread from Mesopotamia to the Indus Valley. Segmented and lentoid beads, pendants, seals, and spacer beads were found at Tepe Giyan to the north of Susa.[62] Further north and east, Tepe Hissar yielded a number of faience objects, including beads, pendants, and several miniature vessels, one of which has an incised geometric design.[63] At the nearby site of Shah Tepe were found faience beads and spacers, a vase, and an unusual flower-shaped button.[64] Further east at Anau and Merv, a few faience beads were recovered from third millennium levels.[65] Faience has also been found in graves at Shahr-i Sokhta, an important entrepôt of one of the major caravan routes.[66]

56. Woolley, *Ur Excavations* IV, p. 43; and II (London, 1934), pls. 131–35. See also K. R. Maxwell-Hyslop, "The Ur Jewelry," *Iraq* 22 (1960):105–15.

57. T. A. Madhlum, "Ḥafriyyātu Tall al-Wilāyah," *Sumer* 16 (1960) (Arabic portion): 91–92.

58. Recent study of early Indus sites indicates that the terms *early Indus, mature Indus,* or *early Harappan, mature Harappan* more accurately reflect the archaeological record than the terms *pre-Indus* and *pre-Harappan.* See M. R. Mughal, "New Evidence of the Early Harappan Culture from Jalipur, Pakistan," *Archaeology* 27 (1974):106–13; and B. K. Thapar, "New Traits of the Indus Civilization at Kalibangan," in N. Hammond ed., *South Asian Archaeology* (London, 1973), pp. 84–104.

59. The relationship between the "idea and stimulus-diffusion from Mesopotamia" and the "genius loci" has been discussed by B. K. Thapar in "New Traits," *South Asian Archaeology,* p. 91.

60. See figure 14, p. 342, in M. R. Mughal's University of Pennsylvania dissertation, "The Early Harappan Period in the Greater Indus Valley and Northern Baluchistan" (1970), and also the maps pp. 12–13 in A. H. Dani's study "Origins of Bronze Age Cultures in the Indus Basin," *Expedition* 17 (1975).

61. The evidence for the sea route has been assembled by E. C. L. During Caspers in "New Archaeological Evidence for Maritime Trade in the Persian Gulf During the Late Protoliterate Period," *East and West* 21 (1971), p. 22 and n. 5. G. Dales has also stressed the importance of the maritime link in his study "Harappan Outposts on the Makran Coast," *Antiquity* 36 (1962):86–92.

62. D. B. Harden, "Pottery and Beads from Near Nehavand, Northwest Persia, in the Ashmolean Museum," *Ancient Egypt and the East,* 1935, pl. IV, p. 79.

63. Schmidt, *Tepe Hissar,* pp. 223, 229–30; and "Tepe Hissar," *Museum Journal* 23 (1933):431, 438.

64. J. Arne, *Excavations at Shah Tepe, Iran* (Stockholm, 1945), figs. 601–10, 642, and pl. 76.

65. R. Pumpelly, *Explorations in Turkestan* (Washington, 1908), pp. 160, 200; on p. 173 he reports "glazed pottery" from an uncertain context at Anau.

66. M. Piperno and M. Tosi, "The Graveyard of Shahr-i Sokhta, Iran," *Archaeology* 28 (1975), graves 7 and 8.

It is more difficult to trace the dissemination of faience along the maritime route, partly because the intermediary points were established as distribution centers for goods, rather than as potential markets for luxury products.[67] At Bampur, however, a complete necklet of faience was found.[68] Third millennium graves at Hafit in the Buraimi Oasis of Oman have yielded over fifty segmented and cylindrical faience beads.[69]

In the Indus Valley itself, faience has been found in abundance at Mohenjo-Daro, Chanhu-Daro, and Harappa, as well as at Nal and Gumla. A wide variety of amulets,[70] beads,[71] buttons,[72] pendants,[73] and hemispherical necklace terminals[74] was found at Mohenjo-Daro. Also recovered from that site were flower-shaped hairpin heads,[75] solar ornaments,[76] and large numbers of inlays, some decorated with grooves, rosettes, and bands.[77] Many species of faience animals and birds were discovered at Mohenjo-Daro, including squirrels, hares, rams, monkeys, sheep, dogs, as well as doves, hens, ducks, and peacocks.[78] Miniature vessels, boxes, and toilet jars were found in quantity.[79] It is unlikely that these were children's playthings because of their fine workmanship and attention to detail, and they may have served instead as containers for cosmetics and perfumes or as votive offerings.[80]

Additional evidence for large-scale faience manufacture at Mohenjo-Daro is provided by two kilns on the southwest wing of the palace.[81] These lack the necessary vents or drafts for fusing copper, and they bear traces of ledges too closely spaced to have held trays of ceramics, but ideal

67. The characteristics of this "central place trade" have been set forth by C. C. Lamberg-Karlovsky in "Trade Mechanisms in Indus-Mesopotamian Interrelations," *JAOS* 92 (1972):222–29. At places such as Bahrein and Tepe Yahya, merchants acted as middlemen in the transshipment of goods between distant areas such as Mesopotamia and the Indus.

68. B. de Cardi, "Excavations at Bampur," *Anthropological Papers of the American Museum of Natural History* 51 (1970), pp. 330–31 and fig. 47 (8), (9).

69. K. Frifelt, "A Possible Link Between the Jemdet Nasr and the Umm an-Nar Graves of Oman," *Journal of Oman Studies* I (1975):61, 63, 65–66.

70. Mackay, *Further Excavations at Mohenjo-Daro*, pp. 350, 355–63, and pl. 90, #16, 18.

71. Mackay, *Mohenjo-Daro*, pp. 495–97, 515–22.

72. Mackay, *Mohenjo-Daro*, pp. 542–44.

73. Mackay, *Mohenjo-Daro*, p. 522.

74. E. Mackay, "Further Links between Ancient Sind, Sumer and Elsewhere," *Antiquity* 5 (1931):459–73, especially 462.

75. Marshall, *Mohenjo-Daro and the Indus Civilization* II, pl. 158 #4, 6.

76. Mackay, *Mohenjo-Daro*, pl. 111 #11, 23, 24.

77. Marshall, *Mohenjo-Daro and Indus* II, pp. 570–74 and pl. 155, #68, 69; pl. 157 #13–53. Mackay, *Mohenjo-Daro*, pl. 111 #67, 68; pl. 91 #12; pl. 92 #1.

78. Marshall, *Mohenjo-Daro and Indus* I, pp. 346–55 and pl. 90 #7. Mackay, *Mohenjo-Daro*, pl. 74 #20, 6, 9; pl. 77 #8, 9, 13, 19, 20; pl. 78 #2, 4, 9; pl. 80 #1, 3, 13, 24. See also note 45 above.

79. Mackay, *Mohenjo-Daro*, pl. 56 #24; pl. 105 #34, 35; pl. 106 #10, 25; pl. 107 #2, 3; pl. 142 #46, 47. Marshall, *Mohenjo-Daro and Indus* II, pp. 365–66; pl. 101.

80. So Mackay suggests in *Mohenjo-Daro*, pp. 318–20.

81. Mackay, *Mohenjo-Daro*, pp. 49–50.

for trays of small faience objects. Further evidence is provided by the finding at Mohenjo-Daro of numerous slabs of faience apparently set aside for regrinding.[82]

Further south at Chanhu-Daro faience was also produced in quantity. Many of the pieces closely resemble those from Mohenjo-Daro, such as the necklace terminals,[83] pendants,[84] buttons,[85] miniature vessels,[86] and animal figurines.[87] Some are more unusual, such as the nose plugs,[88] gamesmen,[89] and a set of tetrahedron weights.[90]

Large numbers of faience objects were recovered from Harappa in the upper Indus Valley. Among the pieces are beads, buttons and brooches,[91] miniature vessels, including one with a perforated bottom,[92] seals,[93] and animal figurines.[94] Eight brick-lined, pear-shaped kilns were excavated at Harappa, all of which were fairly small and had evidently been used for intensive firing at high temperatures, since the brick surfaces were almost vitrified.[95] These may well have been used for manufacturing faience or possibly for glazing steatite or etching carnelian.

From these three Indus centers of faience production, faience was distributed to other sites in the Indus Valley. A small group of beads was found at Nal, a settlement to the northwest of Mohenjo-Daro.[96] At Gumla in the Gomal Valley, faience beads and a button similar to those from Harappa were found.[97] Faience beads and bangles have been discovered as far east as Alamgirpur, an outpost six hundred miles east of Mohenjo-Daro.[98]

The explanation for the abundance of Indus faience may be tied to the role of Afghanistan and the Indus Valley in supplying Mesopotamia with lapis lazuli. Both at Chanhu-Daro and Shahr-i Sokhta were found lapidary tools and drills for polishing and cutting, holders for beads, and numerous containers filled with semiprocessed lumps of lapis.[99] Close

82. Mackay, *Mohenjo-Daro*, p. 583 and pl. 111 #56, 66; Marshall, *Mohenjo-Daro and Indus* II, pl. 154 #2, 3.

83. Mackay, *Chanhu-Daro Excavations* (New Haven, 1943), pl. 80 #21–25, pl. 85 #32.

84. Mackay, *Chanhu-Daro*, pp. 202–8, 210, and pls. 80, 85, 89.

85. Mackay, *Chanhu-Daro*, pp. 26, 63, 197.

86. Mackay, *Chanhu-Daro*, pp. 48, 57, 139.

87. Mackay, *Chanhu-Daro*, pp. 35, 60.

88. Mackay, *Chanhu-Daro*, pp. 197–98.

89. Mackay, *Chanhu-Daro*, pp. 35, 43, 55, 57, 169–70.

90. Mackay, *Chanhu-Daro*, pp. 244–46.

91. Vats, *Excavations at Harappa*, pp. 403–6, 437.

92. Vats, *Harappa*, pp. 111, 311–12, and pl. 82 #10.

93. Vats, *Harappa*, pp. 328–35, passim.

94. Vats, *Harappa*, pp. 300–309, passim.

95. Vats, *Harappa*, pp. 470–74.

96. S. Piggott, *Prehistoric India* (Baltimore, 1961), p. 92.

97. A. H. Dani, *Excavations in the Gomal Valley* [= *Ancient Pakistan* 5] (1970–71), pp. 47, 86–87.

98. M. Wheeler, *The Indus Civilization* (Cambridge, 1968), p. 66.

99. E. Mackay, "Bead-making in Ancient Sind," *JAOS* 57 (1937): 1–15; M. Tosi, "Excavations at Shahr-i Sokhta," *East and West* 19 (1969), pp. 371–74 and figs. 248–58; Piperno and Tosi, "The Graveyard of Shahr-i Sokhta," *Archaeology* 28 (1975):186–97.

study of the lapis recovered at Shahr-i Sokhta suggests that the stone was semirefined at that site, not far from its source,[100] and then shipped to Mesopotamia.[101] This implies that the resulting savings in transportation costs must have been greater than the workshop charges for processing.[102] This also means that it would have been more lucrative to export lapis than to retain it for local use, since high or inflated prices could easily have been charged by the refining centers.[103] Faience, therefore, was probably produced in the Indus as a lapis substitute, not because the more valuable material was unavailable, but because it was more profitable to export true lapis lazuli to the much wealthier markets in the west.

Egypt continued to be an important center of faience manufacture in the third millennium. Under pharaonic patronage, technically and artistically innovative faience objects were produced. These include the small, skillfully modeled human and animal figurines of faience, ivory, and stone found in an Early Dynastic deposit at Abydos[104] and a set of gold and faience amulets recovered from a First Dynasty grave at Naga-ed-Der.[105] The largest of these scarab-shaped amulets was inlaid with a faience design "of the crossed arrows and shields of the Delta Goddess Neith of Sais, on a standard."[106] Another interesting piece, from an Early Dynastic royal tomb at Abydos, is a wooden chairback with a geometric design of faience triangles.[107]

A large number of brilliant blue faience tiles was used along the galleries of the subterranean passageways of the Third Dynasty Step Pyramid at Saqqara.[108] The tiles were apparently intended to simulate windows hung with reed matting. One of the most striking uses of faience in the Fourth Dynasty may be seen on the chair, bed, and chest of Hetep-heres,

100. See notes 27 and 28 in chapter 1 for work on the sources of lapis lazuli.

101. M. Tosi, "Lithic Technology behind the Ancient Lapis Lazuli Trade," *Expedition* 15 (1973):15–23.

102. P. L. Kohl's stylistic and technical study of "Carved Chlorite Vessels: A Trade in Finished Commodities in the Mid-Third Millennium," *Expedition* 18 (1975):18–31 has suggested that somewhat different economic considerations governed the stone vessel trade. He argues, "The fact that luxury articles, like the carved chlorite vessels, were produced in far-distant lands increased their value and made such trade all the more attractive" (p. 31). For another stylistic study, see F. A. Durrani, "Stone Vases as Evidence of Connection between Mesopotamia and the Indus Valley," *Ancient Pakistan* 1 (1964): 51–96.

103. As for the price of lapis, it is interesting to note that lapis does not appear in the standard merchants' account texts of the Ur III period, nor are there any Sargonic prices attested for lapis. Only two Ur III texts mention lapis; these give its price as 11,520 grains of silver and 162,000 grains of silver for one mina of lapis, or .5 kg. (personal communication, D. C. Snell).

104. W. S. Smith, *The Art and Architecture of Ancient Egypt* (Baltimore, 1965), p. 14; also Metropolitan Museum of Art 03.4.16 and 59.109.1–9 are representative Early Dynastic faience figurines and inlays.

105. G. A. Reisner, *The Early Dynastic Cemeteries of Naga-ed-Der* I (Leipzig, 1908), pls. 6, 8.

106. Smith, *Art and Architecture*, p. 27.

107. W. M. F. Petrie, *The Royal Tombs of the First Dynasty* I (London, 1900), pl. 37 #76; and II (London, 1901), pls. 43 #22; 44 #10.

108. J.-P. Lauer, *La Pyramide à Degrés* (Cairo, 1936), pp. 36–38.

the mother of Cheops. The furniture was encrusted with faience, gold, silver, and semiprecious stones in a rich variety of geometric and stylized designs.[109] Later in the Old Kingdom, faience reproductions of Early Dynastic stone beads with spirals in relief became popular at Qau and Badari.[110]

Just as faience gradually spread eastward to the Indus Valley in the third millennium, so did it spread westward to the East Mediterranean in the same period. The question of the origin of the earliest faience found on Crete is discussed in greater detail in chapter 3, section 1 below. This material consists of cylindrical and spherical beads from Early Minoan Mesara tombs,[111] convex-sided tubular beads from the Trapeza cave,[112] and pear-shaped and tubular beads and a badly corroded faience bowl, now disintegrated, from a rich Early Minoan Mochlos tomb.[113] On the Greek mainland, at Molyvo Pyrgo in Chalcidice, a necklace of one pear-shaped faience bead and tooth, claw, and bone beads has been dated to the middle of the Early Bronze Age.[114] Since the stone axes and pottery found at Molyvo Pyrgo resemble those from the Troad,[115] the faience bead was probably imported from there. Late third millennium contexts at Troy have yielded several spherical faience beads,[116] themselves imported from eastern Anatolia or northern Syria.

The same is probably true for the origin of the faience beads found in the Early Cypriote II/III tombs at Vounous on the north coast of Cyprus. In addition to bronze weapons and tools and gold, silver and stone jewelry, spherical and globular faience beads were recovered from half a dozen tombs.[117] The affluence indicated by the necropolis finds may be attributed to the site's important copper mining and smelting activities towards the end of the third millennium.[118] Contemporaneous and slightly later tombs at Lapithos, also on the north coast, have yielded necklaces with spherical and globular beads and occasionally with bronze clasps.[119] The presence of faience beads at Vounous and Lapithos attests to an expansion

109. Smith, *Art and Architecture*, p. 51 and figs. 19, 20, 21 c.

110. G. Brunton, *Qau and Badari* II (London, 1928), pp. 23–24.

111. S. Xanthoudides, *The Vaulted Tombs of Mesara* (Manchester, 1924): Koumasa, pp. 31, 48; Porti, p. 69; Kalathiana, p. 84; Platanos, pl. 58.

112. M. B. Money-Coutts, "The Cave of Trapeza: Miscellanea," *BSA* 36 (1935–36), pl. 19 e and fig. 26 e.

113. R. B. Seager, *Explorations in the Island of Mochlos* (Boston, 1912), pp. 35, 53, and fig. 25.

114. W. A. Heurtley and C. A. R. Radford, "Two Prehistoric Sites in Chalcide, I," *BSA* 29 (1928), pp. 149–50 and fig. 29.

115. Heurtley and Radford, "Two Sites," *BSA* 29 (1928):181.

116. C. W. Blegen, *Troy II: The Third, Fourth and Fifth Settlements* (Princeton, 1951), p. 215.

117. P. Dikaios, "The Excavations at Vounous-Bellapis in Cyprus 1931–2," *Archaeologia* 88 (1940), pp. 8, 36, 46, 47, 53, 69 and fig. 15.

118. V. Karageorghis, *Cyprus* (London, 1969), p. 112.

119. E. Gjerstad, *The Swedish Cyprus Expedition* I (Stockholm, 1934), pp. 93–95, 148–54 passim; V. Grace, "A Cypriote Tomb and Minoan Evidence for its Date," *AJA* 44 (1940), pp. 49–50 and fig. 31 #28, 30, 69, 79.

in Cypriote contacts with the northern Levant and to an increase in Cypriote wealth.

Two points about second millennium faience should be kept in mind. First, small faience objects, especially beads, acquired in this period a certain commercial value as attractive, inexpensive trinkets, and as such they found their way to nearly every part of the world known to Near Eastern traders. Second, faience was recognized and exploited, notably in Egypt and the Aegean, as a medium with particular characteristics. This may be attributed to the growing specialization of craftsmen in the second millennium, to more skillful application of techniques, and to increasingly more sophisticated taste.

Nearly every Middle Kingdom Egyptian site has yielded faience jewelry, amulets, scarabs, household dishes, and human and animal figurines. Small faience offering stands and vessels were often accompanied by faience models of fruit and vegetables displayed on separate tiles.[120] Tiles were also used as ornamental revetments on doors and windows.[121] Mirror handles, sistra, playing pieces for *senet* games, and maceheads were frequently made of faience.[122] Amulets, dishes, scarabs, and plaques were placed as foundation deposits beneath the Twelfth Dynasty pyramids at Lisht.[123] Of interest are the well-made kohl pots and salve jars from the tombs at El-Bersheh,[124] a cosmetic container in the form of a falcon from northern Thebes,[125] and an infant's feeding cup ornamented with bands of animals.[126]

It was in the Middle Kingdom that the small figures of hippopotami covered with plant and geometric designs became popular. These have been studied in some detail with regard to their botanical information and their analogies with open faience bowls with vegetal patterns.[127] Other decorated figurines include a tattooed dancing girl found in a Middle Kingdom Theban tomb[128] and an ithyphallic figurine wearing a kilt with spiral patterns resembling Minoan designs and a net side panel and shoulder straps of Nubian type.[129] It is unclear whether this figurine was intended to represent a Minoan envoy, a foreign slave, a Cretan resident in Egypt, or a political cartoon.

The hoard of Middle Kingdom faience found at Kerma is noteworthy

120. W. C. Hayes, *The Scepter of Egypt* I (New York, 1953), pp. 201, 336–38 and fig. 225; F. W. von Bissing, *Fayencegefässe* (Vienna, 1902), #3662–65. W. C. Hayes's work provides a rich source of information on Egyptian art objects from many sites and museums, not only those in the Metropolitan Museum.

121. Hayes, *Scepter* I, pp. 257–58.

122. Hayes, *Scepter* I, pp. 241, 248, 250, 283.

123. Hayes, *Scepter* I, pp. 176, 184, 193.

124. von Bissing, *Fayencegefässe*, #3631–35, 3641–61.

125. von Bissing, *Fayencegefässe*, #3667.

126. Hayes, *Scepter* I, p. 247.

127. M. L. Keimer, "Remarques sur l'Ornementation des Hippopotames en Faïence du Moyen Empire," *Revue de l'Égypte Ancienne* 2 (1930):214–53.

128. Hayes, *Scepter* I, p. 202.

129. E. Riefstahl, "An Enigmatic Faience Figure," *Miscellanea Wilbouriana* 1 (1972): 137–43.

for the general excellence of the workmanship. A wide variety of beads, amulets, animal figurines, boat models, vessels, and inlays was recovered,[130] as well as fragments of a frieze depicting lions, palmettes, and Nubian captives.[131] Evidence for faience manufacture at Kerma is provided by the discovery of improperly fired, imperfect pieces and setter pebbles for supporting objects in the kilns. In addition, many of the faience vessels are of types derived from local forms.[132] The industry was probably established there in order to supply faience to regions further south, chiefly in exchange for gold and copper.[133] Faience has in fact been found in a mid-second millennium Nakuru burial near Lake Victoria.[134]

Kerma faience is also remarkable for its extensive use of Mediterranean spiralform designs, presumably copied from Minoan and Syrian textiles and pottery.[135] This was encouraged and perhaps introduced by Hepzefa, a governor of Kerma, who was inspired by Middle Minoan pottery designs to paint the ceiling of his Assiut tomb with elaborate spirals, scrolls, and plant stems on a dark background.[136] The effect was repeated in one of the Kerma chapels, where six-lobed shapes of blue faience were inlaid in stone.[137] Other Kerma inlays and vessels were decorated with the connected spirals, single and garlanded palmettes, and interlocking plant and net patterns[138] characteristic of Aegean designs.[139]

New Kingdom faience production was stimulated by the growth of Egyptian interest in elegant and sometimes ostentatious details of dress, possessions, and surroundings.[140] Quantities of faience amulets, scarabs, beads, bracelets, pendants, counterpoises and collar terminals, gameboards

130. G. A. Reisner, *Excavations at Kerma*, (Cambridge, Mass., 1923), pp. 134–75.

131. W. S. Smith, *Interconnections in the Ancient Near East* (New Haven, 1965), fig. 60 (reconstruction drawing).

132. Reisner, *Kerma*, p. 17.

133. Smith, *Art and Architecture*, p. 40. P. C. Smither's study of a group of documents sent from the cataract fort at Semnah to high officials at Thebes affords insight into the mechanics of this trade ("The Semnah Dispatches," *JEA* 31 [1945]:3–10). The records left by Egyptian traders and private citizens in Nubia have been examined by J. Vercoutter in "Upper Egyptian Settlers in Middle Kingdom Nubia," *Kush* 5 (1957):61–69.

134. S. Piggott, "Early Foreign Trade in East Africa," *Man* 48 (1948):23–24.

135. There has been much discussion concerning the origin of the Egyptian spiralform motif. H. J. Kantor has set forth the relevant material in *The Aegean and the Orient in the Second Millennium B.C.* (Bloomington, 1947), pp. 21–30, with references to previous literature on the subject. For a concise statement of the problem, see F. Schachermeyr, *Ägäis und Orient* (Vienna, 1967), p. 40. Both conclude the Egyptian spiral was Aegean in origin. W. A. Ward has recently examined third millennium Egyptian material and determined that all the artistic principles necessary for spiralform ornamentation were present in Egypt, but given impetus by exposure to Aegean usage (*Egypt and the East Mediterranean World 2200–1900 B.C.* [Beirut, 1971], pp. 104–19).

136. M. C. Shaw, "Ceiling Patterns from the Tomb of Hepzefa," *AJA* 74 (1970):25–30.

137. Smith, *Art and Architecture*, p. 117.

138. For example, see the decorated sherds in Reisner, *Kerma*, pls. 45–47 and in Smith, *Art and Architecture*, pl. 80 B.

139. Smith has noted, "It is the interweaving character of some of the new designs, which connect all parts of the surface in a continuous all-over pattern, that suggests the Aegean" (*Art and Architecture*, p. 118).

140. Hayes, *Scepter* II, p. 150.

and playing pieces, kohl pots, vessels, inlays, plaques, *shawabtis*, and discs to sew on clothing were manufactured. These discs formed elaborate beadwork compositions which were used as decorative bands, collars, hassock covers, and assorted garments.[141] Countless faience rings were distributed free on festival days and at banquets.[142]

Two major Eighteenth Dynasty manufacturing centers have been identified. One was located near the palace of Amenhotep III at Malkata, Thebes,[143] and the other at El-Amarna.[144] From both of these sites, a large number of molds and unfinished or discarded objects was recovered, while at El-Amarna pans were found which were placed in the kilns to catch drops of liquefying glaze.[145]

At Akhenaten's city faience was used lavishly, and many unusual pieces were designed, such as the royal footstool,[146] the royal table service,[147] wigs with incised hair patterns,[148] and fish-shaped bowls.[149] Walls, doorways, and window frames were embellished with faience inlays, usually painted with the delicate plant and animal designs that were the hallmark of the Amarna style.[150] Reconstructions of the faience dadoes in Smenkhare's festival hall show a stylized formal pattern of white daisies with yellow centers and dark leaves on a blue green background, combined with freely drawn birds, thistles, and other flowers.[151]

The palace of Ramses II at Kantir had a similarly elaborate program of faience inlays. Plaques in the shapes of bound captives and lions attacking foreign prisoners were fastened to the stairways and platforms of throne daises.[152] Windows, balconies, and doorways were outlined with plaques in the forms of bound prisoners and tiles decorated with floral designs and marsh scenes.[153]

For his Medinet Habu temple, Ramses III commissioned faience plaques of foreign captives,[154] as well as friezes of birds, flowers, and geometric patterns.[155] Some of these were apparently set into frames of wood and

141. K. Bosse-Griffiths, "The Use of Disc-Beads in Egyptian Bead-Compositions," *JEA* 61 (1975): 114–24.

142. Hayes, *Scepter* II, p. 250.

143. Hayes, *Scepter* II, pp. 245, 254.

144. W. M. F. Petrie, *Tell-el-Amarna* (London, 1894), pp. 25–30 and pls. 14–20.

145. Petrie, *Tell-el-Amarna*, pl. 13 #62.

146. J. D. S. Pendlebury, *The City of Akhenaten* III (London, 1951), pl. 107 #9, 10, and p. 229.

147. Petrie, *Tell-el-Amarna*, pl. 13 #18, 28, 37.

148. Pendlebury, *City* III, pl. 79 #5, 6.

149. Pendlebury, *City* III, pl. 107 #7, 8.

150. H. Frankfort and J. D. S. Pendlebury, *The City of Akhenaten* II (London, 1933), pl. 29 #6; pl. 30 #1–5 (the private houses of the northern suburb); Pendlebury, *City* III, pl. 62 #2, 3 (temple annex); pl. 72 #1–7, 9 (coronation hall); Petrie, *Tell-el-Amarna*, p. 28 (columns of the harem suite).

151. Smith, *Art and Architecture*, p. 200 and pl. 154 A.

152. W. C. Hayes, *Glazed Tiles from a Palace of Ramesses II at Kantir* (New York, 1937), fig. 1 and pls. 2–6.

153. Hayes, *Glazed Tiles*, pls. 7–12.

154. U. Hölscher, *The Mortuary Temple of Ramses III* II (Chicago, 1951), pls. 30–34.

155. Hölscher, *Mortuary Temple* II, pl. 35, 37; in the same volume, see R. Anthes, "Catalogue of Tiles and other Inlays," pp. 42–47.

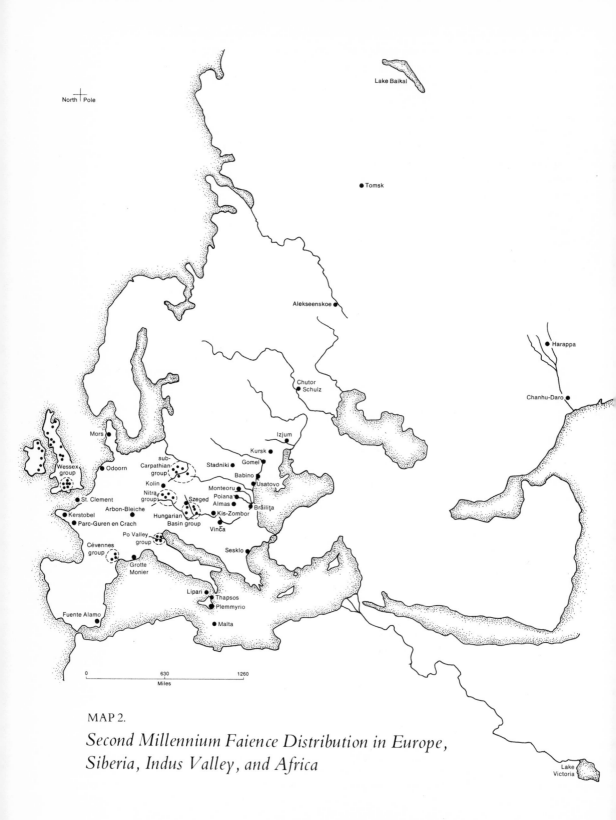

North Pole

Lake Baikal

Tomsk

Alekseenskoe

Harappa

Chutor
Schulz

Chanhu-Daro

Mors

Izjum

Kursk

sub-
Carpathian
group

Stadniki

Gomel

Wessex
group

Odoorn

Babino

Usatovo

Kolin

Monteoru

Nitra
group

Szeged

Poiana
Almas

Brăilița

St. Clement

Kis-Zombor

Kerstobel

Arbon-Bleiche

Hungarian
Basin group

Vinča

Parc-Guren en Crach

Po Valley
group

Sesklo

Cévennes
group

Grotte
Monier

Lipari

Thapsos

Plemmyrio

Fuente Alamo

Malta

Lake
Victoria

0 630 1260
Miles

MAP 2.

*Second Millennium Faience Distribution in Europe,
Siberia, Indus Valley, and Africa*

38

held in place by gypsum.[156] At Ramses III's palace at Tell el Yahudiyeh were found plaques and inlay pieces similar to those in the palaces of his predecessors. One unusual faience frieze was designed with interspersed rosettes, grape clusters, and radiating lotus petals.[157]

Numerous second millennium sites in Europe, Siberia, the Caucasus, and the Caspian Sea area have yielded faience. This is because of the Near East's interest in these regions as sources for gold, copper, silver, and amber and as markets for finished products.[158] Those who traded in faience trinkets may have chosen their wares with local tastes in mind, carrying quoit beads to England and four-rayed star beads to Hungary, for instance.[159] Another explanation for this geographical particularization of bead type may be that some beads were locally made, once the technique had been introduced.[160] It is interesting to note that the corpus of European faience consists entirely of beads. Does this reflect the limited technical abilities of a nascent faience industry? Is this because of accidents of discovery or preservation or the preponderance of burials in the total number of sites excavated? Or does this show a lack of demand for the figurines, vessels, plaques, inlays, and elaborate faience ornaments so popular in the Near East?

From a Sesklo grave in northern Greece were recovered several faience beads associated with Middle Helladic dagger blades and pottery.[161] As yet faience is unknown from the Balkans. Between the lower Danube and the Dniester, a number of burials have yielded faience beads.[162] These include Vinča and Kis-Zombor, near Belgrade;[163] Almas in the Trei Scaune district of eastern Romania;[164] Brăiliţa near the confluence of

156. This cloisonné work is described in Hölscher, *Mortuary Temple* II, pp. 40–42.

157. Hayes, *Scepter* II, fig. 232 and pp. 367–68.

158. For general discussions of the economic relationship between the East Mediterranean and Europe, see S. Foltiny, "Mycenae and Transylvania," *Hungarian Quarterly* 3 (1962): 132–40; J. Bouzek, "The Aegean and Central Europe," *Památky Archeologické* 57 (1966): 242–76. The interregional exchange of goods is reflected stylistically in numerous objects. A good example is a bone scepter from Transylvania, whose decoration can be paralleled at Alalakh, Kültepe, Kakovatos, and Mycenae (I. A. Aldea, "Un Sceptre en Os de l'établissment Wietenberg de Lancram," *Bolletino del Centro Camuno di Studi Preistorici* 11 [1974]: 119–27).

159. Stone, "Use and Distribution," *PPS* 22 (1956): 61.

160. See notes 22 and 23 in chapter 1 for research on local production of British beads. There is some evidence that Austrian glass beads were made locally, since they seem to have been colored by boron-free Alpine copper (M. Gimbutas, *Bronze Age Cultures in Central and Eastern Europe* [The Hague, 1965], pp. 54–55).

161. V. Milojčić, "Sur Chronologie der jüngeren Stein- und Bronzezeit Südost- und Mitteleuropas," *Germania* 37 (1959): 77.

162. There is evidence for contact between the lower Danube area and the Near East as early as the beginning of the third millennium. See V. Popovitch, "Une Civilisation égéo-orientale sur le moyen Danube," *RA*, 1965, no. 2, pp. 1–66; V. Dumitrescu, "The Chronological Relation between the Cultures of the Eneolithic Lower Danube and Anatolia and the Near East," *AJA* 74 (1970): 43–50; S. Hood, "An Early Oriental Cylinder Seal Impression from Romania?" *World Archaeology* 5 (1973): 187–97; N. Vlassa, "Chronology of the Neolithic in Transylvania," *Dacia* 7 (1963): 485–94.

163. Stone, "Use and Distribution," *PPS* 22 (1956): 54.

164. Gimbutas, *Bronze Age Cultures*, p. 46. This volume is an invaluable compilation of European material, much of which is unpublished or published in inaccessible Eastern European reports.

of the Siret and the Danube;[165] Poiana on the middle Siret;[166] and Monteoru on the Prut.[167] Between the Dniester and the Dnieper, faience has been recovered from the group of burials at Usatovo and Babino near Odessa on the Black Sea,[168] and from the rich Dubno-Ostrog burials at Stadniki, which also contained globular amphorae, bone ornaments, and bronze wire spirals.[169]

Along the lower Dnieper, the Unětice graves of the Strzyżów and Mierzanowice groups yielded faience and shell beads, copper rings, flint axes,[170] and a bone cheek piece "ornamented with the characteristic 'Mycenaean' decorative style."[171] Among the finds from the middle Dnieper group of north Ukranian burials near Gomel were faience beads, shaft-hole axes, and double-spiral pendants.[172] Between the middle Dnieper and the Don, the graves at Vorobjovka near Kursk yielded a few faience beads.[173] Just to the east, at Izjum on the Donetz, was found a small number of cylindrical faience beads.[174]

In Central Europe, faience has been found in three principal regions. The first is located between the upper Dniester and the upper Vistula. The burials with faience belong to the sub-Carpathian barrow grave culture and include the barrows at Kolpiec,[175] Sobow, Zlota, and Raciborowice.[176] In addition to faience, jewelry of bone, bronze, and amber was found together with bronze weapons and tools.[177]

The second region is the Hungarian Basin along the Danube and the Tisza. Near Szeged, segmented, cylindrical, and large globular faience beads have been found at Szoreg, Deszk, Ó Beba, Pitvaros, Dunapentele, Holesov, and Marefy.[178] The grave goods also comprised copper diadems, pins, and spiralform jewelry.[179]

The third concentration of faience is associated with the graves of the Nitra group located north of the Danube between Bratislava and Budapest.[180] Just to the west at Leopoldsdorf, a small segmented bead and pierced animal teeth were found.[181] Segmented, cylindrical, and four-

165. Gimbutas, *Bronze Age Cultures*, p. 45. These beads were associated with copper daggers and spiral rings (her dates c. 1800–1650 B.C.).

166. Stone, "Use and Distribution," *PPS* 22 (1956): 54.

167. Stone, "Use and Distribution," *PPS* 22 (1956): 54.

168. Gimbutas, *Bronze Age Cultures*, p. 45 (c. 1800–1650 B.C.).

169. T. Sulimirski, *Corded Ware and Globular Amphorae North-East of the Carpathians* (London, 1968), pp. 42, 195 (c. 1600 B.C.).

170. Sulimirski, *Carpathians*, pp. 23, 56, 158–60 (c. 1600 B.C.).

171. Sulimirski, *Carpathians*, pp. 23–24.

172. Sulimirski, *Carpathians*, p. 66 (post 1500 B.C.).

173. Gimbutas, *Bronze Age Cultures*, p. 46 (c. 1800–1650 B.C.).

174. Gimbutas, *Bronze Age Cultures*, p. 45 (c. 1800–1650 B.C.).

175. Sulimirski, *Carpathians*, pp. 17, 37 and pl. 8:2.

176. Gimbutas, *Bronze Age Cultures*, p. 45 (c. 1800–1650 B.C.).

177. T. Sulimirski, "Faience Beads in the Polish Bronze Age," *Man* 48 (1948): 124.

178. V. G. Childe, "The Orient and Europe," *AJA* 43 (1939), p. 20 and fig. 8; Gimbutas, *Bronze Age Cultures*, p. 45 (c. 1800–1650 B.C.).

179. Gimbutas, *Bronze Age Cultures*, p. 46.

180. A. Točik, "Die Nitra-Gruppe," *Archeologické Rozhledy* 15 (1963): 755–56.

181. K. Willvonseder, "Gräber der älteren Bronzezeit von Leopoldsdorf," *Germania*

rayed star beads were recovered from Horní Přín in eastern Bohemia, from Mad'arovce in western Slovakia, and Füzesabony in northern Hungary.[182] Faience beads were also found in graves at Polepy near Kolin, Bohemia.[183]

Faience beads have been recovered from several Mediterranean sites to the west of the Aegean. Among the grave goods of the Hal Tarxien cemetery on Malta were numerous faience disc beads, clay idols, and pottery decorated with bird designs, many of which show East Mediterranean influences.[184] Two Sicilian necropoli, Plemmyrio and Thapsos, yielded faience.[185] The Lipari tombs to the north of Sicily contained faience beads, as well as amber necklaces and copper weapons.[186] Lipari seems to have been an important trading station where copper, tin, and amber from the north may have been exchanged for faience and other finished goods from the east.[187]

Segmented and spherical faience beads have been found at sites along the Mediterranean coast of France and in the Cévennes region of the Massif Central. These include Grotte Monier, Treille, Grotte du Ruisseau, Grotte Landric, and Les Mattelles-Hérault.[188] Beads have also been reported from Fuente Alamo on the Mediterranean coast of Spain.[189] Elsewhere in western Europe, unusual faience buttons have been found at sites in the Po Valley, and star and quoit bead fragments have been discovered at a Swiss lake dweller's site at Arbon-Bleiche on Lake Constance.[190] In northwest France a few faience beads have been found in barrows at Kerstobel in Brittany,[191] at St. Clement on the island of Jersey, and at Parc-Guren en Crach in the lower Loire area.[192]

21 (1937), p. 91 (c. 1600–1300 B.C.). Stone terms the bead "glassy faience" but in a note reports it is true glass ("Use and Distribution," PPS 22 [1956], p. 55, n. 1).

182. Gimbutas, Bronze Age Cultures, pp. 52–53 (c. 1650–1450 B.C.).

183. V. Moucha, "Faience and Glassy Faience Beads in the Únětice Culture in Bohemia," Epitymbion Roman Haken (Prague, 1958), p. 47. I am grateful to J. D. Muhly and V. Moucha for providing me with copies of this article.

184. J. D. Evans, "The Prehistoric Culture Sequence in the Maltese Archipelago," PPS 19 (1953): 41–94. With regard to the faience disc beads, C. Renfrew and R. Whitehouse have recently suggested local production, principally on the basis of the beads' similarity to Tarxien ostrich egg shell beads and because of some evidence for Maltese metallurgical skills ("The Copper Age of Peninsular Italy and the Aegean," BSA 69 [1974]: 360–61).

185. Stone, "Use and Distribution," PPS 22 (1956): 49.

186. B. L. Bernabò and M. Cavalier, Meligunìs-Lipára I (Palermo, 1960), pl. 43 (1); Stone, "Use and Distribution," PPS 22 (1956), p. 57 n. 4.

187. S. Marinatos, "The Minoan and Mycenaean Civilization and its Influence on the Mediterranean and on Europe," Atti del VI Congresso Internationale delle Scienze Preistoriche e Protoistoriche I (1962): 166–67. For further discussion of Aegean faience and Aegean trade, see chapter 4, section 2.

188. Stone, "Use and Distribution," PPS 22 (1956), p. 57 and n. 5.

189. S. Piggott, Ancient Europe (Chicago, 1965), p. 136.

190. L. H. Barfield, "North Italian Faience Buttons," Antiquity 52 (1978): 150–53; Stone, "Use and Distribution," PPS 22 (1956): 56.

191. P. R. Giot, Brittany (New York, 1960), p. 145.

192. Stone, "Use and Distribution," PPS 22 (1956), pp. 56–57.

The barrow graves of Great Britain and Ireland have yielded numerous faience beads, primarily of segmented, star, and quoit types.[193] The finds are concentrated in Wessex, the southern Uplands, the Glasgow area, and the northeast coasts of England and Ireland.[194] The question of these beads' local manufacture was raised in chapter 1, section 1. Technical[195] and stylistic[196] analyses have provided some evidence for postulating British production. Still unresolved, however, is the question of an East Mediterranean origin for the technique.

The appearance of faience in England has been associated, particularly in Wessex, with the appearance of other material considered to show Aegean affinities, such as the Rillaton gold cup, the carved dagger at Stonehenge, and the gold-mounted amber discs.[197] On the basis of such East Mediterranean links, Wessex I has been traditionally dated 1560–1500 B.C. and Wessex II, 1500–1400 B.C.[198]

Reexamination of the supposedly Aegean-related Wessex material, however, has established indigenous prototypes for decoration and design and, using internal evidence, has redated Wessex I 2100–1900 B.C. and Wessex II, 1900–1700 B.C.[199] Another reexamination of the same material has restricted Aegean influence to certain helmet and weapon types introduced after 1400 B.C.[200] In the absence of early Wessex contact with the Aegean, it is possible that growing British metallurgical sophistication and demand for personal ornamentation provided the skills and the impetus needed for Wessex faience production. Furthermore, British bone and tin beads may well have furnished the models for faience copies.[201]

British trade across the North Sea[202] was probably responsible for the

193. The standard work on British beads remains H. C. Beck and J. F. S. Stone's compilation "Faience Beads of the British Bronze Age," *Archaeologia* 85 (1936): 203–52. Additional lists of beads have been given by A. Fox and J. F. S. Stone in "A Necklace from a Barrow in North Molton Parish," *The Antiquaries Journal* 31 (1951): 30–31 and by Stone, "Use and Distribution," *PPS* 22 (1956), Appendix, pp. 78–84, which also includes European beads. Study of the grave goods associated with male and female Wessex burials shows that there are more faience beads in female graves (S. Gerloff, *The Early Bronze Age Daggers in Great Britain and a Reconsideration of the Wessex Culture* [Munich, 1975], pp. 198–214).

194. See the map in Stone, "Use and Distribution," *PPS* 22 (1956), fig. 4, p. 60.

195. See above chapter 1, notes 22 and 23; chapter 2, note 160.

196. For British bead parallels in Europe and the Near East, see the examples collected in Beck and Stone, "Faience Beads," *Archaeologia* 85 (1936): 222–27; A. Fox, *South West England* (London, 1964), pp. 82–83.

197. Stone, "Use and Distribution," *PPS* 22 (1956): 59; Gerloff, *Early Bronze Age Daggers*, pp. 214–32.

198. A. M. ApSimon, "Dagger Graves in the 'Wessex' Bronze Age," *Tenth Annual Report of the Institute of Archaeology* (1954), p. 51.

199. C. Renfrew, "Wessex without Mycenae," *BSA* 63 (1968): 277–85.

200. K. Branigan, "Wessex and the Common Market," *SMEA* 15 (1972): 147–55.

201. R. G. Newton and C. Renfrew, "British Faience Beads Reconsidered," *Antiquity* 44 (1970): 205.

202. J. J. Butler, *Bronze Age Connections Across the North Sea* (Groningen, 1963), pp. 165–66.

presence of segmented beads in a stone cist on the island of Mors in north Jutland[203] and in a barrow near Odoorn in the Netherlands.[204]

As for second millennium Siberian faience, beads have been found in graves near Lake Baikal,[205] in barrows near Tomsk,[206] and in the Alekseenskoe cemetery on the upper Tobol.[207] Further west, faience has been recovered from Chutor Schulz on the Volga[208] and from burials at Konstantinovka and Nalchik in Cis-Caucasia.[209] The site of Khorochoj on the Dagestan coast of the Caspian Sea also yielded faience beads.[210]

The rich Caucasian Trialeti Kurgan graves of the mid-second millennium contained faience beads,[211] along with elaborate metal weapons, daggers, pins, spiral-decorated pottery, and other jewelry of carnelian, agate, silver, and gold. The inventory of the grave goods reflects the hybrid nature of the Trialeti culture, with its north Caucasian, indigenous, and Near Eastern components,[212] the last of which accounted for the presence of faience at Trialeti. In Transcaucasia, just south of Trialeti, were found several faience and carnelian beads at Kizilvank.[213] To the east, in the Talych region on the southwest coast of the Caspian Sea, Near Eastern weapons, seals, and faience beads and necklace elements were recovered from six mid-second millennium barrows: Agha-Evlar, Tchila-Khane, Chir-Chir, Hassan-Zamini, Lor-Daghi, and Khodja-Daoud.[214] Faience beads and seals have been found in graves dated to the last quarter of the second millennium at Hasanlu[215] and Geoy Tepe.[216]

There is also second millennium faience from the Indus Valley, Elam, Mesopotamia, Anatolia, and the Levant. The first centuries of the second millennium saw an end of the Indus Valley civilization. Theories proposed to account for its downfall include a series of massacres by Indo-European invaders from the northwest, excessive flooding and the progressive impoverishment of the Indus Valley because of the overexploitation of its resources, and the rioting of rural populations against their urban

203. C. J. Becker, "A Segmented Faience Bead from Jutland," *Acta Archaeologica* 25 (1954): 242.

204. J. V. S. Megaw, "Across the North Sea: A Review," *Antiquity* 35 (1961): 49.

205. Gimbutas, *Bronze Age Cultures*, p. 107.

206. Gimbutas, *Bronze Age Cultures*, pp. 100, 107.

207. Gimbutas, *Bronze Age Cultures*, p. 106.

208. Gimbutas, *Bronze Age Cultures*, p. 106.

209. Schaeffer, *Stratigraphie Comparée*, p. 514.

210. Gimbutas, *Bronze Age Cultures*, p. 89.

211. B. A. Kuftin, *Archaeological Excavations in Trialeti* I (Tiflis, 1941), pls. 6 #2; 22 #2; 23 #6; fig. 87 #3–6; and pp. 166, 170 (English section).

212. D. M. Lang, *The Georgians* (New York, 1966), p. 44; O. M. Japaridze, "Trialeti Culture in the Light of the Latest Discoveries and its Relation to Anterior Asia and Aegean Sea," *Actes du 8. Congrès International des Sciences Préhistoriques et Protohistoriques* III (Belgrade, 1973), pp. 39–44.

213. I. I. Meščaninov, "Kratkie svedenija o rabotah arheologičeskoj ekspedicii v Nagornyj Karabah i Nahičevanskij Kraj," *Soobščenija GAIMK* I (1926): 237.

214. Schaeffer, *Stratigraphie Comparée*, pp. 406–7, 413, 417, 420, and pls. 59, 60.

215. R. H. Dyson, "Problems of Protohistoric Iran," *JNES* 24 (1965): 196 (seals).

216. Brown, *Azerbaijan*, pp. 142–45 (beads).

masters.[217] Archaeologically, disturbances in the Indus Valley may be seen in a clear deterioration in civic standards at Mohenjo-Daro, in the high flood levels discerned at several sites, and in the six groups of unburied individuals found at Mohenjo-Daro, all of whom seem to have met violent ends.[218]

Little faience has been recovered from post-Indus strata. The Jhukar levels at Chanhu-Daro yielded circular stamp seals with Near Eastern geometric and animal designs, some of which were made of faience.[219] A few segmented faience beads have been found at Harappa[220] and Chanhu-Daro.[221] The use of faience by the Jhukar has suggested to some that they "conscripted, or at least were prepared to acquire the products of, local craftsmen skilled in this technique who survived the Harappa disasters."[222] Yet the lack of evidence for second millennium faience manufacture in the Indus Valley, the paucity of recovered faience objects, and their Near Eastern, non-Indus affinities makes it more likely that Jhukar faience was imported from the west.

There the faience industry expanded throughout the second millennium. For the first half of this period, Elam continued to import faience from Mesopotamia. An unusual object is the small Neo-Sumerian style doll's head found in an early second millennium child's grave at Susa.[223] An Elamite center for faience production was established either at Tchoga-Zanbil or at Susa by the middle of the millennium. Seals, inlays and plaques for architectural embellishment, figurines, and ornaments were manu-factured.[224] Interesting pieces from Tchoga-Zanbil include a faience figurine of a recumbent lion,[225] a double perfume vase in the shape of two female heads,[226] and several statuettes of the important Elamite goddess Pinikir.[227] Faience beads, seals, and vessels were distributed from Elam north to Tepe Giyan,[228] Tepe Sialk,[229] and the urban centers in southern Turkmenia, principally Altin-depe.[230] To the south of Susa, a large Middle Elamite building at Malyan contained decorated faience tiles and knobs.[231]

217. For further discussion of these theories and bibliographic references, see J.-F. Jarrige, "La Fin de la Civilisation Harappéenne," *Paléorient* 1 (1973): 263–87.

218. Wheeler, *Indus Civilization*, pp. 127–31.

219. Piggott, *Prehistoric India*, fig. 27, p. 224.

220. Stone, "Use and Distribution," *PPS* 22 (1956): 52.

221. Piggott, *Prehistoric India*, p. 225.

222. Piggott, *Prehistoric India*, p. 226.

223. P. Amiet, *Elam* (Auvers-sur-Oise, 1966), fig. 215, p. 290.

224. E. Porada, *The Art of Ancient Iran* (New York, 1962), p. 68.

225. Amiet, *Elam*, fig. 272.

226. Amiet, *Elam*, fig. 269.

227. Amiet, *Elam*, figs. 267, 268. For text references and discussion of Pinikir's attri-butes, see F. W. König, "Pinikir," *Archiv für Orientforschung* 5 (1928–29): 101–3.

228. R. Ghirshman, *Fouilles du Tepe-Giyan* (Paris, 1935), p. 51 and pl. 7.

229. R. Ghirshman, *Fouilles de Sialk* (Paris, 1938), pp. 57–60 and pls. 27 (12), 95 S.1335a.

230. V. M. Masson and V. I. Sarianidi, *Central Asia: Turkmenia before the Achaemenids* (New York, 1972), p. 115 and fig. 29 d (faience jar).

231. W. Summer, "Excavations at Tall-i Malyan (Anshan)," *Iran* 14 (1976): 112.

Babylon, in southern Mesopotamia, yielded necklace elements and a variety of faience wares, including covered and lidless kernoi and vessels decorated with geometric designs, most of which resemble Kassite pottery types.[232] A finely modeled faience calf's head, probably an ornament for furniture, was found at Dur-Kurigalzu.[233] Seals, jewelry, and rhyta in the shape of female heads were recovered from Ur.[234] A Kassite urn deposit at Nippur yielded more than one hundred polychrome faience discs and crescents, three small alabastra, two blue- and yellow-striped covered boxes, and a knobbed container.[235]

The north Mesopotamian center of faience production shifted several times in the second millennium concomitant with the three major shifts of power during that period. Under the Amorite domination of the eighteenth century B.C., Chagar Bazar was probably the capital.[236] The city was also the principal production center of faience, continuing a pattern established in the third and fourth millennia. Amulets, animal figurines, and the head of a puzuzu demon have been found there, as well as numerous cylinder seals and beads.[237] Further south, at the palace of Mari, were discovered miniature faience lamps, covered cups, jars, and masks.[238]

The sixteenth and fifteenth centuries saw the spread across northern Mesopotamia of the Mitannian kingdom, whose capital, Washukanni, was probably located in the upper Khabur Valley.[239] The quantity of Mitannian "common" style faience seals found at Tell el Rimah,[240] just to the east of the upper Khabur region, points to this area as the center of faience production. Further south at Nuzi, an outpost of the Mitannian kingdom, some unusual faience objects were found, notably a naturalistic boar's head[241] and two bowls with colored striations

232. O. Reuther, *Die Innenstadt von Babylon* (Leipzig, 1926), figs. 10 a–p, 13. The term *kernos* is generally accepted for the Bronze Age containers with cylindrical or rectangular cavities despite the differences between these and classical Greek kernoi. M. Nilsson prefers the term *salt and pepper bowl* (*Minoan-Mycenaean Religion* [Lund, 1950], p. 135 n. 97).

233. T. Baqir, "Iraq Government Excavations at 'Aqar Qûf," *Iraq* supplement, 1944, pl. 20, fig. 33, and p. 13.

234. Mallowan, "Excavations at Brak," *Iraq* 9 (1947): 174. Female-head goblets are discussed more fully in connection with Cypriote faience.

235. J. P. Peters, *Nippur* (New York, 1897), pl. opposite p. 186 and pp. 187–88. This faience is displayed with Parthian material in the Istanbul Archaeological Museum.

236. J.-R. Kupper, "Northern Mesopotamia and Syria," *CAH*³ 2:1, p. 6.

237. M. E. L. Mallowan, "The Excavations at Tall Chagar Bazar, Second Campaign, 1936," *Iraq* 4 (1937), pl. 14 A and pp. 122, 137.

238. A. Parrot, "Les fouilles de Mari," *Syria* 18 (1937), p. 83 and pls. 14 # 3, 4; 15 # 1, 3. Faience masks are discussed at the end of this chapter.

239. W. W. Hallo and W. K. Simpson, *The Ancient Near East: A History* (New York, 1971), pp. 109–11.

240. B. Parker, "Cylinder Seals from Tell al Rimah," *Iraq* 37 (1975), # 21–28, 30, 33, 36–38, 41, 45, 46.

241. H. Frankfort, *The Art and Architecture of the Ancient Orient* (London, 1970), fig. 29, p. 251.

imitating veined stone.[242] At the nearby site of Tell el Fakhar, faience beads, seals, and several vessels were discovered.[243]

With the rise of Assyrian power from 1430 B.C. onward, Assur became the principal commercial and cult city of northern Mesopotamia.[244] A considerable amount of faience was recovered from Assur, and it is probable that the city was the center of production during that period. The finds comprise a large number of beads, pendants, inlay rosettes, and gamesmen,[245] as well as dagger pommels[246] and furniture pieces.[247] Also found were plaques showing seated and standing figures of bound captives[248] and models of human heads, eyes, and feet.[249] In addition, tripodic vessels,[250] a mouthpiece for an ostrich egg rhyton,[251] and several examples of the so-called blossom bowls[252] were recovered at Assur. Elsewhere, Assyrian faience beads and animal figurines were found at Tell el Rimah.[253]

There do not seem to have been any second millennium centers of faience production in Anatolia. The faience beads, spindle whorls, and Ishtar figurine from Alishar Hüyük[254] were imported from northern Mesopotamia, while the metal pins with faience bead heads[255] and the vertically striped vase[256] from the same site were probably made in Syria. The fragments of faience vessels[257] and buttons with geometric designs[258] found at Alaca Hüyük also seem Syrian in origin. Of north Mesopotamian or Syrian manufacture are the beads recovered from graves at Kültepe[259] and Karahüyük.[260] It is probable that the faience beads found at Troy VI[261] and VIIa[262] are Aegean imports, for they

242. R. F. S. Starr, *Nuzi* (Cambridge, Mass., 1939), pl. 119 I, J.

243. Y. M. Al-Khalesi, "Tell al-Fakhar: Report on the First Season's Excavations," *Sumer* 26 (1970), pp. 120–22 and pls. 22, 26, 27.

244. Hallo and Simpson, *Ancient Near East*, pp. 113–17. For a detailed study of Assur's commercial activity in an earlier period, see M. T. Larsen, *The Old Assyrian City-State and its Colonies* (Copenhagen, 1976), pp. 86–102.

245. W. Andrae, *Die jüngeren Ischtar-Tempel in Assur* (Leipzig, 1935), pls. 39, 40, and pp. 96–100.

246. Andrae, *Ischtar-Tempel*, pl. 41 and pp. 98–99.

247. Andrae, *Ischtar-Tempel*, pl. 38 and pp. 95–96.

248. Andrae, *Ischtar-Tempel*, pls. 34, 35 and pp. 80–87.

249. Andrae, *Ischtar-Tempel*, pl. 36 and figs. 69–74, pp. 87–93.

250. Andrae, *Ischtar-Tempel*, pl. 42 and pp. 100–101.

251. A. J. Evans, *PM* 4:2, fig. 760 a. For Minoan parallels, see fig. 760 b and pp. 779–80.

252. A. Haller, *Die Gräber und Grüfte von Assur* (Berlin, 1954), fig. 11a and p. 19. For the origin of the blossom bowl type, see below n. 326.

253. D. Oates, "The Excavations at Tell al Rimah, 1964," *Iraq* 27 (1965): 73–75.

254. Schmidt, *Alishar Hüyük*, pp. 179–81 and fig. 233.

255. Schmidt, *Alishar Hüyük*, fig. 203, p. 162.

256. Schmidt, *Alishar Hüyük*, color pl. III.

257. R. O. Arik, *Les Fouilles d'Alaca Höyük* (Ankara, 1937), p. 40.

258. H. Z. Koşay, *Alaca Höyük Kazısı* (Ankara, 1951), pp. 135–36 and pl. 94.

259. T. Özgüç, *Kultepe Kazısı Raporu* (Ankara, 1953), fig. 612 and p. 201.

260. J. Mellaart, "Anatolian Trade with Europe and Anatolian Geography and Culture Provinces in the Late Bronze Age," *Anatolian Studies* 18 (1968): 194.

261. C. W. Blegen, *Troy III: The Sixth Settlement* (Princeton, 1953), p. 30 and figs. 304, 333, 346, 348. The total number of beads involved is 159.

262. C. W. Blegen, *Troy IV: Settlements VIIa, VIIb and VIII* (Princeton, 1958), p. 17 and figs. 220–21. Eight beads were recovered in all.

closely resemble Minoan and Mycenaean annular, spherical, and cylindrical types. One small inlay fragment was also recovered from Troy VI.[263] Among the offerings at the Late Bronze Age East Shrine at Beycesultan were necklaces of faience, carnelian, and cowrie shells, probably all imported from the East Mediterranean.[264]

The second millennium faience found in Syria/Palestine is an amalgamation of indigenous styles and foreign artistic traditions derived principally from Egypt, the Aegean, and Mesopotamia. This combination of diverse elements is a result of the geographical, political, and cultural position of Syria/Palestine during the period[265] and is clearly reflected in Levantine decorative arts, particularly ivory[266] and faience work.

Faience from Syria/Palestine will be considered in three groups. The first of these comprises material from Ras Shamra, Minet-el-Beida, and Alalakh. The discovery of a small faience head in the bottom of an oven along with several tablets attests to the establishment of a center of faience production at Ras Shamra.[267] A number of unique pieces were made there, notably a chariot with two occupants and a horse,[268] an incense spoon with a duck- or goose-head handle,[269] a rhyton with a painted design of two animals flanking a tree,[270] and two plaques showing bearded Syrians.[271] Ornate goblets, vessels, and bowls occur there, some of which are Egyptian or Egyptianizing.[272] At Minet-el-Beida, the port of Ras Shamra, a number of similarly decorated faience vessels was discovered.[273]

From Ras Shamra, faience was probably sent a short distance north to

263. Blegen, *Troy* III, p. 374.

264. S. Lloyd, *Beycesultan* III (Ankara, 1972), p. 32 and pl. 21 b.

265. Studies elucidating the Levant's relations with Egypt and Mesopotamia in the second millennium have been done by G. Posener and J. Bottéro, "Syria and Palestine c. 2160–1780 B.C.," *CAH*[3] 1:2, pp. 532–66; Helck, *Die Beziehungen Ägyptens zu Vorderasien*, passim; W. A. Ward, "Egypt and the East Mediterranean in the Early Second Millennium B.C.," *Orientalia* 30 (1961): 22–45, 129–55. Others have focused on individual sites, such as P. Montet, *Byblos et l'Égypte* (Paris, 1928); C. F. A. Schaeffer, "Matériaux pour l'étude des Relations entre Ugarit et l'Égypte," *Ugaritica* III (Paris, 1956), pp. 164–226; A. F. Rainey, "Business Agents at Ugarit," *IEJ* 13 (1963): 313–21; J. A. Wilson, "The Egyptian Middle Kingdom at Megiddo," *AJSemL* 58 (1941): 225–36.

266. There is a large corpus of ivory carvings from Syria/Palestine. Studies have been prepared by H. J. Kantor, "Syro-Palestinian Ivories," *JNES* 15 (1956): 153–74; C. D. de Mertzenfeld, *Inventaire Commenté des Ivoires Phéniciens* (Paris, 1954); R. D. Barnett, "Phoenicia and the Ivory Trade," *Archaeology* 9 (1956): 87–97. For a detailed study of first millennium ivory, see I. J. Winter, "Phoenician and North Syrian Ivory Carving in Historical Context: Questions of Style and Distribution," *Iraq* 38 (1976): 1–22.

267. C. F. A. Schaeffer, *Ugaritica* IV (Paris, 1962), p. 37 and fig. 40 (2).

268. C. F. A. Schaeffer, *Les Fouilles de Minet-el-Beida et de Ras Shamra: Rapports* (Paris, 1929–37), vol. 7, pl. 18 #1.

269. Schaeffer, *Ras Shamra: Rapports*, vol. 9, pl. 22 #2 and p. 241.

270. Schaeffer, *Ras Shamra: Rapports*, vol. 7, fig. 8.

271. Schaeffer, *Ras Shamra: Rapports*, vol. 7, p. 114, fig. 7.

272. Schaeffer, *Ras Shamra: Rapports*, vol. 3, pl. 11; vol. 4, pl. 12 #1, 2; *Ugaritica* IV, p. 101.

273. C. F. A. Schaeffer, "Les Fouilles de Minet-el-Beida et de Ras Shamra: quatrième campagne," *Syria* 14 (1933), pl. 12 #1, 2.

Alalakh. All second millennium levels at that site yielded seals, beads, and amulets, including some finely detailed flies, hedgehogs, frogs, and rabbits.[274] A toilet box lid with radiating stripes,[275] a libation pourer with a human hand modeled in relief,[276] bowls with painted lotus patterns,[277] and a sherd with an unusual seed pattern in relief[278] are among the more interesting pieces. An Egyptian or Egyptianizing bowl fragment shows a sketchy offering scene with lotus and quatrefoil designs and standard hieroglyphic offering formulae.[279]

Faience also seems to have been manufactured at Byblos. In the nineteenth/eighteenth century Obelisk Temple deposit were found nearly 450 faience figurines and other small objects.[280] Though they resemble the hippopotami, dwarves, turtles, cats, and crocodiles popular in Middle Kingdom Egypt, the finding of a faience Syrian bear[281] and miniature vessels of Syro/Palestinian type[282] points to their manufacture at Byblos. The corpus of Late Bronze Age Byblos faience comprises Egyptian imports, such as Bes figurines, amulets, and scarabs,[283] and locally made wares, such as the vase with the cartouche of a Byblite ruler.[284]

Further south, a third center of Levantine production was probably established in the area of Megiddo and Lachish. The former site yielded a number of unusual pieces, including a plaque of a nude dancing girl,[285] a decorated lion's head,[286] and a horse with a garland in its mouth.[287] Sherds with geometric and floral designs,[288] gamesmen,[289] and a headdress[290] were also found at Megiddo, together with amulets, scarabs, and beads, some of which were Egyptian imports.[291] The Egyptian and locally made faience from Lachish is noteworthy for the high quality and unusual character of its decorated vases,[292] flasks,[293] bowls,[294] and kohl pots.[295]

274. C. L. Woolley, *Alalakh* (Oxford, 1955), pp. 268–71 and pl. 68.

275. Woolley, *Alalakh*, fig. 74 (a) 2.

276. Woolley, *Alalakh*, p. 297.

277. Woolley, *Alalakh*, fig. 74 (a) 3, 4, 6.

278. Woolley, *Alalakh*, fig. 74 (a) 5.

279. Woolley, *Alalakh*, pl. 83 h.

280. These are fully catalogued and illustrated in M. Dunand, *Fouilles de Byblos* II (Paris, 1958), pp. 741–80, #15121–566.

281. Dunand, *Byblos* II, pl. 108, #15302.

282. Dunand, *Byblos* II, pl. 111–13; I (Paris, 1939), n. 6, p. 179.

283. Dunand, *Byblos* I, pp. 177–80.

284. Montet, *Byblos et l'Egypte*, pp. 212–14, #853.

285. G. Loud, *Megiddo* II (Chicago, 1948), pl. 241: 5.

286. Loud, *Megiddo* II, pl. 246: 30.

287. Loud, *Megiddo* II, pl. 245: 24.

288. Loud, *Megiddo* II, pl. 191: 1–3, 5–8.

289. Loud, *Megiddo* II, pl. 191: 10–13.

290. Loud, *Megiddo* II, pl. 287: 14.

291. P. L. O. Guy, *Megiddo Tombs* (Chicago, 1938), pp. 178, 181; Loud, *Megiddo* II, pls. 205–17.

292. O. Tufnell et al., *Lachish II: The Fosse Temple* (Oxford, 1940), pl. 22 #55.

293. Tufnell, *Lachish* II, pls. 21 #48; 22 #56.

294. Tufnell, *Lachish* II, pls. 22 #57, 58; 23 #59–74.

295. Tufnell, *Lachish* IV–V, pl. #12–17; see p. 83 for similar faience kohl pots found at Fara, Mirsim, Gezer, and Jericho.

A particularly elaborate necklace from Lachish had colorful faience pendants of flowers, fruit, and thistles.[296]

Near Megiddo and Lachish, tombs at Jericho and Tell Fara contained faience vessels as lavishly decorated with geometric patterns as those from Lachish.[297] Just to the north, sherds with lotus designs[298] and several recumbent lion figurines[299] were recovered from Tell el-Mutesellim, along with imported Egyptian amulets.[300] Two naturalistic ram's-head rhyta[301] and cup fragments with chevron and animal designs[302] were found at Abu Hawām.

The last group of second millennium faience is the material recovered from Cyprus. Middle Cypriote contexts at Lapithos, Ajios Jakovos, and Lambertis yielded beads chiefly of spherical, globular, and cylindrical type.[303] Other shapes include biconical, fluted, rosette, pomegranate, and frog beads, with one unusual bead from Lapithos in the shape of an African head.[304] Except for this bead, the remainder are of shapes found throughout the Near East, and there is no evidence to suggest local Cypriote manufacture. As for the African-head bead, Egyptian examples are rare before the New Kingdom.[305] The facial features resemble those of African-head pendants shown in the MM III Knossos fresco depicting part of a gold necklace.[306] This points to a common origin, perhaps Crete, for the gold pendants and faience copies.

The large number of Middle Cypriote faience beads reflects the expansion of the Cypriote copper industry[307] and the widening of foreign contacts.[308] The Late Cypriote period is characterized by increasingly intensive development along these lines,[309] in conjunction with a decline in Cypriote regionalism[310] and with Mycenaean expansion after 1400

296. Tufnell, *Lachish* II, pl. 14. For other faience jewelry, see pls. 34–36 and *Lachish* IV–V, p. 88.

297. Schaeffer, *Stratigraphie Comparée*, fig. 116 #21, 22 (Jericho); fig. 135 #15 (Fara).

298. C. Watzinger, *Tell el-Mutesellim* II (Leipzig, 1929) figs. 26–29.

299. G. Schumacher, *Tell el-Mutesellim* I (Leipzig, 1908) figs. 128–30.

300. Watzinger, *Tell el-Mutesellim* II, pp. 23, 40, 49–50, 87.

301. R. W. Hamilton, "Excavations at Tell abu Hawām," *QDAP* 4 (1935), pls. 30 #428; 27 #429.

302. Hamilton, "Hawām," *QDAP* 4 (1935), pls. 27 #422, 423; 39 #420, 421.

303. Gjerstad, *Cyprus* I, p. 138; P. Åström, *The Middle Cypriote Bronze Age* (Lund, 1957), p. 158.

304. Åström, *Middle Cypriote Bronze Age*, pp. 158, 203, 255–56 and fig. 18 (African-head bead).

305. Åström, *Middle Cypriote Bronze Age*, p. 256, n. 3 reports the view of A. J. Arkell and T. G. H. James, who doubt its Egyptian origin.

306. *PM* I, figs. 231, 383.

307. H. W. Catling, "The Cypriote Copper Industry," *Archaeologia Viva* 2 (1969): 81–88.

308. P. Åström, "The Economy of Cyprus and its Development in the IInd Millennium," *Archaeologia Viva* 2 (1969): 75.

309. For a study of the transition between MC III and LC I, see R. S. Merrillees, "The Early History of Late Cypriote I," *Levant* 3 (1971): 56–79.

310. Middle Cypriote regionalism has been studied by D. Frankel in "Inter-site Relationships in the Middle Bronze Age of Cyprus," *World Archaeology* 6 (1974): 190–208, with the results diagrammed in fig. 266: 27 b, 28 b. See also R. S. Merrillees, "Reflections on the Late Bronze Age in Cyprus," *Opuscula Atheniensia* 6 (1965): 140–41 for a synopsis

B.C.[311] The Late Cypriote faience industry was stimulated by the establishment of prosperous cities and workshops, particularly at Enkomi and Kition, and by the influx of pottery and other finished products from the Aegean, Egypt, and Syria/Palestine.[312]

The diversity of Late Cypriote faience vessels attests to the variety of ways in which Cypriote types and foreign motifs were employed.[313] Examples discussed here are of LC II date, unless otherwise noted. Egyptian or Egyptianizing pieces consist chiefly of blue green or white shallow bowls with dark brown or black interior decoration. The designs include lotus and papyrus medallions,[314] a mouse-headed bull charging through a papyrus thicket,[315] and scenes with roughly drawn fish, boats, dancing and instrument-playing figures, hieroglyphs, and lotus flowers.[316] Two tombs at Enkomi each yielded kohl jars with Egyptian designs on a lustrous violet green background.[317] Three small pear-shaped bottles from Enkomi illustrate variants of a typical Middle Kingdom jar type.[318]

Cypriote faience adaptations of Mycenaean pottery shapes include pilgrim flasks and false-neck jars from Enkomi, Kition, and near Idalion. The former are decorated with geometric designs and plain or papyrus plant crosses.[319] Of the false-neck stirrup jars, two have geometric patterns in

of ceramic regionalism. East/West competition and friction seems to have subsided by the end of the LC I period (R. S. Merrillees, "Early History," *Levant* 3 [1971]: 76–78), perhaps under pressure from foreign markets for cultural conformity (R. S. Merrillees, "Reflections," *Opuscula Atheniensia* 6 [1965]: 148).

311. For assessments of the influence and role of the Mycenaeans in Cyprus, see Department of Antiquities, Cyprus, *Acts of the International Archaeological Symposium "The Mycenaeans in the Eastern Mediterranean"* (Nicosia, 1973); V. Karageorghis, *Mycenaean Art from Cyprus* (Nicosia, 1968); L. Åström, *Studies on the Arts and Crafts of the Late Cypriote Bronze Age* (Lund, 1967), esp. pp. 146, 148–50; V. R. d'A. Desborough, *The Last Mycenaeans and their Successors* (Oxford, 1964), esp. p. 196; R. S. Merrillees, *Trade and Transcendence in the Bronze Age Levant* [= *SIMA* 39] (Göteborg, 1974), esp. pp. 7–8.

312. A concise statement of the goods traded appears in R. S. Merrillees's review of Åström, *Arts and Crafts* in *PEQ* 100 (1968): 66.

313. These vessels have been studied in detail by E. J. Peltenburg in his dissertation, "Western Asiatic Glazed Vessels of the Second Millennium B.C." An outline of some of his conclusions appears in his article "On the Classification of Faience Vases from Late Bronze Age Cyprus," *Praktikōn tou Prōtou Diethnous Kyprologikou Synedriou*, 1972, pp. 129–36. Two major groups emerge: Egyptian or Egyptianizing, with monochrome and polychrome examples; Western Asiatic, including vessels of north Levantine, Mycenaeanizing, and western Asiatic type.

314. J. L. Myres, *Handbook of the Cesnola Collection* (New York, 1914), #1575, 1576, 1577; P. Dikaios, *Enkomi Excavations 1948–1958* (Mainz, 1969) I, p. 253; III a, pl. 156: 51.

315. Myres, *Handbook*, #1573.

316. Myres, *Handbook*, #1574; British Museum (hereafter cited as BM) 98.12–1.145; P. Dikaios, *Guide to the Cyprus Museum*² (Nicosia, 1953), pl. 33: 5; A. S. Murray et al., *Excavations in Cyprus* (London, 1900), fig. 63; Peltenburg, "Classification," *Praktikōn*, 1972, fig. 1.

317. Murray, *Cyprus*, figs. 40, 67.

318. Murray, *Cyprus*, fig. 63; Dikaios, *Enkomi* I, p. 368; III a, pl. 210: 26.

319. Murray, *Cyprus*, fig. 71; BM 97.4–1.960; examples from Kition and Katydhata cited in Åström, *Arts and Crafts*, p. 53. For other Kition pieces, see E. J. Peltenburg, "Glazed Vases," in V. Karageorghis, *Kition* I (Nicosia, 1974), pp. 112–16. There an Egyptian

dark brown on blue green,[320] while three others are decorated with a combination of semicircles, stripes, rosettes, and dots.[321] The use of dots, especially in panels below the neck, possibly "reflects earlier traditions of Mesopotamian glass and faience-working."[322] The stirrup jars provide a clear illustration of the fusion of elements which is the hallmark of Cypriote faience.[323]

A sizable class of Cypriote vessels is composed of shallow bowls with rounded bases or base-rings, nearly all from Enkomi. These are often decorated with bands of regularly spaced dots around the rim.[324] One Enkomi bowl has on the outside radiating lattice bands in the White Slip II style.[325] To this class also belong the so-called blossom bowls with oblong pentagons arranged like petals around the exterior. The style is pervasive throughout the Near East, possibly originating in Cyprus.[326] Cypriote blossom bowls have pentagonal petals alternating yellow and white,[327] black, green and yellow,[328] or blue and yellow.[329] A somewhat different type is exemplified by a carinated bowl from Kition with round-topped petals in yellow, brown, and blue.[330] Both plain and blossom bowls were sometimes fitted with a horizontal troughlike spout, and examples have been found at Enkomi and Idalion.[331]

Related to the blossom bowls are several examples from Enkomi and Kition of carinated bowls with vertically ribbed sides or pentagonal or

source is suggested based on technical and stylistic analyses, but on the basis of parallels from Lachish, Jericho, Mirsim, and Far'ah, Åström suggests the Cypriote flasks were imported from Palestine (*Arts and Crafts*, p. 122).

320. BM 97.4–1.1143; C. F. A. Schaeffer, *Enkomi-Alasia* (Paris, 1952), color plate B and pl. 43 (1).

321. Myres, *Handbook*, #1572; Gjerstad, *Cyprus* I, pl. 78 (1); Schaeffer, *Enkomi-Alasia*, color plate B and pl. 41 (2).

322. Peltenburg, "Classification," *Praktikōn*, 1972, p. 133 and p. 134 n. 1.

323. Åström assigns these an Egyptian or Syro/Palestinian origin because of similar jars from Thebes, Gurob, Soleb, Nubia, and Ras Shamra (*Arts and Crafts*, p. 121). The popularity of pottery stirrup jars in Cyprus, however, suggests local manufacture of these faience imitations.

324. With rounded bases: Murray, *Cyprus*, fig. 63 (three examples); Gjerstad, *Cyprus* I, p. 566 and pl. 92 (3); Myres, *Handbook*, #1578; J. L. Benson, *Bamboula at Kourion* (Philadelphia, 1972), p. 128 and pl. 36. With base-rings: Murray, *Cyprus*, fig. 62; E. Gjerstad, *Studies on Prehistoric Cyprus* (Uppsala, 1926), p. 251 #4, 5; Gjerstad, *Cyprus* I, p. 478.

325. BM 98.12–1.154.

326. Åström, *Arts and Crafts*, p. 120. Peltenburg considers these blossom bowls to have no certain origin, but to represent an international western Asiatic style ("Classification," *Praktikōn*, 1972, p. 136).

327. Dikaios, *Guide*, p. 129 #5; Schaeffer, *Enkomi-Alasia*, pl. 39 (3); Murray, *Cyprus*, fig. 62; Gjerstad, *Cyprus* I, p. 534.

328. Dikaios, *Enkomi* I, p. 378; III a, pl. 208: 16.

329. Gjerstad, *Cyprus* I, p. 517.

330. Peltenburg, "Glazed Vases," *Kition* I, p. 109; and V. Karageorghis, "Kition: Commercial Centre of the Mycenaean Era," *Archaeologia Viva* 2 (1969), fig. 108.

331. Schaeffer, *Enkomi-Alasia*, color plate B and pl. 41 (1); Gjerstad, *Cyprus* II, p. 554 and pl. 183 (spout fragment); BM 98.12–1.214; Murray, *Cyprus*, fig. 62; Åström, *Arts and Crafts*, fig. 70: 22.

rounded petals.[332] The bowls have two perforated handle projections at the rim, probably for attachment of lids, as well as curved stems. A similar curved stem originally supported a low cylindrical container recovered from a tomb near Idalion.[333] The vessel's interior is decorated with a medallion of lotus petals in black on dark turquoise.

Additional types of Cypriote faience vessels include a pair of tripodic bowls from Enkomi, one of which has traces of a scene with horned animals encircled by a leafy border.[334] Two pomegranate juglets, both from Enkomi, have wavy band decoration imitating glass pieces of the same shape.[335] Other jugs copy Cypriote Base-ring I pottery tankards,[336] Mycenaean biconical juglets,[337] and Mycenaean globular narrow-necked juglets with single vertical handles.[338] Several imitations have been found of squat Mycenaean amphorae with geometric and animal decoration on their shoulders.[339] There are also three ovoid jars from Enkomi, the most interesting of which has a deep yellow pattern of concentric circles and connected triangles on a white ground and probably dates to LC III.[340]

Among the vessels unique in Cypriote faience are: a chevron-decorated tumbler,[341] a convex-sided, rounded-base Enkomi bowl;[342] a squat, globular bowl with horizontal handle projections;[343] a tall goblet from Kourion with blue and yellow pentagonal petals from base to rim;[344] and a flat, loop-handled plate with an interior dotted rosette design from Enkomi.[345] Finally, from Enkomi there is a rectangular tray with sloping sides[346] and a small two-handled bucket,[347] both of which probably imitate metal examples.

332. Karageorghis, "Kition," *Archaeologia Viva* 2 (1969), fig. 104; Murray, *Cyprus*, figs. 63, 76 a; Karageorghis, *Mycenaean Art from Cyprus*, pl. 40.

333. Myres, *Handbook*, #1579. For Cypriote parallels in stone, see Myres, *Handbook*, #1538, 1637; and Murray, *Cyprus*, fig. 63.

334. Murray, *Cyprus*, fig. 63; Dikaios, *Enkomi* I, p. 355 (decorated bowl); III a, pls. 199: 22, 200: 17.

335. Dikaios, *Enkomi* I, p. 378; III a, pl. 208: 20; Karageorghis, *Mycenaean Art from Cyprus*, pl. 40.

336. Åström, *Arts and Crafts*, fig. 70: 31.

337. Åström, *Arts and Crafts*, fig. 70: 29.

338. Peltenburg, "Classification," *Praktikōn*, 1972, fig. 2. The vessel is decorated with yellow, brown, and blue horizontal bands with a panel of brown dots on the shoulder.

339. Myres, *Handbook*, #1570, 1571; Dikaios, *Guide*, p. 129; Benson, *Kourion*, pl. 51.

340. Schaeffer, *Enkomi-Alasia*, color plate B, pl. 43 (2), and fig. 76; also Dikaios, *Enkomi* I, pp. 367, 378; III a, pls. 211: 38, 208: 18.

341. Åström, *Arts and Crafts*, fig. 70: 26 and for Egyptian stone and faience parallels, see p. 121.

342. Dikaios, *Enkomi* I, p. 372; III a, pl. 209: 29.

343. Myres, *Handbook*, #1580.

344. Murray, *Cyprus*, fig. 99; for Syrian and Egyptian parallels, see Åström, *Arts and Crafts*, p. 122.

345. Peltenburg, "Classification," *Praktikōn*, 1972, fig. 3 and discussion p. 135 of its Aegean and Near Eastern affinities.

346. Murray, *Cyprus*, fig. 68.

347. Murray, *Cyprus*, fig. 63. Peltenburg notes the popularity of faience buckets in Mesopotamia and the Levant ("Classification," *Praktikōn*, 1972, p. 136).

From an early thirteenth century context at Kition[348] was recovered a remarkable rhyton with polychrome decoration on a lustrous gray blue ground.[349] The upper register depicts a pastoral scene of yellow and scarlet bulls and a yellow goat among scarlet flowers on pale green stylized stems. Below this are two scarlet hunters wearing conical tasselled caps and kilts reminiscent of Aegean styles. One hunter seizes a yellow bull by its hind leg and brandishes a short dagger, while his companion is occupied with a lassoed yellow bull. In the bottom register is a series of vertical panels filled with yellow running spirals of Aegean type.

The rhyton's excellent preservation, unusual motifs, and recovery from a stratified context at Kition have occasioned much discussion of its technique and origin.[350] The rhyton exhibits a characteristic Cypriote/Levantine amalgamation of Aegean and Oriental motifs. Its vivid colors and dark brown outlining of inlaid figures, however, bespeak Nineteenth Dynasty Egyptian techniques. Two sources for the rhyton seem possible: Byblos and southern Cyprus.[351] Both had close links with Egypt, faience industries, and traditions of producing luxury products that combined diverse elements. The rhyton's Cypriote origin is supported by the recent discovery at Atheniou of a thirteenth/fourteenth century ivory rhyton with four registers depicting stylized fish, plants, birds, and human heads.[352]

The class of Cypriote faience rhyta also includes goblets in the shape of female heads and animal-headed containers. From Enkomi were recovered one double-faced goblet[353] and five single-faced goblets. Two of these[354] have fully modeled features with dark brown outlining of eyes and eyebrows, painted choker necklaces, and single curls of hair on cheeks and foreheads.[355] A similar goblet was found in a thirteenth century tomb at Minet-el-Beida.[356] A third Enkomi goblet[357] differs from the first two in its angular features and hair style, with incised fillet and snood to hold

348. For a portrait of Kition before and during this prosperous period, see V. Karageorghis, "Kition: Mycenaean and Phoenician," *ProcBritAc* 59 (1973): 261–66; V. Karageorghis, *Kition: Mycenaean and Phoenician Discoveries in Cyprus* (London, 1976), pp. 26–57.

349. Among the many illustrations of this piece, see Karageorghis, "Kition," *Archaeologia Viva* 2 (1969), pls. 30–33 and the cover of the journal number; also Karageorghis, *Kition* I, color plates A, B, and C.

350. The most complete technical and stylistic study has been done by Peltenburg and H. McKerrell in "Glazed Vases," *Kition* I, pp. 116–35, with bibliography.

351. Peltenburg in "Glazed Vases," *Kition* I, favors Byblos (pp. 134–35); Åström suggests, "This vase seems to be the work of an individual Cypriote artist working under influences from abroad" (*Arts and Crafts*, p. 124).

352. T. Dothan, report to the New York Aegean Bronze Age Colloquium, 15 April 1976.

353. Murray, *Cyprus*, fig. 61.

354. Murray, *Cyprus*, fig. 61; H. R. Hall, *The Civilization of Greece in the Bronze Age* (London, 1928), fig. 297.

355. E. J. Peltenburg suggests the forehead curls may represent "the Asiatic indication of divinity by horns" ("Classification," *Praktikōn*, 1972, p. 134).

356. Schaeffer, "Fouilles de Minet-el-Beida," *Syria* 14 (1933), pl. 11 (1).

357. Murray, *Cyprus*, pl. 3.

the bun in place.[358] The same rendering of features may be seen in a goblet from Abu Hawām,[359] a Syrian wooden goblet found in Egypt,[360] and a fragmentary goblet from Enkomi.[361] Only the face of the fifth Enkomi goblet is preserved;[362] this shows flattened, stylized features and resembles two Abu Hawām goblets.[363] The question of the goblets' place of manufacture, whether Cyprus or the Levant,[364] is difficult to resolve, but it seems clear that the workshops must have been in close contact with each other.

Enkomi also yielded three animal-headed rhyta: a carefully modeled ram's head[365] with a parallel from Abu Hawām,[366] a yellow and brown horse's head,[367] and a highly naturalistic yellow and black deer's head.[368] Faience animal figurines from Enkomi include a duck's head[369] and a small yellow and brown recumbent lion on a faience base.[370] As for models of fruit and vegetables, there are bunches of grapes,[371] one of which is paralleled at Abu Hawām,[372] and from Enkomi a blue cucumber- or squash-shaped object with dark blue veins and a hole at its narrow end.[373] Plants are also represented on a set of five circular inlays with yellow-centered white daisies on brown or blue gray backgrounds[374] and an inlay piece with a blue and turquoise lotus pattern.[375]

Late Cypriote faience beads have been found in quantity at nearly all sites and are particularly numerous in LC II levels.[376] The largest group consists of globular or spherical beads in plain and fluted styles. Ribbed melon, oval, cylindrical or ring-shaped, convex tubular, and joined tubular spacer beads also occur with regularity. More unusual beads include a

358. E. D. van Buren has remarked that this hair-do is "the correct head-gear for Ištar in one particular aspect" (review of Andrae, *Ischtar-Tempel* in *Archiv für Orientforschung* 10 [1935–36]: 291), while W. Culican sees it as "peculiar to votaresses of Ishtar" ("Two Syrian Objects from Egypt," *Levant* 3 [1971]: 87).

359. Hamilton, "Abu Hawām," *QDAP* 4 (1935), pl. 29 #426; pl. 28 #425.

360. Culican, "Two Syrian Objects," *Levant* 3 (1971): 86–89.

361. Åström, *Arts and Crafts*, fig. 70: 33 and p. 123 for a suggested parallel with a goblet found in the Ishtar Temple of Tukulti-Ninurta at Assur.

362. Peltenburg, "Classification," *Praktikōn*, 1972, pl. 24 (2).

363. Hamilton, "Abu Hawām," *QDAP* 4 (1935), pl. 27 #427; pl. 29 #426.

364. Culican proposes that they are Mitannian products ("Two Syrian Objects," *Levant* 3 [1971]: 88), while Åström favors a Cypriote origin (*Arts and Crafts*, p. 123).

365. Murray, *Cyprus*, fig. 61.

366. Hamilton, "Abu Hawām," *QDAP* 4 (1935), pl. 30 #428.

367. Murray, *Cyprus*, pl. 3.

368. Gjerstad, *Cyprus* I, pl. 84 (2).

369. Gjerstad, *Studies on Prehistoric Cyprus*, pp. 252, 288 (no illustration).

370. Murray, *Cyprus*, fig. 62. A blue lion catalogued in the Cesnola collection (Myres, *Handbook*, #1566) is now missing.

371. Metropolitan Museum of Art 74.51.4522 and 4523.

372. Hamilton, "Abu Hawām," *QDAP* 4 (1935), pl. 39 (2).

373. Murray, *Cyprus*, fig. 66.

374. Metropolitan Museum of Art 74.51.4545 a-e.

375. Metropolitan Museum of Art 74.51.4546.

376. For a detailed listing and classification, see Åström, *Arts and Crafts*, pp. 48–51.

lantern bead from Enkomi[377] and a pair of yellow and black bull's-head beads from Akhera.[378]

This geographical and historical survey of faience distribution ends with a note on a group of enigmatic objects. These are small faience plaques of female faces, usually known as masks. They have been found in assorted contexts at Ur, Uruk, Tell Billa, Nippur, Sippar, Kish, Susa, Tchoga-Zanbil, Alalakh, Ras Shamra, Hala Sultan Tekke, Tell el Rimah,[379] Isin,[380] and at Mari on the chest of a buried individual.[381] Among the objects' proposed interpretations are that they are elements of composite statues, amulets, pendants, masks, decorative plaques of the "woman in the window" type, protective genies, or fragments of female-head rhyta. In the absence of convincing evidence, the objects' use remains an unresolved problem.

377. Gjerstad, *Cyprus* I, pl. 78 (2).

378. V. Karageorghis, *Nouveaux Documents pour l'étude du Bronze Récent à Chypre* (Paris, 1965), fig. 37 # 50, 70.

379. Examples and interpretations have been collected by H. Kühne in "Rätselhafte Masken," *Baghdader Mitteilungen* 7 (1974): 101–110 and by A. Parrot, "Masques Énigmatiques," in C. F. A. Schaeffer, *Ugaritica* VI (Paris, 1969): 409–18. The most complete study to date is E. J. Peltenburg, "A Faience from Hala Sultan Tekke and Second Millennium B.C. Western Asiatic Pendants Depicting Females," in P. Åström et al., *Hala Sultan Tekke* 3 [=*SIMA* 45:3] (Göteborg, 1977): 177–200.

380. J. N. Postgate, ed., "Excavations in Iraq 1975," *Iraq* 38 (1976): 69–70. One of the two Isin masks had inlaid eyes.

381. A. Parrot, "Masques," *Ugaritica* VI, fig. 2.

3
Aegean
Faience

THE CORPUS OF AEGEAN FAIENCE is divided here into three sections: Minoan faience, faience from the Greek mainland, and Aegean island faience. Within each section objects are treated in groups: vessels and containers, including rhyta; representations of humans, animals, fish, plants, shells, and rocks; plaques and inlays; and jewelry, seals, ornaments, and other objects.

Section 1 MINOAN FAIENCE

Early Minoan Mesara and Mochlos tombs and the Trapeza cave have yielded the earliest faience objects from Crete. All of these are beads of simple geometric shapes, with the exception of a fragile bowl from Mochlos which disintegrated soon after excavation.[1] At present one cannot say with certainty if this Early Minoan faience was Minoan made or imported. If it was native faience, this means that Crete was a third center of invention. If it was imported, as seems more likely, I believe that its origin was north Syria, rather than Egypt.

There are three reasons for making this suggestion. The first is based on the postulated nature of Crete's shipping activity during the Early Minoan period.[2] Cargoes exported from Crete to Syria, the Cyclades, and Egypt[3]

1. See above, chapter 2, notes 111, 112, 113.

2. Crete's Early Minoan trade is treated in detail by C. Renfrew in *The Emergence of Civilisation* (London, 1972), pp. 89, 94, 444–55. For possible shipping routes, see W. A. Ward, "Egypt and the East Mediterranean from Predynastic Times to the End of the Old Kingdom," *JESHO* 6 (1963): 55; R. D. Barnett, "Early Shipping in the Near East," *Antiquity* 32 (1958): 220–30. K. Branigan, *The Foundations of Palatial Crete* (New York, 1970), pp. 180–82 discusses the difficulties in assessing Early Minoan overseas connections.

3. Discussion of Early Minoan trade also relies to a large extent on extrapolations from evidence for later Minoan trade. This has been collected by F. Schachermeyr in "Die Beziehungen zu Vorderasien und Ägypten 2000 bis 1700 v. Chr.," chap. 7 (pp. 77–83) in his study *Minoische Kultur des alten Kreta* (Stuttgart, 1964). See his *Ägäis und Orient* (Vienna, 1967), pp. 62–63 for a summary of the principal points. W. A. Ward discusses traded goods in "Egypt and the East Mediterranean," *JESHO* 6 (1963): 27–34. Evidence for later Minoan and Mycenaean imports and exports has been gathered by A. Furumark, among others, in "The Settlement at Ialysos and Aegean History c. 1550–1400 B.C.," *Opuscula Archaeologica* 6 (1950): 248. R. S. Merrillees and J. Winter have paid particular attention to which substances were most likely to have been carried in the Minoan pottery found in Egypt ("Bronze Age Trade between the Aegean and Egypt," *Miscellanea Wil-*

may have consisted of textiles, wine, olive oil, and lichens for bread making. Imports to Crete from the Levant and Egypt[4] probably included ivory, gold, perfumes, spices, precious and semiprecious stones, scarabs, amulets,[5] a flint knife,[6] and perhaps ostrich eggs among other curiosities. Stone bowls of Old Kingdom type found in Crete may or may not have been imported from Egypt during this period. Recent studies of these vessels have shown that it is risky to assume that all of the stoneware was imported during the Old Kingdom,[7] or even that the vessels were all from Egypt.[8]

One may conclude from this that Early Minoan boats[9] regularly traveled the shipping routes[10] connecting Crete with the Levant. I suggest that the faience that Minoan traders obtained came from the production centers of north Syria and north Mesopotamia. Cretan traders were familiar with Levantine marketplaces, and faience beads would have been attractive, novel souvenirs. It is by no means certain that Early Minoan traders themselves continued to Egypt after stopping along the Levantine coast. If they did, it is admittedly possible that the faience was acquired there.

Two additional arguments, however, strongly suggest that north Syria was the source of Early Minoan faience and the inspiration for the Aegean

bouriana I [1972]: 110–15). Certain products such as perfumed oil have received individual treatment: E. D. H. Foster, "The Manufacture and Trade of Mycenaean Perfumed Oil," dissertation, Duke University, 1974. For ostrich eggs, see below chapter 3, note 331.

4. For later Minoan periods, see J. D. S. Pendlebury, *Aegyptiaca: a Catalogue of Egyptian Objects in the Aegean Area* (Cambridge, 1930). An attempt to bring this list up to date has been made by R. B. Brown in "A Provisional Catalogue and Commentary on Egyptian and Egyptianizing Artifacts Found on Greek Sites," dissertation, University of Minnesota, 1975.

5. K. Branigan, "Minoan Foot Amulets and their Near Eastern Counterparts," *SMEA* 11 (1970): 7–23 discusses a type of amulet meant to ward off snakebites.

6. G. Cadogan, "An Egyptian Flint Knife from Knossos," *BSA* 61 (1966): 147–48.

7. A comprehensive work on the classification and contexts of these vessels is P. Warren, *Minoan Stone Vases* (Cambridge, 1969). Also valuable is his article "The First Minoan Stone Vases and Early Minoan Chronology," *KrChr* 19 (1965): 7–43. G. A. Reisner was among the first to treat this topic in his notes on "Stone Vases Found in Crete and Babylonia." *Antiquity* 5 (1931): 200–212. Recently, L. Pomerance has suggested that Eighteenth Dynasty tomb robbers were partly responsible for the importation of Old Kingdom stoneware to Crete ("The Possible Role of Tomb Robbers and Viziers of the Eighteenth Dynasty in Confusing Minoan Chronology," *Temple University Aegean Symposium* 1 [1976]: 1–2).

8. S. Hood, *The Minoans* (New York, 1971) points out on p. 103 that "some of the earliest Cretan stone vases are incised with hatched triangles, suggestive of Syrian rather than Egyptian inspiration."

9. S. Marinatos has reconstructed Minoan boat types based on their representations on vases, utensils, jewelry, and in models ("La Marine Créto-Mycénienne," *BCH* 57 [1933]: 170–235).

10. The later predominance of Minoan boats does not mean that Crete had political control over the waterways, that is, a thalassocracy. S. Dow has assessed the so-called Minoan thalassocracy in light of political events of the mid-second millennium in his study "The Greeks in the Bronze Age," *XIᵉ Congrès International des Sciences Historiques*, 1960, especially pp. 8–13. See also C. G. Starr, "The Myth of the Minoan Thalassocracy," *Historia* 3 (1954/55): 282–91.

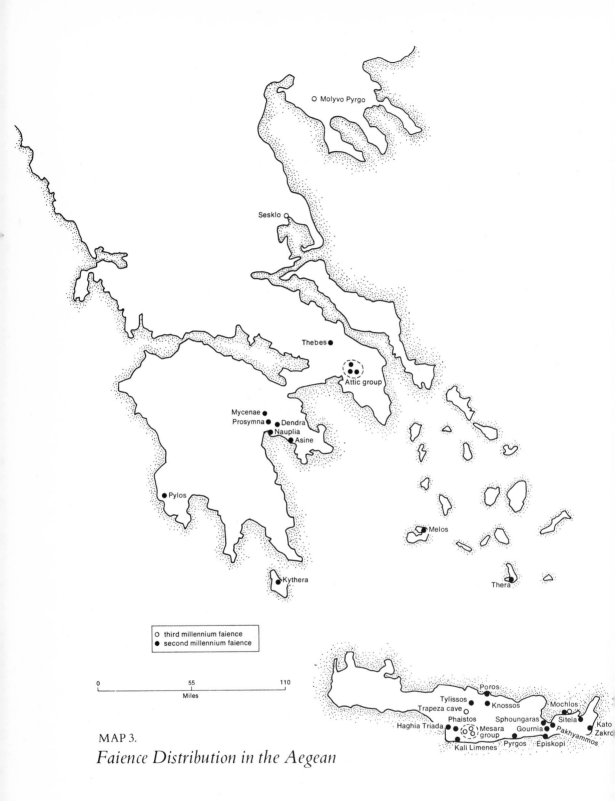

O Molyvo Pyrgo

Sesklo O

Thebes ●

Attic group

Mycenae ●
Prosymna ● ● Dendra
Nauplia ●
● Asine

● Pylos

● Melos

● Kythera

Thera ●

○ third millennium faience
● second millennium faience

0 55 110
 Miles

MAP 3.

Faience Distribution in the Aegean

Poros ●
Tylissos ● ● Knossos Mochlos ●
Trapeza cave ○ Siteia ●
Phaistos ● Sphoungaras ● ● Kato
Haghia Triada ● ○ ○ Mesara Gournia ● Pakhyammos ● Zakro
 group ● Episkopi
Kali Limenes ● ● Pyrgos

58

industry. It is significant that the development of Early Minoan metal-lurgical[11] and gold-working skills, including granulation, shows north Syrian rather than Egyptian influence.[12] Both of these techniques are related to faience techniques in their requirements of sophisticated firing capabilities and trained, specialized practitioners.

Finally, north Syria and north Mesopotamia were dynamic and innovative centers of faience production, actively involved in the spread of that art throughout the Near East at the end of the third millennium. For these three reasons, therefore, one may object to the traditional view that faience technology "had been beyond all doubt implanted there in Crete, together with many other technical acquirements, through that early contact with Egypt."[13]

The faience industry expanded rapidly in Crete. The fragmentary inlays from the MM Ia Vat Room deposit[14] and the fine MM II gold and faience vase from the Knossos Kamares deposit (plate 1) are among the earliest certain examples of Minoan faience products. This expansion took place in part because of repeated stimulation from north Syria and Mesopotamia and in part because of long-standing Minoan experimentation in the decorative arts. Innovations in ceramic techniques, for example, can be seen in the Early Minoan white, buff, and black and in the Middle Minoan red, white, gray, and brown polychrome ware. A particularly interesting experiment was the Early Minoan Vasilike ware. This is thought to have been produced by oxidizing, reducing, and slightly reoxidizing vessels whose surfaces had been specially painted. The painting involved a combination of red-slipped, reserved, and outlined areas.[15] These deliberate efforts made to control the mottling were usually successful and created discernible patterns of dark and light values.[16] The important Minoan innovation of polychrome faience was no doubt an outgrowth, albeit some centuries later, of this sort of skillful experimentation in the decorative arts.

On Crete, workshop areas for faience production have been identified in the southern wing of the palace of Zakros. Discovered there were partially vitrified pieces, unfinished sculptures, and other fragments of faience.[17] Grinding stones and tools were also found, as well as a clay grill

11. Branigan, *Foundations of Palatial Crete*, p. 182.

12. R. A. Higgins, *Greek and Roman Jewellery* (London, 1961), p. 22 for the origin of the granulation technique and p. 56 for Near Eastern parallels to Early Minoan styles and types.

13. *PM* I, p. 488. After the completion of this manuscript, I learned of K. Branigan's article "Crete, the Levant and Egypt in the Early Second Millennium B.C.," *Acts of the Third Cretological Congress, 1971* (Athens, 1973), pp. 22–27; his conclusions about Early Minoan Crete's contact with the Levant rather than with Egypt confirm my conclusions about the faience interconnections.

14. *PM* I, p. 170.

15. P. Warren, *Myrtos* (Oxford, 1972), pp. 129–31, with further references in notes; M. Farnsworth and I. Simmons, "Coloring Agents for Greek Glazes," *AJA* 67 (1963): 392–93.

16. J. D. S. Pendlebury, *Archaeology of Crete* (London, 1939), pl. X, 2, d, for instance. A corpus of Vasilike ware is presently being prepared by P. P. Betancourt (personal communication).

17. N. Platon, *Zakros* (New York, 1971), p. 218.

that may have been used in faience making.[18] In the same area other raw materials and tools for perfume, crystal, ivory, and lapidary industries were recovered, attesting to that palace's importance as a center for production of luxury goods.

At Knossos were found thick, almost cylindrical cakes of unfired, pre-molded faience material alongside the finished pieces of the Temple Repository.[19] A black steatite mold for faience objects was recovered from a dependency on the northwest of the palace at Knossos. This contained eight matrices for shells, rosettes, a bracket, bracelet, and a clenched human fist.[20] Faience workshops might well have been located near the grinding equipment of the lapidary shops opening off the east corridor of the palace, in the Royal Road area, or in proximity to the palace pottery kiln area.[21]

The marks often found on the backs of inlays give some insight into their manufacture. Many of these marks resemble signs in the Minoan linear scripts and appear on faience discs from the Knossos throne room,[22] and from Phaistos and Haghia Triada.[23] The reverse sides of bone fish-shaped pieces from Knossos also bear marks,[24] as do bracelet fragments[25] and elements of draughtboards from Knossos and Mycenae.[26] Faience and steatite inlays from Phaistos, as well as stone blocks, have similar signs.[27] While it is possible these marks represent the signary of a Minoan inlayer's guild,[28] it seems more likely that they are the notations of individuals responsible for certain aspects of the entire task.[29] These might include preparation of the faience mixture, application of decoration, and extraction from molds.

1a *Vessels and Containers*

Minoan faience vessels have been recovered chiefly at Knossos. A faience and gold miniature vase (plate 1) was found in the MM IIb Loom-weight deposit, together with a small terra-cotta shrine and its accessories, a clay pan containing a gold spray of leaves, and other miniature clay vessels.[30]

18. Platon, *Zakros*, p. 215.

19. A. J. Evans, "The Palace of Knossos," *BSA* 9 (1902–3), p. 64 and fig. 20 c, f, g, h, i, k.

20. *PM* 1, p. 488 and fig. 349 a, b, c.

21. *PM* 3, pp. 268–70, 277. The Royal Road area was probably a site for glass manufacture in the LM I period, to judge from the pellets and lumps found there (G. Cadogan, "Some Faience, Blue Frit and Glass," *Temple University Aegean Symposium* 1 [1976]: 18).

22. *PM* 4:2, fig. 913.

23. *PM* 1, p. 488 n. 2.

24. *PM* 3, fig. 269.

25. *PM* 3, fig. 271.

26. *PM* 1, fig. 347; Cadogan, "Some Faience, Blue Frit and Glass," *Temple University Aegean Symposium* 1 (1976): 18.

27. L. Pernier, *Il Palazzo Minoico di Festòs* (Rome, 1935) I, pp. 311–15 and 400–13; II, fig. 214 a and b (ribbed inlays).

28. *PM* 3, pp. 408–9.

29. This idea has been advanced by C. Nylander with regard to the craftsmen's marks found on blocks at Persepolis and is equally valid here ("Masons' Marks at Persepolis," paper given at the Archaeological Institute of America meetings, December 1975).

30. *PM* 1, pp. 252–53.

PLATE I
Gold and faience vase,
Loom-weight deposit, Knossos.
Scale: actual size

FIGURE I
Gold and faience vase,
Loom-weight deposit,
Knossos.
Scale: ⅔ actual size

The vase has an incurving gold neck and foot, with a thimblelike depression under the base (figure 1).[31]

Two MM IIIb pieces from Knossos provide good instances of translation into faience from stone, ceramic, and metal prototypes. The first is a fragment of a blossom bowl (plate 2) showing the reduplicated fluting and overlapping petals found in steatite and eggshell ware examples of the same class.[32] The other is a blue green spouted ewer (figure 2) recovered from the MM IIIb deposit in the Treasury of the Sanctuary Hall along with stone libation vessels, rhyta, and triton shells.[33] The ewer is decorated with a row of bosses at the intersection of the body and neck and a thin lilac band where the tapered foot joins the body. A close parallel is afforded by a silver teapot from a slightly earlier chamber tomb at Byblos.[34]

A group of small faience vessels was found in the sunken cists of the MM IIIb Temple Repository. Among these miniature wares is a sinuous-sided, pale blue green beaker, decorated by a raised band with vertical incised lines (plate 3). This band progresses in a continuous spiral about

31. For the depression, see *PM* 1, fig. 189 a, where the vase is drawn upside down.
32. *PM* 2:2, p. 697. This piece is dated on the basis of its find-spot in the filling of the MM III House of the Sacrificed Oxen near the southeast angle of the palace. The sherd is not on exhibit in the Heraklion Museum.
33. *PM* 2:2, fig. 537.
34. *PM* 2:2, fig. 541 a.

PLATE 2
Blossom bowl fragment, filling of the
House of the Sacrificed Oxen, Knossos.
Scale: actual size

FIGURE 2
Ewer, Treasury of the Sanctuary Hall, Knossos.
Scale: $\frac{1}{4}$ actual size

the vessel, tapering as it encircles the base and rim. The vessel is an unusual one; no parallels are known to me. There were two baskets recovered, both pale blue green and originally equipped with rounded, upright handles. One is decorated with cockleshells set around the rim (figure 3) and resembles Middle Minoan clay bowls with similar appliqués from Mallia and Knossos.[35] The other basket has a fluted rim which perhaps at opposite ends was pinched outward to form pouring lips (figure 4). The round-bottomed shape may be derived from that of two-handled copper caldrons, such as those from Shaft Grave IV, Mycenae.[36]

Also placed in the Temple Repository were two brown chalices, each of which has a flaring mouth and a flattened horizontal handle extending from the rim. The larger of the two (figure 5) has a dark brown band painted around the rim which is set off by a small ridge at the point where the handle rejoins the body. Another band of the same width and color encircles the base. The body of the chalice has a painted dark brown, fernlike pattern of two fronds symmetrically arranged on either side of a single stalk. A parallel to this foliate pattern may be found on a gold repoussé cup from Shaft Grave IV, Mycenae.[37] The second Temple Repository chalice (figure 6) differs from the first chiefly in its vegetal decoration. This consists of one tall central plant flanked by two shorter ones, again with leaves symmetrically arranged on the stems. On both chalices the plants grow from the apexes of solid painted triangles as though the leaves were rooted in mounds of earth. A faience chalice from

35. H. and M. van Effenterre, *Fouilles Exécutées à Mallia* [=*Études Crétoises* 17] (Paris, 1969), pl. 73 C1380, C1001; *PM* 4:1, figs. 75, 82.

36. H.-G. Buchholz and V. Karageorghis, *Prehistoric Greece and Cyprus* (New York, 1973), #1091–94, 1411.

37. *PM* 2:1, p. 188; see also *PM* 4:1, pl. XXIX F for a MM II ewer with a similar dark-on-light plant design.

PLATE 3
Vase, Temple Repository, Knossos.
Scale: actual size

grave Alpha of the Second Grave Circle, Mycenae (plate 32) is similar
in shape and banded decoration and is discussed below in section 2, 1a.

Decorative elements similar to those of the three chalices appear on a
handleless faience flask (figure 7) from the Temple Repository. The vessel
is of the pilgrim's flask type and has a dark central medallion on one face,
a characteristic feature of MM III/LM I ceramic flasks.[38] A dark band out-
lines the edges, just as dark bands of the same width outline the rims and
bases of the chalices. In contrast to the chalices' stiff, formalized foliate
patterns, here a naturalistic spray of sculptured rose leaves arcs down from
the vessel's neck, crosses the outer band, and almost touches the central
medallion. In the same way, the static treatment of the painted flowers on
the faience votive garments (figures 17, 18, 19) contrasts with the fluid
modeling of the faience lily (plate 14), all from the Temple Repository.

Two additional faience vessels were found in the Temple Repository.
Figure 8 shows the top view of a shallow open bowl with a wide, turned-
out lip. Attached to the lip at the cardinal points are four figure-eight shields
similar to the faience models of such shields from Knossos and Mycenae
(figures 25, 91; plate 47). A pale blue green ewer (plate 4) provides a faience
example of the Linear B ideogram for the qe-ra-na vessel which is drawn

38. *PM* 2:1, fig. 121 b, c. The flask is not displayed in the Heraklion Museum, so it has
not been possible to determine what, if any, decoration exists on the other face.

FIGURE 3
Basket, Temple Repository, Knossos.
Scale: ½ actual size

FIGURE 4
Basket, Temple Repository, Knossos.
Scale: ½ actual size

on Knossos tablet K 93.[39] The ewer, with its high-swung handle and undulating rim, was probably copied from metal prototypes. Other vessels of this shape include the gold ewer from Shaft Grave IV, Mycenae,[40] the silver jug from the South House at Knossos,[41] and the white marble pitcher from Zakros.[42] The shape is often depicted on sealing.[43] The Temple Repository ewer is decorated with a single relief band of running spirals placed around the widest part of the body. The pattern appears also on metalwork, for example, on a gold-plated ewer from Shaft Grave V, Mycenae,[44] and on a cup from a Late Minoan warrior's grave at Knossos.[45]

In the LM Ib Treasury behind the central shrine at Zakros were found fragments of faience vessels, together with numerous stone and crystal jugs, cups, rhyta, maceheads, and bronze double axes. Among the faience pieces were a one-handled cup, an open bowl in the shape of a flower calyx, a small offering table, and models of fruits and plants with spearlike leaves.[46] In addition, four unusual faience objects were discovered: two bull's-head rhyta (plate 5); a wild-cat's-head rhyton (figure 9; plate 6); and a container in the shape of an argonaut shell (plate 16). The first three are discussed in 1b below and the last with the other Minoan shells in 2c below.

1b *Rhyta*
Theriomorphic vessels appear in Crete from the beginning of the Middle

39. J. Chadwick, *Documents*[2] (Cambridge, 1973), pp. 324–25, 494.

40. *PM* 1, pp. 498–99.

41. *PM* 2:1, fig. 221.

42. Platon, *Zakros*, p. 137.

43. M. Nilsson, *The Minoan-Mycenaean Religion and its Survival in Greek Religion*[2] (Lund, 1950), pp. 146–53 (hereafter cited as *MMR*[2]).

44. *PM* 2:2, fig. 411 b.

45. Schachermeyr, *Minoische Kultur*, fig. 146 B.

46. Platon, *Zakros*, p. 147 (no illustration); these are not displayed in the Heraklion Museum.

FIGURE 5
Chalice, Temple Repository, Knossos.
Scale: $\frac{2}{3}$ actual size

FIGURE 6
Chalice, Temple Repository, Knossos.
Scale: $\frac{2}{3}$ actual size

FIGURE 8
Bowl, Temple Repository, Knossos.
Scale: $\frac{1}{2}$ actual size

FIGURE 7
Flask, Temple Repository, Knossos.
Scale: $\frac{2}{3}$ actual size

Minoan period onward.[47] Their origin is thought to be Mesopotamia,[48] despite spotty evidence for the claim.[49] It is often maintained that they had cultic significance and were possibly used for blood libations from sacrificed oxen.[50] In view of the lack of specific substantiation for their use in ritual,[51] it seems likely that most Minoan rhyta were luxury products, designed to satisfy a taste for the unusual.

The rhyta recovered from Minoan palaces and villas bear this out. Among these are a LM I lioness-head vessel of translucent limestone, remarkable for its sculptural qualities and flawless workmanship,[52] and two chlorite bull's heads with gilded wooden horns.[53] Knossos tablet K 872 mentions three rhyta of this last type and includes ideograms of two rhyta in profile.[54]

The two faience bull's-head rhyta from the Treasury of the Shrine at Zakros provide examples of this class of vessel manufactured in less costly

47. G. Karo has prepared a lengthy study of "Minoische Rhyta" in *JdI* 26 (1911): 249–70.

48. *PM* 2:1, pp. 259–65; *PM* 4:2, p. 425. R. Dussaud, discussing the Aegean rhyta from Ras Shamra, has described them as "un choc en retour" ("Rapports entre la Crète Ancienne et la Babylonie," *Iraq* 6 [1939]: 61).

49. Among others, H. J. Kantor has pointed out in *Aegean and Orient* (Bloomington, 1947), "The claim of an Asiatic origin for Aegean rhytons should be regarded with considerable caution" (p. 46 n. 120).

50. S. Alexiou, *Minoan Civilization* (Heraklion, n.d.), pp. 100–1.

51. Nilsson, *MMR*², p. 145.

52. *PM* 2:2, fig. 542 a, b, and pl. 31 a.

53. Platon, *Zakros*, frontispiece and pp. 161–63; *PM* 2:2, fig. 330.

54. Chadwick, *Documents*², p. 330.

PLATE 4
Ewer, Temple Repository, Knossos.
Scale: actual size

PLATE 5
Bull's-head rhyta, Treasury of the Shrine, Zakros.
Scale: ½ actual size

material.[55] One (plate 5, right) is decorated with dark brown markings behind the head and has rosettes about its eyes, a convention often used to indicate the dappled hides of animals.[56] The other (plate 5, left) has a more prominent poll, but with the same sketchy rendering of hair. Of special note is the orientation of each head along the same axis as the neck. Other bull's-head rhyta differ in that the head is set upright at a ninety-degree angle to the horizontal neck. In addition, neither of these faience rhyta has provision for inserting horns, and it may well be that these represent calves rather than full-grown bulls.

Figure 9 and plate 6 show a polychrome rhyton in the shape of a wild-cat's-head, also from the Treasury of the Shrine at Zakros. Several fragments of the rhyton exist, of which the largest show the animal's forehead and eyes. Its eyes are fully modeled, with black outlining and cream corneas, black irises, and dark red pupils encircled in white. This is no doubt

55. At Gournia a clay mold for a bull's-head rhyton was found in the LM I shrine, which attests further to production of small, inexpensive copies of more elaborate versions (H. B. Hawes, *Gournia, Vasiliki . . .* [Philadelphia, 1908], pl. 11 #19 A).

56. Minoan use of rosettes, stars, and crosses to show hide markings can be seen, for example, in frescoes depicting bulls (*PM* 3, fig. 144); on the faience plaque of cows (figure 21, below); on a clay bull's-head rhyton (*PM* 2:2, fig. 342 a); and on the bull's-hide figure-eight shields of the Hall of the Double Axes (*PM* 3, fig. 196).

68

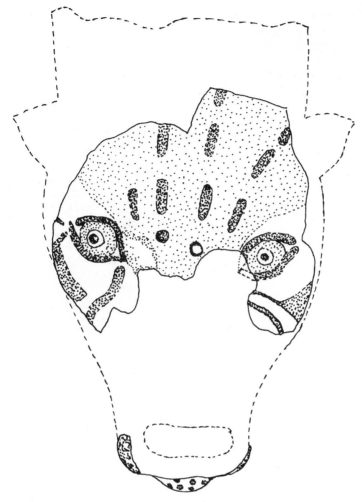

FIGURE 9
Wild-cat's-head rhyton, Treasury of the Shrine, Zakros.
Scale: actual size

in imitation of the jasper and crystal eyes of more elaborate animals.[57]
Beneath the eyes are red and black striations on a cream ground. Two
black bosses mark the place for forehead whiskers. The forehead is done
in red and set off from the rest by a slight ridge. Patterns of fur are shown
by black dashed lines. Smaller fragments belong to the lower jaw, which
is rendered in red and cream, with black-filled incised dots. The faience
rhyton resembles the terra-cotta head of a wild cat found in the domestic

57. *PM* 2:2, fig. 543 (lioness); *PM* 2:2, p. 530 (bull). Similarly modeled eyes appear
on a fragmentary terra-cotta rhyton in the shape of a dog's head, perhaps from Mycenae
(R. Laffineur, "Le rhyton égéen en forme de tête de chien," *Bulletin des Musées Royaux
d'Art et d'Histoire* 45 [1973]: 291–300).

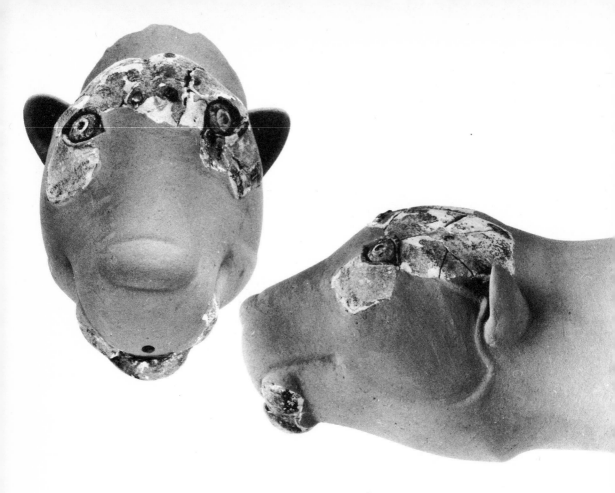

PLATE 6
Wild-cat's-head rhyton, Treasury of the Shrine, Zakros.
Scale: ¾ actual size (side view)
Scale: ⅔ actual size (front view)

area at Zakros,[58] the limestone lioness mentioned above, and a clay cat's-
head rhyton from Thera with similar markings.[59]

2a *Human Figurines*

Of the many faience objects recovered from the cists of the Knossos MM
IIIb Temple Repository, the three human figurines are the most interesting
iconographically.

The largest of the three (plates 7 and 8) is known as the Snake Goddess
because of the several spotted snakes that encircle her tiara, descend her
outstretched arms, and coil in a knot below her waist. Her costume of
close-fitting, short-sleeved bodice, short apron, and bell-shaped skirt re-
flects the elaborate clothing of the Neo-Palatial Period. Each garment is
lavishly decorated: the yellow bodice with dark brown interlocking and
running spirals; the apron with its border of running S-hooks and field of

58. Platon, *Zakros*, p. 262.
59. S. Marinatos, *Thera* V (Athens, 1972), pl. 80.

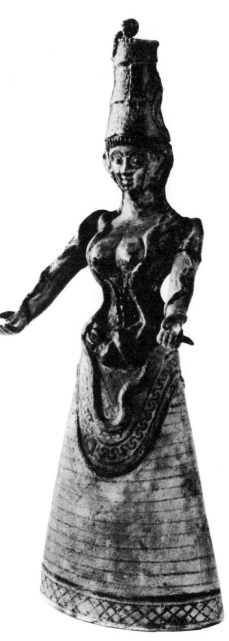

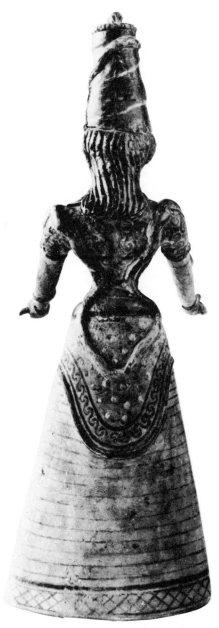

PLATE 7
Principal snake handler, front view, Temple
Repository, Knossos.
Scale: ³⁄₇ actual size
Cliché Cahiers d'Art, Paris

PLATE 8
Principal snake handler, rear view, Temple
Repository, Knossos.
Scale: ³⁄₇ actual size
Cliché Cahiers d'Art, Paris

evenly spaced circles; and the cream skirt with its reconstructed bottom border of dark brown lozenges and narrow horizontal stripes. Her costume is completed by a string of beads painted around her neck, a tightly laced waistband, and a pin that secures material just below the waist. Her skin is white, and the details of her face and bare bosom are added in black. She has straight, dark, shoulder-length hair and bangs surmounted by a high, purple brown tiara.

Plate 9 and figure 10 show the skirt, apron, and waistband of a second figurine. The similarities are marked between the costume's color, pattern, and design and those preserved of the figurine described above. The incomplete figurine differs in its lack of waist-encircling knotted snakes and their replacement by a plain band decorated with running S-hooks.[60] Above that is a laced cummerbund, perhaps secured with a vertical pin.

The third figurine (plates 10 and 11) holds two writhing snakes in her upraised hands and wears a different type of costume from those of her companions. The open-front, dark orange bodice has brown suspenders and panels on the elbow-length sleeves.[61] Her waist is cinched by a ribbed belt and closely gathered lacings. She wears a yellow flounced skirt decorated with a brown checkerboard pattern of alternating squares and vertical stripes, perhaps meant to show pleated fabric. Over the skirt is a short double apron consisting of a horizontally striped underpiece and an overpiece with a dark brown net pattern.[62] Her dark, straight hair reaches below her waist and is capped by a beretlike headpiece encircled with raised medallions,[63] perhaps meant to represent flowers.[64] Atop this, a miniature spotted wild cat or leopard sits on its haunches.[65]

This association with a wild feline has suggested to many that the third figurine is a representation of the so-called Mistress of the Animals. On Minoan and Mycenaean gems and seals, women flanked by felines in heraldic groupings or accompanied by striding lions are often referred to as Mistresses of the Animals.[66] None shows a cat seated on the Mistress's head; there is one example, in fact, of a goddess seated on the head of a beast, "proof that she is a goddess."[67] Accordingly, one should consider the Temple Repository figurine a participant in the cult of snake handlers, rather than a Mistress of Animals.

The precise nature of the snake handlers' cult is itself incompletely eluci-

60. A steatite figurine supposedly from Tylissos wears an almost identical skirt and apron, which is said to attest to its authenticity (*PM* 3, fig. 293).

61. See also the sleeve designs on the dresses from the Temple Repository (figures 17, 18) and on a fragment of a wall painting found just south of Knossos (*PM* 4:2, fig. 320).

62. For similar net patterns, see *PM* 2:2, p. 734 and fig. 457 a.

63. See Nilsson, *MMR*[2], figs. 168, 169 for two gems depicting individuals with headpieces formed of three contiguous balls.

64. *PM* 1, p. 504.

65. It should be noted that the cat was not found attached to the beret, but placed there because of identical rivet holes on the underside of the cat and top of the beret (*PM* 1, p. 504).

66. Nilsson, *MMR*[2], pp. 354–61.

67. Nilsson, *MMR*[2], fig. 170 and p. 359.

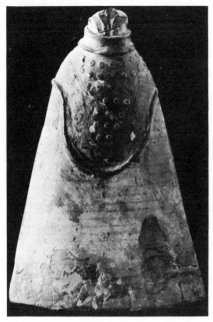

PLATE 9
Assistant snake handler, lower portion,
Temple Repository, Knossos.
Scale: ⅘ actual size
Cliché Cahiers d'Art, Paris

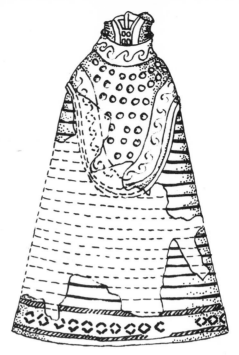

FIGURE 10
Assistant snake handler, lower portion, Temple
Repository, Knossos.
Scale: ½ actual size

dated by the available evidence. Study of modern snake handlers has shown that such individuals perform a variety of functions which range from the practical aspects of dealing with snakes to the more esoteric exercise of supernatural power. N. L. Corkill has clearly set forth the snake handlers' activities:

> They may seek out, detect, handle, and remove snakes; they may manipulate them for entertainment; they may possess, claim, or confer impunity in the handling of snakes and immunity to their venoms, and they may possess or claim special powers in the treatment of snake poisoning; finally they may train apprentices to these various ends. Such specialists ... are often persons endowed with supernatural power in other spheres of activity.[68]

68. N. L. Corkill, "Snake Specialists in Iraq," *Iraq* 6 (1939): 45–52. It is interesting to note that members of a contemporary Tennessee sect handle snakes as part of their service of worship, believing that snake handling proves divine annointing (L. Alther, "'They Shall Take Up Serpents,'" *New York Times Magazine* 6 June 1976, pp. 19–20, 28, 35). A snake handler whom I observed in Egypt concluded his performance by holding the snake in a pose identical to that of the faience principal snake handler. Several types of snake dances are performed in present-day Greece; these are discussed by L. B. Lawler in "Snake Dances," *Archaeology* 1 (1948): 110–13.

73

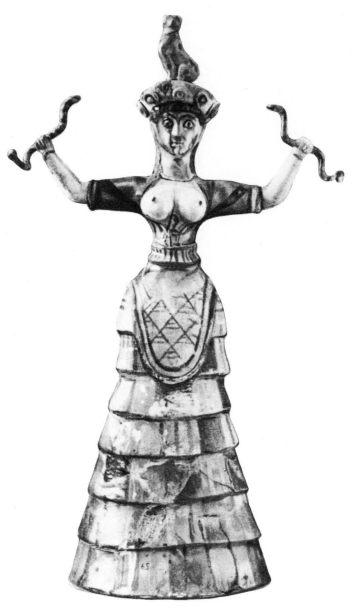

PLATE 10
Assistant snake handler, front view, Temple Repository, Knossos.
Scale: $\frac{1}{2}$ actual size
Cliché Cahiers d'Art, Paris

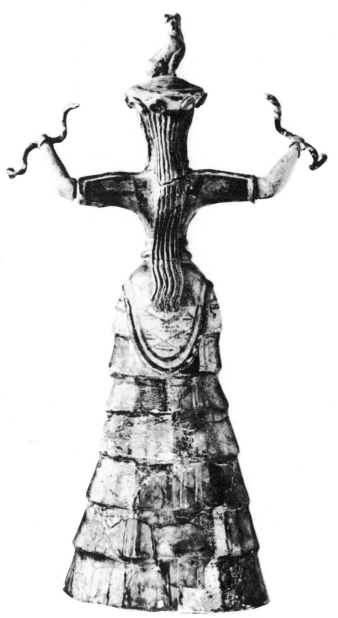

PLATE II
Assistant snake handler, rear view, Temple Repository, Knossos.
Scale: $\frac{1}{2}$ actual size
Cliché Cahiers d'Art, Paris

The three faience pieces from the Temple Repository might well represent the central figures in a cult of snakes and their handlers.

Since figurines holding or encircled by snakes have not been found in cave or open-air sanctuaries, it is probable that the cult was a domestic one.[69] This is borne out by the fact that a small domestic shrine at Gournia contained bell-shaped idols with snakes entwined about their shoulders and bodies.[70] Another bell-shaped idol from the Little Palace at Knossos is similarly festooned with snakes.[71] If the snake handlers' cult was a domestic one, this implies that the snake had domestic significance.

The snake in Near Eastern contexts has been assigned several roles: the embodiment of the male and female principle,[72] the guarantor of fertility,[73] and the representative of the dead.[74] The Minoan evidence fails to support any of these interpretations, and it points instead to a fourth role: the snake as genius, protector, and guardian of the house.[75] As such, it assumed a central position in the domestic cult which made both the snake[76] and its handlers[77] prominent figures.

The three faience figurines from the Temple Repository, therefore, may be identified as principal snake handler and two assistants, each with special characteristics and probably individual functions in the cult. The same hierarchy can be seen in the drawing of three female figures on the interior of a MM IIb bowl from Phaistos. Two individuals with outstretched arms flank a central figure with two snakes wriggling down either side of her triangular body.[78] The hierarchy is also evident in a LM III Palaikastro

69. Nilsson, *MMR²*, p. 321. K. Branigan ("The Genesis of the Household Goddess," *SMEA* 8 [1969]: 29–38) suggests that the goddess of the Early Minoan peak sanctuaries eventually became the principal figure of the MM III palatial household shrines of the snake cult.

70. Nilsson, *MMR²*, pp. 310–11.

71. A. J. Evans, "The Tomb of the Double Axes," *Archaeologia* 65 (1914), p. 75 and fig. 84 a, b.

72. E. D. van Buren, "Entwined Serpents," *Archiv für Orientforschung* 10 (1935–36): 54.

73. P. Amiet in B. Buchanan, "A Snake Goddess and Her Companions," *Iraq* 33 (1971): 5.

74. Buchanan, "Snake Goddess," *Iraq* 33 (1971): 8. See also Nilsson, *MMR²*, p. 324 for a discussion of this aspect of the snake in later Greek religion.

75. Nilsson, *MMR²*, pp. 325–29. See also *PM* 4:1, pp. 138–68 for a comprehensive treatment of evidence for a domestic snake cult, including the snake rooms of the private houses at Knossos and the so-called snake tubes. The most complete study of snake tubes is now G. C. Gesell, "The Minoan Snake Tube: A Survey and Catalogue," *AJA* 80 (1976): 247–59.

76. Two clay models of coiled snakes were found in the Room of the Idols at the Citadel House, Mycenae; these provide additional substantiation for the importance accorded to the snake (W. D. Taylour, "Mycenae, 1968," *Antiquity* 43 [1969], pl. 9 a, b and p. 93).

77. As A. Furumark has suggested, the Temple Repository figurines form "only part of a large collection of votive figurines and other objects, which show clearly that these are representations of worshippers or priestesses engaged in sacred rites" ("Gods of Ancient Crete," *Opuscula Atheniensia* 6 [1965]: 91).

78. D. Levi, *The Recent Excavations at Phaistos* [=*SIMA* 11] (Lund, 1964), fig. 24. G. Walberg, *Kamares* [= *Boreas* 8] (Uppsala, 1976), p. 68 n. 161 reports that A. Furumark in his forthcoming *Linear A and Minoan Religion* considers this scene a depiction of two dancers eliciting a divine epiphany.

model of three dancers encircling a fourth, who is more elegantly costumed than the rest, and on a seal from Haghia Triada showing two small dancers/votaries and a larger female figure.[79]

Three stone snake handlers differ from those of the Temple Repository chiefly in details of gesture and placement of the snakes. The figurines show the cinched and laced waist, pin, bodice, and double apron of plate 10 and the high tiara of the principal snake handler. One grasps a long sinuous snake in both hands,[80] while another stands snakeless with arms akimbo,[81] and a third, also snakeless, cups her bare breasts with both hands.[82] None of these three figurines was recovered from an archaeological context, and their authenticity may be questioned, though they are reputed to come from the harbor town of Knossos.[83] The same is true of a bronze female figurine with snakes coiled in her hair, the provenance of which was once thought to be Troy.[84] Also of uncertain origin is the ivory and gold figurine, known as the Boston Goddess, who grasps two snakes in her outstretched hands.[85]

Several interesting representations of snake handlers, however, were found in archaeological contexts. Among the earliest is an EM II vessel from a Koumasa tomb in the shape of a female figure with two snakes wrapped about its neck and extending down its body.[86] LM II ceramic examples come from a domestic shrine at Gournia and show snakes loosely draped over the stiff upraised arms and thick cylindrical bodies typical of the figurines of that period.[87] A unique carnelian gem from a Knossos LM Ia bronze hoard perhaps depicts a snake handler with a large-headed snake rising at a sharp angle from the bottom of the figure's skirt.[88]

Among the Minoan representations of snake handlers of unquestioned authenticity, the faience figurines from the Temple Repository stand alone in their high level of stylistic and technical achievement.

Little has been found of earlier faience figurines. A small forearm (plate 12) was recovered from the MM I Vat Room deposit at Knossos. In addition to this arm, a variety of fine objects of obsidian, crystal, gold foil, eggshell ware, and faience beads was found.[89] It has been suggested

79. *PM* 3, fig. 41 and discussion p. 73 (model); B. Rutkowski, *Cult Places in the Aegean World* (Warsaw, 1972), fig. 73 (seal).

80. *PM* 4:1, figs. 149–50.

81. *PM* 4:1, fig. 21 and suppl. plate XLIV.

82. *PM* 2:1, fig. 133. This is known as the Fitzwilliam Goddess.

83. *PM* 4:1, pp. 35–36 for the circumstances of recovery. References to literature on the issue of authenticity are given in Nilsson, *MMR*[2], n. 20, pp. 313–14.

84. *PM* 1, p. 507 and fig. 365.

85. *PM* 3, pp. 439–43 and fig. 305. Though this figurine may have been among those created by two Cretan restorers whose story is told by C. L. Woolley in *As I Seem to Remember* (London, 1962), pp. 21–23, Platon "was able to trace the accidental discovery of the statuette in Crete, and . . . believes it to be genuine" (C. Kardara, "Problems of Hera's Cult Images," *AJA* 64 [1960], p. 343 n. 4). I owe these two references to T. Kendall of the Museum of Fine Arts, Boston.

86. *PM* 4:1, fig. 121.

87. *PM* 4:1, fig. 110 m, n and pp. 158–59.

88. *PM* 2:2, fig. 517.

89. *PM* 1, fig. 120.

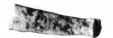

PLATE 12
Forearm, Vat Room deposit,
Knossos.
Scale: about ½ actual size

FIGURE 11
Female figurine, East
Entrance Propylaeum,
Knossos.
Scale: actual size (?)

that the presence of the arm indicates the Vat Room deposit was a precursor to the Temple Repository assemblage of figures and other objects.[90] The finding of a small and very fragile faience hand and a flattened skirtlike shape at Zakros hints at the existence of additional figurines, perhaps other faience snake handlers.[91]

Four MM III brown faience figurines were found near the propylaeum of the East Entrance at Knossos.[92] All four, one of which is illustrated in figure 11, wear a long skirt (perhaps wide trousers) with incurving rows of flounces, an often depicted Mycenaean and Minoan costume from the sixteenth century B.C. onward.[93] Around their necks are short necklaces of closely set figure-eight shields, a gold example of which was found in a Late Cypriote tomb at Enkomi.[94] They hold their hands in an unusual position, curved above their bare breasts. The back of each piece is flat, perhaps indicating that they were originally attached to a level surface.

2b Animal Figurines and Fish

Faience figurines of animals have been infrequently recovered. A fragment of a small bull's head (figure 12) was found with the MM IIIa Ivory Deposit at Knossos. Its off-white surface was probably originally painted with the conventional dark rosettes indicating a dappled or piebald hide. In its cylindrical poll, gold tubes were placed for the insertion of the now-missing

90. *PM* 1, p. 170.
91. Platon, *Zakros*, p. 218 (not illustrated) and personal communication.
92. *PM* 2:2, p. 702. I have not examined these figurines.
93. For a survey of Minoan and Mycenaean clothing styles, see E. Vermeule, *Greece in the Bronze Age* (Chicago, 1968): 178–80.
94. Buchholz and Karageorghis, *Prehistoric Greece and Cyprus*, #1790.

FIGURE 12
Bull's head, Ivory Deposit, Knossos.
Scale: twice actual size

horns. Traces remain of the shell and blue glass paste inlays of its eyes. Holes in the back show where the head was once attached to the body. In style, workmanship, and sophisticated use of different materials, the bull's head anticipates the elaborate examples mentioned in 1b above. The Ivory Deposit also contained small, finely carved acrobatic figures of ivory, an ivory column capital, and fragments of miniature frescoes showing bulls and architectural friezes.[95] In conjunction with one or more small faience bulls, these may well have formed a model of a bull-jumping arena,[96] similar to what can be reconstructed on the basis of the stucco reliefs and frescoes from the cists in the Thirteenth Magazine at Knossos.[97]

The leg of a miniature faience bull was found below the Vestibule of the Hall of the Jewel Fresco at Knossos.[98] This may have been part of a

95. For the acrobatic figures, see *PM* 3, pp. 428–33; the frescoes are shown in *PM* 3, figs. 141–42. Platon believes the bull's head is also ivory (personal communication); positive identification awaits further study.

96. *PM* 3, p. 435. For the techniques of bull leaping and illustrations of the sport, see J. G. Younger, "Bronze Age Representations of Aegean Bull-Leaping," *AJA* 80 (1976): 125–37.

97. Pendlebury, *Archaeology of Crete*, p. 156.

98. A. J. Evans, "Palace of Minos," *BSA* 10 (1903–4): 31 (no illustration). I have not seen this piece.

FIGURE 13
Bird's head, provenance
unknown.
Scale: actual size

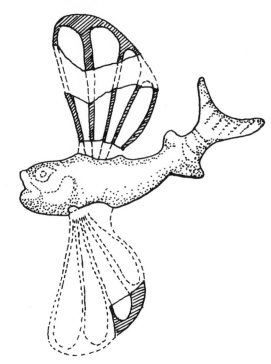

FIGURE 14
Flying fish, Temple Repository, Knossos.
Scale: ⅞ actual size

small rhyton in the form of a bull, such as the MM III/LM I ceramic ones
from Pseira,[99] or perhaps it belonged to another tableau of bulls, per-
formers, and audience.

Figure 13 shows the neck and head of a polychrome bird of uncertain
provenance. It is provisionally considered faience and awaits further study.
There are traces of red on its eyes, and its long sturdy neck has an irregular
checkerboard pattern of black on green, intended to show variegated
plumage. Black lines delineate its rounded bill and are drawn on its throat.
It is difficult to determine the type of bird, though it appears to be of the
grouse family. Somewhat similar birds are painted in the "Partridges and
Hoopoes" fresco of the Caravanserai at Knossos.[100] Another parallel may
be seen in the Thera vessel spout in the shape of a bird's head and neck.[101]

The faience plaques of cows, calves, and goats (figures 21, 22, 23) are
discussed in 3a below, while the inlay pieces with representations of donkeys
and goats (figures 45, 46, 47) are included in 3b below.

Among the faience objects from the Temple Repository at Knossos
were two red brown flying fish, one of which is illustrated in figure 14.
Both are rendered in the same position, with black-veined wings spread

99. C. Zervos, *L'Art de la Crète Néolithique et Minoenne* (Paris, 1956), figs. 448, 487.
100. *PM* 2:1, frontispiece.
101. S. Marinatos, *Thera* IV (Athens, 1971), pl. 96 d.

80

and mouths slightly open. They closely resemble the blue, yellow, and buff flying fish of the MM III fresco from Phylakopi[102] and the gold flying fish inlaid on the MM III bronze blade from the Vapheio Tomb.[103] The three depictions of flying fish differ primarily in the way the wings are treated. Those of the faience fish have three black veins and are outlined in black; the painted fish have double sets of wings, some of which are shown rimmed with a petal-like border, while others have closely set striations; and those of the gold flying fish have dark spots along the wing tips and dark bands across the veins.

It has been suggested that the fish were the central figures in a panel surrounded by the plaques and three-dimensional models of rocks and shells which were also found in the Temple Repository (plate 13).[104] The panel might originally have formed a marine counterpart to the faience plaques of animals and their young (figures 21, 22, 23).[105]

2c *Plants, Shells, and Rocks*

Another Temple Repository panel may have been composed of faience models of flowering plants and fruit. Plate 14 illustrates a ribbed stem and flower of the day lily family with the characteristic upward-facing, triangular petals and long, swordlike leaves. The purple striations on the petals and leaves are perhaps adapted from the conventional method of rendering palm leaves, such as those painted on a MM IIIb vessel.[106] In gold working, naturalistic treatment of three-dimensional lilies may be seen in the delicately shaped lily-headed gold pins from EM II Mochlos tombs[107] and the gold lilies from Late Helladic tholoi at Volos and Dimini.[108] In vase and fresco painting, by contrast, lilies are nearly always shown as though seen in stiff cross-section, with two outcurving petals flanking several stamens.[109] The so-called w3d lily, frequently depicted from MM III onward, combines the stylized cross-section lily with the triangular tuft of the papyrus.[110] A faience pendant from the Temple Repository (figure 83) exhibits this hybridization, as do many beads and ornaments in other materials.[111]

A purple brown model of a fruit, perhaps a plum, with a green stem

102. T. Atkinson and R. Bosanquet, *Excavations at Phylakopi in Melos* [= *JHS* supplement 1] (London, 1904), pl. III.

103. *PM* 3, fig. 82 a. See also fig. 83 for a photograph of a live specimen of a flying fish.

104. The reconstructed composition is based on a similar arrangement of argonaut shells and rockwork in a fresco from the MM III House of the Frescoes at Knossos (*PM* 2:2, fig. 305).

105. *PM* 1, pp. 521–22.

106. *PM* 1, fig. 436 c.

107. *PM* 1, fig. 67.

108. *PM* 1, fig. 68.

109. See for instance *PM* 1, figs. 196 (MM II bowl); 443 (MM III lily jars); 444 (MM III lily fresco from Haghia Triada); color plate VI (fresco from South East House, Knossos).

110. *PM* 2:2, figs. 285 d, e, g, h (LM ceramic examples); 504b (crown of LM I Priest King relief); 505a (gold plate from Shaft Grave IV, Mycenae).

111. For representative types, see R. A. Higgins, *Greek and Roman Jewellery* (London, 1961), p. 80 and pls. 9, 10h.

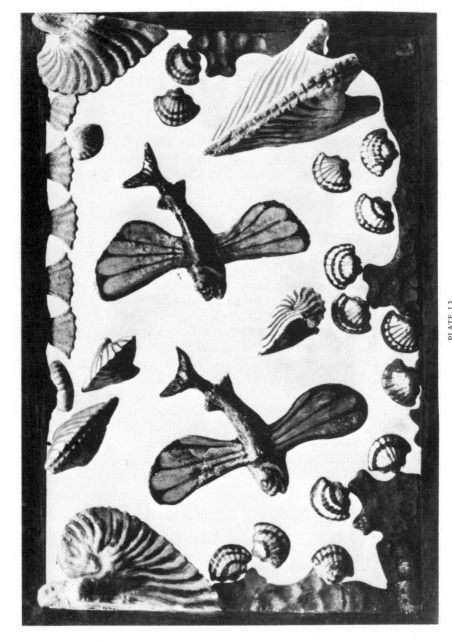

PLATE 13
Flying fish, shells, and rocks, Temple Repository, Knossos.
Scale: ½ actual size

PLATE 14
Lily, fruit, safflowers, and buds, Temple Repository, Knossos.
Scale: ¾ actual size

(plate 14) probably was part of the floral panel, along with two purple safflowers and green buds (plate 14). There is evidence for the sale of small quantities of safflower (ka-na-ko) in several Linear B texts from the House of the Sphinxes at Mycenae.[112] Safflower was valued for the red dye made from its florets and the oil extracted from its seeds. A set of bone models of pomegranate buds was also recovered from the Temple Repository.[113] These may have been part of the original composition of flowers, fruit, and other vegetation.

Faience models of shells were included in the Temple Repository panel of flying fish. Plate 13 illustrates representative examples of the graduated sizes of argonaut shells. In some cases the ribbing on the outside of the shell is indicated by black lines painted on the green surface, while in others the

112. Chadwick, *Documents*² Ge 602, 603, 604 and discussion pp. 225–31. C. Murray and P. Warren ("PO-NI-KI-JO among the dye-plants of Minoan Crete," *Kadmos* 15 [1976]: 40–60) suggest that this also refers to safflower.
113. *PM* I, fig. 354 a.

PLATE 15
Cockleshells, workshop of the Shrine, Zakros.
Scale: ⅘ actual size

ribbing is modeled.[114] Small green scallop shells with ribs and concentric bands painted in black may have been attached to the outcroppings of rock that bordered the flying fish panel. Along the upper edge of plate 13 are five shells of no identifiable species. These are composite stylizations of the ribbed surface and shape of many varieties of shells.[115]

In addition to the faience shells, hundreds of real seashells were found in the Temple Repository, including Venus clams, thorny oysters, cockles, tellin clams, and trochus shells.[116] They had been painted in oranges, browns, greens, and black in streaks and bands, often emphasizing the natural contours of the shells. Traces of white and blue paint showing similar embellishment can be seen on the molded terra-cotta crabs, barnacles, shells, and rocks recovered from the MM III rubbish pit in the West Court at Knossos.[117] The association of shells, water-worn sherds, and rounded pebbles with cult objects seems to have been a Neolithic tradition which continued into the Late Minoan period.[118] The placement of painted shells and faience models among the other precious objects of the Temple Repository is in keeping with this tradition. The decorated or manufactured marine objects may have been intended "as a more sumptuous substitute"[119] for the real specimens, bespeaking the technical sophistication and artistic inventiveness of those who made and commissioned them.

From the workshop of the Shrine at Zakros were recovered ivory inlays

114. A ceramic prototype for argonaut shells with modeled ribbing comes from a MM IIa pottery group from Knossos (*PM* 4:1, fig. 97).

115. For another example of composite shells, see *PM* 4:1, fig. 84a, "Venus-Pecten" shell.

116. *PM* 1, fig. 378 and p. 517 n. 3 for a partial list of species.

117. *PM* 1, fig. 380. Evans suggests, "The moulds for some of these reliefs were formed on the natural objects themselves" (*PM* 1, p. 522).

118. For several examples of floors and altars of shrines lined with shells and stones, see *PM* 1, p. 517 nn. 1 and 2; p. 521.

119. *PM* 1, p. 521.

FIGURE 15
Trochus shell, Isopota
Tomb 6.
Scale: ⅔ actual size

FIGURE 16
Nasa or *Scalaria* shell,
Isopota Tomb 6.
Scale: ⅔ actual size

of double axes and light blue faience models of cockleshells (plate 15). The cockleshell shape has been modified, especially on the sides of the pieces, suggesting that the shells were designed to fit a particular pattern. This is borne out by evidence that the inlays belonged to wooden boxes fallen from the floor above the workshop.[120] Cockleshells were a common type of appliqué for boxes, vessels (figure 3), and other objects. In addition to faience models, examples have been found in stone, clay,[121] and bronze.[122]

Two faience shells were among the finds in the LM IIIa Isopota Tomb 6, near the Tomb of the Double Axes at Knossos. Both the pale lilac trochus shell (figure 15) and the *Nasa* or *Scalaria* shell (figure 16) recall the realistic rendering of sea life on vessels of the LM Ib Marine Style[123] and the later, more conventionalized Palace Style. The shells are perforated, perhaps for suspension.

Plate 16 illustrates the mottled green and pale pink argonaut container which was among the rhyta, cups, maceheads, and other precious objects in the LM Ib Treasury of the Shrine at Zakros. The faience model faithfully imitates the ribbed surface of the argonaut's egg case, as well as its so-called golden spiral shape and thin calciferous shell. The reddish faience triton from the LM I villa at Pyrgos[124] and the faience triton shell from Shaft Grave III, Mycenae (plate 44) are similarly sensitive and skillful translations of the natural shell into another medium.

The modeled brown and black rock border of the flying fish panel, of which a portion is shown in plate 13, is a common motif on wall paintings, seals, and vessels of the Marine Style.[125] Individual rocks were amalgamated into a solid structure with varying degrees of stylization. The interstices

120. Platon, *Zakros*, p. 131; J.-C. Poursat considers the Zakros shells to be ivory (*Les Ivoires Mycéniens* [Paris, 1977], p. 105).

121. Nilsson, *MMR²*, p. 153.

122. Hawes, *Gournia*, pl. 11 #16.

123. Typical patterns are given in Pendlebury, *Archaeology of Crete*, fig. 37.

124. G. Cadogan, "Pyrgos, Crete, 1970–7," *Archaeological Reports*, 1977–78, p. 77 and fig. 26.

125. See for instance *PM* 2:2, figs. 305 (panel from the House of the Frescoes); 306 (seal impression); 308 (steatite vessel fragment); Marinatos, *Thera IV*, color plate A ("Lilies" fresco).

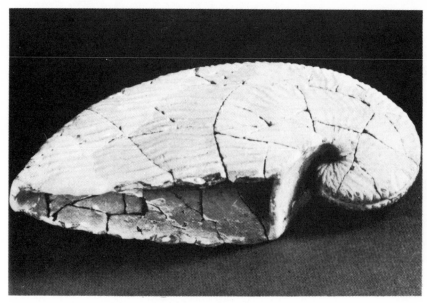

PLATE 16
Argonaut container, Treasury of the Shrine, Zakros.
Scale: ½ actual size

were frequently shown with darker patterns indicating seaweed or coral-
line growth. Often the rock faces were treated as though cut in sections,
which reveal their cross striations and complicated veining.[126] Occasion-
ally stylization of rock formations became grotesque parody, as on MM IIb
seal impressions of grottoes, overhanging crags, and rock chimneys.[127]

3a *Plaques*

Faience plaques representing dresses and girdles were placed with the
snake handlers' cult objects as votive wardrobe offerings. This is in keeping
with traditions surviving to the present day of providing revered images
with special garments.[128] The larger of the two dresses (plate 17 and figure
17) has a short-sleeved green bodice banded in brown across the sleeves
and in a double V-shape down the high-neck front. Around the waist is a
rolled girdle of pale brown. The brown skirt has a wide bottom border of
dark brown saffron flowers above which a clump of saffron flowers and
buds grows from a brown hillock. This flower group is framed by an un-
dulating double canopy; the rest of the skirt has narrow horizontal stripes.
The second dress (figure 18) differs principally in the design of the skirt,

126. Examples of such variegated rockwork appear in the "Blue Monkey" fresco
(*PM* 2:2, colored plate X), in the "Blue Bird" fresco (*PM* 2:2, colored plate XI), and,
in a more abstract style, in the "Partridges and Hoopoes" fresco from the Caravanserai
(*PM* 2:1, frontispiece).

127. *PM* 2:2, p. 453 and fig. 265.

128. Nilsson, *MMR²*, p. 311.

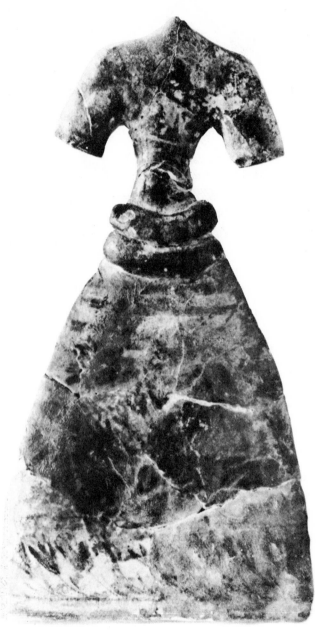

PLATE 17
Dress plaque, Temple Repository, Knossos.
Scale: $\frac{2}{3}$ actual size
Cliché Cahiers d'Art, Paris

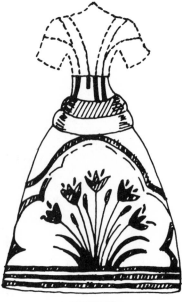

FIGURE 18
Dress plaque, Temple Repository,
Knossos.
Scale: ½ actual size

FIGURE 17
Dress plaque, Temple Repository, Knossos.
Scale: ½ actual size

with its cusped canopy and its plain bottom border of three stripes from which a somewhat smaller clump of saffron flowers grows.

The dress patterns find parallels in other decorative arts, though their combination of elements is unique. The saffron crocus was a common motif, almost always shown symmetrically with three triangular petals and two sets of stamens. This conventionalized rendering appears on MM II light-on-dark ware[129] and Late Minoan dark-on-light ware.[130] In the same style, saffron flowers are painted in the MM III so-called "Saffron Gatherer" fresco from Knossos,[131] which has been reinterpreted as a depiction of a blue monkey pulling saffron plants out of flowerpots.[132] The plant was cultivated for the yellow coloring and flavoring agent extracted

129. *PM* 1, fig. 197, for instance.
130. *PM* 2:2, fig. 276 gives typical examples.
131. *PM* 1, color plate IV.
132. N. Platon, "Symbolē eis tēn spoudēn tēs Minōikēs toichographias: o krokosyl-lektēs pithēkos," *Krchr* 1 (1947), pp. 505–24 and color plate opp. p. 512.

88

FIGURE 19
Girdle plaque, Temple Repository,
Knossos.
Scale: ½ actual size

FIGURE 20
Girdle plaque, Temple Repository,
Knossos.
Scale: ½ actual size

from its stigmas. The Linear B ideogram ⚡ may represent saffron in texts dealing with the measurements of small quantities of the substance.[133]

Clumps of alternating flowering and budding saffron plants appear elsewhere, as in the fragmentary frieze from the House of the Frescoes at Knossos[134] and the Peak Sanctuary rhyton from Zakros.[135] The formalized arrangement, perhaps derived from Egyptian compositions of radiating plant groups,[136] provides an interesting contrast to the floral border of figure 17, where stems and petals are painted as though swayed by wind.[137] The canopies above the flower groups are unusual, especially the cusped one in figure 18. This appears also on a MM III jar as an archway over vegetation.[138]

One of the model girdles (figure 19) is decorated with stylized brown saffron flowers whose stems curve in tight spirals.[139] The other girdle (figure 20) has an interlocking net design of roundels with alternating asterisks and medallions. The intricacy of the pattern recalls embroidery designs reconstructed from details of MM III miniature frescoes.[140]

The Temple Repository plaques of animals suckling their young, together with the pair of panels of marine and plant life discussed above, form a complete decorative program. Figure 21 and plate 18 show a piebald cow turning to lick the hindquarters of its suckling piebald calf. The animals are dark red with black markings and stand on a decorative base of alternately green and black squares. The adult cow's long curving horns show it to be a domesticated descendant from *Bos primigenius*.[141] A second, more fragmentary plaque (figure 22) depicts a kneeling calf suckling.[142] The motif recurs on Minoan and Mycenaean seals, with cow and calf executed with

133. Chadwick, *Documents*[2], p. 130.

134. *PM* 2:2, fig. 271.

135. Platon, *Zakros*, pp. 165–67.

136. *PM* 2:2, p. 476.

137. For two other examples of vegetation in wind, see *PM* 1, fig. 519 (MM III seal impression) and *PM* 1, color plate VI (lily petals on fresco).

138. *PM* 1, color plate VII, left.

139. For a similar pattern, see Pernier, *Festòs* I, fig. 93:3 (MM II sherd).

140. *PM* 2:2, figs. 456–58.

141. Hood, *The Minoans*, p. 89 and p. 157 n. 14. The profession of cowherd, qo-u-ko-ro, is attested in Linear B records: Pylos An 830, An 20 (Chadwick, *Documents*[2], pp. 179, 182 respectively).

142. I have not seen this piece.

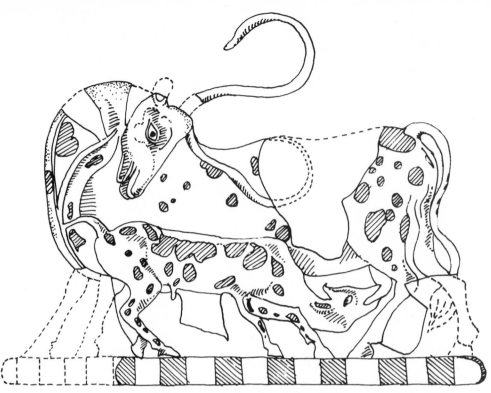

FIGURE 21
Cow and calf plaque, Temple Repository, Knossos.
Scale: ⅔ actual size

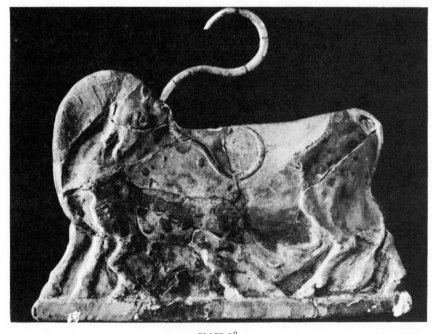

PLATE 18
Cow and calf plaque, Temple Repository, Knossos.
Scale: ½ actual size
Cliché Cahiers d'Art, Paris

FIGURE 22
Calf plaque, Temple Repository, Knossos.
Scale: $\frac{7}{8}$ actual size (?)

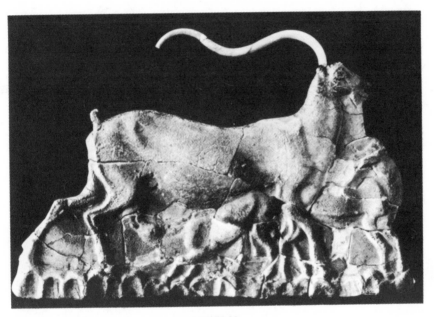

PLATE 19
Wild goat or antelope and kids plaque, Temple Repository, Knossos.
Scale: $\frac{1}{2}$ actual size
Cliché Cahiers d'Art, Paris

varying degrees of stylization.[143] The faience cow and calves from the Temple Repository are remarkable for their compositional harmony and sensitivity to details of anatomy and gesture.

The same is true of the plaque showing a wild goat or antelope and her two kids standing on a conventionalized green and brown rock base (figure 23; plate 19). Particularly effective are the black markings outlining the adult's green back, face, neck, and legs. These emphasize the animal's graceful form and liveliness, anticipating similar treatment of the antelopes

143. *PM* 4:2, figs. 513–15.

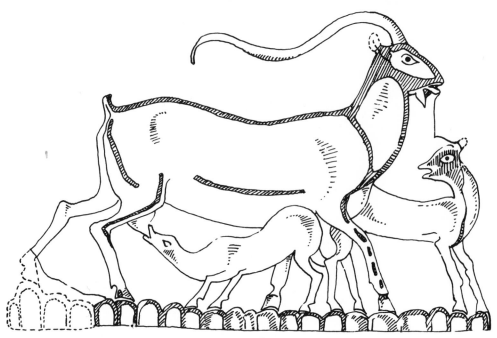

FIGURE 23

Wild goat or antelope and two kids plaque, Temple Repository, Knossos.
Scale: ⅔ actual size

in a Late Minoan fresco from Thera.[144] The theme of goat and kid is less frequently repeated than that of the cow and calf; a seal impression shows a nursing goat with a tufted cow's tail.[145]

3b *Inlays*

Throughout the Bronze Age Near East, boxes, chests, furniture, draught-boards, and other objects were often richly ornamented with faience, ivory, crystal, and bone inlays. MM Ia fragments of faience inlays from the Vat Room Deposit at Knossos attest to early Minoan use of faience for this type of decoration.[146] On the basis of shell inlays, which were better preserved than the faience, it has been possible to reconstruct a pattern of medallions whose quatrefoil centers were originally filled with faience.[147]

The setting of colored faience in a white matrix may also be seen in the MM III/LM I panel from a Tylissos chest or piece of furniture (plate 20).[148] The pattern consists of three rows of four contiguous ivory roundels, each containing a faience rosette with inner petals of ivory and a faience center.

144. Marinatos, *Thera* IV, color plate D.
145. *PM* 4:2, fig. 512.
146. *PM* 1, p. 170.
147. *PM* 1, fig. 120.
148. J. Hazzidakis, *Tylissos* (Paris, 1921), fig. 33; positive identification as faience awaits further study because of the very poor condition of the inlays.

PLATE 20
Faience and ivory inlaid panel, Tylissos.
Scale: $\frac{3}{5}$ actual size

PLATE 21
Draughtboard inlays, Temple Repository, Knossos.
Scale: $\frac{3}{5}$ actual size

FIGURE 24
Disc inlay, Throne Room, Knossos.
Scale: actual size

FIGURE 25
Figure-eight shield inlay,
Temple Repository,
Knossos.
Scale: actual size

Faience pieces set between the roundels form a subsidiary design of incurved lozenge shapes.

The combination of contiguous roundels, central rosettes, and faience interstices appears on the elaborate draughtboards from Knossos and Mycenae. In the Temple Repository were found fragments of incurved lozenge shapes of pale green and dark brown striped faience (plate 21:4) as well as pieces of a molded green faience frame also banded in brown (plate 21:3) and ribbed faience bars alternating with ribbed crystal strips (plate 21:1). Crystal petals and gold and silver foil were recovered from the same repository.[149] These formed part of a gameboard similar to the Royal Draughtboard from Knossos,[150] and the gameboards from Shaft Grave IV, Mycenae (figure 92)[151] and Kakovatos Tomb A, Pylos.[152] A group of discs, bars, and borders recently found in the Royal Road area at Knossos might well have belonged to another gameboard.[153] Besides being opulent, highly decorative objects, the gameboards seem to have been used in playable race games, perhaps with the rosettes as safety zones.[154]

A set of MM IIIb faience discs was recovered from the Throne Room at Knossos, together with crystal and lapis lazuli inlays and pieces of gold foil. All were found facedown, suggesting that they originally decorated panels along the walls or ceiling. The discs, one of which is illustrated in figure 24, have three or four gray brown segments, or *vesicae piscis*, "fish bladders,"[155] enclosing incurved lozenge shapes of gray and cream stripes. The pattern is found on pottery from EM II onward.[156]

149. *PM* I, fig. 337.

150. *PM* I, color plate V. N. Platon believes that the Draughtboard's plain border and corner designs are faience, rather than glass paste covered plaster, as described in *PM* I, pp. 472–73 (personal communication).

151. *PM* I, fig. 346.

152. K. Müller, "Alt-Pylos II," *AthMitt* 34 (1909), pl. 14 #14, 15.

153. Cadogan, "Some Faience, Blue Frit and Glass," *Temple University Aegean Symposium* I (1976): 18. There is also a cream-colored faience fragment that may be a knucklebone used in the game. For the use of knucklebones in ancient Egyptian games, see T. Kendall, *Passing through the Netherworld* (Belmont, Mass., 1978), pp. 66–67 and fig. 14 a, b.

154. R. S. Brumbaugh, "The Knossos Game Board," *AJA* 79 (1975): 135–37, with references to previous literature on the playing of ancient Near Eastern board games.

155. So Evans describes them (*PM* I, p. 473).

156. For early examples, see *PM* I, fig. 80 b (1); *PM* 4:1, p. 93.

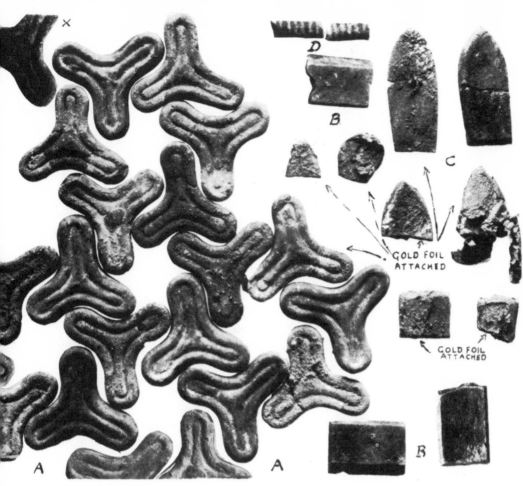

PLATE 22
Trefoil, bar, and petal inlays, Kassella 6, West Palace, Knossos.
Scale: actual size

Other inlays were recovered from MM III contexts at Knossos. In the
Drain Shaft Deposit of the domestic quarter, green faience pieces with
rosettes and brown horizontal stripes were found together with bone,
crystal, and ivory inlays and fragments of a carbonized wooden box.[157]
Kassella 6 of the West Palace Magazine series of floor cists contained gold
foil, carbonized wood and crystal, and a set of interlocking faience trefoil
inlays with raised borders (plate 22). These enclose pinwheel-shaped inter-
stices, perhaps originally filled with bone or ivory. The pattern is a fore-
runner of the Late Minoan interlocking cross designs discussed below. The
inlays were intended to occupy a rectangular space, as can be seen from the
truncation of the corner piece in plate 22. The design was probably framed
by molded faience bars such as the striped ones illustrated in plate 22:D. In

157. *PM* 3, p. 409 (not illustrated).

FIGURE 26
Equal-limbed cross inlay,
Knossos.
Scale: actual size

FIGURE 27
Arching scale inlay,
Haghia Triada.
Scale: actual size (?)

the same kassella were also found faience inlays of daisylike ray petals (plate 22:C), similar to the crystal ones from the Temple Repository.

Figure 25 shows one of five small, buff and purple brown faience models of figure-eight shields which were among the objects from the Temple Repository. Figure-eight shields of this type occur as appliqués (figure 8) and inlays, on rings, gems, and seal impressions, and as elements in jewelry (figure 11).[158] There is inconclusive evidence for the figure-eight shields' symbolic meaning, though it has been proposed that they afford divine protection against evil[159] in a cult of protective weapons.[160]

A small faience equal-limbed cross (figure 26) from Knossos is perhaps of MM III date. A larger marble cross of similar proportions was found in the Temple Repository,[161] and other examples of the motif occur on seals of the same period.[162] The faience differs from these, however, in that it has a purple inner cross. This suggests a later date, based on its correspondence with a LH II wall painting of a textile pattern from Mycenae.[163]

Interlocking crosses with rounded arms seem to have been popular textile designs from MM IIIb/LM Ia onward.[164] The patterns were imitated in faience work (plate 23). This piece was found at Phaistos in a MM III/ LM I deposit in a corridor beside the main entrance, together with ten rectangular faience moldings, of which two are shown. The original panel, with its field of interlocking crosses and faience border, was probably part of a box or inlaid cabinet.

Also recovered from the same corridor at Phaistos was a set of overlapping scale inlays of faience (plate 24). This pattern was commonly used to indicate the rock structure of mountains and cliffs and can be found on pottery,[165] seals,[166] and textile designs.[167] The design also appears as fish

158. Nilsson, *MMR*[2], pp. 408–9 n. 47, collects numerous examples.

159. A. W. Persson, *The Religion of Greece in Prehistoric Times* (Los Angeles, 1942), p. 92.

160. Nilsson, *MMR*[2], p. 406.

161. *PM* I, fig. 376.

162. *PM* I, p. 515.

163. Kantor, *Aegean and Orient*, pl. x I.

164. *PM* 2:2, fig. 456 d, e (kilts from the LM Ib Processional Fresco).

165. Kantor, *Aegean and Orient*, p. 99 n. 137.

166. *PM* 4:2, fig. 597 a (e) (LM II potnia theron on mountain), for example.

167. For instance, C. F. A. Schaeffer, *Ugaritica* I (Paris, 1939), pl. I (back of the skirt of

PLATE 23
Rounded cross and border
inlays, corridor 73, Phaistos.
Scale: actual size

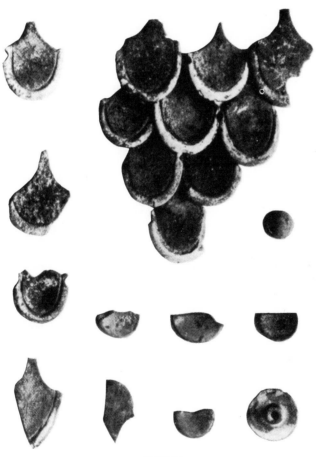

PLATE 24
Overlapping scale inlays, corridor 73, Phaistos.
Scale: actual size

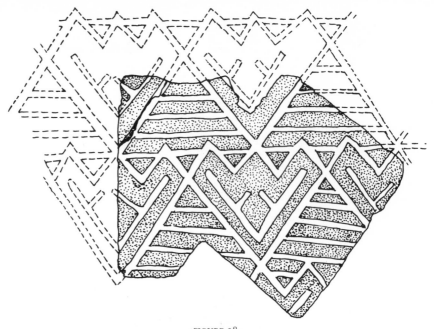

FIGURE 28
Inlay, Knossos.
Scale: $1\frac{1}{10}$ times actual size

scales on a LH III container in the shape of a fish head from Tiryns.[168] Each of the Phaistos scale inlays has a raised border set off by an incised line, and some bear traces of the original green coloring. These are similar to those of the Town Mosaic, discussed below (figure 41).

Figure 27 shows one of fifteen faience squares from a LM I/II context at Haghia Triada. Their ridged pattern of several nesting arches is neither the simple imbrication motif of plate 24 nor the widely used tricurved arch decoration seen on Late Minoan and Mycenaean ceramics, textiles, and frescoes.[169] It is more closely related to the latter and might be termed an "arching scale" pattern.

From Knossos come two unusual faience inlay pieces whose exact provenance and date are uncertain. The first (figure 28; plate 25) has a white-on-gray design composed of rows of two interlocking elements. Horizontally striped triangles alternate with slightly larger inverted triangles whose bases overlap, forming part of a horizontal row of subsidiary triangles. Within each of the inverted triangles is a V-shaped design with two short extensions set at right angles to its arms.[170] The overall effect of the design

the ivory potnia theron from Minet el-Beida); Kantor, *Aegean and Orient*, pl. XXIV F; *PM* 2:2, fig. 456 b (from the "Processional" fresco).

168. Vermeule, *Greece in the Bronze Age*, pl. XLII e.

169. For examples of tricurved arch networks, see Kantor, *Aegean and Orient*, pp. 99–100 and pl. XXV.

170. A very similar pattern in dark gray on cream occurs on a faience sherd from the Royal Road (personal communication, G. Cadogan).

98

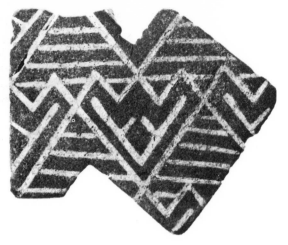

PLATE 25
Inlay, Knossos.
Scale: actual size

is similar to the Middle Minoan rectilinear angle variants of the heart-shaped spiral.[171] The connection is strengthened further by the faience piece's secondary pattern, created by the vertical alignment of the inverted triangles. It seems likely this is related to Middle Minoan ceramic designs of vertical series of hearts[172] and ivy leaves,[173] or even abstracted tun shells.[174]

The second (figure 29; plate 26) is likewise an interesting piece. Reconstruction of the pattern shows two sets of gray zigzags on a white ground. Each zigzag consists of a solid gray band with two pair of parallel lines above. The basic design and variations appear on LM Ib pottery.[175]

The Town Mosaic

The faience inlays showing human and animal figures, plants, water, and house façades, known collectively as the Town Mosaic, merit special attention. The pieces were found at Knossos in filling earth between the MM IIb Loom-weight basement and the substructure of the MM IIIa Northeast Portico.[176] Certain architectural features recall the miniature terra-cotta house models of the MM IIb Loom-weight deposit with their elongated window openings, alternating dark and light masonry, and rows of dots indicating beam ends.[177] While it is possible the Town Mosaic inlays were

171. For Aegean and Egyptian examples, see pl. 6, especially figs. 18 and 20, and discussion on p. 29 in M. Shaw's study "Ceiling Patterns from the Tomb of Hepzefa," *AJA* 74 (1970).

172. A typical example is given in Shaw, "Ceiling Patterns," *AJA* 74 (1970), pl. 6, fig. 10 (MM I cup from Palaikastro).

173. *PM* 2:2, fig. 297 a, for instance.

174. *PM* 4:1, fig. 80 b.

175. A. Furumark, *Mycenaean Pottery* (Stockholm, 1941), fig. 67 #61:7, and p. 387.

176. For the circumstances of discovery, see *PM* 1, pp. 301–2.

177. *PM* 1, fig. 225 a, b for representative specimens.

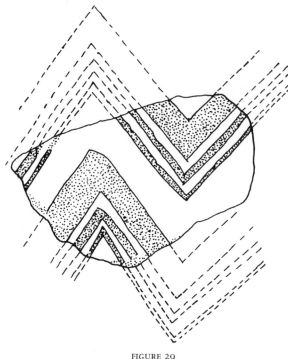

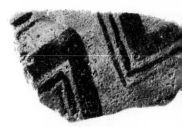

PLATE 26
Inlay, Knossos.
Scale: actual size

FIGURE 29
Inlay, Knossos.
Scale: 1⅓ times actual size

preserved in the MM III period as heirlooms, for several reasons it seems more likely that the Town Mosaic was made in the MM IIIa period. Ivory playing pieces for inlaid MM III draughtboards such as those described above were found in the same deposit,[178] as was a small vase of the MM IIIa period.[179] Furthermore, the inlays' sophisticated use of polychrome techniques shows clear affinities with the MM IIIb Temple Repository faience. As will be noted in the following pages, details of design, gesture, and construction seen in the Town Mosaic pieces readily find parallels from the MM III period and anticipate work of later periods.

Figure 30 illustrates three Town Mosaic figures whose dark gray body color and anatomical features suggest these represent Africans, possibly from Libya. The two inlays in figure 31 have been reconstructed to form an African swimmer,[180] whose frog kick is similar to that of a swimmer on the Shaft Grave IV Siege Rhyton.[181] Depictions of Libyans or Africans in Minoan art include the LM I/II "Captain of the Blacks" fresco[182] and the MM III "Jewel" fresco,[183] both from Knossos. The latter shows beads in

178. *PM* 1, fig. 342.
179. *PM* 3, p. 87 n. 6.
180. W. S. Smith, *Interconnections* (New Haven, 1965), fig. 87 a (= *PM* 1, fig. 228 y and z).
181. *PM* 3, fig. 54 (detail).
182. *PM* 2:2, color plate XIII.
183. *PM* 1, fig. 383.

FIGURE 30
Africans, Town Mosaic, Knossos.
Scale: twice actual size

FIGURE 31
African swimmer, Town
Mosaic, Knossos.
Scale: actual size

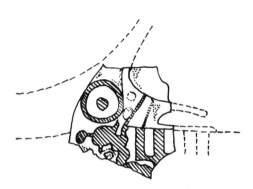

FIGURE 32
Ship's stern, Town Mosaic, Knossos.
Scale: twice actual size

the shape of African heads wearing large triple earrings. The remarkable
Thera "Libya" fresco depicts numerous individuals whose coiffure, accou-
terments, and anatomy seem to point to their Libyan origin.[184] It is
difficult to ascertain whether the Town Mosaic Africans represent friendly,
mercenary, or hostile forces, or groups come to Crete for exploration,
trade, or warfare.

The martial nature of part of the Town Mosaic's activity is indirectly
and ambiguously suggested by the pieces depicting arms and equipment.
Figure 32 shows the back of a vessel with an eye painted on its high stern.
I know of no parallels for Minoan or Mycenaean representations of this
decoration,[185] though it appears on boats in the vase paintings of the
Classical period. The fragmentary nature of the inlay makes it difficult to
identify this vessel as a warship or merchantman; the distinction seems to

184. S. Marinatos, *Thera* VI (Athens, 1974), pp. 45–46, 53–55; pls. 93, 97–100, 106
(summary of anthropological types).

185. Fish ensigns on the prow are known from Early Cycladic graffiti and a Late Helladic
vase painting from Pylos (Hood, *The Minoans*, figs. 104, 106). Several of the ships in the
Thera "Libya" fresco carry flowers, butterflies, and swallows on a spar attached to the
prow (Marinatos, *Thera* VI, fig. 5 and pl. 112). For the rudder type shown here, see
Marinatos, *Thera* VI, pl. 104.

FIGURE 33
Archer (?), Town Mosaic,
Knossos.
Scale: ¾ actual size

FIGURE 34
Bow, Town Mosaic,
Knossos.
Scale: ¾ actual size

FIGURE 35
Spearman, Town Mosaic,
Knossos.
Scale: ¾ actual size

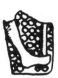

FIGURE 36
Spearman, Town Mosaic,
Knossos.
Scale: ¾ actual size

FIGURE 37
Spearman, Town Mosaic,
Knossos.
Scale: ¾ actual size

FIGURE 38
Grappler, Town Mosaic,
Knossos.
Scale: ¾ actual size

rest on the high fore and aft parapets and long, narrow shape of the former, as opposed to the wide beam of the latter.[186]

The Africans may have come on one or more of these decorated ships either to assist or meet the pale yellow figures shown in relief on other inlays. Some of these may be archers (perhaps figure 33) who carry simple bows such as the one shown in figure 34. Bows of this type seem to have been used both in hunting, as on an inlaid dagger blade from Shaft Grave IV, Mycenae,[187] and in warfare, as on the Siege Rhyton[188] and perhaps on a MM III steatite vase with a bearded archer from the vicinity of Knossos.[189] Other pale yellow figures may be spear carriers (figures 35, 36, 37) or grapplers (figure 38). Two of the inlays show short kilts, which

186. Hood, *The Minoans*, p. 127; L. Casson, "Bronze Age Ships," *International Journal of Nautical Archaeology* 4 (1975): 9. R. W. Hutchinson, however, has pointed out the possibility of interchangeability where "a Minoan warship would simply be a merchant vessel equipped with fighters" (*Prehistoric Crete* [Baltimore, 1968], p. 98).

187. G. Karo, *Die Schachtgräber von Mykenai* (Munich, 1930), #394.

188. *PM* 3, fig. 52 (detail).

189. *PM* 3, fig. 59.

FIGURE 39
Recumbent animal, Town Mosaic,
Knossos.
Scale: twice actual size

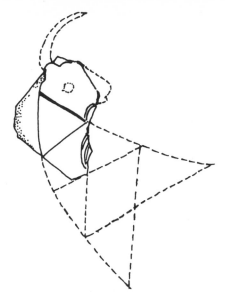

FIGURE 41
Scale inlay, Town Mosaic,
Knossos.
Scale: ¾ actual size

FIGURE 40
Figural inlay, Town Mosaic, Knossos.
Scale: twice actual size

were perhaps worn by all of the light-skinned people, in contrast to the Africans' lack of garments.

Two inlays were thought by A. J. Evans to show an unadorned conical helmet and the plume which was often attached to the top of bell-shaped, conical, or turbanlike helmets.[190] Instead of a plume, N. Platon has seen this more convincingly as a recumbent animal's curling tail, reconstructed accordingly in figure 39.[191] The piece thus belongs with the others showing animals, which will be discussed below. The interpretation of the second inlay (figure 40) remains problematic. The fragmentary tufted tail, possible bull's head, and taut triangular net suggest that the piece forms part of a bull-catching scene, such as that depicted on one of the Vapheio cups.[192] If this is the case, the grappler of figure 38 may also belong to the scene.

Another set of inlays depicts pastoral scenes. Figure 41 shows the reverse of one of several pale yellow, scale-shaped inlays, which conventionally indicate rocky landscapes. The double-axe sign is most likely a craftsman's

190. *PM* 1, p. 308. For a bronze example of the LM II bell-shaped helmet, see S. Hood and P. de Jong, "Late Minoan Warrior Graves from Ayios Ioannis and the New Hospital Site at Knossos," *BSA* 47 (1952), pl. 50. Other Late Minoan and Mycenaean helmet types with and without plumes are given in Chadwick, *Documents*², fig. 26 with discussion pp. 376–79 (Sh series of tablets from Pylos). See also notes 296–99 below.

191. I am very grateful to N. Platon for sharing with me his ideas on this piece, as well as others of the Town Mosaic. For recumbent animals with legs tucked under, see *PM* 4:2, fig. 470 (MM II Siteia seal) and PM 4:2, figs. 539, 540 (seals). The curling tail shown here most resembles the sphinx's tail on a Theban seal (*PM* 3, fig. 282).

192. For a clear photograph of the Vapheio cup scene, see E. N. Davis, *The Vapheio Cups and Aegean Gold and Silver Ware* (New York, 1977), fig. 6; see also her discussion on pp. 38–39 of other Aegean examples of bulls caught in nets.

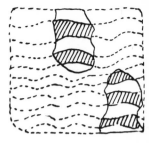

FIGURE 42
Dittany bush, Town Mosaic,
Knossos.
Scale: ¾ actual size

FIGURE 43
Myrtle sprays, Town Mosaic,
Knossos.
Scale: ¾ actual size

FIGURE 44
Water, Town Mosaic,
Knossos.
Scale: ¾ actual size

FIGURE 46
Donkey, Town Mosaic,
Knossos.
Scale: ¾ actual size

FIGURE 45
Goat, Town Mosaic, Knossos.
Scale: ¾ actual size

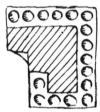

FIGURE 47
Donkey, Town Mosaic,
Knossos.
Scale: ¾ actual size

FIGURE 48
Column capital, Town
Mosaic, Knossos.
Scale: ¾ actual size

FIGURE 49
Column capital, Town
Mosaic, Knossos.
Scale: ¾ actual size

mark, as is an S-shaped notation on another scale,[193] rather than a "consecrating emblem."[194] Two rectangular inlays show vegetation. The first (figure 42) has stems of round, dark green leaves growing from a woody trunk on a yellow ground. The plant is probably a dittany bush, similar to one in which a hoopoe bird perches in the LM Ia Caravanserai painted frieze.[195] The other (figure 43) depicts sprays of dark green myrtle on a

193. Ashmolean Museum 1941. 173.
194. *PM* 1, p. 313.
195. *PM* 2:1, figs. 51 and 50 (spray of dittany).

FIGURE 50
Façade, Town Mosaic,
Knossos.
Scale: slightly enlarged

FIGURE 51
Façade, Town Mosaic,
Knossos.
Scale: slightly enlarged

FIGURE 52
Façade, Town Mosaic,
Knossos.
Scale: slightly enlarged

buff ground. The myrtle plant occurs elsewhere on the Caravanserai panels[196] and on a wall painting from the LM I House of the Frescoes at Knossos.[197] A third rectangular piece (figure 44) is covered with green and buff undulating stripes. This was perhaps meant to represent a fresh-water stream, since seawater was commonly rendered in Aegean work by interlocking tricurved arches.[198] Streams appear in the Thera "Libya" fresco demarcating a pastoral section of vegetation and animals.[199]

Fragmentary inlays depicting goats, oxen, and donkeys in relief have also been recovered, of which figures 45, 46, and 47 provide the best-preserved examples. The pock-marked stippling on one of the donkey's bodies (figure 46) is unusual. All three pieces, the recumbent animal shown in figure 39, as well as several of those with spearmen and grapplers (figures 36, 37, 38) have a background of raised dots arranged in rows and columns. The pattern seems purely decorative and was perhaps derived from the combination of smooth surfaces and granulation in goldworking.[200]

Figures 48 and 49 represent column capitals or flagpole supports[201] with black centers bordered by embossed discs. This type of architectural element is seen, for example, on LM I steatite rhyta[202] and in the "Grand-stand" fresco from Knossos.[203] Figure 48 differs slightly from the standard type in that it seems to be notched on one side, perhaps for a special method of column insertion.

196. *PM* 2:1, figs. 52, 24.

197. *PM* 2:2, fig. 270.

198. As, for example, on the Siege Rhyton (*PM* 3, fig. 54) and in the restoration of the "Dolphin" fresco from the Queen's Megaron at Knossos (Hood, *The Minoans*, pl. 29).

199. Marinatos, *Thera* VI, pl. 112, top left.

200. See, for instance, the MM I gold toad with granulation from Platanos (clear photograph in Branigan, *Foundations of Palatial Crete*, pl. 13 b).

201. S. Alexiou, "Minōikoi Istoi Sēmaiōn," *KrChr* 17 (1963): 339–51.

202. *PM* 1, figs. 507, 508.

203. *PM* 3, color plate XVI and fig. 36 (detail).

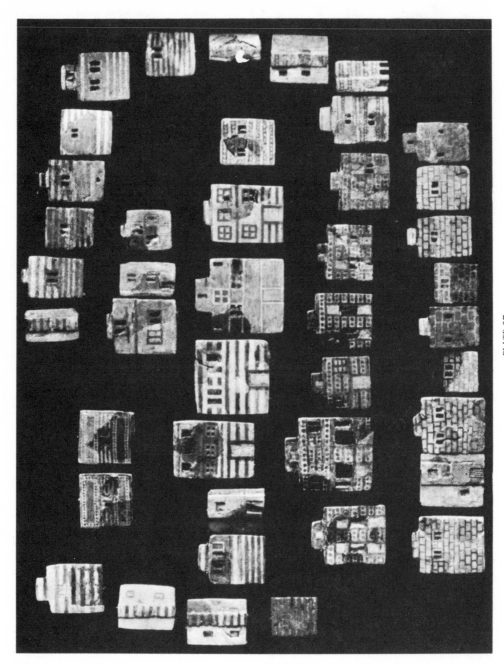

PLATE 27
House façades, Town Mosaic, Knossos.
Scale: $\frac{1}{2}$ actual size

FIGURE 53
Façade, Town Mosaic,
Knossos.
Scale: slightly enlarged

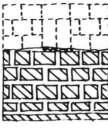

FIGURE 54
Façade, Town Mosaic,
Knossos.
Scale: slightly enlarged

FIGURE 55
Façade, Town Mosaic,
Knossos.
Scale: slightly enlarged

The restorable house façade inlays of the Town Mosaic (plate 27) can be divided into five groups on the basis of their architectural features. Representative examples of these inlays are illustrated in figures 50–81; a key to their color scheme is provided in figure 82.

The first group (figures 50–54) is composed of pieces with ashlar and isodomic masonry. The blocks are brown, white or gray, and the joints are sealed with plaster painted buff or dark gray.[204] This masonry seems to have been a common type of construction and occurs, for example, on the Siege Rhyton,[205] the Thera "Libya" fresco,[206] a LM I steatite vessel from Knossos,[207] a MM III crystal plaque from Knossos,[208] an ivory piece from a Late Minoan I deposit in the Royal Road at Knossos,[209] and a miniature fresco from Tylissos.[210]

The windows are either cut all the way through, as in figures 51 and 53, or slightly hollowed and filled with red, as in figures 50, 52, and 54. The red-filled windows perhaps represent panes of oiled parchment which are rose colored when light passes through them.[211] None of the façades seems to have an entrance at ground level, suggesting an arrangement similar to that of the MM III House of the Fallen Blocks and House of the Sacrificed Oxen at Knossos.[212] These had closed basements and were probably approached by wooden steps or ladders leading to upper stories. Several of the houses have cupolas, some with windows (figure 50) and some without

204. J. W. Shaw, *Minoan Architecture: Materials and Techniques* (Rome, 1973), p. 104 n. 3, and p. 109, where evidence is collected for the use of plaster rather than mortar.
205. *PM* 3, fig. 52.
206. Marinatos, *Thera* VI, pl. 112.
207. *PM* 2:2, fig. 486.
208. *PM* 3, p. 88 (now obliterated).
209. Hood, *The Minoans*, pl. 23.
210. *PM* 3, fig. 49.
211. *PM* 3, p. 342 and color plate XXIV for a watercolor reconstruction of the effect. Since doors are sometimes red-filled (figures 61, 63), window curtains might also be meant by the red coloring.
212. *PM* 2:1, p. 370.

FIGURE 56
Façade, Town Mosaic,
Knossos.
Scale: slightly enlarged

FIGURE 57
Façade, Town Mosaic,
Knossos.
Scale: slightly enlarged

FIGURE 58
Façade, Town Mosaic,
Knossos.
Scale: slightly enlarged

FIGURE 59
Façade, Town Mosaic,
Knossos.
Scale: slightly enlarged

FIGURE 60
Façade, Town Mosaic,
Knossos.
Scale: slightly enlarged

(figures 51, 52). Castellated buildings of this type appear on Late Minoan sealings from Zakros, on the "Megaron" frieze from Mycenae,[213] and on other pieces of the Town Mosaic (figures 58, 59, 61, 62). An elaborate MM III house model recently found at Archanes has a large colonnaded cupola.[214] Three pieces not illustrated also belong to this group: one is identical to figure 52; another resembles figure 50, except it lacks a cupola window and the lower right window is open; and the last is similar to figure 53, with white blocks and gray plaster.

The second group (figures 55–60, 66) includes house façades of a modified half-timbered type with horizontal alternation of gray wood and buff plaster. There is considerable variety in the treatment of windows. Some are set in wide frames of plaster (figure 55, with another reconstruction in figure 66), while others are set unframed directly into the façade (figure 57

213. *PM* 1, fig. 227 a, b (sealings); *PM* 3, fig. 48 e (frieze).
214. A. Lembessi, "O Oikiskos tōn Archanōn," *EphArch*, 1976, pp. 12–43.

FIGURE 61
Façade, Town Mosaic,
Knossos.
Scale: slightly enlarged

FIGURE 62
Façade, Town Mosaic,
Knossos.
Scale: slightly enlarged

FIGURE 64
Façade, Town Mosaic,
Knossos.
Scale: slightly enlarged

FIGURE 63
Façade, Town Mosaic, Knossos.
Scale: slightly enlarged

and one not shown). Pairs of windows may be framed as a unit (figures 58, 59, and three not shown), which is sometimes enclosed by an additional frame (figures 56, 60). The windows are hollowed and generally red-filled. An unusual layout is shown in figure 59, where the two windows in the cupola are red-filled, as are the outer windows of the two pair below, while the inner ones are cut through. Several other façades have cupolas preserved, though none with windows (figure 58 and two not shown that have wide beams similar to figure 55).

To the third group belong façades that combine dark gray wooden timbering with horizontal rows of discs representing the ends of round beams. These are depicted widely spaced in the buff or white plaster (figures 61–65) or contiguous (figures 67–71, 73). The pattern can be seen in the terra-cotta shrine models of the MM IIb Loom-weight deposit,[215] the LM I

215. *PM* I, fig. 166.

FIGURE 65
Façade, Town Mosaic,
Knossos.
Scale: slightly enlarged

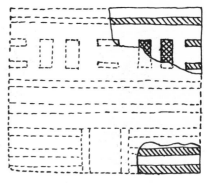

FIGURE 66
Façade, Town Mosaic, Knossos.
Scale: slightly enlarged

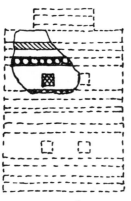

FIGURE 67
Façade, Town Mosaic,
Knossos.
Scale: slightly enlarged

FIGURE 68
Façade, Town Mosaic,
Knossos.
Scale: slightly enlarged

miniature frescoes from Knossos,[216] a Late Helladic gold ornament from Volos,[217] in several Mycenaean wall paintings of palace façades,[218] and in the Thera "Libya" fresco,[219] among other examples.

The façades with widely spaced discs (figures 61–65) generally have two hollowed doorways, which are sometimes filled with red as though covered with a curtain (figures 61, 63). Windows occur singly or in pairs, red-filled or cut through, and occasionally as a transom (figures 61, 62). A six-paned window is illustrated in figure 64, similar to one shown on a miniature

216. For instance, *PM* 2:2, fig. 376; *PM* 3, figs. 16, 48 d.
217. Nilsson, *MMR*², fig. 79. This shows ashlar masonry with intermediate courses of discs.
218. Vermeule, *Greece in the Bronze Age*, figs. 32 b (Orchomenos); 32 c (Pylos); *PM* 3, fig. 48 e (Mycenae).
219. Marinatos, *Thera* VI, pl. 112.

fresco from Tylissos[220] and on the Thera "Libya" fresco.[221] Figure 62 is a unique piece with its sloping roof and inclined cupola, perhaps meant to shed rainwater more easily.[222] A sixth inlay, not illustrated here, closely resembles figure 65. Figure 67 shows a façade with rows of contiguous discs alternating with timbering.

An unusual inlay is illustrated in figure 68; a less well-preserved duplicate was also found. The center of the piece is occupied by a structure with incurved sides framed in woodwork and supported by an upright post and horizontal timbers. This section is enclosed above and below by two dark gray rectangles bordered by closely set discs. Bases with incurved sides have been found in terra-cotta in the Loom-weight deposit[223] and in limestone in the High Priest's House south of the palace at Knossos.[224] The object is depicted on a rock crystal seal from the Idaean cave, where it supports branches and the so-called horns of consecration.[225] Incurved bases appear as designs beneath the lions of the Lions' Gate at Mycenae[226] and on the side of a miniature gold altar from Mycenae.[227] Study of the relationship between incurved base designs and the half-rosette and triglyph frieze has pointed to a close connection. The frieze "seems to have arisen from the endeavor to apply simple rows of rosettes ... to the filling in of such incurved designs. The tendency to elongate and to halve the rosette was a necessary consequence. The central support ... explains the intervening triglyphs of the friezes."[228]

As the incurved base occasionally seems to have had cultic connections, it has been suggested that figure 68 and its mate are sanctuaries.[229] This identification should be viewed with caution, for the space to the left of the upright post in figure 68 is cut through, as though for a window. Furthermore, the so-called altar base has been impractically placed halfway up the side of the building. It seems more likely that the incurved base was used here for decorative reasons, just as the half-rosette and triglyph frieze were employed.

The fourth group (figures 69, 71–76) includes façades with a raised vertical section. In some cases this is shown with horizontal rows of beam-end discs (figures 71, 73) or timbers (figures 72, 74, and one not illustrated), while the rest of the inlay is undecorated. In other cases both the raised and recessed portions are treated alike (figures 69, 75, 76, and one not illustrated). The façades generally have small windows set to one side of the projecting

220. *PM* 3, fig. 49.
221. Marinatos, *Thera* VI, pl. 112 (houses at top left and bottom right).
222. *PM* 1, p. 305. For a detailed discussion of roofs and floors, see J. W. Shaw, "New Evidence for Aegean Roof Construction from Bronze Age Thera," *AJA* 81 (1977): 229–33.
223. *PM* 1, fig. 166 h.
224. *PM* 4:1, fig. 160 a.
225. *PM* 4:1, fig. 162.
226. *PM* 2:2, fig. 381 b.
227. *PM* 2:2, fig. 381 a.
228. *PM* 2:2, pp. 607–8. See also T. Fyfe, "Note on the Triglyph and Half-rosette Band," *PM* 2:2, pp. 605–6.
229. *PM* 1, p. 307.

FIGURE 69
Façade, Town Mosaic,
Knossos.
Scale: slightly enlarged

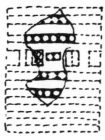

FIGURE 70
Façade, Town Mosaic,
Knossos.
Scale: slightly enlarged

FIGURE 71
Façade, Town Mosaic,
Knossos.
Scale: slightly enlarged

FIGURE 72
Façade, Town Mosaic,
Knossos.
Scale: slightly enlarged

FIGURE 73
Façade, Town Mosaic,
Knossos.
Scale: slightly enlarged

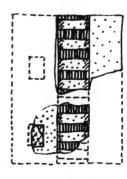

FIGURE 74
Façade, Town Mosaic,
Knossos.
Scale: slightly enlarged

FIGURE 75
Façade, Town Mosaic,
Knossos.
Scale: slightly enlarged

FIGURE 76
Façade, Town Mosaic,
Knossos.
Scale: slightly enlarged

FIGURE 77
Façade, Town Mosaic,
Knossos.
Scale: slightly enlarged

FIGURE 78
Façade, Town Mosaic, Knossos.
Scale: slightly enlarged

FIGURE 79
Façade, Town Mosaic,
Knossos.
Scale: slightly enlarged

FIGURE 80
Façade, Town Mosaic,
Knossos.
Scale: slightly enlarged

FIGURE 81
Façade, Town Mosaic, Knossos.
Scale: slightly enlarged

piece (figures 73, 74, 76). There are four doorways shown in figure 69, of which the second from the right is cut through. The door of figure 75 is scored with vertical stripes not unlike those on a tower depicted in the Siege Rhyton.[230] The plan of the MM I/II round-cornered keep to the northwest of the Central Court at Knossos perhaps supports the proposal that the pieces in this group represent towers and bastions.[231] Three of the outer walls of this massive stone structure had projecting and recessed sections in an arrangement similar to that of the faience inlays.

Façades with four-paned windows compose group five. These windows are shown singly (figures 77, 81) or in threes (figures 80, 81) set into half-timbered walls. Other examples of four-paned windows occur on MM III seal impressions from the Knossos pottery magazines.[232] Figure 78 shows

230. *PM* 3, fig. 52.
231. *PM* 1, pp. 136–41 and fig. 101.
232. *PM* 2:2, fig. 242 a.

white gray

red brown

red in windows blue green

traces of red in windows dark blue

black, dark gray

FIGURE 82
Key to colors of façades, Town Mosaic.

an alternative reconstruction of figure 77, which is partially based on the unusual arrangement of windows in figure 79. Also of note here is the upper row of three open windows above the four-paned ones in figure 80.

The Town Mosaic inlays are remarkable both technically and iconographically. Their polychrome decoration and relief work exhibit a high degree of competence, matched by a scrupulous attention to detail and design. The information gleaned from a study of the façades contributes significantly to an understanding of Minoan architecture.[233] Questions remain, however, as to the Town Mosaic's organization and interpretation.

The inlays were probably arranged in registers on a piece of furniture or wooden panel. They are generally rectangular in format and of uniform size within related groups. This suggests a thematic disposition of elements, borne out by the granulation background shared by all the pieces with animals (figures 45, 46, 47, 39, and others not illustrated). The capitals shown in figures 48 and 49 may have belonged to a series of nonstructural superposed pillars that framed the entire composition or demarcated sections.

As already noted, the Town Mosaic is composed of elements seen in other Minoan and Mycenaean works, in particular the Siege Rhyton and the Thera "Libya" fresco. In these, warriors, watchful citizens, manned fleets, gesticulating women, bastions, dwellings, landscapes, and seascapes are shown. They are arranged in interacting groups, as passive and active agents in scenes of cause and effect. Though historical interpretation remains obscure, the impulse towards narrative is apparent.

By contrast, the Town Mosaic inlays are discrete units aligned within the limitations of the register system. With the possible exception of figure 38, conflicts and confrontations are lacking. Only two inconclusive pieces

233. The correspondence between these façades and contemporary Aegean houses is marked. See, for example, the photograph of modern Greek *Würfelbauten* in Schachermeyr, *Minoische Kultur*, pl. 54 b.

of evidence indicate martial activity: the tentative identification of figures 69 and 71–76 as towers; and the possibly antagonistic presence of dark and and light-skinned individuals. None of the bows, spears, or ships represented need have martial use. The presence of doorways on some façades and the poor preservation of the lower portions of others makes it difficult to maintain that these show "the restricted frontage of houses shut in by city walls."[234]

In light of these points, it seems unlikely that the Town Mosaic commemorates or narrates a military event. Instead, the inlaid registers formed a program of scenes similar to the faience panels of marine, plant, and animal life from the Temple Repository. The Linear B furniture descriptions attest to the variety of decorative elements employed in such panels: "pomegranates and helmets";[235] "figures of men and lions";[236] "a man and a horse and an octopus and a griffin."[237] In their original setting, the colorful faience inlays of the Town Mosaic anticipated the style and opulence of Late Minoan and Mycenaean inlaid furniture.

4a *Jewelry, Seals, and Ornaments*

The corpus of second millennium Minoan faience jewelry consists for the most part of beads in simple geometric forms. Light blue and green spherical and disc-shaped beads were among the objects found in the MM I Vat Room deposit at Knossos.[238] White, blue, and brown faience beads, mostly fluted, globular, and oval in shape, occurred in a MM IIb deposit at Mavro Spelio.[239] MM II tombs at Mochlos yielded ribbed melon beads and convex-sided tubular beads with incised lines around the edges.[240] Segmented faience beads first appeared in Crete in the Temple Repository, together with globular and convex-sided tubular beads.[241] Also from the Temple Repository came a finely made faience pendant (figure 83). This has a symmetrical design of two w3d lilies with outcurved petals flanking a central tuft of papyrus.[242] The stems descend from a cylinder perforated for suspension.

Spherical and segmented faience beads were found in LM I pithos burials at Sphoungaras[243] and in the LM Ia robbers' cache from the Temple Tomb at Knossos.[244] An unusual prism-shaped bead was part of the grave goods

234. *PM* 1, p. 307. There is, however, definite evidence for the existence of Middle Minoan fortifications on Crete: Mallia (MM I/II) mudbrick on stone foundations (J. Deshayes and A. Dessenne, *Mallia* [Paris, 1959], pp. 4–5); Knossos (MM I/II) stone keep in Central Court area (*PM* 1, pp. 136–41).

235. Chadwick, *Documents*², p. 339 (Ta 642).

236. Chadwick, *Documents*², p. 344 (Ta 708).

237. Chadwick, *Documents*², p. 345 (Ta 722).

238. *PM* 1, fig. 120.

239. Pendlebury, *Archaeology of Crete*, p. 140.

240. R. B. Seager, *Explorations in Mochlos* (Boston, 1912), figs. 20, 30.

241. *PM* 1, figs. 351, 352 #13, 14. Steatite segmented beads were found in MM I tholoi at Platanos and elsewhere in the Mesara (*PM* 2:1, p. 179).

242. *PM* 1, p. 499. For other examples of the w3d lily design, see n. 110 above.

243. E. H. Hall, *Sphoungaras* (Philadelphia, 1912), p. 67.

244. *PM* 4:2, pp. 963–64; color plate XXXIV.

FIGURE 83
Pendant, Temple
Repository, Knossos.
Scale: ½ actual size

FIGURE 84
Bracket, Knossos.
Scale: actual size (?)

placed in an LM Ia larnax burial from Pyrgos.[245] LM II/III shaft graves
near Knossos yielded globular gadrooned beads and a faience cylinder seal
with a stylized design of a stag with standing figures.[246] LM II/III burials
excavated near Siteia contained convex-sided tubular beads with incised
decoration, pear-, melon-, and heart-shaped beads,[247] as did tombs at
Gournia, Episkopi near Hierapetra, and other sites in East Crete, including
the rich burial at Arkhanes.[248] A LM IIIa tomb near Knossos was supplied
with tubular and ribbed melon beads, as well as rods and small bars of
faience.[249]

Pear-shaped, segmented, cylindrical, and ribbed melon beads were found
in LM III graves at Phaistos.[250] A clay jewelry box from a LM III tomb
at Pakhyammos held spherical and globular faience beads as well as other
jewelry of gold and glass paste.[251] An unusual ribbed oval bead was re-
covered from the LM IIIa Mace-bearer's Tomb near the Tomb of the
Double Axes at Knossos.[252] This bead was decorated with crossed, raised
bands perhaps derived from the double-axe design. Several LM III tombs
south of Knossos yielded cylindrical, heart-shaped, ribbed melon, and
rosette faience beads among other jewelry of gold, ivory, glass paste, and
semiprecious stones.[253]

Minoan faience seals first appear in the EM III/MM I transitional period.
Examples include a cylinder with a quatrefoil design and S-spirals,[254] as

245. *PM* 2:1, fig. 34 f.

246. A. J. Evans, "The Prehistoric Tombs of Knossos," *Archaeologia* 59 (1905), pp. 449,
461–62; fig. 81 b (seal impression).

247. Haghios Nicolaos Museum, Room 3, pyramid case.

248. Heraklion Museum, case 139; J. A. Sakellarakis, "A Mycenaean Grave Circle at
Crete," *Athens Annals of Archaeology* 5 (1972), fig. 14; J. A. Sakellarakis, "Minoan Ceme-
teries at Arkhanes," *Archaeology* 20 (1967): 278.

249. M. Popham, "Sellopoulo Tombs 3 and 4," *BSA* 69 (1974): 210–11, 223–24.

250. *PM* 1, fig. 352 #16; Heraklion Museum, case 86.

251. Heraklion Museum, case 137.

252. A. J. Evans, "The Tomb of the Double Axes," *Archaeologia* 65 (1914), fig. 22;
see also fig. 26 for a segmented faience bead from the same tomb.

253. S. Hood, G. Huxley, and N. Sandars, "A Minoan Cemetery on Upper Gypsades,"
BSA 53–54 (1958–59), fig. 12 b; pl. 59 a.

254. J. A. Sakellarakis and V. E. G. Kenna, *Iraklion Sammlung Metaxas* (Berlin, 1969),
#27.

116

well as a theriomorphic seal in the shape of two embracing monkeys,[255] both from Kali Limenes, south of the Mesara. Middle Minoan faience seal designs were taken from a limited repertory of hatched triangles and segments, quartered fields with chevrons, simple foliate sprays, and small concentric circles; the white or yellow seals are generally cylindrical, barrel shaped, scaraboid, or theriomorphic.[256] An unusual scaraboid seal from Tsoutsouros, to the east of Kali Limenes, shows a short-kilted male figure standing astride a seated long-horned goat.[257]

By the end of the MM III period, Minoan glyptic had evolved into a distinctive medium for depicting a wide variety of themes and compositions.[258] This change was accompanied by increasing sophistication in the use of the fast drill and wheel and decreasing use of cutting and scraping tools alone.[259] While the latter were successfully employed on soft materials such as steatite, ivory, and faience, the fast drill and wheel were particularly suited to carving hard stones such as agate, carnelian, jasper, marble, sard, sardonyx, and serpentine. As a result, faience seems to have been abandoned in the Late Minoan period as a sphragistic material.

4b Other Objects

Figure 84 shows a faience bracket with three receding steps. This is similar in design to the stucco base beneath the LM I frieze of columns and sphinxes in the East Hall of Knossos.[260] It is possible that the faience piece supported plaques such as those from the Temple Repository (figures 21, 22, 23) or a light shelf displaying small precious objects. A more elaborate style of bracket has a rolled projection above reduplicated fluting that ends in an architectural molding. Ornamental brackets of this type occur frequently in faience and ivory, especially in LH II/III contexts (figures 94, 95).[261]

There has been considerable discussion as to the interpretation of the so-called sheep-bells, a faience example of which is illustrated in plate 28. These objects are generally of clay and are bell-shaped, with two hornlike projections flanking a suspension loop. They have been found associated with Middle Minoan material at Knossos, Tylissos, and Vorou in the Mesara.[262] The MM II faience specimen from Poros, the second millen-

255. Sakellarakis and Kenna, *Metaxas*, #28. The base has a quartered field design with chevrons.

256. Sakellarakis and Kenna, *Metaxas*, #102, 104–13 (cat) from Kali Limenes and Lenda; #154 from Tsoutsouros; V. E. G. Kenna, *Cretan Seals* (Oxford, 1960) #87 (sleeping duck) and #88 from unknown provenances. See also #7, 19, 20, 23 in Gemmae Dubitandae section of Sakellarakis and Kenna, *Metaxas*.

257. Sakellarakis and Kenna, *Metaxas*, #98.

258. Kenna points to the Knossos seals from the Temple Repository and the Hieroglyphic Deposit as the first examples of Minoan glyptic as a "fine art" (*Cretan Seals*, p. 48).

259. Kenna, *Cretan Seals*, pp. 70–77.

260. *PM* 3, fig. 359; see also *PM* 1, figs. 507, 508 for such supports used in architectural contexts.

261. *PM* 1, pp. 488–89; fig. 350 "development of bracket based on section given in mould." (See note 20 above.)

262. For discussion and references to numerous examples, see Nilsson, *MMR²*, pp. 191–93 and addenda, p. xxiii.

PLATE 28
"Sheep bell," harbor of Knossos.
Scale: about actual size

nium harbor of Knossos, is unique in its black painted eyes, eyebrows, triangular nose, and mouth, though others have linear decorations and eye-shaped perforations. The presence of human features on the "sheep-bells" suggests that these are representations of masks worn by those involved in cultic activities.[263] Other less plausible interpretations are that they are votive bells, primitive idols with upraised arms, or models of sacred robes.[264]

Section 2 GREEK MAINLAND FAIENCE

With the exception of the pear-shaped faience bead from the third millennium site of Molyvo Pyrgo in Chalcidice,[265] faience first appears on the Greek mainland in the Mycenaean Shaft Graves. These graves are remarkable for the opulence and sophistication of their goods, amassed in two

263. N. Platon, "Nouvelle interprétation des idoles-cloches du Minoen Moyen I," *Mélanges Picard* II (Paris, 1948), pp. 841–43.
264. Nilsson, *MMR*[2], pp. 192–93.
265. W. A. Heurtley and C. A. R. Radford, "Two Prehistoric Sites in Chalcide, I," *BSA* 29 (1928), pp. 149–50 and fig. 290; it is not certain that this material is Early Bronze.

grave circles between about 1650 and 1510 B.C.[266] The shafts held quantities of gold, silver, amber, ivory, faience, and other precious materials, many of which had been fashioned into objects of consummate workmanship.[267] The Shaft Graves' treasures have been studied in some detail, especially with regard to their Minoan, Near Eastern, and European affinities, and more recently with respect to their Helladic characteristics.[268] Several historical and archaeological questions about the Shaft Graves have direct bearing on the origins of Mycenaean faience.

One of these questions involves the relationship of the Shaft Graves and their luxury goods to earlier mainland assemblages. There is little in Middle Helladic tomb architecture or material remains to foreshadow the rich furnishings of the Shaft Graves. By the beginning of the seventeenth century B.C., however, there seems to have been an increasing variety in pottery shapes and decoration, coincidental with an influx of imported wares.[269] At Eleusis, Pylos, Samikon, Aphidna, and Delos, graves were constructed with greater ostentation and a somewhat richer complement of goods.[270] In light of these gradual developments and the lack of evidence to the contrary, one may assert that the Shaft Grave people were indigenous Helladic folk, perhaps an elite "warrior aristocracy," rather than conquerors bringing new ways and goods from another region.[271]

A second problem, therefore, is to account for the basis of their wealth and their growing interest in acquiring and manufacturing hitherto unknown luxury products such as faience. One tenuously substantiated and unsatisfactory explanation is that they were supposedly remunerated for acting as mercenaries in the Egyptian battles against the Hyksos.[272] A more plausible theory suggests that the early Mycenaeans were middlemen for

266. The more recently discovered Grave Circle B is dated about 1650 to 1550; Grave Circle A is dated about 1600 to 1510. For a survey of the principal finds in each and details of construction, see G. E. Mylonas, *Ancient Mycenae: the Capital City of Agamemnon* (Princeton, 1957) and *Grave Circle B of Mycenae* [= *SIMA* 7] (Lund, 1964). Graves with Roman numerals belong to Grave Circle A; those with Greek letters belong to Grave Circle B.

267. For a detailed and fully illustrated inventory of the riches of Grave Circle A, see Karo, *Die Schachtgräber von Mykenai* (hereafter cited as *Schgr*). For the final publication of Grave Circle B, see G. E. Mylonas, *O Taphikos Kyklos B' tōn Mykenōn* (Athens, 1973).

268. References to the literature are given in J. D. Muhly, *Copper and Tin* (Hamden, Conn., 1973), notes 38 and 39, p. 415. To these add E. Vermeule, *The Art of the Shaft Graves of Mycenae* (Norman, Oklahoma, 1975), with bibliography and notes.

269. Vermeule, *Greece in the Bronze Age*, pp. 75–76, 80; pp. 334–35 n. 1.

270. Vermeule, *Greece in the Bronze Age*, pp. 80–81 and fig. 15; O.T.P.K. Dickinson, *The Origins of Mycenaean Civilisation* [= *SIMA* 49] (Göteborg, 1977), pp. 36–38.

271. Vermeule, *Greece in the Bronze Age*, p. 110. Sometimes one reads that the putative arrival of the Shaft Grave people is reflected mythologically in the legends of Danaus and Pelops. For a summary of these opinions and myths, as well as a sample of the conclusions reached therefrom, see F. H. Stubbings, "The Rise of Mycenaean Civilization," *CAH*³ 2:1, pp. 635–40.

272. See Stubbings, "Mycenaean Civilization," *CAH*³ 2:1, pp. 634–35, where the evidence is discussed and evaluated; see also Vermeule, *Shaft Graves*, p. 19 n. 32, for a cogent dismissal of the theory.

the copper and tin funneling into the East Mediterranean and the Near East from the rest of Europe.[273] Profitable Helladic dealings in Cypriote[274] and Sardinian copper[275] might well have enabled the accumulation of the Shaft Grave riches. The presence of faience and other luxury products in the Grave Circles attests to the impact that cosmopolitan contacts and increasing wealth had on Helladic taste.

The Shaft Graves' resulting international admixture of quality and style contributes to a third problem, that is, to determine what were imported and what were locally made products. Study of specific classes of Shaft Grave material has done much to clarify the issues. Detailed examination of the gold and silver ware and the "niello" work, for instance, has pointed to differences in technique, shape, and style between Minoan-made and Mycenaean-made vessels.[276] Some Shaft Grave stone vessels seem to have been made on the mainland, with the rest sent from Crete together with Minoan adaptations of Egyptian stoneware.[277] Some of the pottery seems likewise to have been imported from Crete, though much of it, on the other hand, is unparalleled elsewhere in the Aegean.[278] Close study of the jewelry has suggested that for the most part it was made on the mainland, perhaps under Minoan supervision, with the wire jewelry possibly from Syria or Mesopotamia.[279]

Stylistic analysis of the Shaft Grave faience presented in detail below points to three possibilities for its origin. Some faience was imported from Crete, while other pieces were made at Mycenae, modeled on Minoan examples and perhaps under Minoan guidance. The third and smallest group of faience seems to have been designed and made by mainland workshops.[280]

Archaeological evidence for centers of faience manufacturing on the mainland comes chiefly from the finding of Late Mycenaean molds for

273. G. Cadogan, "Was there a Minoan Landed Gentry?" *Bulletin of the Institute of Classical Studies* 18 (1971): 145–48. Dickinson (*Origins of Mycenaean Civilisation*, pp. 54–56) posits that the Shaft Grave rulers first secured control of good agricultural land, then gained access to raw materials, especially metals, for which they were well paid by the Minoans.

274. Muhly, *Copper and Tin*, pp. 187–88, with reservations about the use of Alpine copper in Greece; p. 198 where the tin-bearing, and possibly non Cypriote, Shaft Grave copper is discussed.

275. Muhly, *Copper and Tin*, pp. 280–88.

276. E. N. Davis, "Metal Inlaying in Minoan and Mycenaean Art," *Temple University Aegean Symposium* 1 (1976): 3–6; Davis, *The Vapheio Cups and Aegean Gold and Silver Ware*, especially pp. 213–20, 249–51, 332.

277. Warren, *Minoan Stone Vases*, p. 107; J. A. Sakellarakis, "Mycenaean Stone Vases," *SMEA* 17 (1976): 173–87.

278. Vermeule, *Greece in the Bronze Age*, pp. 105–6.

279. Higgins, *Greek and Roman Jewellery*, p. 69.

280. A. W. Persson was among the first to point to local faience and glass paste manufacture on the mainland; he proposed that itinerant craftsmen or prisoners of war brought to Greece were responsible for their production (*New Tombs at Dendra near Midea* [Lund, 1942], pp. 147–49).

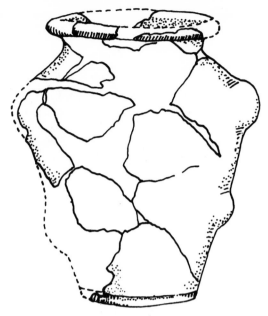

FIGURE 85
Jar, Shaft Grave II, Mycenae.
Scale: $\frac{1}{2}$ actual size

faience and glass paste jewelry.[281] Several particularly well-equipped
LH IIIa/b Theban workshops stocked with gold, ivory, lapis, and other
semiprecious stones give a good idea of what mainland faience workshops
must have been like. Interestingly, one of the Theban shops contained a
faience mold for making a gold trochus shell ornament.[282]

1a *Vessels and Containers*
The class of Mycenaean faience vessels and containers is mainly composed
of pieces from the Shaft Graves and objects from the LH IIIb House of
Shields at Mycenae. A pale yellow squat jar with four lugs and traces of
black markings on the rim (figure 85) was recovered from Shaft Grave II.
Its shape is a cross between that of a pithoid jar and that of an Egyptian
cylindrical alabastron.[283] Its Egyptian features led J. D. S. Pendlebury to
assume that the faience piece was an Egyptian import.[284] Ceramic[285] and

281. For a list and description of molds recovered, see E. Vermeule, "Graffito on a
Steatite Jewelry Mold from Mycenae," *Kadmos* 5 (1966), n. 7 and p. 145; "A Mycenaean
Jeweler's Mold," *BMFA* 65 (1967), n. 4.

282. K. Demacopoulou, "Mycenaean Jewellery Workshop in Thebes," *Athens Annals
of Archaeology* 7 (1974): 173; see also S. Symeonoglou, *Kadmeia* I [= *SIMA* 35] (Göteborg,
1973), pp. 63–71.

283. Furumark, *Mycenaean Pottery*, p. 45 n. 4 (hereafter cited as *MycPot*).

284. Pendlebury, *Aegyptiaca*, p. 55.

285. Furumark, *MycPot*, shape #32 with examples given.

PLATE 29
Cup, Shaft Grave IV, Mycenae.
Scale: actual size

stone[286] examples of the shape have been found, however, both on Crete and on the mainland. The faience vessel was probably copied from these prototypes and could well have been made at Mycenae.

The same is true of the gray white cup (plate 29) from Shaft Grave IV. The shape seems to have been copied from stone models such as the nearly identical alabaster cup from Shaft Grave III.[287] Similarly inspired by stone shapes are two gray white faience vessels from Shaft Grave I. One is a small globular alabastron,[288] and the other is a baggy, flat-bottomed alabastron.[289] Both shapes seem to have been ultimately derived from Egyptian stone antecedents, of which numerous alabaster examples have been found on Crete.[290]

Shaft Grave III contained the upper portion of an unusual white double-mouthed vessel (plates 30, 31). G. Karo has proposed that the black-bordered double mouth was intended to catch inadvertently spilled droplets, perhaps of an expensive aromatic oil.[291] Ceramic examples of double-mouthed vessels have been found at Phylakopi and Gournia.[292]

286. *PM* 2:1, fig. 34 a (Pyrgos LM Ia), for instance.

287. Karo, *Schgr*, pl. CLXVI (#165). Minoan examples of this class are discussed in Warren, *Minoan Stone Vases*, pp. 21–22.

288. Karo, *Schgr*, pl. CLXVIII (#201), sherds illustrated.

289. Karo, *Schgr*, pl. CLXVIII (#202), sherds illustrated.

290. Warren, *Minoan Stone Vases*, pp. 112–13; *PM* 2:2, fig. 537 k; Evans, "Tomb of the Double Axes," *Archaeologia* 65 (1914), figs. 3, 4 and "Prehistoric Tombs of Knossos," *Archaeologia* 59 (1905), pl. 99 #3, 4, 5.

291. Karo, *Schgr*, p. 242.

292. Atkinson and Bosanquet, *Excavations at Phylakopi*, pl. 27 #8, 9 and p. 136; Hawes, *Gournia*, pl. VII #37.

PLATE 30
Double-mouthed vessel, side view, Shaft
Grave III, Mycenae.
Scale: ½ actual size

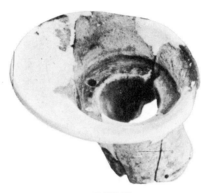

PLATE 31
Double-mouthed vessel, top view, Shaft
Grave III, Mycenae.
Scale: ½ actual size

A stone plaque shaped like a double-beaked ewer was recently excavated at Thera.[293]

Plate 32 illustrates the sole faience vessel recovered from Grave Circle B. This is a dark turquoise green chalice decorated by dark blue bands around the base and rim, with a fragmentary spray of leaves painted below the rim. There are marked similarities in shape, size, and banded decoration between this Mycenaean chalice from Shaft Grave Alpha and the chalices (figures 5, 6) and flask (figure 7) from the Temple Repository at Knossos. The Mycenaean chalice differs in its color combination and rudimentary, indistinct foliate pattern. These differences suggest that the four pieces were not necessarily produced in the same Knossian workshop and that the Shaft Grave chalice was perhaps commissioned at Mycenae as a copy of the others.

293. Marinatos, *Thera* VII, pl. 54c.

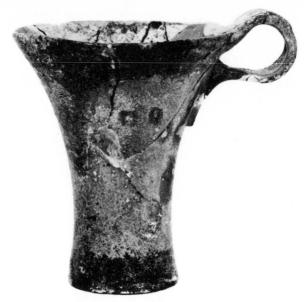

PLATE 32
Chalice, Shaft Grave Alpha, Mycenae.
Scale: $\frac{3}{4}$ actual size

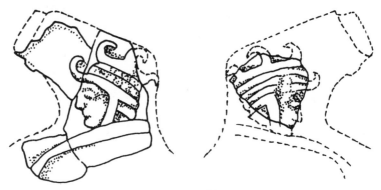

FIGURE 86
Jug with helmeted figures, Shaft Grave III, Mycenae.
Scale: $1\frac{1}{2}$ times actual size

PLATE 33
Jug with helmeted figures, Shaft Grave III,
Mycenae.
Scale: actual size

124

In addition to the double-mouthed vessel described above, Shaft Grave III held fragments of a pale green faience beaked jug (figure 86; plate 33). The shape is a characteristic Minoan one,[294] with the boss below the spout reminiscent of the rivets of metal protoypes.[295] On opposite sides of the neck are modeled in relief two warrior's heads in profile. The upper edge of one warrior's large round body shield is preserved. Both are accoutered in helmets with chin straps, horizontal bands representing leather or thick padding, and four curving horn-shaped protuberances.[296] Warriors with related types of hornless helmets are shown on a seal impression from the Treasury of the Domestic Quarter, Knossos,[297] and on two faience vessels from the House of Shields, Mycenae (plates 37, 38). Such a helmet also appears on a LM Ia polychrome goblet from the Tomb of the Double Axes.[298] A seal from the Vapheio cist depicts a boar's-tusk helmet with large ram's horns on either side.[299] Plain conical helmets with several horns seem to have been characteristic headdresses of Hittite gods[300] and were also worn by Hittite royalty.[301]

For several reasons one may suggest that the Shaft Grave jug was produced at Mycenae.[302] First, it is significant that a relief technique, rather than the painting or appliqué techniques usually seen in Minoan faience, was chosen for the execution of the warriors' head. This decision is paralleled by the choice of relief for showing combat and hunting scenes on the Shaft Grave stelae.[303] Second, the warriors' profiles, with their almond-shaped eyes, straight noses, and high cheekbones, are much like the Mycenaean physiognomies of the Shaft Grave masks and the portrait gem from Grave Gamma.[304] Indeed, the faience jug ought perhaps to be added to the list of early Mycenaean portraits. As C. W. Blegen has noted with respect to the Pylos and Mycenae silver cups with inlaid heads, "If some rulers had their own portraits carved on their personal sealstones, it is not inconceivable that others might have wished to have a favorite wine cup similarly adorned."[305] Third, though the combination of horns and helmets can be paralleled elsewhere, the arrangement here is unique to

294. See, for instance, *PM* 2:1, fig. 125 for a MM III jug whose proportions are very like those of the faience copy.

295. See *PM* 1, fig. 47 a and p. 80 for a discussion of ceramic bosses and metal studs.

296. Chadwick, *Documents*², p. 377. For a catalogue and discussion of fancy Mycenaean helmets, see G. S. Korres, "The Splendour of Mycenaean Helmets," *Athens Annals of Archaeology* 2 (1969): 455–62.

297. *PM* 3, fig. 205.

298. *PM* 3, fig. 198 b.

299. *PM* 4:2, fig. 675.

300. K. Bittel, *Hattusha* (New York, 1970), p. 95 and pl. 19b; H. Frankfort, *Art and Architecture of the Ancient Orient* (Baltimore, 1970), fig. 265 (Yazılıkaya sword god).

301. As recognized by Evans, *PM* 4:2, fig. 673 a, b. See also Bittel, *Hattusha*, fig. 24 (gate inscription of Tuthaliya IV, 1250–1220 B.C.).

302. At variance with Pendlebury who classed it with Egyptian imports (*Aegyptiaca*, p. 56) and Karo "gute kritische Arbeit" (*Schgr*, p. 61), among others.

303. For a representative group, see Vermeule, *Greece in the Bronze Age*, fig. 17.

304. These are discussed by C. W. Blegen in "Early Greek Portraits," *AJA* 66 (1962): 245–47.

305. Blegen, "Portraits," *AJA* 66 (1962): 247.

PLATE 34
Lid, Chamber Tomb 529, Mycenae.
Scale: ⅓ actual size

this piece and probably native to Mycenae. In view of these considerations, it seems likely that the Shaft Grave jug was modeled on a Minoan vessel type, but decorated in a distinctive Mycenaean manner with a particular client in mind.

Plate 34 illustrates a LH II/III pale green faience lid recovered fom Chamber Tomb 529, Mycenae. The piece, with its flat cylindrical knob handle and plain rim, was perhaps modeled on the pawn-handled lids intended for Minoan bird's nest, blossom, and other stone bowls.[306] Another faience lid was found at Akrotiri and is discussed below.

The remaining vessels in this group were found in the LH IIIb House of Shields at Mycenae. Plates 35, 36, 37, and 38 show the monochrome ware; plate 39 and 40 illustrate fragments of two polychrome pieces.

A pair of stemmed bowls belongs to the monochrome group of vessels. Both have short stems supporting rounded bowls, rolled handles, and dark brown body and rim decoration. The buff body of one (plate 35), from the West Room of the House of Shields, has a gadroon pattern fringed on the top by incurved triangular patches. Above this is a plain band surmounted by a wider band of connecting lozenges, most of which have dots in their centers. An identical lozenge design also decorates the rim. The other bowl (plate 36), from the North Room of the House of Shields, is pale green and decorated by a panel of three-petal lotus flowers, above which is a plain band. Just below the lip is a gadroon pattern rising from a border of incurved triangles.

Two additional monochrome faience sherds with dark brown decoration on buff grounds are illustrated in plates 37 and 38. These show helmeted men in profile, each raising his right arm. The flowing locks in plate 37 and the neatly trimmed beard in plate 38 are paralleled by the hair styles seen on the male heads inlaid in a LH IIIb silver cup from Pylos[307] and a LH II/III silver cup from a Mycenaean chamber tomb.[308] The conical helmets with concentric bands are similar to those shown on the Shaft Grave jug (figure 86), but lack the horned projections. The larger fragment (plate 37), from the West Room of the House of Shields, probably formed part of a conical

306. Warren, *Minoan Stone Vases*, pp. 68–71.
307. C. W. Blegen and M. Rawson, *Palace of Nestor* I (Princeton, 1966), fig. 261.
308. C. Tsountas, "Anaskaphai Taphōn en Mykēnais," *EphArch*, 1888, pl. 7:2.

PLATE 35
Stemmed bowl, House of Shields, Mycenae.
Scale: $\frac{3}{4}$ actual size

rhyton.[309] Its heavy rolled lip bears a herringbone design with solid inner triangles. The other piece (plate 38), from the North Room of the House of Shields, has a border of nesting connecting lozenges above the figure.

For several reasons it seems probable that this monochrome ware was made at Mycenae.[310] First, the stemmed cup shape is typically Mycenaean,[311] as are most of the stylistic motives seen on all four pieces: the helmets, the lozenge chains,[312] the herringbone borders,[313] and the

309. A. J. B. Wace, "Mycenae 1939–1955," *BSA* 51 (1956): 109.
310. So Wace cautiously suggested, then rejected, because of misgivings about its apparent rarity and diversity; his tentative conclusion was that it was Syrian ("Mycenae 1939–1955," *BSA* 51 [1956]: 111–12).
311. Furumark, *MycPot*, p. 56; type #255, fig. 16.
312. Furumark, *MycPot*, motif #73.
313. Furumark, *MycPot*, motifs #61:10; 61A:2.

PLATE 36
Stemmed bowl, House of Shields, Mycenae.
Scale: $\frac{3}{4}$ actual size

gadroon patterns with solid triangular fringes.[314] Second, the lotus petal design of plate 36 is a simple, easily imitated Nilotic motif. Mycenaean metal vessels carried in Egyptian tomb reliefs of the mid-Eighteenth Dynasty have similar arrangements of wide zones of fluting surmounted by two borders with geometric designs.[315] Furthermore, the foot, body, and handle of the stemmed cups were made in separate molds,[316] a technique readily adaptable from Mycenaean jewelry-making methods.

Study of the polychrome ware from the House of Shields suggests that it was also made at Mycenae. Plate 39 illustrates a polychrome flat ribbon handle, which was probably attached to the lip and shoulder of a large jar, perpendicular to the neck. The decoration still retains its brilliant color and consists of two borders of blue and yellow bars enclosing a single chain of connected lozenges. These are arranged in a series of four—blue, red, yellow, red—on a bright yellow ground. Counterparts to both the

314. Furumark, *MycPot*, motif #42:30.
315. See, for instance, those shown on registers 1 and 2 of the Tomb of Menkhepere-seneb (served under Thutmosis III and Amenhotep II), clearly illustrated in Furumark, "Ialysos and Aegean History," *Opuscula Archaeologica* 6 (1950), fig. 25. I am grateful to M.-H. Carre Gates for drawing this similarity to my attention.
316. Wace, "Mycenae 1939–1955," *BSA* 51 (1956): 110.

PLATE 37
Sherd with helmeted figure, House of Shields, Mycenae.
Scale: actual size

decorative motives[317] and the handle type[318] are commonly found in Mycenaean ceramics.

Also Mycenaean in style and subject matter is the composition partially reconstructed in plate 40. The faces and portions of the bodies of a yellow lion and a blue griffin are outlined in black on a buff ground. The juxtaposition of these animals was standard in the Mycenaean repertory and appears particularly often on ivory plaques.[319] Though the two creatures are also shown with other quarry,[320] the combination of lion and griffin seems to have permitted the fullest expression of the "passionate vigor

317. Furumark, *MycPot*, "panelled triglyph with lozenges," fig. 72 #14.

318. Furumark, *MycPot*, fig. 24, p. 91.

319. See, for example, the LH IIIb plaque from Delos in which the lion bites the griffin (H. Gallet de Santerre and J. Tréheux, "Rapport sur le dépot égéen et géometrique de l'Artemesion à Délos," *BCH* 71–72 [1947–48], pl. XXIX); see also the thirteenth century Mycenaeanizing ivory plaque from Megiddo that shows a griffin with a long curving beak in the process of attacking a lion (G. Loud, *The Megiddo Ivories* [Chicago, 1939], pl. 5:7).

320. A variety of examples is illustrated in *PM* 4:2, pp. 528–40; a deer and griffin combat is depicted on the LH IIIa ivory pyxis from an Agora tholos tomb (T. L. Shear, "The Mycenaean Tomb," *Hesperia* 9 [1940], fig. 29).

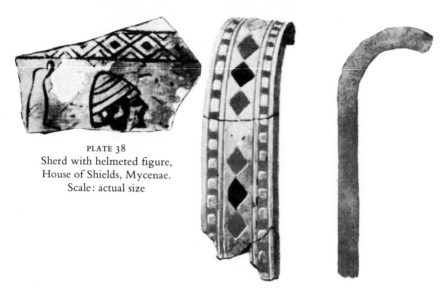

PLATE 38
Sherd with helmeted figure,
House of Shields, Mycenae.
Scale: actual size

PLATE 39
Handle, House of Shields, Mycenae
Scale: actual size

and movement of the animals."[321] Much of this is lost here because of the fragmentary condition of the faience piece. Nonetheless, the spirited drawing of the griffin's eye, its powerful beak, and the lion's tufted mane suggests the quality of the whole. The colors are still vivid, recalling the striking contrast of the violet griffin and yellow lion of the Pylos fresco.[322] The piece attests to the verve with which Late Mycenaean faience manufacturers continued the polychrome traditions begun in MM III Crete.

1b *Rhyta*

The corpus of Mycenaean faience rhyta comprises vessels of the ostrich egg class; there are no theriomorphic rhyta. The class of ostrich egg rhyta includes those with mouth and underpieces attached to ostrich eggs, as well as the stylized variants of the peg-top, elongated, and pear-shaped type, which were made in faience, clay, stone, and other materials.[323]

From Shaft Graves IV and V were recovered whole and fragmentary ostrich eggs, an egg with faience dolphin appliqués, faience mouth and underpieces, and a gold underpiece. Various schemes for the reconstruction of these rhyta have been proposed; the combinations adopted here are those currently shown in the National Archaeological Museum, Athens.

Figure 87 illustrates egg #552 with faience mouthpiece #567 and faience underpiece #573, all from Shaft Grave IV (see also plate 41). Both

321. H. J. Kantor, "Syro-Palestinian Ivories," *JNES* 15 (1956): 169.
322. M. Lang, *Pylos: The Frescoes* (Princeton, 1969), pl. P #21 C 46.
323. *PM* 2:1, fig. 128 shows a modern Sudanese ostrich egg container; *PM* 2:1, fig. 129 outlines the development of the class of the ostrich egg rhyta, with examples from Egypt, Crete, and Mycenae.

PLATE 40
Sherds with griffin and lion, House of Shields, Mycenae.
Scale: $1\frac{2}{5}$ times actual size

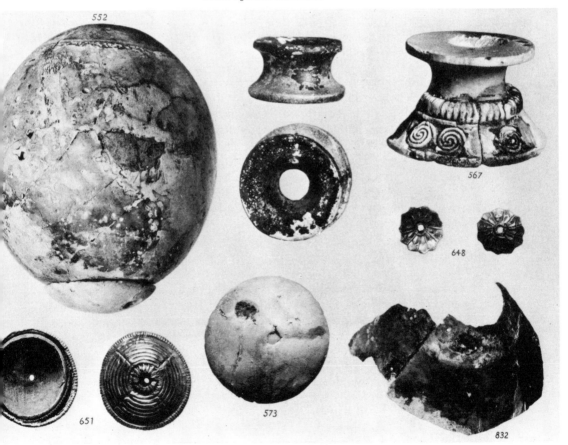

PLATE 41
Ostrich eggs and fittings, Shaft Graves IV and V, Mycenae.
Scale: $\frac{3}{7}$ actual size

FIGURE 87
Ostrich egg rhyton, Shaft Grave IV,
Mycenae.
Scale: ⅓ actual size

FIGURE 88
Ostrich egg rhyton with dolphins,
Shaft Grave V, Mycenae.
Scale: ⅓ actual size

the egg and the mouthpiece have signs of green discoloration, indicating they were originally covered with bronze foil.[324] The practice of covering vessels with foil was intended to be decorative, to enhance the vases' appearance, and perhaps also to provide a less expensive substitute for all-metal vessels.[325] Egg #832 (plate 41) from Shaft Grave V seems to have been similarly covered with bronze and gold foil sheets fastened through pairs of small holes in the egg.[326]

Egg #552 was correctly paired with mouthpiece #567 by A. J. Evans, though he reconstructed an ornate beaded lip.[327] The light brown mouthpiece has traces of pale yellow coloring and is decorated with a band of running spirals in relief, surmounted by a fluted ridge. The pale yellow underpiece #573 completes the reconstruction of this rhyton, as suggested by G. Karo[328] and at variance with A. J. Evans.[329]

Figure 88 and plate 42 show egg #828 from Shaft Grave V with appliqués of faience dolphins. These are discussed below in 2b. Also from Shaft Grave V is the gray green incurving cylindrical faience mouthpiece #774 (plate 41). This seems to have been attached directly to the egg, without

324. Karo, *Schgr*, p. 114.

325. Warren, *Minoan Stone Vases*, p. 163. See Davis, *Vapheio Cups*, pp. 331–32, for a discussion of the possible techniques used in gilding and silver plating Minoan vessels.

326. Karo, *Schgr*, p. 147.

327. *PM* I, fig. 436 b. V. Staïs had paired this mouthpiece with egg #828 (Karo, *Schgr*, p. 116).

328. Karo, *Schgr*, p. 116.

329. *PM* I, fig. 436 b shows the gold underpiece #651, now correctly placed with egg #828.

567

828

651

PLATE 42
Ostrich egg rhyton with dolphins, Shaft Grave V, Mycenae.
Scale: $\frac{7}{10}$ actual size

the decorated flange of neck #567. Shaft Grave V also contained a gold-covered wooden underpiece #651 (plate 41) which was combined by Karo with egg #828 on the basis of their similar dimension.[330] The underpiece is elaborately designed, with concentric ribbed bands encircling a small, petal-rimmed aperture.

It is difficult to determine whether these eggs were fitted with their attachments in Crete or at Mycenae. The eggs themselves were not necessarily imported from Libya, the Sudan, or Nubia, since "for all we know, someone kept a pair of pet ostriches at Zakro and speculated on plain and fancy eggs."[331] In view of the evidence brought forward here for local faience manufacture in the Shaft Grave period, it is possible that some of these mouth and underpieces were made at Mycenae, perhaps under Minoan guidance or perhaps in imitation of Minoan, Egyptian, or Mycenaean examples. A pointed bottom rhyton with running spiral decoration from Shaft Grave IV attests to Mycenaean acquaintance with ostrich egg rhyton types.[332] This question will be considered again in connection with the dolphin appliqués of 2b.

Plate 43 illustrates a faience example of the elongated ovoid ostrich egg rhyton type which was recovered from the House of Shields, Mycenae. The pale blue vessel has a small rolled handle, short neck, and a ridge with incised black lines joining the neck to the body. The rhyton's body is decorated with a series of separate, parallel bands of running spirals bordered by cables. The bands are aligned at an oblique angle and seem to twist slightly, creating an effect of torsion on the vessel's surface. Both the spiral and cable designs are commonly found in the Mycenaean repertory.[333] The body of the rhyton was molded in two halves, with neck and handle perhaps attached individually.[334] As seems to be the case with the other faience vessels from the House of Shields, the stylistic and technical evidence suggests local manufacture for this piece.

2a Human Figurines

The pieces illustrated in figures 89 and 90 are the only Mycenaean examples of faience human figures. The larger of the two (figure 89) was recovered from Chamber Tomb 9, Dendra (LH II/III) and shows a woman wearing the flounced skirt, short-sleeved bodice, and choker necklace characteristic of Aegean female costume of this period. Her head is in profile, while her arms, breasts, and shoulders are seen in front view. The lower portion of her body is rendered in three-quarter view. This twisted, half-seated pose is repeated with varying degrees of grace in numerous examples, among them the ivory pyxis lid from Minet-el-Beida,[335] an ivory plaque

330. Karo, *Schgr*, p. 125.

331. Vermeule, *Shaft Graves*, p. 20.

332. *PM* 2:1, fig. 129 #10.

333. The cable motif is discussed in Furumark, *MycPot*, p. 359. For the combination of spiral and cable, see *MycPot*, fig. 72 #11.

334. Wace, "Mycenae 1939–1955," *BSA* 51 (1956): 110; one fragment of the lower half was found.

335. Kantor, *Aegean and Orient*, pl. 22 J, with comparative material on the same plate.

PLATE 43
Rhyton, House of Shields, Mycenae.
Scale: $\frac{3}{5}$ actual size

FIGURE 90
Female figurine,
Acropolis, Mycenae.
Scale: actual size

FIGURE 89
Female figurine,
Chamber Tomb 9,
Dendra.
Scale: actual size

from Chamber Tomb 49, Mycenae,[336] and the "Grandstand" fresco from Knossos.[337] The mold-made faience piece has a flat back, indicating it was probably an appliqué for a panel, box, or garment.

Figure 90 illustrates one of eleven tiny faience figurines from the acropolis, Mycenae. Their miniature size, flat backs, and perforations point to their having been made as ornaments for clothing or as necklace elements. The pieces are similar in style, gesture, and details of costume to the gold cut-outs from the Shaft Graves[338] and the four faience figurines from Knossos (figure 11).

2b Animal Figurines and Fish

To this group[339] belong five faience dolphins from Shaft Grave V, Mycenae (figure 88; plate 42). The gray green dolphins were set as appliqués on the surface of the ostrich egg #828, described above in 1b. Their arrangement is a naturalistic display of dolphins arcing through the water in different positions. A dark-on-light MM III jar from Pachyammos shows a similar design,[340] as does a light-on-dark jar from the same site.[341] A more formalized rendering of the subject was painted on the walls of the

336. C. Tsountas, "Anaskaphai taphōn en Mykēnais," *EphArch*, 1888, pl. 8: 1, 2.

337. *PM* 3, color plate XVII.

338. Vermeule, *Greece in the Bronze Age*, fig. 19, upper left provides an example of one of these gold cut-outs.

339. Four dogs on a sycamore wood box from Shaft Grave V, Mycenae, have been described sometimes as faience (e.g., A. Sakellariou, *A Brief Guide to the Prehistoric Collections, National Archaeological Museum* [Athens, 1973], p. 30). The box and its appliqués of dogs and ivory ledges have been discussed with respect to their stylistic features by B. Schweitzer in "Hunde auf dem Dach," *AthMitt* 55 (1930): 116–18; clear photographs appear in Karo, *Schgr*, pl. CXLV (#812). Certain identification of the dogs' material awaits further study, but it is unlikely the material is faience. The dogs' color is dark brown with blue patches, and their surface is grainy, suggesting some type of discolored wood other than sycamore. J.-C. Poursat does not consider the dogs to be ivory (*Catalogue des Ivoires Mycéniens* [Paris, 1977], p. 62).

340. *PM* 1, fig. 447 b.

341. *PM* 1, fig. 447 a.

PLATE 44
Triton shell, Shaft Grave III, Mycenae.
Scale: ½ actual size

MM III/LM Ia Queen's Megaron, Knossos.[342] The individual dolphins closely resemble in size and curvature of tails and bodies the faience flying fish from the Temple Repository (figure 14; plate 13).

In view of the dolphins' strong Minoan affinities, it seems probable that they were made on Crete and exported to Mycenae already affixed to the ostrich egg. If so, the egg's faience mouth and gold-covered underpiece were also made on Crete, since it is unlikely that the rhyton was exported from Crete in an incomplete state. Furthermore, the practice of capping Minoan ostrich eggs with gold is shown by a MM IIa polychrome rhyton with orange decoration on white, imitating gold plating on ostrich egg.[343] As for the Shaft Grave IV ostrich egg rhyton, the available evidence remains inconclusive as to the Minoan or Mycenaean manufacture of its faience fittings. The importing of one finished rhyton does not necessarily imply the importing of others.

2c *Plants, Shells, and Rocks*

The white triton shell (plate 44) from Shaft Grave III is the only Mycenaean faience object in this group. The piece is particularly fine, with molded ribs indicating the parts of the triton shell. These shells seem to have been used secularly as drinking vessels and ornaments, while in various cults they served as trumpets and votive objects.[344] Of special note is the engraved gem from the Idaean cave which shows a woman blowing a triton shell; she stands before an altar with so-called horns of consecration and boughs upon it.[345]

Triton shells have been found in a MM IIb shrine at Phaistos,[346] near the Magazine of the Lily Vases, Knossos,[347] and in numerous other Minoan

342. *PM* 3, fig. 251.
343. *PM* 1, fig. 436 A 2.
344. Nilsson, *MMR*², p. 154.
345. *PM* 1, fig. 167.
346. *PM* 1, fig. 165.
347. *PM* 1, fig. 419.

PLATE 45
"Sacral knots," Shaft Grave IV, Mycenae.
Scale: ⅔ actual size

deposits.[348] Equally common are models of triton shells in other materials. Miniature red and white striped terra-cotta shells were found in the Loom-weight deposit,[349] while light-on-dark painted clay ones were part of a MM II deposit on the East Slope, Knossos.[350] Stone triton shells were recovered from the Zakros LM I workshop,[351] from the LM I Treasury of the Sanctuary Hall, Knossos,[352] and from elsewhere at Knossos, Haghia Triada, and Phaistos.[353] The closest parallel to the Shaft Grave shell is the faience triton from LM I Pyrgos.[354]

In light of the large number of triton shells in Minoan contexts and their frequent reproduction in other materials, it is probable that the faience shell from Shaft Grave III is a Minoan import. Moreover, the

348. Instances cited in Nilsson, *MMR²*, p. 154 nn. 75, 76.
349. *PM* I, fig. 168.
350. *PM* 4:1, p. 111.
351. Platon, *Zakros*, pp. 220–21.
352. *PM* 2:2, fig. 539 A.
353. Nilsson, *MMR²*, p. 154 n. 78.
354. See note 124 above.

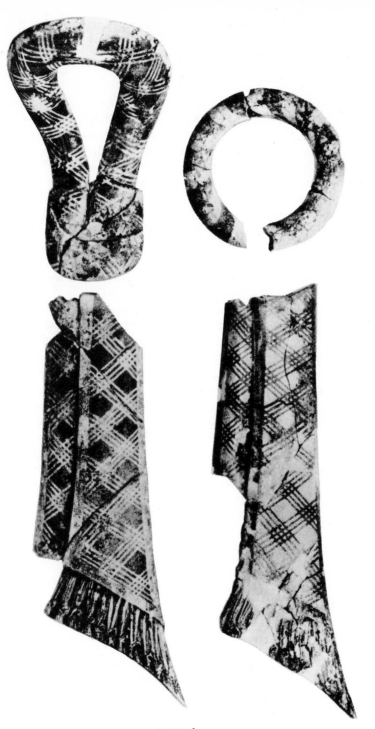

PLATE 46
"Sacral knots" and ring, Shaft Grave IV, Mycenae.
Scale: ½ actual size

quantity of faience shells from the Temple Repository (plate 13) attests to Minoan facility in naturalistic modeling of faience seashells in a period contemporary with that of the Shaft Graves.

3a *Plaques*

The class of Mycenaean plaques is composed chiefly of faience models of tied cloth, the so-called sacral knots recovered from Shaft Grave IV, Mycenae. The plaques show a strip of fabric knotted to produce a large loop with two long ends, one of which has a tassel fringe. The knots themselves are stylized, for none accurately depicts a true knot.[355] The faience fringe reproduces the way cloth tassels were made. This was done by gradually cutting groups of threads from the loom and then tying each group together with the following thread before proceeding to the next group.[356] The material pattern is a simple tartan design on the bias done in white on brown (plates 45, 46, left) or brown on pale blue green (plate 46, right). Other features are the perforations or nail holes above the knot and the partially hollow undersides, the flat portions of which sometimes bear craftsmen's marks.[357]

Knots of similar type appear in a variety of media and contexts. An ivory example with a bias tartan pattern was found in the MM III Southeast House, Knossos.[358] An ivory plaque from Palaikastro shows a knot in conjunction with a double axe,[359] a stylization of which was a common decorative motive in the Late Minoan period.[360] Additional examples of these knots include the stone knots attached to the rim of a stone rhyton from the Central Treasury shrine at Zakros[361] and the faience knot perhaps used as a handle or ornament on an inlaid gameboard from the LM Ib Royal Road deposit at Knossos.[362] "La Parisienne" from the Northwest Palace, Knossos, wears a blue and red striped knot at the nape of her neck.[363] Fragments of a wall painting from the LM Ia building at Nirou Khani near Mallia show knots with herringbone patterns.[364] MM III/LM Ia

355. In their *Encyclopedia of Knots and Fancy Rope Work* (Cambridge, Maryland, 1952), R. Graumont and J. Hensel have noted that ancient art "failed to show a knot of any kind in its actual or true form. There is nothing to indicate this was done purposely" (p. 4). Study of the many types of knots illustrated in the *Encyclopedia* has not disclosed parallels for any of the Aegean "sacral knots."

356. E. Gullberg and P. Åström, *The Thread of Ariadne: A Study of Ancient Greek Dress* [= *SIMA* 21] (Göteborg, 1970), p. 22.

357. *PM* 1, fig. 347 A.

358. *PM* 1, fig. 308.

359. *PM* 1, fig. 310 d.

360. *PM* 1, fig. 310 e.

361. Platon, *Zakros*, p. 135 (no illustration).

362. Cadogan, "Some Faience, Blue Frit and Glass," *Temple University Aegean Symposium* 1 (1976): 18.

363. *PM* 4:2, color plate XXXI. A new join completes the knot's fringed end; see M. Cameron and S. Hood, *Catalogue of Plates in Sir Arthur Evans' Knossos Fresco Atlas* (London, 1967), back cover.

364. *PM* 2:1, fig. 168. The building may have been a storage or distribution center for articles connected with Minoan cults, for large numbers of tripods, double axes, and other items were found there (*PM* 2:1, p. 284).

Minoan seals depict knots and fringed ends being transported[365] or displayed in scenes of bull-jumping.[366] A gold signet ring from Mycenae illustrates knots affixed to the top of a pillar,[367] while another shows a knot tied to a figure-eight shield lying to one side of a field in which two individuals are dancing.[368] Two fringed ends flank a bull's head and double axe on an onyx lentoid from Argos.[369]

The knots have been seen as ornamental details of Aegean fashion,[370] as votive items of apparel,[371] as cross-cultural links with the bundle of tied reeds used in Mesopotamia as the symbol for the goddess Inanna,[372] and as attachments for inlaid gameboards.[373] The knots' last use may account for the slightly raised upper half of the loop of #560. While it is possible the Shaft Grave knots were copied from Knossian models and made at Mycenae, it seems more likely that these faience pieces are Cretan in origin. The Shaft Grave gameboard is discussed below in 3b.

The brown and blue green striped faience ring from Shaft Grave IV (plate 46, upper right) should also be included in the group of Mycenaean plaques. The underside of this piece is flat, with its interior hollowed out. The illustration shows the way in which the right-hand end of the ring was shaped as though it originally enclosed a spherical object.[374] The left-hand end is chipped, so it is difficult to tell whether the two ends interlocked or were similarly shaped. The purpose of this ring is at present unknown.

3b *Inlays*

This group comprises several figure-eight shield inlays[375] and a set of pieces from a Shaft Grave gameboard. Figure 91 illustrates two shield inlays from an unspecified burial at Mycenae. Each is decorated with trefoils of dark painted dots, meant to represent the piebald markings of Aegean bulls' hides. Examples of shield inlays with this convention include the ivory ones from the House of Shields, Mycenae,[376] and the gold shields with granulated dot triplets from a LH II Pylos tholos.[377] These parallels indicate a LH II/III date for the faience shields, as well as suggest their local design and manufacture. Of a somewhat later date is the plain faience shield inlay (plate 47) recovered from the 1200 B.C. destruction

365. It is unclear whether some of these fringed ends are parts of knots or are meant to represent flounced divided skirts (*PM* I, fig. 312 a, b).

366. *PM* I, fig. 310 a.

367. *PM* I, fig. 310 b.

368. *PM* I, fig. 310 c.

369. *PM* I, fig. 312 c.

370. Nilsson, *MMR*[2], pp. 163–64, where their connection with cultic activities is questioned.

371. *PM* I, pp. 434–35.

372. Alexiou, "Contribution to the Study of the Minoan 'Sacred Knot,'" *Europa*, pp. 1–6.

373. *PM* I, pp. 483–84; see also n. 362 above.

374. This was observed and described by Karo in *Schgr*, p. 115.

375. For Minoan examples of figure-eight shields, see n. 158 above.

376. A. J. B. Wace, "Mycenae 1939–1953," *BSA* 49 (1954), p. 236 and pl. 34 a, e.

377. C. W. Blegen, "Excavations at Pylos 1953," *AJA* 58 (1954), pl. 9:14.

FIGURE 91
Figure-eight shield inlays, Mycenae.
Scale: ½ actual size

PLATE 47
Figure-eight shield inlay,
Mycenae.
Scale: 1⅕ times actual size

levels at Mycenae. The piece is virtually identical to the bronze shield inlays set along the blade of a Shaft Grave IV sword,[378] providing a clear instance of Mycenaean stylistic conservatism.

Among the faience objects from Shaft Grave IV, Mycenae, were fragments of an inlaid gameboard, a reconstruction of which is shown in figure 92. The design consists of four discs grouped about an incurving lozenge striped in pale blue green and dark brown. Each brown disc has a pale blue green rosette pattern with brown inner petals radiating from a brown-ringed center. In arrangement, proportions, and details of decoration, the Shaft Grave gameboard pieces closely resemble the Tylissos box lid (plate 20) and the faience and crystal board from the Temple Repository (plate 21). The Shaft Grave gameboard inlays appear to have been manufactured on Crete and exported to the mainland.

4a Jewelry, Seals, and Ornaments

The earliest Mycenaean faience jewelry comes from the Shaft Graves. Grave Upsilon yielded a double necklace of faience amulets, gold, silver, and semiprecious stones,[379] while Grave Xi contained a rock crystal necklace with a single faience pendant (figure 93). This is a pale blue rectangle with two beaded borders and raised decoration of two intersecting triangles forming a central lozenge. From Shaft Grave III were recovered two spherical faience beads[380] and a pair of gray white rectangular pendants (plate 48). Each has a molded, stylized ivy leaf between ribbed edges, a plant design frequently used in later Mycenaean ornaments.[381] A faience

378. Karo, *Schgr*, pl. LXXXV (#404).
379. G. E. Mylonas, *Grave Circle B of Mycenae* [=*SIMA* 7] (Lund, 1964), fig. 6.
380. Karo, *Schgr*, #111.
381. Examples of the ivy leaf's variations are given by Buchholz and Karageorghis in *Prehistoric Greece and Cyprus*, fig. 37 #1317, 1318, 1319, 1331.

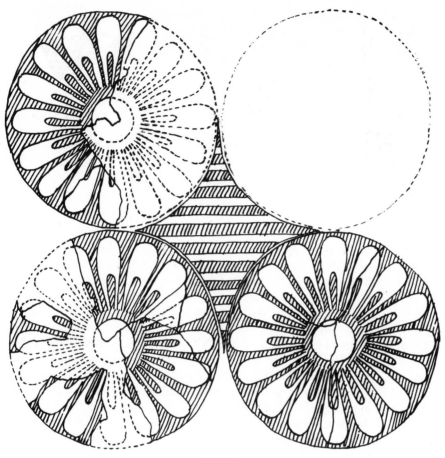

FIGURE 92
Gameboard inlays, Shaft Grave IV, Mycenae.
Scale: $\frac{1}{2}$ actual size

FIGURE 93
Pendant, Shaft Grave Xi,
Mycenae.
Scale: actual size

71

PLATE 48
Pendants, Shaft
Grave III, Mycenae.
Scale: actual size

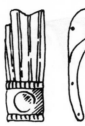

FIGURE 96
Bull's-head bead,
Chamber Tomb 10,
Dendra.
Scale: actual size

FIGURE 95
Bracket, Pylos.
Scale: actual size

FIGURE 94
Bracket, Mycenae.
Scale: actual size

button from Mycenae probably should be included in the group of Shaft Grave jewelry on the basis of its incised design of wavy bands, a pattern seen on a Shaft Grave IV spoon and ivory buttons.[382]

Two examples of ornamental faience brackets are illustrated in figures 94 and 95. The first, from Mycenae, has the characteristic Late Helladic reduplicated fluting, triple projections, and architectural molding, while the other, from a LH I/II Pylos tholos, has a single roll of fluting above the molding. A. J. B. Wace has seen a connection between the second type and the curled leaf ornament that often appears as a necklace element.[383] Both have narrow stems ending in rolls, solid in the case of the bracket and open in the case of the curled leaf.

Faience beads have been recovered from numerous LH II/III burials, palace sites, and settlements. At Prosymna were found white, blue, and green beads, chiefly of spherical, disc, gadrooned, segmented, and radially grooved spherical type.[384] Tombs at Asine yielded rosette, cockle, and convex tubular beads with incised decoration.[385] Faience and glass paste beads were occasionally combined, as in a necklace from an unspecified LH III Attic grave with glass paste rosettes and lentoid faience spacers and in a necklace from a LH IIIa/b tomb at Varkiza.[386]

Tholos tombs and pits at Dendra contained ribbed, wheat grain, and fluted beads, as well as a tubular bead with a net design.[387] In Dendra Chamber Tombs 10 and 11 were found gadrooned, melon, and spherical

382. Karo, *Schgr*, button, p. 271 n. 1 (#2831/2); spoon, fig. 62 (#824/5); other buttons, p. 270. I have not examined the faience button.

383. A. J. B. Wace, "The Curled Leaf Ornament," *BSA* 25 (1923): 397–402.

384. C. W. Blegen, *Prosymna: The Helladic Settlement Preceding the Argive Heraeum* (Cambridge, 1937), pp. 306–12.

385. O. Frödin and A. W. Persson, *Asine: Results of the Swedish Excavations 1922–1930* (Stockholm, 1938), fig. 243 and pp. 374–76.

386. Buchholz and Karageorghis, *Prehistoric Greece and Cyprus*, #1311, p. 111; P. G. Themelis, "A Mycenaean Gold Ring from Varkiza," *Athens Annals of Archaeology* 7 (1974), fig. 4.

387. A. W. Persson, *Royal Tombs at Dendra near Midea* (Lund, 1931), pls. 8, 26; pp. 27, 30, 39, 40–41, 60.

FIGURE 97
Lantern bead,
Chamber Tomb 526,
Mycenae.
Scale: actual size

FIGURE 98
Hammerhead bead,
Chamber Tomb 526,
Mycenae.
Scale: actual size

FIGURE 99
Seal, Tomb 38, Prosymna.
Scale: actual size

beads.[388] Figure 96 illustrates one of eight bull's-head beads from Chamber Tomb 10, Dendra. Eyes, muzzle, and poll are delineated, with the string hole passing through the poll. No other faience beads of this type are known; similar bull's-head beads in amethyst and gold have been found at Mochlos, Haghia Triada, and Enkomi,[389] providing a clear example of the substitution of faience for more expensive materials.

The chamber tombs at Mycenae held convex, tubular, wheat grain, radially grooved spherical, and lantern-shaped beads.[390] The last variety is illustrated in figure 97. Green and blue faience lantern beads are known from Mycenae, Nauplia, Goumenitsa, Enkomi, Ialysos, and Ras Shamra,[391] with identical gold examples from Mycenae, Trialeti, Nosiri, and Partskhanakanevi.[392] Chamber Tomb 526 at Mycenae also contained the unusual bead illustrated in figure 98. This is a miniature gray white hammer head of a full-size type commonly found in stone from the Early Minoan period onward.[393] These hammers generally have cylindrical bodies with flaring ends, capped by cones in the case of the faience bead. Small finds of faience beads, especially spheroid and ribbed melon beads, occurred elsewhere at Mycenae, including the sites of the so-called Tomb of Clytemnestra[394] and the north terrace deposit.[395]

In addition to faience and other beads, the north terrace deposit contained a scupltured ivory group of two women and a child, LH III pottery, a white stone pommel, fragments of painted stucco, and a faience cylinder seal.[396] The seal (plate 49) has a bird design and three human figures

388. Persson, *New Tombs*, figs. 95, 108:4, 5.

389. Persson, *New Tombs*, p. 87.

390. A. J. B. Wace, *Chamber Tombs* (Oxford, 1932), pp. 9, 26, 61, 62, 72–74, 205–6; fig. 12 e, f.

391. See Wace, *Chamber Tombs*, p. 94 for discussion and collected occurrences.

392. C. F. A. Schaeffer, *Stratigraphie Comparée* (London, 1948), pp. 514–15, where he describes the type as a "rouelle avec ses rais."

393. Examples are given by Buchholz and Karageorghis in *Prehistoric Greece and Cyprus*, p. 46; #234 illustrates a typical LM 1 stone hammer from Palaikastro.

394. A. J. B. Wace, "Excavations at Mycenae: The Tholos Tombs," *BSA* 25 (1921–23), fig. 81 b.

395. A. J. B. Wace, "Mycenae," *BSA* 52 (1957):199.

396. The deposit may represent the contents of a trinket box or may have belonged to a shrine (A. J. B. Wace, "Mycenae," *BSA* 52 [1957]: p. 199).

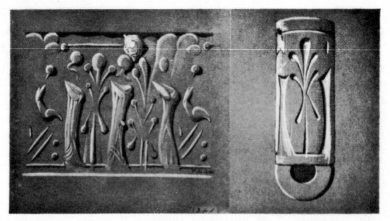

PLATE 49
Seal, north terrace deposit, Mycenae.
Scale: 3 times actual size

.

PLATE 50
Seal, Chamber Tomb 517, Mycenae.
Scale: actual size

FIGURE 100
Hilt and handgrip, Acropolis, Mycenae.
Scale: actual size

separated by two trees. Study of the seal indicates that notwithstanding its Mitannian style, it might well have been made in the eastern Mediterranean.[397] Related faience seals include ones from Beisan, Zapher Papoura,[398] and a LH I/II chamber tomb, Mycenae. The chamber tomb seal (plate 50) depicts a horned animal flanked by two human figures and two trees, all of which are rendered in a stick-figure style. The seal resembles a gem from the acropolis of Mycenae with three stick-figure people standing in a row.[399] It was probably made in western Asia within the sphere of influence of Mitannian glyptic.[400]

Two white LH II faience seals from Prosymna tombs exhibit a more pronounced linear style. One (figure 99), from Tomb 38, depicts a tree, a person, an unidentified object, and perhaps a campstool. The other, from Tomb 24, has two registers, the lower badly worn and the upper decorated with a linked pattern of dots and lines.[401] There is little evidence to warrant proposing either local or foreign origin for these two seals.

4b *Other Objects*

This group comprises three pale green ornamental faience sword elements: a cruciform hilt and covering for the handgrip (figure 100) from the acropolis at Mycenae; a cruciform hilt (figure 101) from Chamber Tomb 102, Mycenae; and a sword pommel (plate 51) from Chamber Tomb 529, Mycenae. The first two are decorated with bosses in imitation of the rivets used to attach metal hilts to blades and covers to handgrips.[402] Simulated double thongs separate the hilts from the handgrips. The presence of vessels of the early Palace style in Chamber Tomb 102 indicates an early LH II date for the nearly identical hilts. The faience sword pommel has a central hole for fastening it to the end of the tang, and the top was probably decorated with four circular inlays. It may have belonged to a dagger found in the same tomb.[403]

There has been considerable study of Aegean swords, especially with regard to the development of the cruciform sword (Type D). Long swords with narrow tangs and high midribs (Type A) were used chiefly in Crete, while short stout swords with broad tangs, rivers, and flanged shoulders (Type B) were used primarily on the mainland from the time of the Shaft Graves onward.[404] The enlargement of the tang and shoulders into a genuine hilt of the cruciform type seems to have been a Mycenaean innovation.[405] Some cruciform hilts, however, are also found in Crete,[406]

397. E. Porada and A. J. B. Wace, "A Faience Cylinder," *BSA* 52 (1957): 200–204.
398. Porada and Wace, "Cylinder," *BSA* 52 (1957), pl. 38 d and c respectively.
399. Wace, *Chamber Tombs*, p. 197 and pl. 20 a.
400. Porada and Wace, "Cylinder," *BSA* 52 (1957):203.
401. Blegen, *Prosymna*, p. 280 and fig. 596.
402. For a typical LM II sword with the parts labeled, see Chadwick, *Documents*², fig. 24.
403. Wace, *Chamber Tombs*, pl. 7.
404. N. K. Sandars, "The First Aegean Swords and their Ancestry," *AJA* 65 (1961), pp. 17–29, especially p. 25.
405. A. M. Snodgrass, *Arms and Armour of the Greeks* (London, 1964), p. 16.
406. *PM* 4:2, fig. 837, for instance.

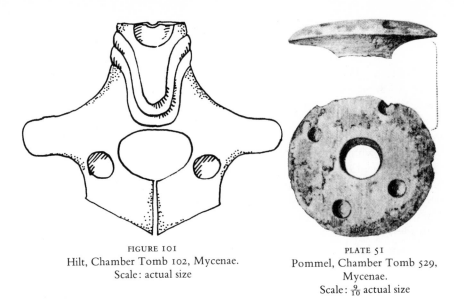

FIGURE 101
Hilt, Chamber Tomb 102, Mycenae.
Scale: actual size

PLATE 51
Pommel, Chamber Tomb 529,
Mycenae.
Scale: $\frac{9}{10}$ actual size

suggesting a parallel Minoan development from Type A swords with horned shoulders.[407]

Whether Minoan or Mycenaean in origin, metal cruciform swords provided models for the sword elements made of faience and other semi-precious materials. On the one hand, N. K. Sandars has opposed their Mycenaean manufacture, "for who would treasure incomplete and unfinished products if he had only to go down the road to procure complete ones?"[408] On the other hand, luxury products characteristically reproduce items used for practical purposes. This argues for Mycenaean manufacture of these faience sword parts, especially in view of the cruciform sword's popularity on the mainland.

Section 3 AEGEAN ISLAND FAIENCE

Little faience has been recovered from Aegean island sites. What few pieces there are belong chiefly to the years of increasing Minoan expansion during the first part of the Late Minoan period.[409] During the LH II/III period, some faience jewelry was exported to Ialysos from mainland Greece.[410] There is no evidence for faience manufacture on the islands. The white, blue, and red pigments occasionally found in seashells and other containers were intended for painting figurines and frescoes and for

407. Hood, *The Minoans*, p. 119 and fig. 93 b, c.
408. N. K. Sandars, "Later Aegean Bronze Swords," *AJA* 67 (1963):127.
409. Minoan material from Cycladic sites has been studied by C. Renfrew in "Crete and the Cyclades before Rhadamanthus," *KrChr* 18 (1964):107–41, especially pp. 133–34; and J. L. Caskey, "Greece and the Aegean Islands in the Middle Bronze Age," *CAH*³ 2:1, pp. 129–31, among others.
410. The relationship between Ialysos and the rest of the Aegean has been discussed in detail by A. Furumark in "The Settlement at Ialysos and Aegean History," *Opuscula Archaeologica* 6 (1950):150–271.

FIGURE 103
Rim sherd, Tomb A,
Kythera.
Scale: ⅔ actual size

FIGURE 102
Beaker, Kythera.
Scale: ½ actual size

toilette purposes.[411] The use of molds seems to have been restricted to weapon and tool making.[412]

One may attribute the paucity of island faience to two factors: first, the necessity of importing all pieces from Crete, the mainland, or elsewhere; and second, the general lack so far of rich island grave hoards, palace repositories, cist deposits, and wealthy private households. These are the contexts from which faience objects have been usually recovered on Crete and the mainland. Further investigation of island sites, including ones identified through survey work,[413] will no doubt enlarge the corpus of island faience.

1a Vessels and Containers

Two objects in this group were found on the island of Kythera. Figure 102 illustrates a small, blue green beaker originally fitted with a boss-shaped lug and two horizontal handles. It closely resembles LM I stone bucket-jars;[414] the Minoan-made beaker was almost certainly copied from such examples. The blue green faience rim sherd shown in figure 103 is decorated with a dark blue band around the rim. Its size and profile suggest that it was either of a cup with incurving sides[415] or part of a conical rhyton.[416]

Plate 52 shows a green faience lid from the south layer of destruction in Xesté 3, a private house area at Akrotiri on Thera. The lid is decorated by a relief design of outer and inner flower petals arranged about a plain center. Parallels to this design may be seen on the angular relief petals on a one-talent scale weight from Akrotiri,[417] on the rosettes on a Thera

411. E. Sapoura-Sakellarakis, *Cycladic Civilization* (Athens, n.d.), ills. 5 (#6204, 1–5); 22 (#4949). Stone pestles and grinding surfaces for preparing the pigments have also been found; see ills. 22 (#4772) and 25 (#4778,3), for example.

412. Sapoura-Sakellarakis, *Cycladic Civilization*, p. 18.

413. As, for instance, R. H. Simpson, *A Gazetteer and Atlas of Mycenaean Sites* (London, 1965); K. Scholes, "The Cyclades in the Later Bronze Age," *BSA* 51 (1956):9–40; and further afield, S. Benton, "The Ionian Islands," *BSA* 32 (1931–32):213–46.

414. Warren, *Minoan Stone Vases*, pp. 34–35.

415. The shape is a common one, and ceramic examples were recovered from other tombs at Kythera; see, for instance, J. N. Coldstream and C. L. Huxley, *Kythera* (London, 1972), fig. 83:2, second row, for a close parallel.

416. Coldstream and Huxley, *Kythera*, p. 228.

417. S. Marinatos, *Thera* VII (Athens, 1976), pl. 55 c.

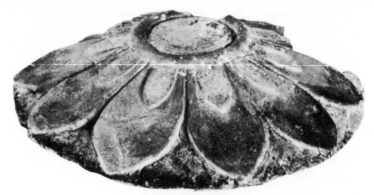

PLATE 52
Lid, Xesté 3, Thera.
Scale: ½ actual size

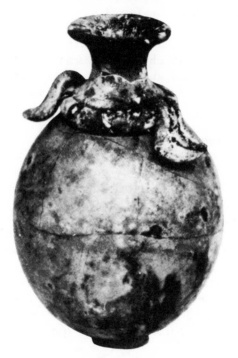

PLATE 53
Ostrich egg rhyton, Room Δ16, Thera.
Scale: ½ actual size

wall painting,[418] and on the faience gameboard inlays from Shaft Grave IV (figure 92). A clay pyxis lid from Akrotiri has a more freely drawn rosette painted on the top.[419] The faience lid provides a good sample of the high quality luxury products exported from Crete for prosperous Therans or resident Minoan entrepreneurs.

418. Marinatos, *Thera* VII, pl. 41 b.
419. Marinatos, *Thera* VII, pl. 52 a.

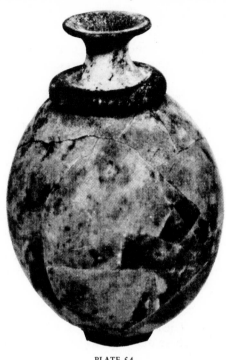

FIGURE 104
Underpiece to ostrich egg
rhyton, Room Δ16, Thera.
Scale: ¾ actual size

PLATE 54
Ostrich egg rhyton, Room Δ16, Thera.
Scale: ½ actual size

1b *Rhyta*

Excavations at Akrotiri have yielded two ostrich-egg rhyta, both with
green faience mouth and underpieces (plates 53, 54). The vessels were
recovered from Room Δ 16, along with quantities of broken pottery,
shattered triton shells, metal implements, and stone objects.[420] The material
from the destruction levels at Thera, particularly the pottery, has been
closely examined in order to determine its LM Ia or LM Ib date.[421] The
evidence afforded by the faience rhyta fittings is presented here and recon-
sidered in the next chapter.

The mouthpieces were attached to the eggs in an ingenious fashion
which represents a technical improvement over the riveting and fixatives
used in the Shaft Grave rhyta (plates 41, 42). Each mouthpiece has a hollow
interior cylinder whose base was made with two diametrically opposed
projections.[422] These match the notches cut into the circumference of the

420. Plates 30–35 in Marinatos, *Thera* V show the extent of the destruction in Room Δ
16; Plate 36 b pictures the rhyta as found.

421. For the latest investigation of the evidence as well as a synthesis of the large body
of literature on the subject, see J. V. Luce, "Thera and the Devastation of Minoan Crete:
A New Interpretation of the Evidence," *AJA* 80 (1976):9–16; and K. Bolton, "Addendum
to J. V. Luce's Article 'Thera and the Devastation of Minoan Crete . . . '" *AJA* 80 (1976):
17–18. There the Thera destruction is dated to LM Ib (1470 B.C.) and is linked with the
LM Ib destruction on Crete in a "single-phase" devastation theory. Also see below,
chapter 4, section 1, for further discussion and references.

422. Marinatos, *Thera* V, pls. 82, 83; description pp. 35–36.

upper hole of the egg.[423] For attachment, the notches and projections were aligned, and then the mouthpiece was lowered slightly and turned so that it could not be removed without realignment. The mouthpieces' rolled collars held the arrangement in position. The underpieces were affixed in the usual way.

A date later than that of the Shaft Grave rhyta is also suggested by the reduplicated green and dark brown fluting of the collar in plate 53. This resembles the collar of a LM Ib limestone rhyton from Knossos.[424] In addition, the embellishment of the mouthpiece shown in plate 53 with two fluted tongues as well as the exaggerated roll of the blue collar in plate 54 point to a later, LM Ib date.

Each faience underpiece, one of which is shown in figure 104, has a gray green rosette with rounded petals on a brown ground. The style is similar to the rosettes on MM III medallion pithoi from Knossos[425] and the rosette and looped band designs on LM Ia/LM Ib amphorae from Knossos.[426]

The pair of rhyta was equipped with faience fittings on Crete, exported to Akrotiri, and stored with other precious goods in Room Δ16 just prior to the final disaster on Thera.[427]

4a Jewelry, Seals, and Ornaments

An unspecified number of pale green talismanic seals was recovered from tombs on the island of Melos.[428] These depict genii bearing ewers and were associated with pottery of the LM Ib period. Similar seals were found in MM III contexts at Sphoungaras.[429]

From the Mycenaean phase of the settlement at Ialysos on Rhodes were recovered characteristic LM III beads and necklaces of spherical, gadrooned melon, convex tubular, rosette, wheat grain, and lantern type.[430]

4b Other Objects

Near the ashlar building at Akrotiri was found an enigmatic level with extensive burning. In addition to pottery of the Middle Cycladic period and obsidian pieces, the layer yielded a "heavy and compact object, like an ancient alabastron . . . covered by a faience-layer."[431] According to the excavator, the object is 0.14m in length and has a hole in the upper part. It is difficult to determine the type of object from the description or to state if it is faience or glazed steatite. Another possibility is that the material had a high silicon content and was accidentally glazed as a result of the fire.

423. Marinatos, *Thera* V, pl. 84 a left.
424. *PM* 2:1, fig. 129:17.
425. *PM* 4:1, fig. 177.
426. *PM* 4:1, fig. 282.
427. Marinatos has suggested that some objects, like those of Room Δ 16, were stored in roofed areas after the initial earthquake and before the eruption (*Thera* V, p. 20).
428. *PM* 4:2, p. 445 (not illustrated). I have not seen these seals.
429. Hall, *Sphoungaras*, fig. 45.
430. A. Furtwängler and G. Loeschcke, *Mykenische Vasen* (Berlin, 1886), pl. A #8, 12, 13, 16; pl. B #10, 24, 25; pl. C #5, 12, 15, 16, 17, 18 (lantern).
431. S. Marinatos, *Thera* III (Athens, 1970), p. 20 (no illustration). I have not seen this object.

4
Characteristics
and Distribution
of Aegean Faience

Section 1 CHARACTERISTICS
AND HISTORICAL DEVELOPMENT OF AEGEAN FAIENCE

THE PRECEDING CHAPTER has paid close attention to typological groups of Aegean faience objects, particularly with respect to parallels for their form and decoration. This section describes the general characteristics and development of the Aegean faience industry. I have rearranged the objects into chronological groups, beginning with MM I and II (2000–1700 B.C.) material from Crete and concluding with Late Helladic IIIb (1300–1250 B.C.) pieces. Diagram 4 presents the results schematically.

The MM Ia Knossos Vat Room deposit includes the earliest Minoan-made faience. Reconstruction of a white shell and colored faience inlay composition found there shows two features that were to become hallmarks of the Aegean use of faience: the effective combination of faience with other materials, especially the pairing of blue or green faience with shell, ivory, or crystal; and the treatment of faience as a medium well suited for stenciled designs. A small faience arm (plate 12) from the same deposit foreshadows a third characteristic of the later Aegean faience industry: the recognition of faience's sculptural, three-dimensional properties and its suitability for naturalistic figures and models.

Of MM II date is a miniature faience vase with gold fittings (figure 1; plate 1) from the Knossos Loom-weight deposit. This vase provides early evidence that Aegean faience was valued for its own sake, and not because it could serve as a less expensive substitute for lapis or turquoise. The "sheep bell" from Poros (plate 28) also belongs to this period, as do numerous beads and seals.

The first half of the Neo-Palatial phase on Crete and the Shaft Grave period on the Greek mainland saw an efflorescence of the Aegean faience industry. The most significant development of the MM IIIa period (1700–1650/00 B.C.) was polychrome faience. The Town Mosaic (figures 30–81; plate 27) shows a careful application and overlaying of colors to produce inlay pieces notable as much for their delicate hues and controlled draftsmanship as for their subject matter. Gray, brown, and white were used primarily, with some scarlet, blue green, and dark blue. The drawing

Date	Minoan Faience	Island Faience	Mainland Faience
2000	MM I Knossos: Vat Room deposit: beads, inlays, forearm Mesara: seals MM II Knossos: Loom-weight deposit: gold and faience vase (MM IIb) Poros: "sheep bell" Mochlos: beads Mavro Spelio: beads		
1700	MM IIIa Knossos: Town Mosaic, head of bull figurine (?)		
1650/00	MM IIIb Knossos: Temple Repository: vessels, inlays, figurines, models, plaques, beads, ornaments; inlays, vessels, beads		Shaft Grave period, Mycenae: Grave Circle B: chalice, ornaments Grave Circle A: vessels, inlays, models, ostrich egg rhyta fittings, knots, jewelry
1550	LM I Knossos: Royal Road deposit: inlays, vessels, knot; beads Tylissos: inlays Phaistos: inlays Haghia Triada: inlays Zakros: vessels, models, rhyta, inlays Pyrgos: shell model, beads Sphoungaras: beads	Kythera: vessels Melos: seals Thera: lid, ostrich egg rhyta fittings	
			LH II/III Mycenae: lid, appliqués, beads, seals
?1470/50	LM II at Knossos		Dendra: appliqués, beads Prosymna: seals, beads
1425/00	LM II/III Knossos, Siteia, Gournia, Episkopi: beads LM IIIa Knossos: shells, beads Phaistos, Pakhyammos, Zapher Papoura: beads	Ialysos: beads	Asine, other Argolid and Attic: beads LH IIIb Mycenae: vessels; beads Thebes: mold LH IIIc Mycenae: appliqués

DIAGRAM 4

Chronological Distribution of Aegean Faience

anticipates the precision of the miniature frescoes fashionable after about 1600 B.C.

A large and varied group of Minoan faience was recovered from the MM IIIb (1650/00–1550 B.C.) Temple Repository at Knossos. The monochrome pieces are small in scale, with shape and decoration adapted to their size and material. This is particularly true of the vessels (figures 3–8; plates 3, 4) and the w3d lily pendant (figure 83). Polychrome and sculpturing techniques were combined to great advantage in the faience models of marine (figure 14; plate 13), animal (figures 21–23; plates 18, 19), and plant life (plate 14). The three figurines of snake handlers (plates 7, 9, 10) are remarkable works, both iconographically and technically. They show a painstaking rendering of textiles and human and animal features. In general, the Temple Repository faience is characterized by the use of opaque earth colors, chiefly dark brown, yellow, buff, pale green, and burnt sienna. The colors were skillfully overlaid, and clarity of design was maintained without recourse to dark outlining.

Other MM IIIb Knossos faience includes a blossom bowl (plate 2) and a ewer (figure 2) whose translation into faience from stone and metal prototypes is capable, though somewhat awkward. The MM IIIb polychrome faience inlay work (figure 24; plates 21, 22) retains the stencil quality of earlier compositions, but combines these pieces with molded faience frames and borders.

In the LM I period (begins 1550 B.C.), two important changes occurred in the pattern of Aegean faience manufacture. The first was the establishment of a subsidiary center of faience production at Zakros in eastern Crete. There cups, bowls, models of plants, and shell-shaped inlays (plate 15) were made. The mottled green and pink faience argonaut (plate 16) represents a high point in naturalistic faience sculpture. Somewhat less carefully modeled are the bull's-head rhyta (plate 5). These and the polychrome cat's-head rhyton (figure 9; plate 6) point to a growing tendency for faience objects to serve as imitations of luxury products.

The second change is the dissemination of Minoan faience throughout Crete and to the rest of the Aegean. At Haghia Triada and Phaistos, for instance, were found inlays of complex interlocking designs (figure 27; plates 23, 24). Tylissos yielded a formal panel of faience rosettes inlaid in ivory (plate 20) that recalls the MM Ia Vat Room composition. Other wealthy households of the LM I period contained faience objects such as the naturalistic triton shell from the villa at Pyrgos.

Increasingly far-ranging Cretan economic interests[1] resulted in the spread of Minoan faience objects to the islands of Thera (figure 104; plates 52–54), Melos, and Kythera (figures 102, 103).

The Shaft Grave period (1650–1510 B.C.) marks the first appearance of Minoan faience on the Greek mainland. Pieces imported from Crete

1. For an assessment of the so-called Minoanization of this period, see S. Dow, "The Greeks in the Bronze Age," *XIᵉ Congrès International des Sciences Historiques: Rapports II* (Uppsala, 1960), especially pp. 9, 21 and p. 30 n. 36; T. L. Shear, "Minoan Influence on the Mainland: Variations of Opinion since 1900," in P. W. Lehmann, ed., *A Land Called Crete* (Northampton, 1968), pp. 47–65.

include the knots (plates 45, 46); gameboard inlays (figure 92); the highly naturalistic triton shell (plate 44); and most of the ostrich-egg rhyta fittings (figures 87, 88). A nascent mainland faience industry might well have been responsible for the chalice (plate 32); the small monochrome vessels (figure 85; plate 29); the beaked jug with warriors' heads in relief on the neck (figure 86); and an assortment of pendants, beads, and buttons (figure 93; plate 48).

The difficulties involved in securely identifying mainland faience products of the Shaft Grave period make it hard to appraise the characteristics of early Mycenaean faience. There is clearly a reliance on Minoan prototypes of the sort so well represented in the Temple Repository and at Zakros. Colors are more muted, and shapes seem more conservative than their Minoan counterparts. Faience was combined with other materials, but with decreasing harmony and skill. The sole area of mainland innovation seems to have been in jewelry design.

From about 1450 B.C. to 1300 B.C., there seems to have been little Aegean faience manufacture. On Crete, LM II/III graves near Knossos, Siteia, Gournia, Episkopi, and other eastern sites have yielded beads. After 1400 B.C. there was a slight revival of interest in faience. At Knossos models of shells (figures 15, 16) were made, and beads have been recovered from Knossos, Phaistos, Pakhyammos, and Zapher Papoura.

A similar situation existed on the Greek mainland. LH II/III faience is restricted to sword elements (figures 100, 101; plate 51) from Mycenaean chamber tombs containing early Palace style pottery; the distinctive lantern beads from several sites (figure 97); and a bracket (figure 95) from a Pylos tomb possibly of earlier date. LH II/III contexts at Dendra have yielded some unusual bull's-head beads (figure 96) and an awkwardly executed appliqué of a half-seated woman (figure 89). A LH II/III Mycenaean chamber tomb contained a neatly made monochrome lid (plate 34) probably modeled on stone examples.

The monochrome and polychrome faience vessels from the LH IIIb (1300–1250 B.C.) House of Shields at Mycenae represent a resurgence of the Aegean industry. The linear decoration of the monochrome ware (plates 35–38, 43) is well, but not painstakingly, drawn. Influences of ceramic, stone, and metal work are apparent. The polychrome ware (plates 39, 40) exhibits competence in the use of opaque primary colors: blue, red, and yellow. Plate 40 shows anatomical details and outlining done in black. Other Late Helladic faience includes seals and beads of simple geometric shapes recovered from mainland and Rhodian sites.

The preceding discussion has shown several features to be characteristic of Aegean faience. First, there is a clear continuity of traditions underlying successive innovations, especially with respect to color choice and combinations, naturalistic modeling, and careful draftsmanship and rendering. Second, though designs and shapes are freely borrowed from a variety of media, there is an overall sensitivity to the possibilities and limitations of faience. Finally, the use of this faience as an inexpensive substitute for other materials seems to have been subsidiary to its use as a special, particular medium.

Stylistically, Aegean faience may be readily distinguished from other Near Eastern faience.[2] Egyptian work, for instance, typically is a translucent blue green or blue gray, with a standard repertory of motifs and hieroglyphic formulae executed in narrow, brown black lines. Vases often have thin walls and bear traces of cloths inserted between vessel and mold before firing.[3] Polychrome pieces, especially in the Amarna period, show a preference for white backgrounds, mottled shading, and inlaid colors.[4]

Egyptian faience products found in the Aegean are of representative types. Eighteenth Dynasty open bowls with dark brown lotus rosettes were recovered from a LH II Argive Heraion tholos,[5] from the House of Shields, Mycenae,[6] and from the Knossos Royal Road.[7] Excavations on the acropolis of Mycenae and in the Citadel House vicinity have yielded scarabs and fragmentary inlays inscribed in black with names and epithets, among them those of Amenhotep III and Queen Tiy.[8] Also from the Mycenaean acropolis comes a small blue monkey with the cartouche of Amenhotep II in yellow on its right shoulder.[9] A LH IIIa Mycenaean chamber tomb contained a handleless blue vase decorated with incised white lotus leaves and the cartouche of Amenhotep III.[10]

Faience vessels modeled on Aegean ceramic shapes and designs were produced in Cyprus and Syria/Palestine. These pieces also differ significantly from Aegean faience. LC II vessels from Kition, for example, are characterized by an extensive use of brown, finely carved surfaces, and matte colors.[11] Marks on the sides of some pieces indicate they were supported on tripods during firing.[12]

The decline in Aegean faience production in the mid-second millennium was quantitative and, to a certain extent, qualitative (diagram 4). On Crete the LM II/III faience consists of a small number of beads and ornaments. From LH II and III contexts on the Greek mainland and Rhodes, there are chiefly beads, ornaments, and several sword elements. There is no faience recalling the numerous and remarkable objects of the Town Mosaic, the Shaft Graves, or the Temple Repository, except for a group of vessels from the LH IIIb House of Shields at Mycenae.

Aesthetic, economic, geological, and political considerations may have

2. The author hopes to examine by X-ray fluorescence the elemental composition of Aegean faience; the results will be compiled in a future study.

3. E. J. Peltenburg, "On the Classification of Faience Vases from Late Bronze Age Cyprus," *Praktikōn tou Prōtou Diethnous Kyprologikou Synedriou* (Nicosia, 1972), p. 133.

4. E. J. Peltenburg, "Glazed Vases," in V. Karageorghis, *Kition* I (Nicosia, 1974), pp. 130–32.

5. A. J. B. Wace, "Mycenae 1921–23," *BSA* 25 (1921–23), fig. 68 g.

6. A. J. B. Wace, "Mycenae 1939–53," *BSA* 49 (1954), pl. 36 a.

7. G. Cadogan, "Some Faience, Blue Frit and Glass," *Temple University Aegean Symposium* 1 (1976), p. 18. Also from the Royal Road come several sherds with imitation basket work similar to faience from Kerma.

8. J. D. S. Pendlebury, *Aegyptiaca* (Cambridge, 1930), p. 55 #2566, 2718, 2719, 2530; W. D. Taylour, "Mycenae 1968," *Antiquity* 43 (1969):95.

9. Pendlebury, *Aegyptiaca*, pl. IV #4573.

10. C. Tsountas, "Anaskaphai Taphōn en Mykēnais," *EphArch*, 1888, fig. 10 #2491.

11. Peltenburg, "Glazed Vases," *Kition* I (1974), pp. 108–10.

12. Peltenburg, "Classification," *Praktikōn*, 1972, p. 133.

been responsible for this decline in faience production. Study of Mycenaean aesthetics shows a marked concentration on designs intended for personal adornment and small-scale embellishment.[13] There is some innovation in jewelry making, such as the champlevé work done using blue glass paste to fill hollows in gold surfaces.[14] In general, however, the forms are standardized, with combinations and shapes varied only by different media and scales. One may suggest that these aesthetic tastes and preferences prevailed in faience production as well. The results were the almost exclusive manufacture of faience for jewelry and the virtual cessation in the production of more ambitious faience works. While LH II/III lantern and bull's-head beads are unusual, new types, the majority of the beads are repetitions of spherical, rosette, gadrooned melon, and convex tubular shapes. Though the beads are usually well made, one's over-all impression is of mechanical production rather than inspired design.

From an economic standpoint, the scarcity of gold and silver in the Late Helladic period[15] was undoubtedly a significant factor in the decline of the Aegean faience industry. With precious and semiprecious goods not readily available, manufacture of substitutes became increasingly important. After 1400 B.C. there is a noticeable "cheapness in funeral gifts" and an abundance of "deliberately inexpensive copies of precious objects."[16] Faience was among the materials whose imitative qualities were exploited and other possibilities neglected. In addition, the development of the glass and glass paste industries in the mid-second millennium provided competition for faience.[17] Glass and glass paste were not only more novel and perhaps less expensive than faience, but they also more closely resembled semiprecious stones, especially lapis.

The monochrome vessels and polychrome sherds from the House of Shields at Mycenae attest to a brief revival of interest in mainland faience manufacture between 1300 and 1250 B.C. This may have been caused by the vagaries of fashion or the inclinations of a wealthy thirteenth century Mycenaean. Almost all of the numerous Cypriote faience containers were recovered from contemporaneous, LC II (about 1300–1230 B.C.) contexts. Perhaps in the Aegean and East Mediterranean the period saw a new vogue and market for elegant faience vessels.

Political and geological circumstances may also have occasioned the decline of Minoan faience production at the close of the LM I period. In view of the uninspired, limited nature of LM II/III faience, it is perhaps appropriate to speak of a disruption or a near cessation of Minoan faience production, rather than a decline. Not only the Cretan faience industry was disrupted in the mid-second millennium. There is evidence for wide-

13. For a survey of Mycenaean ivory work, gems, and jewelry, see E. Vermeule, *Greece in the Bronze Age* (Chicago, 1964), pp. 218–21, 223–27.

14. R. A. Higgins, *Greek and Roman Jewellery* (London, 1961), pp. 24–25.

15. Higgins, *Greek and Roman Jewellery*, p. 70.

16. Vermeule, *Greece in the Bronze Age*, p. 225.

17. Wace was among the first to comment on the relationship between the Mycenaean faience and glass paste industries ("Mycenae," *BSA* 25 [1921–23], p. 387 n. 4).

spread devastation throughout eastern Crete[18] and ensuing cultural change at post-destruction Knossos.[19] The involved and at times ambiguous nature of this evidence has made satisfactory analysis of these changes difficult and has resulted in a welter of conflicting arguments and hypotheses.

The intent of the following paragraphs is first to review briefly some of these proposals and then to present the relevant evidence afforded by Aegean faience. A. J. Evans grouped the post-destruction Knossos material under the label LM II and assigned the period the span of years between 1450 B.C., his suggested end of LM Ib, and 1400 B.C., his proposed beginning of LM IIIa.[20] S. Hood has upheld this chronology and has maintained that the destruction levels of 1450 B.C. were the work of Mycenaean invaders.[21]

S. Marinatos was among the first to proceed on an entirely different assumption. His excavations at Akrotiri and preliminary collection of data bearing on mid-second millennium volcanic activity on Thera led him to assert that the Thera eruption, associated earthquakes, and tidal waves caused the destruction in eastern Crete.[22] Ceramic evidence and stratigraphic finds of volcanic tephra at Zakros have indicated to N. Platon that two eruptions took place, one in 1500 B.C. at the end of LM Ia and one in 1450 B.C. at the end of LM Ib.[23] Other views also entail a two-phase eruption, but with the first terminating LM Ia and wrecking Akrotiri in 1500 B.C. and the second destroying eastern Crete in 1450 B.C.[24] Still another theory, of which J. V. Luce is the principal proponent, has compressed events into a single-phase set of disturbances and eruptions, lasting about two years c. 1470 B.C.[25]

The precise chronology of the Thera eruption and the LM I period as a whole remains a controversial matter. Radiocarbon dates from Thera and eastern Crete have yet to yield a cohesive picture, especially with regard

18. For a tally of the sites with destruction levels, see the chronological tables in J. Chadwick, *Documents*[2] (Cambridge, 1973), p. 28; S. Hood, *The Minoans* (New York, 1971), pp. 52–60.

19. For a succinct description of the new pottery shapes, the so-called Palace style of decoration, and the warrior graves near Knossos, see Hood, *The Minoans*, pp. 58–60.

20. J. D. S. Pendlebury, *A Handbook to the Palace of Minos, Knossos* (London, 1954), p. 12.

21. See Hood, *The Minoans*, pp. 54–60 for the salient points.

22. For bibliography and exposition of the "volcanic destruction" theory, see S. Marinatos, *Thera* I (Athens, 1968), pp. 3–12. For a geological history of Thera from the Triassic period to 1750 A.D., see B. Kleinmann, "Die Katastrophe von Thera: Geologie eines Vulkans," *JRGZM* 21 (1974):12–45.

23. N. Platon, *Crete* (Geneva, 1966), pp. 197–98.

24. The evidence and a review of the hypotheses have been presented by J. V. Luce in "Thera and the Devastation of Minoan Crete," *AJA* 80 (1976):9–12. To these add the theory of O. Höckmann, who puts the eruption at 1425 B.C., based mainly on studies of pottery styles on Thera and Crete ("Die Katastrophe von Thera: Archäologische Gesichtspunkte," *JRGZM* 21 [1974]:46–92).

25. Luce, "Thera," *AJA* 80 (1976):12–16.

to their integration with traditional relative chronologies.[26] Nor has the collection of volcanic tephra from Thera and Minoan sites and deep-sea sediment cores proved conclusive, in part because tephra easily migrates between levels and may be dislodged by traffic or wind.[27] Initial examination of tree rings for dark lines indicative of massive volcanic eruptions has indicated that such activity occurred in 1626 B.C.[28] This date, however, is greatly at variance with the synchronism-based 1482 B.C. as the terminus ante quem for the beginning of LM Ib.[29]

In addition to problems of chronology, estimates vary as to the damage done to eastern Crete by the volcanic and seismic upheavals. The most cataclysmic of these estimates envisions volcanic fallout, tidal wave inundations, decimation of crops, herds and populations, and massive refugee problems.[30]

Controversy has also arisen over the date Mycenaeans established themselves at Knossos. One reconstruction holds that the Mycenaeans capitalized on Crete's weakened post-disaster state and "judged it safe, as much as a generation later, to attack in strength and destroy all the centres of Minoan power save one, Knossos."[31]

L. R. Palmer has proposed a different sequence of events, based on

26. The most recent and complete study of the relevant radiocarbon information is P. P. Betancourt and G. A. Weinstein, "Carbon-14 and the Beginning of the Late Bronze Age in the Aegean," *AJA* 80 (1976):329–48. The problem was given special consideration at the 1977 Archaeometry and Archaeological Prospection Symposium, in a session entitled "The Calibration of Radiocarbon Dates and the Chronology of the Aegean in the Late Bronze Age." Four of the papers presented have been published in *Archaeometry* 20 (1978): 197–214.

27. For a dialogue on the tephra question, see C. J. and D. B. Vitaliano, "Volcanic Tephra on Crete," *AJA* 78 (1974): 19–24; L. Pomerance, "Comments on the Vitaliano Geological Report," *AJA* 79 (1975): 83–84; C. J. and D. B. Vitaliano, "Reply to Comments by Leon Pomerance," *AJA* 79 (1975): 367–68; L. Pomerance, "The Peripatetic Santorini Tephra," *AJA* 80 (1976): 305; A. L. Wilson, "The Presence in Crete of Volcanic Ash from Thera," *AJA* 80 (1976): 419–20; and N. D. Watkins et al., "Volume and Extent of the Minoan Tephra from Santorini Volcano," *Nature* 271 (1978): 122–26. According to H. Pichler and W. Schiering ("The Thera Eruption and Late Minoan IB Destructions on Crete," *Nature* 267 [1977]: 819–22), there is geological evidence that the Thera eruption and the collapse of the caldera occurred at the same time. The authors also suggest that the ensuing tidal waves were shallow and that a regional earthquake caused the LM Ib damage on Crete. On the other hand, R. S. J. Sparks et al. disagree with this view and favor a time gap between the eruption and caldera collapse, with ash fall definitely covering part of eastern Crete ("The Thera Eruption and Late Minoan IB Destruction on Crete," *Nature* 271 [1978]:91).

28. S. W. Matthews, "What's Happening to Our Climate?" *National Geographic* 150 (1976):610.

29. G. Cadogan, "Dating the Aegean Bronze Age Without Radiocarbon," *Archaeometry* 20 (1978):209–14; also Betancourt and Weinstein, "Carbon-14," *AJA* 80 (1976): 338–39.

30. For a graphic reconstruction of the Thera eruption and its aftermath, based to a great extent on evidence from Krakatoa, see J. V. Luce, *The End of Atlantis* (St. Albans, 1970), pp. 60–83. Archaeological evidence for destruction levels has been assembled by S. Hiller in "Die Explosion des Vulkans von Thera und andere Zerstörungshorizonte zu Beginn der Späten Bronzezeit," *Gymnasium* 82 (1975):32–74.

31. J. Chadwick, *The Mycenaean World* (Cambridge, 1976), p. 12.

philological investigation of the Knossos and mainland Linear B archives and on architectural and ceramic material from site notebooks and reports. He has argued for the contemporaneity of the Knossos and mainland Linear B archives, thereby necessitating a radical downward chronological shift.[32] According to his view, the period 1450–1400 B.C. marked a time of interrupted Minoan/Mycenaean relations, with the arrival of the Greeks, the use of Linear B, and the building of the "last palace" at Knossos dated 1400–1300 B.C.

Another reconstruction has been proposed by E. Vermeule, whose study of LM II material has led her to assert: "Late Minoan II is an expression of the Greek influence at Knossos rather than a chronological phase."[33] She has suggested that the Greeks arrived at the end of the Shaft Grave period, coexisted amicably at Knossos, and departed when the palace burned again in about 1400 B.C.[34] Others have likewise envisioned a period of economic, social, and artistic collaboration throughout the fifteenth century B.C.[35]

Though contemporaneous Egyptian records mention Keftiu, that is, Crete and Minoans,[36] these documents neither support nor refute hypotheses about the Mycenaeans' arrival on Crete. Egyptian topographical lists of Aegean place names, such as on a statue base of the reign of Amenhotep III (1402–1363 B.C.),[37] demonstrate Egyptian acquaintance with the Aegean rather than intra-Aegean relationships.

The same is true of Egyptian pictorial information about Aegeans. This comes principally from the Eighteenth Dynasty Theban nobles' painted tombs, especially those of Senmut, Useramon, Menkhepereseneb, and Rekhmire.[38] The wall paintings are deceptive in their ostensible attention

32. L. R. Palmer's *Mycenaeans and Minoans* (London, 1965) presents his arguments; they are schematized on pp. 360–61.

33. Vermeule, *Greece in the Bronze Age*, p. 146, with amplification pp. 144–47.

34. Vermeule, *Greece in the Bronze Age*, pp. 145–54.

35. M. R. Popham, "Mycenaean-Minoan Relations between 1450 and 1400 B.C.," *Bulletin of the Institute of Classical Studies* 23 (1976):119–21; V. Hankey, "Mycenaean Trade with the South-eastern Mediterranean," *Mélanges de l'Université Saint-Joseph* 46 (1970–71):11–30, especially 16–17; S. A. Immerwahr, "Mycenaeans at Thera: Some Reflections on the Paintings from the West House," in K. H. Kinzl, ed., *Greece and the Eastern Mediterranean* (Berlin, 1977), pp. 173–91.

36. On the identification of Keftiu as Crete, see J. Vercoutter, *Essai sur les Relations entre Égyptiens et Préhellènes* (Paris, 1954), pp. 44–45; J. D. S. Pendlebury, "Egypt and the Aegean in the Late Bronze Age," *JEA* 16 (1930):75–92 passim, and "Egypt and the Aegean," *Studies Presented to David Moore Robinson* (St. Louis, 1951), pp. 184–97 passim; F. Matz, "The Maturity of Minoan Civilization," *CAH*[3], 2:1, p. 163. For the proposal that Keftiu was located on the north Syrian coast, or possibly Cilicia, see G. A. Wainwright, "Asiatic Keftiu," *AJA* 56 (1952):196–208 and A. Furumark, "The Settlement at Ialysos and Aegean History," *Opuscula Archaeologica* 6 (1950):239–46.

37. K. A. Kitchen, "Theban Topographical Lists, Old and New," *Orientalia* 34 (1965): 1–9 and "Aegean Place Names in a List of Amenophis III," *BASOR* 181 (1966):23–24; M. C. Astour, "Aegean Place-Names in an Egyptian Inscription," *AJA* 70 (1966):313–17; P. Faure, "Toponymes Créto-mycéniens dans une Liste d'Aménophis III," *Kadmos* 7 (1968):138–49.

38. For a thorough examination of these tombs, see H. J. Kantor, *Aegean and Orient* (Bloomington, 1947), pp. 41–49. For a summation of the material, see Vermeule, *Greece in the Bronze Age*, pp. 148–51.

to details. After close study, H. J. Kantor has cautioned that "the Aegeans in Egyptian tombs cannot be differentiated into Minoans or mainlanders by their physical appearance or dress."[39] She adds, "The evidence yielded by the tomb paintings is inconclusive in regard to the Minoan or mainland origin of the majority of Aegean objects shown by the Egyptians."[40]

Less ambiguous is the evidence provided by the Minoan and Mycenaean pottery found in Egypt.[41] There is no LM Ib pottery from contexts later than the reign of Thutmosis II (1500–1490 B.C.). The earliest LH II pottery, however, occurs in no contexts earlier than the reign of Hatshepsut (1490–1469 B.C.). Furthermore, while Minoan pottery from Egypt is typologically mixed, the Mycenaean wares consist mainly of alabastra, squat one-handled jars, pilgrim flasks, and stirrup jars.

One may now return to the problem of the decline and disruption of the Aegean faience industry. The first task is to set forth the evidence for internal synchronisms among mid-second millennium Aegean faience pieces. The second task is to relate these observations and synchronisms to the larger chronological scheme in order to see how they contribute to a more precise formulation of events.

The most important synchronisms are those between LM Ib Cretan faience and objects from the middle Shaft Graves. There is a clear homogeneity of type and style, as in the case of the faience shells from LM Ib Zakros and Pyrgos and Shaft Grave III, Mycenae, and the gameboards and knots from LM Ib Knossos and Shaft Grave IV, Mycenae. This faience was certainly produced by contemporaneous Cretan workshops. This implies that the period of the middle Shaft Graves and the end of the LM Ib period ought to be dated no farther apart than the creative lifetime of a small group of faience workshops.

The faience from Akrotiri confirms this. As shown in chapter 3, section 3, there is justification for dating the ostrich-egg rhyta fittings later than those from Shaft Graves IV and V, but all of the fittings definitely belong to the same stylistic tradition. In addition, the Thera lid design clearly recalls the Shaft Grave IV gameboard pattern.

One may hypothesize seventy or eighty years of homogeneous faience workshop production and use this proposal to fix the chronological relationship between the middle Shaft Graves and the end of LM Ib. The span of years would have sufficed for manufacture of objects by masters, apprentices, and apprentices-turned-masters. Stylistic conservatism need not have lengthened the time span, because there seems to have been a fairly rapid evolution of Minoan faience from period to period.

39. Kantor, *Aegean and Orient*, p. 44.
40. Kantor, *Aegean and Orient*, p. 48.
41. Ongoing studies by R. S. Merrillees and others have elucidated a good deal of this material. See R. S. Merrillees, "Aegean Bronze Age Relations with Egypt," *AJA* 76 (1972):281–94; R. S. Merrillees and J. Winter, "Bronze Age Trade between the Aegean and Egypt," *Miscellanea Wilbouriana* I (1972): 101–33. A forthcoming work by B. Kemp and R. S. Merrillees will catalogue Minoan pottery found in Egypt (personal communication, B. Kemp).

If Shaft Graves III, IV, and V may be dated about 1550 B.C.,[42] the end of LM Ib should therefore be dated about 1480–1470 B.C. This is in line with the date noted above of 1482 B.C. as the terminus ante quem for LM Ib and the dearth of LM Ib pottery in Egypt after 1490 B.C. Furthermore, this argues against a fifty-year gap between the destruction of Thera and that of Crete and in favor of a single-phase set of seismic upheavals about 1480 or 1470 B.C.

Following these natural catastrophes, why was good quality Minoan faience production not resumed? If within a few years Greeks came to Crete, why did they not revive the craft? If Greeks had already been ensconced at Knossos, why did they not continue production? They were certainly familiar with faience and quite probably had founded a mainland industry at Mycenae a hundred years or so before the Thera eruptions. LM II material from Knossos attests to a Mycenaean taste for opulence and luxury goods, yet no significant or unusual LM II/III faience has been discovered.

A reason for the decline of Aegean faience making may be that "a result of the Greek take-over in Crete was doubtless to reinforce the movement of Cretan craftsmen to the mainland."[43] But why did these craftsmen, presumably trained by the masters of LM I Zakros and Knossos, fail to continue production on the same scale? And was nobody left at Knossos willing or able to carry on traditions of excellence in faience manufacture?

At present these questions remain unresolved, in part because of the lack of further evidence about Late Bronze Aegean faience manufacture and in part because they reflect the lack of consensus about Late Bronze Age Aegean archaeological problems. It is clear, however, that a combination of factors—aesthetic, economic, geological, and political—brought about the decline of the Aegean faience industry and influenced its historical development. Furthermore, the disruption and changes in the nature of Aegean faience production were part of large-scale disruptions and changes in the Late Bronze Age Aegean.

Section 2 AEGEAN FAIENCE
AND AEGEAN FOREIGN RELATIONS

Much of the evidence for Minoan and Mycenaean activity beyond the Aegean[44] may be found in the dissemination of Aegean pottery,[45] espe-

42. E. Vermeule, *Art of the Shaft Graves* (Cincinnati, 1975), p. 8 describes Grave I as youngest, Graves VI and II as oldest, with Graves III, IV, and V in between.

43. Chadwick, *The Mycenaean World*, p. 12. See also above chapter 1, note 69.

44. A comprehensive work on "Minoan and Mycenaean Foreign Relations" is being prepared as a dissertation for Oxford by G. Cadogan (reported in *Nestor* 1 [September 1975]: 1008).

45. The pioneering work on this subject was done by C. W. Blegen and A. J. B. Wace in "The Determination of Greek Trade in the Bronze Age," *Proceedings of the Cambridge Philosophical Society* 169 (1938): 1–2 (summary) and "Pottery as Evidence for Trade and Colonization in the Aegean Bronze Age," *Klio* 32 (1939): 131–47.

cially to Cyprus,[46] the Levant,[47] Egypt,[48] and the western Mediter-
ranean.[49] Local imitation of Mycenaean wares and products, such as at
Tell Ashdod,[50] also provides information about Aegean foreign contacts.
Other evidence for Aegeans abroad includes the influence of Aegean
styles in such diverse areas as Cypriote architecture and decorative arts[51]
and gold granulation techniques in the Caucasus.[52]

The evidence afforded by extra-Aegean faience distribution is com-
prised entirely of the beads found at numerous European sites. The present
discussion focuses therefore on the European aspect of Aegean foreign
relations. In chapter 2, European sites with faience were enumerated,[53]
and the principal finds were shown on map 2. The beads are mostly
annular, segmented, or cylindrical in shape, with a few unusual star and
quoit forms. The find-spots are concentrated along the Danube and Upper
Vistula rivers, in the regions to the north of the Black Sea, and in the
British Isles. No faience has been reported from the Balkans, the Baltic
coast, Scandinavia, or the Atlantic coast of southern France and Spain.

46. For a series of reports on Aegean ware found in Cyprus, among other topics, see
the symposium volume *The Mycenaeans in the Eastern Mediterranean* (Nicosia, 1973).
For Minoan-Cypriote connections, see A. W. Catling and V. Karageorghis, "Minoika
in Cyprus," *BSA* 55 (1960):109–27; and M. R. Popham, "Two Cypriote Sherds from
Crete," *BSA* 58 (1963):89–93.

47. F. H. Stubbings, *Mycenaean Pottery from the Levant* (Cambridge, 1951), esp. pp.
106–8. The corpus has been added to by V. Hankey, "Mycenaean Pottery in the Middle
East," *BSA* 62 (1967):107–47. A more general work on Levantine-Mycenaean relations
has been done by A. Leonard in "The Nature and Extent of the Aegean Presence in Western
Asia during the Late Bronze Age," dissertation, University of Chicago, 1976 (personal
communication).

48. For pottery studies, see note 41 above. For the late Bronze Age, the standard syn-
thesis of the topic is F. Schachermeyr, *Ägäis und Orient* (Vienna, 1967). W. A. Ward has
covered a slightly earlier period in *Egypt and the East Mediterranean World 2200–1900 B.C.*
(Beirut, 1971).

49. J. D. Evans, "The Prehistoric Culture Sequence in the Maltese Archipelago,"
PPS 19 (1953): 41–94; M. Cavalier, "Les Cultures Préhistoriques des Iles Éoliennes et
leur Rapport avec le Monde Égéen," *BCH* 84 (1960): 319–46; S. A. Immerwahr,
"Mycenaean Trade and Colonization," *Archaeology* 13 (1960): 4–13; A. F. Harding,
"Ilyrians, Italians and Mycenaeans," *Studia Albanica* 9 (1972): 215–21.

50. F. Asaro, I. Perlman, and M. Dothan, "Mycenaean IIIC 1 Ware from Tel Ashdod,"
Archaeometry 13 (1971): 169–75.

51. V. Karageorghis, *Mycenaean Art from Cyprus* (Nicosia, 1968) includes much of the
relevant material from Kition and Enkomi. For information from Sinda, see A. Furumark,
"The Excavations at Sinda," *Opuscula Atheniensia* 6 (1965):96–116.

52. W. Culican, "Spiral-end Beads in Western Asia," *Iraq* 26 (1964):36–43; D. L.
Carroll, "A Classification for Granulation in Ancient Metalwork," *AJA* 78 (1974):33–39;
K. Rubinson, "Trialeti: Aegean Connections?" paper given 30 December 1975 AIA
meetings; C. F. A. Schaeffer, *Stratigraphie Comparée* (London, 1948), especially p. 514.

53. To the bibliographic information given in chapter 2, add the catalogue of European
beads assembled by A. F. Harding, "The Earliest Glass in Europe," *Archeologické Rozhledy*
23 (1971): 188–200. As the title of the article suggests, Harding considered all beads to
be different types of glass (p. 188), but has since modified this view (added note, p. 194).
The catalogue, however, does not distinguish among faience, glass paste, and glass beads.
One cannot be certain that all of the imported European faience is Aegean, but it is unlikely
that very many beads came from points further east, given our present knowledge of
second millennium interconnections.

The presence of faience beads in European burials has been linked repeatedly with mid-second millennium trade in amber. Faience and amber have been seen as counterpart trade items[54] in a reciprocal arrangement that sent faience north and west and amber south and east.[55] The routes apparently followed the major river systems that run diagonally across Central Europe. A third material supposedly disseminated southward along these routes was tin.[56] By means of a complex system of middlemen, exchanges, and agreements,[57] faience, amber, and tin were purportedly distributed throughout Europe and the East Mediterranean. A necklace from Odoorn in the Netherlands has often been cited as a clear example of this trade, with its four segmented faience beads, twenty-five tin beads, and fourteen lumps of perforated amber.[58]

The complex nature of the evidence for Bronze Age traffic in amber, tin, and faience makes it necessary to examine each material and its trade in turn. The following pages will be devoted to a survey of the extensive literature on the subject and will indicate some of the problems involved in its study. The section will conclude with an assessment of faience found in Europe, its connection with the amber and tin trade, and its significance in defining the Aegean's relations with Europe.

As for amber and its distribution, two topics need to be considered. The first involves the characteristics of amber, and the second concerns the elucidation of the amber routes. Amber is a fossil resin formed sixty million years ago by exudations from conifers, most of which grew in an area now covered by the Baltic Sea. As a result, amber is found in highest concentration along the southern Baltic coast.[59]

Baltic amber was at first thought to be chemically distinctive on the basis of its succinic acid content,[60] thereby providing a clear test for the provenance of amber artifacts. Amber showing no succinic acid was considered non-Baltic, with its chemical composition dependent on the type of source

54. C. C. Lamberg-Karlovsky, "Amber and Faience," *Antiquity* 37 (1963): 301–2.

55. The theory has been advanced in numerous instances, among them, J. D. Muhly, *Copper and Tin* (Hamden, Conn., 1973), p. 250; J. G. D. Clark, *Prehistoric Europe* (London, 1952), pp. 268–69; A. Fox and J. F. S. Stone, "A Necklace from a Barrow in North Molton Parish," *Antiquaries Journal* 31 (1951): 25–29; S. Piggott, *Ancient Europe* (Chicago, 1965), pp. 136–38; C. J. Becker, "A Segmented Faience Bead from Jutland," *Acta Archaeologica* 25 (1954): 251–52; J. J. Butler, *Bronze Age Connections Across the North Sea* (Groningen, 1963), pp. 165–66.

56. Muhly, *Copper and Tin*, pp. 276–77, 336–38.

57. One such postulated agreement is that Lipari was a duty-free port. See S. Marinatos, "The Minoan and Mycenaean Civilization and its Influence on the Mediterranean and on Europe," *Atti del VI Congresso ...* (Rome, 1962): 161–76; R. B. Revere, "No Man's Coast," in K. Polanyi et al., eds., *Trade and Markets* (Glencoe, 1957), pp. 38–63.

58. J. G. D. Clark, *Prehistoric England* (London, 1940), pl. 57 and p. 63; J. V. S. Megaw, "Across the North Sea," *Antiquity* 53 (1961): 49.

59. C. W. Beck, "Amber in Archaeology," *Archaeology* 23 (1970), p. 8 and fig. 2; R. C. A. Röttlander, "Der Bernstein und seine Bedeutung in der Ur- und Frühgeschichte," *Acta Praehistorica et Archaeologica* 4 (1973): 11–18.

60. O. Helm tested amber in 1885 and asserted that only Baltic amber had succinic acid. For a report of his work and that of his successors, see C. W. Beck, "Analysis and Provenience of Minoan and Mycenaean Amber I," *GRBS* 7 (1966): 192–200.

tree rather than the location of the deposit.[61] Recent work, however, on the formation and source identification of amber has suggested that succinic acid results from normal oxidation of amber and shows the degree and state of aging in a piece of amber, rather than its place of origin.[62]

There is now a more reliable means of amber differentiation. This entails analysis of the infrared spectra of amber samples.[63] An extensive spectroscopic project has shown that Baltic amber exhibits a distinctive pattern with a horizontal shoulder followed by a sharp absorption peak. Of 264 pieces of analyzed amber from Aegean contexts, 230 have been identified spectroscopically as Baltic in origin.[64] Some of the remaining 34 samples, including 13 from Mycenae, were too badly weathered or contaminated to permit identification.[65] Less than one-tenth of the Greek amber artifacts analyzed was non-Baltic, among them pieces from Pylos and Kakovatos.[66] As yet there is no way to assign a more specific origin to this non-Baltic amber.

While spectroscopic analysis indicates Baltic and non-Baltic provenance for Bronze Age Greek amber, it does not provide evidence with which to extrapolate the amber routes of the period. Reconstruction of these routes depends almost exclusively on compilations of amber distribution and on stylistic analysis of European and Aegean amber.

An interesting sidelight on the problem of the amber routes is the description in Herodotus and Pausanias of how precious items wrapped in straw were carried by the Hypoboreans from their upper Danube home to Greece.[67] A pair of gold and amber objects from Tiryns has afforded possible corroboration of this legendary and perhaps symbolic transport of valued goods. The Tiryns pieces are small circlets of woven gold wire in which are set two crossed bronze rods, each skewering several irregularly shaped nuggets of amber.[68] Since infrared analysis has indicated the amber is Baltic[69] and since the woven gold work has convincing parallels in Bohemian and Lusatian wire coils,[70] the Tiryns objects might well repli-

61. C. W. Beck et al., "The Infra-red Spectra of Amber and the Identification of Baltic Amber," *Archaeometry* 8 (1965): 104.

62. R. C. A. Rottländer, "On the Formation of Amber from *Pinus* Resin," *Archaeometry* 12 (1970): 35.

63. For a description of the technique, see C. W. Beck, "Amber in Archaeology," *Archaeology* 23 (1970): 9–11.

64. C. W. Beck, "The Provenience of Amber in Bronze Age Greece," *BSA* 69 (1974): 171, tabulation of results.

65. C. W. Beck et al., "Analysis and Provenience of Minoan and Mycenaean Amber IV: Mycenae," *GRBS* 13 (1972): 385.

66. C. W. Beck et al., "Analysis and Provenience of Minoan and Mycenaean Amber III: Kakovatos," *GRBS* 11 (1970): 21–22; Beck, "Amber in Archaeology," *Archaeology* 23 (1970): 11.

67. For text references (Pausanias I.31.2; Herodotus IV.32–5) and commentary, see C. W. Beck et al., "Analysis and Provenience of Minoan and Mycenaean Amber II: Tiryns," *GRBS* 9 (1968): 17.

68. See pl. 1 in Beck et al., "Amber II: Tiryns," *GRBS* 9 (1968).

69. Beck et al., "Amber II: Tiryns," *GRBS* 9 (1968): 14.

70. J. Bouzek, "The Aegean and Central Europe," *Památky Archeologické* 57 (1966): 274–75.

cate or embody the Hypoboreans' gift to Apollo and Greece.[71]

On the basis of amber distribution, an early reconstruction postulated three phases and routes: an Early Bronze central one from Jutland up the Elbe to northern Italy; a Middle Bronze western one from Jutland to the Rhine to Italy; and a Late Bronze eastern route from the Baltic coast up the Vistula and down the Danube.[72] The most recent study of Aegean amber acquisition has dated the three phases as follows: the first in 1600 B.C.; the second in 1500 B.C.; and the last in 1200 B.C.[73] The principal routes that seem to have been used include the three river paths along the Elbe, Rhine, and Vistula/Danube. Other major north-south and east-west routes may have been: an overland route from Jutland to the Netherlands and across the Channel to Wessex;[74] a Mediterranean route linking southern France, Lipari, and the western coast of Greece;[75] and an overland route across Central Europe to the head of the Adriatic and thence to western Greece.[76]

Between 1600 B.C. and 1200 B.C., quantities of amber moved toward the Aegean, of which over 3,400 pieces have been recovered from sixty-five sites.[77] There were 1,290 beads found among the riches of Shaft Grave IV, Mycenae.[78] Shipping this large amount of amber to the Aegean over a period of 400 years entailed using a combination of overlapping and separate routes, with some used frequently, some hardly ever, and some at one time and not at others.[79] Mycenaean participation in the amber trade probably extended part way along these routes, perhaps only as far as the head of the Adriatic.[80] Middlemen were responsible for most of the

71. Beck et al., "Amber II: Tiryns," *GRBS* 9 (1968): 17; see the suggestion there that the amber also represents the sacrifices of asses which the Hypoboreans made to Apollo.

72. J. M. de Navarro, "Prehistoric Routes between Northern Europe and Italy Defined by the Amber Trade," *Geographical Journal* 66 (1925), pl. 1 opposite p. 484.

73. A. F. Harding and H. Hughes-Brock, "Amber in the Mycenaean World," *BSA* 69 (1974): 159.

74. Butler, *Bronze Age Connections*, pp. 159–64.

75. Marinatos, "Minoan and Mycenaean Civilization," *Atti del VI Congresso . . .* (1962): 166–67.

76. Harding and Hughes-Brock, "Amber," *BSA* 69 (1974): 159; this route was probably used after 1250 B.C. Of thirty-five pieces of Bronze and Iron Age Yugoslavian amber recently analyzed, thirty-one are Baltic in origin, further substantiating this route (J. M. Todd, M. H. Eickel, C. W. Beck, and A. Macchiarulo, "Bronze and Iron Age Amber Artifacts in Croatia and Bosnia-Hercegovina," *Journal of Field Archaeology* 3 [1976]: 313–27).

77. Harding and Hughes-Brock, "Amber," *BSA* 69 (1974), tabulation on p. 151 and listing by period and site on pp. 148–49. Distribution maps of LH I–II, IIIa and IIIb–c amber are provided in figs. 1, 2, and 3.

78. Harding and Hughes-Brock, "Amber," *BSA* 69 (1974): p. 147.

79. Beck et al., "Amber III: Kakovatos," *GRBS* 11 (1970): p. 18.

80. Muhly, *Copper and Tin*, p. 276. Mycenaeans were certainly in Albania, to judge from the amber and LH IIIc pottery found at Barç; see Harding, "Ilyrians, Italians and Mycenaeans," *Studia Albanica* 9 (1972): 215. The presence in Europe of Mycenaean-like faience beads, daggers, and swords does not in itself automatically bespeak direct Mycenaean familiarity with Central and Western Europe, as V. Milojčić has assumed in "Neue Bernsteinschieber aus Griechenland," *Germania* 33 (1955): 317. The problem is discussed again below.

transshipments. Trading stations at strategic points assumed importance, as for example the entrepôt at Kieskau, located at the junction of the Elster and Saale, where 120 amber pieces were found.[81]

On the basis of stylistic features, two major groups of Aegean amber may be distinguished. The first comprises irregularly shaped or flattened globular beads, most of which were probably imported as finished products.[82] The second group is made up of flat and trapezoidal spacers with ornamental perforations of parallel, Y-shaped, and converging borings. These have been found in the Aegean in Shaft Graves IV, V, and Omicron at Mycenae; in Kakovatos Tholos A and other graves at Pylos; and at Khaniale Tekke near Knossos.[83]

The purpose of spacer plates is to separate strings of beads. Some of the more elaborate borings seen on amber plates may have been intended to enhance the natural translucence of the amber.[84] The first manufacture of simple amber spacers has been attributed to the area of southern Jutland.[85] This region was using quantities of amber as early as the beginning of the Danish Neolithic, to judge from the 13,000 amber beads found at Skive in northwest Jutland and the hoards of unworked nuggets elsewhere on the peninsula.[86] In the British Isles amber spacers may have developed independently from Neolithic crescentic jet necklace elements.[87]

Of particular interest for tracing amber routes are the complex amber spacers with Y-shaped perforations. Pieces of this type have been found in Greece (four), Britain (eight), France (seven), and Germany (thirty-one).[88] There is divided opinion as to the origin and distribution of these clearly related spacers. On the one hand, study has indicated that spacers from Greece and Wessex have in common their use in beaded collars, their techniques of drilling, and plate shapes.[89] A Wessex-Greece connection is strengthened by the probable import from Wessex of gold-rimmed amber

81. Butler, *Bronze Age Connections*, p. 198. Other information about these amber trading stations may be derived from excavations of first millennium centers such as Komorowo on the lower Warta (T. Malinowski, "An Amber Trading-Post in Early Iron Age Poland," *Archaeology* 27 [1974]:195–200).

82. Harding and Hughes-Brock, "Amber," *BSA* 69 (1974):154–55. The amygdaloid beads may have been worked in Greece. A catalogue of all Aegean amber is given on pp. 159–67; European amber is listed on pp. 167–69, and Near Eastern amber on pp. 169–70.

83. Harding and Hughes-Brock, "Amber," *BSA* 69 (1974):155.

84. Beck et al., "Amber III: Kakovatos," *GRBS* 11 (1970):14.

85. R. Hachmann, "Bronzezeitliche Bernsteinschieber," *Bayerische Vorgeschichtsblätter* 22 (1957):24; Butler, *Bronze Age Connections*, pp. 163–64.

86. Butler, *Bronze Age Connections*, pp. 159–64. The economic importance of Danish amber products may have been their value as exchange payment for metals. See E. Lomborg, "An Amber Spacer-bead from Denmark," *Antiquity* 41 (1967):222.

87. A. M. ApSimon, "Dagger Graves in the 'Wessex' Bronze Age," *Tenth Annual Report of the Institute of Archaeology*, 1954, p. 49.

88. Harding and Hughes-Brock, "Amber," *BSA* 69 (1974):156.

89. Hachmann, "Bronzezeitliche Bernsteinschieber," *Bayerische Vorgeschichtsblätter* 22 (1957):1–36, especially 9, 24; Harding and Hughes-Brock, "Amber," *BSA* 69 (1974), table 3, p. 157 shows dimensions of Wessex and Aegean spacers.

discs found in the Tomb of the Double Axes near Knossos.[90] On the other hand, there are unmistakable similarities in perforation patterns between the Pylos and south German spacers.[91] There is good reason, moreover, to believe that the complex spacer developed in southern Germany, because at Württemberge a group of mid-second millennium amber complex spacers was found together with "survivors of basic-pattern spacers, along with degenerate and re-used beads."[92]

Very little information is available with which to reconstruct Late Bronze Age tin routes or even to assert the source of Aegean tin. In theory, tin from Wessex mines at Cornwall reached the Aegean by way of one route across Central Europe to the Adriatic and another via France and across the Mediterranean.[93] It is unlikely that Bronze Age tin was obtained from Saxony or Bohemia. These deposits are veined in hard rock, rather than being alluvial, and therefore were inaccessible to the Bronze Age miner.[94]

The preceding discussion has outlined the principal issues bearing on the Aegean-European amber and tin trade of the mid-second millennium. We can conclude that most Aegean amber is Baltic in origin, that it arrived in several stages, that many pieces were shipped as finished products, and that Aegean amber spacers are related to Wessex and south German spacers. Even these conclusions are somewhat problematic.

For one thing, Baltic amber is not restricted to a small geographical area; it has washed up on seacoasts from eastern England to Finland and northern Poland and on riverbanks as far south as the lower Dnieper.[95] Second is the problem of the documented Aegean use of non-Baltic amber and the sources, as yet unknown, from which this was obtained. Third, though stages in amber's distribution to the Aegean can be discerned, one cannot determine a precise chronology of intra-European amber exchange.[96] All one can say is that "trade in amber and tin was already well-established between northern Europe and the British Isles before contact was made with the Aegean . . . which represented new markets for trade goods already in circulation."[97]

As for the amber and tin routes, there is insufficient archaeological evidence to state precisely where these routes were. It is clear from its distribution, however, that amber moved from source areas to regions lacking in amber and that its dissemination chiefly followed river systems across

90. A. J. Evans, "The Tomb of the Double Axes," *Archaeologia* 65 (1914), figs. 56, 57; Harding and Hughes-Brock, "Amber," *BSA* 69 (1974):158.

91. G. von Merhart, "Die Bernsteinschieber von Kakovatos," *Germania* 24 (1940): 99–102.

92. N. K. Sandars, "Amber Spacer Beads Again," *Antiquity* 33 (1959):295.

93. Muhly, *Copper and Tin*, p. 277. Appendix II, "Wessex and Mycenae: the Question of Aegean Tin" (pp. 343–50) considers the problem in detail.

94. J. D. Muhly, *Supplement to Copper and Tin* (Hamden, Conn., 1976), p. 99.

95. Beck, "Amber in Archaeology," *Archaeology* 23 (1970), p. 8 and fig. 2, which shows deposits of Baltic and other amber.

96. E. Neustupný, "Absolute Chronology of the Neolithic and Aeneolithic Periods in Central and South-eastern Europe," *Slovenská Archeológia* 16 (1968):31.

97. Muhly, *Copper and Tin*, pp. 344–45.

Central Europe. To assert that "the amber routes appear to be fictions"[98] because they cannot be pinpointed is overly cautious and negativistic. The problem of mapping the tin routes concerns both the source of Aegean tin and the ways tin might have reached the East Mediterranean.

The picture that emerges from a study of the European-Aegean amber and tin trade is one of certain contact between the two regions. What remains hypothetical is the exact nature, chronology, and traffic pattern of this contact. The picture is equally hypothetical for European-Aegean contact as defined by other types of trade. Included are the Wessex-Mycenaean connections discussed in chapter 2; the Central European weapons, carvings, and pottery designs with Mycenaean parallels;[99] the Mycenaean-like rapiers and swords from Transylvania;[100] the Balkan ornaments, pottery, and violin-bow fibulae similar to those from Mycenae;[101] and the bronze double and trunnion axes of Aegean type found at several European sites.[102]

As a result, it is difficult to set up a chronology for the period of Aegean contact and trade with Europe. Dating of European sites has relied heavily on presumed stylistic synchronisms of the sort noted just above and on the ambiguous presence of faience in European contexts.[103] Attempts to place European chronology on another basis have resulted in drastic upward revisions of 500 or more years occasioned by the use of carbon 14 dates.[104] Calibration of carbon 14 dates may be done in several ways, each providing somewhat different calendar dates,[105] which have yet to be integrated satisfactorily with the traditional relative chronologies for Europe.

In the light of the foregoing discussion, the significance of Aegean faience in elucidating Aegean foreign relations with Europe may now be reconsidered. The first question is whether any of the faience from European sites may have been locally produced. Technical analysis of British faience beads has shown many to have a greater proportion of tin and

98. Rottländer, "On the Formation of Amber," *Archaeometry* 12 (1970):50.

99. Bouzek, "The Aegean and Central Europe," *Památky Archeologické* 57 (1966): 248–51.

100. S. Foltiny, "Mycenae and Transylvania," *Hungarian Quarterly* 3 (1962):135–36.

101. J. Bouzek, "Bronze Age Greece and the Balkans," in R. A. Crossland and A. Birchall, eds., *Bronze Age Migrations in the Aegean* (London, 1973), pp. 171–73.

102. A. F. Harding, "Mycenaean Greece and Europe: the Evidence of Bronze Tools and Implements," *PPS* 41 (1975):200.

103. The most complete relative chronology has been prepared by H. L. Thomas, *Near Eastern, Mediterranean and European Chronology* [= *SIMA* 17] (Lund, 1967). N. Tasić's perceptive article "The Problem of 'Mycenaean Influences' in the Middle Bronze Age Cultures in the Southeastern Part of the Carpathian Basin," *Balcanica* 4 (1973):19–37 points out the pitfalls of dating Carpathian sites on the basis of stylistic synchronisms.

104. C. Renfrew, "Carbon 14 and the Prehistory of Europe," in *Old World Archaeology* (San Francisco, 1972), pp. 201–9; J. A. S. Evans, "Redating Prehistory in Europe," *Archaeology* 30 (1977): 76–85; A. Snodgrass, "Mycenae, Northern Europe and Radiocarbon Dates," *Archaeologia Atlantica* 1 (1975): 33–48.

105. See, for instance, R. M. Clark, "A Calibration Curve for Radiocarbon Dates," *Antiquity* 49 (1975): 251–66, esp. 264–65, for sets of calibration tables and comparisons for Carbon 14 dates.

magnesium than Aegean beads.[106] Analysis of a group of Hungarian and Czechoslovakian faience beads has proven these to have a higher percentage of antimony and copper than beads from the Aegean.[107] This evidence for local faience production is strengthened by the fact that Austrian glass beads were colored by copper obtained from boron-free local ores.[108]

In addition, the existence of a European faience industry is supported by the quantity of Central European beads, the number of bead shapes peculiar to Europe, and the undiagnostic nature of other bead shapes.[109] Among these is the segmented type, often erroneously considered an exclusively Egyptian and East Mediterranean form. The requisite technological sophistication for faience manufacture might have come from the development of European metallurgy in the second millennium.[110]

Several points argue against local production of all of the faience beads found in Europe. First is the lack of faience other than beads. While it is characteristic of nascent faience industries to produce chiefly beads, the earliest faience industries in the Near East and Aegean manufactured vessels, inlay pieces, and a variety of ornaments. None of these types of faience objects has been found in Europe. Neither have kilns, workshops, or molds for faience making been found, nor unfinished pieces.

Of particular importance is the question of technical prerequisites for European faience production. In the Near East and Aegean, these included experiments with glazed steatite, ceramic, pyrotechnical, and metallurgical innovations, and sophisticated methods of working with semiprecious stones, especially lapis lazuli and turquoise. With the exception of metallurgical developments, there seems to have been little European interest in, or experience with, these necessary skills.

In view of the material discussed above that attests to Aegean-European contact, it is reasonable to uphold the view that faience objects and manufacturing methods were introduced to Europe from the Aegean. There was probably some local production in England and Central Europe, but the initiative for this production was contact with the Aegean and its wares.

The routes by which faience reached Europe cannot be mapped with exactitude. Furthermore, there is no archaeological evidence for linking its distribution with that of amber and tin. The theory that amber and faience used the same routes "has the merit of accounting for both the main distributions at once,"[111] but no evidence to support it. As demonstrated above, the amber routes are themselves possibilities based primarily on the

106. R. G. Newton and C. Renfrew, "British Faience Beads Reconsidered," *Antiquity* 44 (1970): 199–206.

107. A. F. Harding and S. E. Warren, "Early Bronze Age Faience Beads from Central Europe," *Antiquity* 47 (1973): 64–66; L. H. Barfield, "North Italian Faience Buttons," *Antiquity* 52 (1978): 153.

108. M. Gimbutas, *Bronze Age Cultures* (The Hague, 1965), pp. 54–55.

109. Harding, "Earliest Glass," *Archeologické Rozhledy* 23 (1971): 188–94.

110. Harding, "Earliest Glass," *Archeologické Rozhledy* 23 (1971): 193.

111. J. G. D. Clark, *Prehistoric Europe* (London, 1952), pp. 268–69.

distribution of finds along natural pathways across Europe. The same is true of the faience routes.

What emerges from this investigation is, first, a reassertion that Europe provided markets for Aegean goods in the mid-second millennium. Second, assessment of faience, amber, and tin distribution shows no evidence at present for interdependent, reciprocal trade. Finally, one may credit the dissemination of Aegean faience throughout Europe with stimulating new centers of faience production in the British Isles and Central Europe.

5
Conclusions

FROM THIS STUDY of Aegean faience of the Bronze Age, several tentative conclusions may be drawn, some of which apply specifically to Aegean faience and some of which concern the Bronze Age faience industry in general.

First, Aegean faience should be regarded stylistically as a coherent corpus, with particular and often unique characteristics. Most remarkable are its innovation and skillful use of polychrome techniques. Also noteworthy is the degree of naturalism achieved, especially in the snake handler figurines, the plaques of marine, animal, and plant life, and the models of seashells. Translations into faience from stone, ceramic, and metal prototypes are generally sensitive adaptations, of which the wild-cat's-head rhyton from Zakros and the sword elements from Mycenae are good examples. Prior to the mid-second millennium, very little Aegean faience imitates more costly objects solely for the sake of providing less expensive substitutes.

The second conclusion concerns the use or nonuse of faience as a surrogate for semiprecious materials. This may be stated as an axiom: The greater the availability and exploitation of valuable materials, the greater the stimulus and freedom to produce nonimitative faience. In those areas where lapis lazuli, turquoise, ivory, crystal, and other semiprecious materials were readily accessible and widely used, as in the Aegean, Egypt, and southern Mesopotamia, new faience techniques and forms were invariably developed.

A corollary to this axiom is that innovative faience manufacturing centers, such as those at Knossos, El-Amarna, and Mohenjo-Daro, were established where political, mercantile, or cultic wealth was concentrated. Centers whose faience products were more imitative than creative were established at sites having political or cultic importance, but with limited means of acquiring quantities of semiprecious materials.

The third conclusion is that there were technical prerequisites for establishing new centers of faience production: experience in working with glazed steatite; knowledge of kiln operation and firing temperatures; experimentation with ceramic, metallurgical, and other pyrotechnical innovations; and skill in working on a small scale in other media. Principal faience manufacturing centers were established where most if not all of these conditions were satisfied. Subsidiary centers were generally estab-

lished where there was sufficient contact with principal centers or impetus to learn faience production skills.

The fourth result of this study is an assessment of the historical development of the Aegean faience industry and its significance for reconstructions of Aegean chronology and Aegean foreign relations. The technique of faience manufacture was probably introduced to Crete from north Syria and Mesopotamia, rather than from Egypt. A principal production center was established at Knossos in the MM I period, with a subsidiary one set up at Zakros in the LM I period. The possibility of Mycenaean production as early as the Shaft Grave period has been discussed in detail. Mainland-made faience pieces may include several Shaft Grave vessels, monochrome and polychrome wares from the House of Shields, and ornaments.

In the mid-second millennium, Aegean faience production declined because of geological, political, economic, and aesthetic factors. The second millennium also saw the expansion of Mycenaean faience into European markets, along with other Helladic products. At present there is no evidence for linking geographically or commercially the dissemination of Aegean faience with Mycenaean acquisition of amber and tin. There is some justification, however, for connecting the distribution of Mycenaean faience with the emergence of a nascent faience industry in Central Europe and the British Isles.

Select
Bibliography

Albright, William F. "A New Hebrew Word for 'Glaze' in Proverbs 26:23." *BASOR* 98 (1945): 24–25.

Aldea, Ioan Al. "Un Sceptre en Os de l'établissment Wietenberg de Lancram." *Bolletino del Centro Camuno di Studi Preistorici* 11 (1974): 119–27.

Alexiou, Stylianos. "Minōikoi Istoi Sēmaiōn." *KrChr* 17 (1963): 339–51.

Alexiou, Stylianos. "Contribution to the Study of the Minoan 'Sacred Knot.'" In *Europa: Studien zur Geschichte und Epigraphik der Frühen Aegaeis*, edited by William C. Brice, pp. 1–6. Berlin, 1967.

Alexiou, Stylianos. *Minoan Civilization*². Heraklion, n.d.

Al-Khalesi, Yasin Mahmoud. "Tell al-Fakhar: Report on the First Season's Excavations." *Sumer* 26 (1970): 109–26.

Alther, Lisa. "'They Shall Take Up Serpents.'" *New York Times Magazine*, 6 June 1976, pp. 18–20, 28, 35.

Amiet, Pierre. *Elam*. Auvers-sur-Oise, 1966.

Andrae, Walter. *Die archaischen Ischtar-Tempel in Assur* [= *WVDOG* 39]. Leipzig, 1922.

Andrae, Walter. *Die jüngeren Ischtar-Tempel in Assur* [= *WVDOG* 58]. Leipzig, 1935.

ApSimon, A. M. "Dagger Graves in the 'Wessex' Bronze Age." *Tenth Annual Report of the Institute of Archaeology*, 1954, pp. 37–62.

Arik, Remzi Oguz. *Les Fouilles d'Alaca Höyük*. Ankara, 1937.

Arne, A. J. *Excavations at Shah Tepe, Iran*. Stockholm, 1945.

Asaro, F., Perlman, I., and Dothan, M. "Mycenaean IIIc 1 Ware from Tell Ashdod." *Archaeometry* 13 (1971): 169–75.

Aspinall, A., Warren, S. E., Crummett, J. G., and Newton, R. G. "Neutron Activation Analysis of Faience Beads." *Archaeometry* 14 (1972): 27–40.

Astour, Michael C. "Greek Names in the Semitic World and Semitic Names in the Greek World." *JNES* 23 (1964): 193–201.

Astour, Michael C. "Aegean Place-Names in an Egyptian Inscription." *AJA* 70 (1966): 313–17.

Astour, Michael C. "The Merchant Class of Ugarit." *Bayerische Akademie der Wissenschaften: Abhandlungen* 75 (1972): 11–26.

Åström, Lena. *Studies on the Arts and Crafts of the Late Cypriote Bronze Age*. Lund, 1967.

Åström, Paul. *The Middle Cypriote Bronze Age*. Lund, 1957.

Åström, Paul. *Excavations at Kalopsidha and Ayios Iakovos in Cyprus* [= *SIMA* 2]. Lund, 1966.

Åström, Paul. "The Economy of Cyprus and its Development in the IInd Millennium." *Archaeologia Viva* 2 (1969): 73–80.

Atagarryev, E., and Berdyev, O. "The Archaeological Exploration of Turkmenistan in the Years of Soviet Power." *East and West* 20 (1970): 285–306.

Atkinson, T., Bosanquet, R., et al. *Excavations at Phylakopi in Melos* [= *JHS* Supplement 1]. London, 1904.

Banti, Luisa. "I Culti Minoici e Greci di Haghia Triada (Creta)." *ASAtene* 3–5 (1941–43): 2–74.

Baqir, Taha. "Iraq Government Excavations at ʿAqar Qûf." *Iraq* supplement, 1944.

Barag, Dan. "Mesopotamian Glass Vessels of the Second Millennium B.C.: Notes on the Origin of the Core Technique." *Journal of Glass Studies* 4 (1962): 9–27.

Barag, Dan. "Mesopotamian Core-Formed Glass Vessels (1500–500 B.C.)." In *Glass and Glassmaking*, edited by A. L. Oppenheim, pp. 131–99. Corning, 1970.

Barfield, L. H. "North Italian Faience Buttons." *Antiquity* 52 (1978): 150–53.

Barnett, R. E. "Early Shipping in the Near East." *Antiquity* 32 (1958): 220–30.

Baumgartel, Elise J. *The Cultures of Prehistoric Egypt.* Oxford, 1947.

Beck, Curt W. "Analysis and Provenience of Minoan and Mycenaean Amber I." *Greek, Roman and Byzantine Studies* 7 (1966): 191–211.

Beck, Curt W. "Amber in Archaeology." *Archaeology* 23 (1970): 7–11.

Beck, Curt W. "The Provenience of Amber in Bronze Age Greece." *BSA* 69 (1974): 170–72.

Beck, Curt W., Southard, C., and Adams, A. B. "Analysis and Provenience of Minoan and Mycenaean Amber II: Tiryns." *Greek, Roman and Byzantine Studies* 9 (1968): 5–19.

Beck, Curt W., Fellows, A., and Adams, A. "Analysis and Provenience of Minoan and Mycenaean Amber III: Kakovatos." *Greek, Roman and Byzantine Studies* 11 (1970): 5–22.

Beck, Curt W., Southard, C., and Adams, A. "Analysis and Provenience of Minoan and Mycenaean Amber IV: Mycenae." *Greek, Roman and Byzantine Studies* 13 (1972): 359–85.

Beck, Curt W., Wilbur, E., Meret, S., Kossove, M., and Kermani, K. "The Infra-red Spectra of Amber and the Identification of Baltic Amber." *Archaeometry* 8 (1965): 96–107.

Beck, Horace C. "Beads from Nineveh." *Antiquity* 5 (1931): 427–37.

Beck, Horace C. "Glass before 1500 B.C." *Ancient Egypt and the East*, 1934, pp. 7–21.

Beck, Horace C. "Notes on Glazed Stones: Part I: Glazed Steatite." *Ancient Egypt and the East*, 1934, pp. 69–83.

Beck, Horace C. "Notes on Glazed Stones: Part II: Glazed Quartz." *Ancient Egypt and the East*, 1935, pp. 19–37.

Beck, Horace C. and Stone, J. F. S. "Faience Beads of the British Bronze Age." *Archaeologia* 85 (1936): 203–52.

Becker, C. J. "A Segmented Faience Bead from Jutland with Notes on Amber Beads from Bronze Age Denmark." *Acta Archaeologica* 25 (1954): 241–52.

Benson, J. L. *Bamboula at Kourion: The Necropolis and the Finds.* Philadelphia, 1972.

Benton, S. "The Ionian Islands." *BSA* 32 (1931–32): 213–46.

Bernabò, Brea Luigi, and Cavalier, Madeleine. *Meligunìs-Lipára* I. Palermo, 1960.

Betancourt, Philip P., and Weinstein, Gail A. "Carbon-14 and the Beginning of the Late Bronze Age in the Aegean." *AJA* 80 (1976): 329–48.

von Bissing, Freihern W. *Fayencegefässe* [= *Catalogue général des Antiquités Égyptiennes du Musée du Caire* 4]. Vienna, 1902.

Bittel, Kurt. *Hattusha, The Capital of the Hittites.* New York, 1970.

Bjorkman, Judith Kingston. *Meteors and Meteorites in the Ancient Near East* [= *Center for Meteorite Studies Publications* 12]. Tempe, 1973.

Blegen, Carl W. *Prosymna: The Helladic Settlement Preceding the Argive Heraeum.* Cambridge, 1937.

Blegen, Carl W. *Troy II: The Third, Fourth and Fifth Settlements.* Princeton, 1951.

Blegen, Carl W. *Troy III: The Sixth Settlement.* Princeton, 1953.

Blegen, Carl W. *Troy IV: Settlements VIIa, VIIb and VIII.* Princeton, 1958.

Blegen, Carl W. "Excavations at Pylos 1953." *AJA* 58 (1954): 27–32.

Blegen, Carl W. "Early Greek Portraits." *AJA* 66 (1962): 245–47.

Blegen, Carl W., and Rawson, M. *The Palace of Nestor at Pylos I: The Buildings and their Contents.* Princeton, 1966.

Blegen, Carl W., and Wace, A. J. B. "The Determination of Greek Trade in the Bronze Age." *Proceedings of the Cambridge Philological Society* 169 (1938): 1–2.

Bolton, Kathleen. "Addendum to J. V. Luce's Article: 'Thera and the Devastation of Minoan Crete: A New Interpretation of the Evidence.'" *AJA* 80 (1976): 17–18.

Bouzek, Jan. "The Aegean and Central Europe: an Introduction to the Study of Cultural Interrelations 1600–1300 B.C." *Památky Archeologické* 57 (1966): 242–76.

Bouzek, Jan. "Bronze Age Greece and the Balkans: Problems of Migrations." In *Bronze Age Migrations in the Aegean*, edited by R. A. Crossland, and A. Birchall, pp. 169–77. London, 1973.

Braidwood, R. J., and L. S. *Excavations in the Plain of Antioch I: The Earlier Assemblages* [= *OIP* 61]. Chicago, 1960.

Branigan, Keith. "The Genesis of the Household Goddess." *SMEA* 8 (1969): 29–38.

Branigan, Keith. *The Foundations of Palatial Crete.* New York, 1970.

Branigan, Keith. "Minoan Foot Amulets and their Near Eastern Counterparts." *SMEA* 11 (1970): 7–23.

Branigan, Keith. "Wessex and the Common Market." *SMEA* 15 (1972):

147–55.

Branigan, Keith. "Radio-carbon and the Absolute Chronology of the Aegean Bronze Age." *KrChr* 25 (1974): 352–74.

Brill, R. H. "Ancient Glass." *SciAm* 209 (November 1963): 120–30.

Brown, T. Burton. *Excavations in Azarbaijan, 1948.* London, 1951.

Brumbaugh, Robert S. "The Knossos Game Board." *AJA* 79 (1975): 135–37.

Brunton, Guy. *Qau and Badari* II. London, 1928.

Brunton, Guy, and Caton-Thompson, Gertrude. *The Badarian Civilisation and Predynastic Remains Near Badari.* London, 1928.

Buchanan, Briggs. "A Snake Goddess and her Companions." *Iraq* 33 (1971): 1–18.

Buchholz, Hans-Günter, and Karageorghis, Vassos. *Prehistoric Greece and Cyprus.* New York, 1973.

Budge, E. A. W. *Facsimiles of Egyptian Hieratic Papyri in the British Museum, IInd Series.* London, 1923.

van Buren, E. Douglas. "Entwined Serpents." *Archiv für Orientforschung* 10 (1935–36): 53–65.

van Buren, E. Douglas. "Review of W. Andrae, *Die jüngeren Ischtar-Tempel in Assur.*" *Archiv für Orientforschung* 10 (1935–36): 287–93.

Butler, J. J. *Bronze Age Connections Across the North Sea* [= *Paleohistoria* 9]. Groningen, 1963.

Cadogan, Gerald. "An Egyptian Flint Knife from Knossos." *BSA* 61 (1966): 147–48.

Cadogan, Gerald. "Was There a Minoan Landed Gentry?" *Bulletin of the Institute of Classical Studies* 18 (1971): 145–48.

Cadogan, Gerald. "Faience from Sinai and Cyprus." *JEA* 59 (1973): 233.

Cadogan, Gerald. "Some Faience, Blue Frit and Glass from Fifteenth Century Knossos," *Temple University Aegean Symposium* 1 (1976): 18–19.

Caley, Earle R., and Richards, John C. *Theophrastos: On Stones.* Columbus, 1956.

Cameron, M. A. S. "Unpublished Paintings from the 'House of the Frescoes' at Knossos." *BSA* 63 (1968): 1–32.

Canby, Jeanny Vorys. "Early Bronze 'Trinket' Moulds." *Iraq* 27 (1965): 42–61.

de Cardi, Beatrice. "Excavations at Bampur, a Third Millennium Settlement in Persian Baluchistan, 1966." *Anthropological Papers of the American Museum of Natural History* 51 (1970): 231–356.

Carroll, Diane Lee. "A Classification for Granulation in Ancient Metalwork." *AJA* 78 (1974): 33–39.

Carter, Howard. "An Ostracon Depicting a Red Jungle-fowl." *JEA* 9 (1923): 1–4.

Caskey, John L. "Greece and the Aegean Islands in the Middle Bronze Age." *CAH*[3] 2:1, pp. 117–40.

Caspers, E. C. L. During. "Further Evidence for Cultural Relations between India, Baluchistan, and Iran and Mesopotamia in Early Dynastic Times." *JNES* 24 (1965): 52–56.

Caspers, E. C. L. During. "New Archaeological Evidence for Maritime Trade in the Persian Gulf during the Late Protoliterate Period." *East and West* 21 (1971): 21–44.

Casson, L. "Bronze Age Ships: The Evidence of the Thera Wall Paintings." *International Journal of Nautical Archaeology* 4 (1975): 3–10.

Catling, H. W. "The Cypriote Copper Industry." *Archaeologia Viva* 2 (1969): 81–88.

Catling, H. W., and Karageorghis, Vassos. "Minoika in Cyprus." *BSA* 55 (1960): 109–27.

Cavalier, M. "Les Cultures Préhistoriques des Iles Éoliennes et leur Rapport avec le Monde Égéen." *BCH* 84 (1960): 319–46.

di Cesnola, Louis Palma. *Cyprus: Its Ancient Cities, Tombs, and Temples.* London, 1877.

di Cesnola, Louis Palma. *A Descriptive Atlas of the Cesnola Collection of Cypriote Antiquities in the Metropolitan Museum of Art.* Boston, 1885.

Chadwick, John. *Documents in Mycenaean Greek²*. Cambridge, 1973.

Chapouthier, Fernand, and Demargne, Pierre. *Fouilles Exécutées à Mallia* [= *Études Crétoises* 12]. Paris, 1962.

Chase, W. T. "Egyptain Blue as a Pigment and Ceramic Material." In *Science and Archaeology,* edited by Robert H. Brill, pp. 80–90. Cambridge, Mass., 1968.

Childe, V. Gordon, "The Orient and Europe." *AJA* 43 (1939): 10–26.

Clark, J. G. D. *Prehistoric England.* London, 1940.

Clark, J. G. D. *Prehistoric Europe.* London, 1952.

Coldstream, J. N., and Huxley, G. L. *Kythera.* London, 1972.

Cooney, John D. "Glass Sculpture in Ancient Egypt." *Journal of Glass Studies* 2 (1960): 11–44.

Corkill, N. L. "Snake Specialists in Iraq." *Iraq* 6 (1939): 45–52.

Courtois, Jacques-Claude. "Enkomi-Alasia: Glorious Capital of Cyprus." *Archaeologia Viva* 2 (1969): 93–100.

Crawford, H. E. W. "Mesopotamia's Invisible Exports in the Third Millennium." *World Archaeology* 5 (1973): 232–41.

Crompton, W. M. "Two Glazed Hippopotamus Figures Hitherto Unpublished." *Ancient Egypt and the East,* 1931, pp. 21–27.

Crossland, R. A., and Birchall, Ann, eds. *Bronze Age Migrations in the Aegean.* London, 1973.

Culican, William. "Spiral-end Beads in Western Asia." *Iraq* 26 (1964): 36–43.

Culican, William. "Two Syrian Objects from Egypt." *Levant* 3 (1971): 86–89.

Dales, George F. "Harappan Outposts on the Makran Coast." *Antiquity* 36 (1962): 86–92.

Dales, George F. "A Suggested Chronology for Afghanistan, Baluchistan, and the Indus Valley." In *COWA,* pp. 257–84.

Dani, Ahmad Hassan. *Excavations in the Gomal Valley* [= *Ancient Pakistan* 5]. Peshawar, 1970–71.

Dani, Ahmad Hassan. "Origins of Bronze Age Cultures in the Indus Basin: A Geographic Perspective." *Expedition* 17 (1975): 12–18.

Davis, Ellen N. "Metal Inlaying in Minoan and Mycenaean Art." *Temple University Aegean Symposium* 1 (1976): 3–6.

Davis, Ellen N. *The Vapheio Cups and Aegean Gold and Silver Ware.* New York, 1977.

Dawkins, R. M., and Droop, J. P. "The Excavations at Phylakopi in Melos." *BSA* 17 (1910–11): 1–22.

Demacopoulou, K. "Mycenaean Jewellery Workshop in Thebes." *Athens Annals of Archaeology* 7 (1974): 172–73.

Demargne, Pierre. *Mallia: Nécropoles* I [= *Études Crétoises* 7]. Paris, 1945.

Department of Antiquities, Cyprus. *Acts of the International Archaeological Symposium "The Mycenaeans in the Eastern Mediterranean."* Nicosia, 1973.

Desborough, V. R. d'A. *The Last Mycenaeans and Their Successors.* Oxford, 1964.

Deshayes, J., and Dessenne, A. *Fouilles Exécutées à Mallia: Exploration des Maisons et Quartiers d'Habitation* [= *Études Crétoises* 11]. Paris, 1959.

Dickinson, O.T.P.K. *The Origins of Mycenaean Civilisation* [= *SIMA* 49]. Göteborg, 1977.

Dietrich, M., and Loretz, O. "Der Vertrag zwischen Šuppiluliuma und Niqmandu." *Die Welt des Orients* 3 (1966): 206–45.

Dikaios, Porphyrios. "The Excavations at Vounous-Bellapais in Cyprus 1931–2." *Archaeologia* 88 (1940): 1–174.

Dikaios, Porphyrios. *A Guide to the Cyprus Museum*². Nicosia, 1953.

Dikaios, Porphyrios. *Enkomi Excavations 1948–1958* I–III. Mainz, 1969.

Dow, Sterling. "The Greeks in the Bronze Age." *XIᵉ Congrés International des Sciences Historiques; Rapports II: Antiquité*, pp. 1–34. Uppsala, 1960.

Dumitrescu, Vladimir. "The Chronological Relation between the Cultures of the Eneolithic Lower Danube and Anatolia and the Near East." *AJA* 74 (1970): 43–50.

Dunand, Maurice. *Fouilles de Byblos* I, II. Paris, 1939, 1958.

Durrani, F. A. "Stone Vases as Evidence of Connection between Mesopotamia and the Indus Valley." *Ancient Pakistan* 1 (1964): 51–96.

Dussaud, René. "Rapports entre la Crète Ancienne et la Babylonie." *Iraq* 6 (1939): 53–65.

van Effenterre, Henri and Micheline. *Fouilles Exécutées à Mallia: le Centre Politique I: l'Agora* [= *Études Crétoises* 17]. Paris, 1969.

Ehrich, Robert W., ed. *Chronologies in Old World Archaeology.* Chicago, 1965.

Ehrich, Robert W. "Geographical and Chronological Patterns in East Central Europe." In *COWA*, pp. 403–58.

Ellis, Richard S. *Foundation Deposits in Ancient Mesopotamia* [= *Yale Near Eastern Researches* 2]. New Haven, 1968.

Erichsen, W. *Papyrus Harris* I [= *Bibliotheca Aegyptiaca* 5]. Brussels, 1933.

Erman, Adolph, and Grapow, Hermann. *Wörterbuch der ägyptischen Sprache.* Berlin, 1926–31.

Evans, Arthur J. "Knossos—The Palace." *BSA* 6 (1899–1900): 3–69.

Evans, Arthur J. "The Palace of Knossos." *BSA* 9 (1902–3): 1–153.

Evans, Arthur J. "Palace of Knossos—1904 Report." *BSA* 10 (1903–4):

1–62.

Evans, Arthur J. "The Prehistoric Tombs of Knossos." *Archaeologia* 59 (1905): 391–562.

Evans, Arthur J. "The Tomb of the Double Axes." *Archaeologia* 65 (1914): 1–94.

Evans, Arthur J. *The Palace of Minos at Knossos*. London, 1921–36.

Evans, J. A. S. "Redating Prehistory in Europe." *Archaeology* 30 (1977): 76–85.

Evans, John D. "The Prehistoric Culture Sequence in the Maltese Archipelago." *PPS* 19 (1953): 41–94.

Farnsworth, M., and Simmons, I. "Coloring Agents for Greek Glazes." *AJA* 67 (1963): 389–96.

Faure, Paul. "Toponymes Créto-mycéniens dans une Liste d'Aménophis III." *Kadmos* 7 (1968): 138–49.

Fleming, A. "Territorial Patterns in Bronze Age Wessex." *PPS* 37 (1971): 138–66.

Foltiny, Stephen. "Mycenae and Transylvania." *Hungarian Quarterly* 3 (1962): 133–40.

Forbes, R. J. *Studies in Ancient Technology* 5. Leiden, 1966.

Fox, Aileen. *South West England* [= *Ancient Peoples and Places* 41]. London, 1964.

Fox, Aileen, and Stone, J. F. S. "A Necklace from a Barrow in North Molton Parish." *The Antiquaries Journal* 31 (1951): 25–31.

Frankel, David. "Inter-site Relationships in the Middle Bronze Age of Cyprus." *World Archaeology* 6 (1974): 190–208.

Frankfort, Henri. *Tell Asmar, Khafaje and Khorsabad* [= *OIC* 16]. Chicago, 1933.

Frankfort, Henri. *The Art and Architecture of the Ancient Orient*. Baltimore, 1970.

Frankfort, Henri, and Pendlebury, J. D. S. *The City of Akhenaten II: The North Suburb and Desert Altars*. London, 1933.

Frifelt, Karen. "A Possible Link Between the Jemdet Nasr and the Umm an-Nar Graves of Oman." *Journal of Oman Studies* 1 (1975): 57–80.

Frödin, Otto, and Persson, Axel W. *Asine: Results of the Swedish Excavations 1922–1930*. Stockholm, 1938.

Frumkin, Grégoire. *Archaeology in Soviet Central Asia*. Leiden, 1970.

Furtwängler, Adolf, and Loeschcke, Georg. *Mykenische Vasen*. Berlin, 1886.

Furumark, Arne. *The Mycenaean Pottery: Analysis and Classification*. Stockholm, 1941.

Furumark, Arne. *The Chronology of Mycenaean Pottery*. Stockholm, 1941.

Furumark, Arne. "The Settlement at Ialysos and Aegean History c. 1550–1400 B.C." *Opuscula Archaeologica* 6 (1950): 150–271.

Furumark, Arne. "Gods of Ancient Crete." *Opuscula Atheniensia* 6 (1965): 85–98.

Furumark, Arne. "The Excavations at Sinda: Some Historical Results." *Opuscula Atheniensia* 6 (1965): 99–116.

Gallet de Santerre, Hubert, and Tréheux, J. "Rapport sur le Dépôt

Égéen et Géométrique de l'Artémision à Délos." *BCH* 71–72 (1947–48): 148–254.

Gardner, Ernest. "Palladia from Mycenae." *JHS* 13 (1893): 21–24.

Garner, Harry. "An Early Piece of Glass from Eridu." *Iraq* 18 (1956): 147–49.

Gelb, I. J. "Makkan and Meluḫḫa in Early Mesopotamian Sources." *RAssyr* 64 (1970): 1–8.

Gerloff, Sabine. *The Early Bronze Age Daggers in Great Britain and a Reconsideration of the Wessex Culture* [= *Prähistoriche Bronzefunde* 6:2]. Munich, 1975.

Gesell, Geraldine C. "The Minoan Snake Tube: A Survey and Catalogue." *AJA* 80 (1976): 247–59.

Ghirshman, R. *Fouilles du Tepe-Giyan*. Paris, 1935.

Ghirshman, R. *Fouilles de Sialk*. Paris, 1938.

Gimbutas, Marija. *Bronze Age Cultures in Central and Eastern Europe*. The Hague, 1965.

Ginsberg, H. L. "The North Canaanite Myth of Anath and Aqhat." *BASOR* 98 (1945): 15–23.

Giot, P. R. *Brittany* [= *Ancient Peoples and Places* 13]. New York, 1960.

Gjerstad, Einar. *Studies on Prehistoric Cyprus*. Uppsala, 1926.

Gjerstad, Einar. "The Colonization of Cyprus in Greek Legend." *Opuscula Archaeologica* 3 (1944): 107–23.

Gjerstad, Einar et al. *The Swedish Cyprus Expedition* I–IV. Stockholm, 1934–48.

Goedicke, Hans. "Ägäische Namen in ägyptischen Inschriften." *WZKM* 62 (1969): 7–10.

Goetze, Albrecht. "Contributions to Hittite Lexicography: (1) kuwanna(n) 'copper, azurite, (azurite) bead.'" *JCS* 1 (1947): 307–20.

Grace, Virginia. "A Cypriote Tomb and Minoan Evidence for its Date." *AJA* 44 (1940): 10–52.

Graumont, R., and Hensel, J. *Encyclopedia of Knots and Fancy Rope Work*. Cambridge, Md. 1952.

Gullberg, Elsa, and Åström, Paul. *The Thread of Ariadne: A Study of Ancient Greek Dress* [= *SIMA* 21]. Göteborg, 1970.

Guy, P. L. O. *Megiddo Tombs* [= *OIP* 33]. Chicago, 1938.

Hachmann, R. "Bronzezeitliche Bernsteinschieber." *Bayerische Vorgeschichtsblätter* 22 (1957): 1–36.

Haevernick, Thea Elisabeth. "Mycenaean Glass." *Archaeology* 16 (1963): 190–93.

Haevernick, Thea Elisabeth. "Beiträge zur Geschichte des Antiken Glases, XIII. Nuzi-Perlen." *JRGZM* 12 (1965): 35–40.

Haevernick, Thea Elisabeth. "Assyrisches Millefioriglas." *Forschungen und Berichte, Archäologische Beiträge, Staatliche Museen zu Berlin* 10 (1968): 63–70.

Hall, Edith H. *Excavations in Eastern Crete—Sphoungaras* [= *University of Pennsylvania Museum Anthropological Publications* 3:2]. Philadelphia, 1912.

Hall, H. R. "Minoan Fayence in Mesopotamia." *JHS* 48 (1928): 64–74.

Haller, Arndt. *Die Gräber und Grüfte von Assur* [= *WVDOG* 65]. Berlin, 1954.

Halleux, R. "Lapis-lazuli, Azurite ou Pâte de Verre? À propos de kuwano et kuwanowoko dans les tablettes mycéniennes." *SMEA* 9 (1969): 47–66.

Hallo, William W., and Simpson, William Kelly. *The Ancient Near East: A History*. New York, 1971.

Hamilton, R. W. "Excavations at Tell Abu Hawām." *QDAP* 4 (1935): 1–69.

Hammond, N. G. L. "Grave Circles in Albania and Macedonia." In *Bronze Age Migrations*, edited by R. A. Crossland and A. Birchall, pp. 189–97. London, 1973.

Hankey, Vronwy. "Late Mycenaean Pottery at Beth-Shan." *AJA* 70 (1966): 169–71.

Hankey, Vronwy. "Mycenaean Pottery in the Middle East: Notes on Finds Since 1951." *BSA* 62 (1967): 107–47.

Hankey, Vronwy. "Mycenaean Trade with the South-eastern Mediterranean." *Mélanges de l'Université Saint-Joseph* 46 (1970–71): 11–30.

Harden, D. B. "Pottery and Beads from near Nehavand, NW Persia, in the Ashmolean Museum." *Ancient Egypt and the East*, 1935, pp. 73–81.

Harding, Anthony F. "The Earliest Glass in Europe." *Archeologické Rozhledy* 23 (1971): 188–200.

Harding, Anthony F. "Illyrians, Italians and Mycenaeans: Trans-Adriatic Contacts during the Late Bronze Age." *Studia Albanica* 9 (1972): 215–21.

Harding, Anthony F., and Warren, S. E. "Early Bronze Age Faience Beads from Central Europe." *Antiquity* 47 (1973): 64–66.

Harding, Anthony F. "Mycenaean Greece and Europe: The Evidence of Bronze Tools and Implements." *PPS* 41 (1975): 183–202.

Harding, Anthony F., and Hughes-Brock, H. "Amber in the Mycenaean World." *BSA* 69 (1974): 145–70.

Harris, J. R. *Lexicographical Studies in Ancient Egyptian Minerals* [= *Deutsche Akad. der Wiss. zu Berlin: Institut für Orientforschung, Publications* 54]. Berlin, 1961.

Hawes, Harriet Boyd. *Gournia, Vasiliki and other Prehistoric Sites on the Isthmus of Hierapetra*. Philadelphia, 1908.

Hawkes, C. F. C. *The Prehistoric Foundations of Europe to the Mycenaean Age*. London, 1940.

Hayes, William C. *Glazed Tiles from a Palace of Ramesses II at Ḳantîr* [= *Metropolitan Museum of Art Papers* 3]. New York, 1937.

Hayes, William C. *The Scepter of Egypt*. New York, 1953.

Hazzidakis, Joseph. *Tylissos à l'Époque Minoenne*. Paris, 1921.

Hazzidakis, Joseph. *Les Villas Minoennes de Tylissos* [= *Études Crétoises* 3]. Paris, 1934.

Helck, W. *Die Beziehungen Ägyptens zu Vorderasien im 3. und 2. Jahrtausend v. Chr.* [= *Ägypt. Abhand.* 5]. Wiesbaden, 1962.

Hencken, Hugh. "Beitzsch and Knossos." *PPS* 18 (1952): 36–46.

Herrmann, Georgina. "Lapis Lazuli: The Early Phases of its Trade."

Iraq 30 (1968): 21–57.

Heubeck, A. "Mycenaean qe-qi-no-me-no." In *Proceedings of the Cambridge Colloquium on Mycenaean Studies*, edited by L. Palmer and J. Chadwick, pp. 229–37. Cambridge, 1966.

Heurtley, W. A. *Prehistoric Macedonia*. Cambridge, 1939.

Heurtley, W. A., and Radford, C. A. R. "Two Prehistoric Sites in Chalcide, I." *BSA* 29 (1928): 117–86.

Higgins, R. A. *Greek and Roman Jewellery*. London, 1961.

Higgins, R. A. "Foreign Influence in the Latest Mycenaean Jewellery." *Institute of Classical Studies Bulletin* 21 (1974): 160.

Höckmann, Olaf. "Die Katastrophe von Thera: Archäologische Gesichtspunkte." *JRGZM* 21 (1974): 46–92.

Hogarth, D. G. "Excavations at Zakro, Crete." *BSA* 7 (1900–01): 121–49.

Holmes, Y. Lynn. "Egypt and Cyprus: Late Bronze Age Trade and Diplomacy." *Alter Orient und Altes Testament* 22 (1973): 91–98.

Hölscher, Uvo. *The Mortuary Temple of Ramses III*, part II [= *OIP* 55]. Chicago, 1951.

Hood, Sinclair. *The Minoans* [= *Ancient Peoples and Places* 75]. New York, 1971.

Hood, Sinclair. "An Early Oriental Cylinder Seal Impression from Romania?" *World Archaeology* 5 (1973): 187–97.

Hood, Sinclair. "Mycenaean Settlement in Cyprus and the Coming of the Greeks." In *The Mycenaeans in the Eastern Mediterranean*, edited by the Department of Antiquities, Cyprus, pp. 40–50. Nicosia, 1973.

Hood, Sinclair, and DeJong, P. "Late Minoan Warrior-Graves from Ayios Ioannis and the New Hospital Site at Knossos." *BSA* 47 (1952): 243–77.

Hood, Sinclair, Huxley, George, and Sandars, Nancy K. "A Minoan Cemetery on Upper Gypsades." *BSA* 53–54 (1958–59): 194–262.

Hornblower, G. D. "The Barndoor Fowl in Egyptian Art." *Ancient Egypt and the East*, 1934–35, p. 82.

Hutchinson, R. W. *Prehistoric Crete*. Baltimore, 1968.

Immerwahr, Sara A. "Mycenaean Trade and Colonization." *Archaeology* 13 (1960): 4–13.

Immerwahr, Sara A. "Mycenaeans at Thera: Some Reflections on the Paintings from the West House." In *Greece and the Eastern Mediterranean in Ancient History and Prehistory*, edited by K. H. Kinzl, pp. 173–91. Berlin, 1977.

Ingholt, Harald. *Sept Campagnes de Fouilles à Hama en Syrie*. Copenhagen, 1940.

James, T. G. H. "Aegean Place Names in Egypt." *Institute of Classical Studies Bulletin* 18 (1971): 144.

Japaridze, O. M. "Trialeti Culture in the Light of the Latest Discoveries and its Relation to Anterior Asia and Aegean Sea." *Actes du 8. Congrès International des Sciences Préhistoriques et Protohistoriques* III (Belgrade, 1973): 39–44.

Jarrige, Jean-François. "La Fin de la Civilisation Harappéenne." *Paléorient* 1 (1973): 263–87.

Kantor, Helene J. *The Aegean and the Orient in the Second Millennium B.C.* [= *Archaeological Institute of America Monographs* 1]. Bloomington, 1947.

Kantor, Helene J. "Further Evidence for Early Mesopotamian Relations with Egypt." *JNES* 11 (1952): 239–50.

Kantor, Helene J. "Syro-Palestinian Ivories." *JNES* 15 (1956): 153–74.

Kantor, Helene J. "Ivory Carving in the Mycenaean Period." *Archaeology* 13 (1960): 14–25.

Kantor, Helene J. "The Relative Chronology of Egypt and its Foreign Correlations before the Late Bronze Age." In *COWA*, pp. 1–46.

Karageorghis, Vassos. *Nouveaux Documents pour l'étude du Bronze Récent à Chypre* [= *Études Chypriotes* 3]. Paris, 1965.

Karageorghis, Vassos. *Mycenaean Art from Cyprus*. Nicosia, 1968.

Karageorghis, Vassos. *Cyprus*. London, 1969.

Karageorghis, Vassos. "The Flowering of Cypriote Art." *Archaeologia Viva* 2 (1969): 131–34.

Karageorghis, Vassos. "Kition: Commercial Centre of the Mycenaean Era." *Archaeologia Viva* 2 (1969): 113–15.

Karageorghis, Vassos, "Kition: Mycenaean and Phoenician." *ProcBritAc* 59 (1973): 259–81.

Karageorghis, Vassos. *Excavations at Kition I: The Tombs*. Nicosia, 1974.

Karageorghis, Vassos. *Kition: Mycenaean and Phoenician Discoveries in Cyprus*. London, 1976.

Karo, Georg. "Minoische Rhyta." *JdI* 26 (1911): 249–70.

Karo, Georg. *Die Schachtgräber von Mykenai*. Munich, 1930.

Keimer, M. Ludwig. "Remarques sur l'Ornementation des Hippopotames en Faïence du Moyen Empire." *Revue de l'Égypte Ancienne* 2 (1930): 214–53.

Kenna, V. E. G. *Cretan Seals*. Oxford, 1960.

Kiefer, Charles, and Allibert, A. "Pharaonic Blue Ceramics: The Process of Self-Glazing." *Archaeology* 24 (1971): 107–17.

Kitchen, K. A. "Theban Topographical Lists, Old and New." *Orientalia* 34 (1965): 1–9.

Kitchen, K. A. "Aegean Place Names in a List of Amenophis III." *BASOR* 181 (1966): 23–24.

Kleinmann, Barbara. "Die Katastrophe von Thera: Geologie eines Vulkans." *JRGZM* 21 (1974): 12–45.

Kohl, Philip L. "Carved Chlorite Vessels: A Trade in Finished Commodities in the Mid-Third Millennium." *Expedition* 18 (1975): 18–31.

König, Friedrich Wilhelm. "Pinikir." *Archiv für Orientforschung* 5 (1928–29): 101–3.

Korres, G. S. "The Splendour of Mycenaean Helmets." *Athens Annals of Archaeology* 2 (1969): 446–62.

Koşay, Hamit Zubeyr. *Alaca Höyük Kazısı*. Ankara, 1951.

Kourouniōtēs, K. "Pylou Messēnianēs Tholōtos Taphos." *EphArch*, 1914, pp. 99–117.

Kuftin, B. A. *Archaeological Excavations in Trialeti I: An Attempt to Periodize Archaeological Materials*. Tiflis, 1941.

Kühne, Hartmut. "Glas B: nach archäologischem Material." *Reallexikon der Assyriologie* III (1957): 410–27.

Kühne, Hartmut. "Rätselhafte Masken—zur Frage ihrer Herkunft und Deutung." *Baghdader Mitteilungen* 7 (1974): 101–10.

Kühne, Klaus. *Zur Kenntnis silikatischer Werkstoffe und der Technologie ihrer Herstellung im 2. Jahrtausend vor unserer Zeitrechnung* [= *Abh. der deutschen Akademie d. Wiss. zu Berlin*]. Berlin, 1969.

Lamberg-Karlovsky, C. C. "Amber and Faience." *Antiquity* 37 (1963): 301–2.

Lamberg-Karlovsky, C. C. *Excavations at Tepe Yahya, Iran, 1967–1969.* Cambridge, Mass., 1970.

Lamberg-Karlovsky, C. C. "Trade Mechanisms in Indus-Mesopotamian Interrelations." *JAOS* 92 (1972): 222–29.

Lambert, M. "Le Destin d'Ur et les Routes Commerciales." *RStO* 39 (1964): 89–109.

Landsberger, B. "Einige unerkannt gebliebene oder verkannte nomina des Akkadischen." *Die Welt des Orients* 3 (1966): 246–60.

Lang, David Marshall. *The Georgians* [= *Ancient Peoples and Places* 51]. New York, 1966.

Lang, Mabel L. *The Palace of Nestor at Pylos in Western Messenia II: The Frescoes.* Princeton, 1969.

Laroche, E. "Études de Linguistique Anatolienne, II." *RHA* 24 (1966): 160–84.

Larsen, Mogens Trolle. *The Old Assyrian City-State and its Colonies.* Copenhagen, 1976.

Lauer, Jean-Philippe. *La Pyramide à Degrés.* Cairo, 1936.

Lawler, Lillian B. "Snake Dances." *Archaeology* 1 (1948): 110–13.

Leemans, W. F. *Foreign Trade in the Old Babylonian Period.* Leiden, 1960.

Levi, Doro. *The Recent Excavations at Phaistos* [= *SIMA* 11]. Lund, 1964.

Lindgren, Margareta. "Two Linear B Problems Reconsidered from a Methodological Point of View." *Opuscula Atheniensia* 8 (1968): 61–76.

Lloyd, Seton. *Beycesultan* III: 1. Ankara, 1972.

Lomborg, Ebbe. "An Amber Spacer-bead from Denmark." *Antiquity* 41 (1967): 221–23.

Long, Charlotte R. "A Wooden Chest from the Third Shaft Grave." *AJA* 78 (1974): 75–78.

Loud, Gordon. *The Megiddo Ivories* [= *OIP* 52]. Chicago, 1939.

Loud, Gordon. *Megiddo* II [= *OIP* 57]. Chicago, 1948.

Lucas, A., and Harris, J. R. *Ancient Egyptian Materials and Industries*[4]. London, 1962.

Luce, J. V. *The End of Atlantis.* St. Albans, 1970.

Luce, J. V. "Thera and the Devastation of Minoan Crete: A New Interpretation of the Evidence." *AJA* 80 (1976): 9–16.

Mackay, Ernest. *Report on the Excavation of the "A" Cemetery at Kish, Mesopotamia* [= *Field Museum of Natural History Anthropological Memoirs* 1:1, 2]. Chicago, 1925 and 1929.

Mackay, Ernest. "Further Links between Ancient Sind, Sumer and Elsewhere." *Antiquity* 5 (1931): 459–73.

Mackay, Ernest. *Report on Excavations at Jemdet Nasr* [= *Field Museum of Natural History Anthropological Memoirs* 1:3]. Chicago, 1931.

Mackay, Ernest. "Bead-making in Ancient Sind." *JAOS* 57 (1937): 1–15.

Mackay, Ernest. *Further Excavations at Mohenjo-Daro*. Delhi, 1937.

Mackay, Ernest. *Chanhu-Daro Excavations*. New Haven, 1943.

Madhlum, Tariq Abd-al-Wahab. "Ḥafriyyātu Tall al-Wilāyah." *Sumer* 16 (1960): 62–92 (Arabic portion).

Malinowski, Tadeusz. "An Amber Trading-Post in Early Iron Age Poland." *Archaeology* 27 (1974): 195–200.

Mallowan, M. E. L. "The Excavations at Tall Chagar Bazar, and an Archaeological Survey of the Ḥabur Region." *Iraq* 3 (1936): 1–86.

Mallowan, M. E. L. "The Excavations at Tall Chagar Bazar, Second Campaign, 1936." *Iraq* 4 (1937): 91–177.

Mallowan, M. E. L. "Revelations of Brilliant Art in North-east Syria over 4000 Years Ago." *ILN*, 15 October 1938, pp. 697–701.

Mallowan, M. E. L. "Excavations at Brak and Chagar Bazar." *Iraq* 9 (1947): entire issue.

Mallowan, M. E. L. "The Mechanics of Ancient Trade in Western Asia." *Iran* 3 (1965): 1–7.

Mallowan, M. E. L., and Rose, J. C. "Excavations at Tall Arpachiyah 1933." *Iraq* 2 (1935): 1–178.

Marinatos, Spyridon. "La Marine Créto-Mycénienne." *BCH* 57 (1933): 170–235.

Marinatos, Spyridon, and Max Hirmer. *Crete and Mycenae*. New York, 1960.

Marinatos, Spyridon. "The Minoan and Mycenaean Civilization and its Influence on the Mediterranean and on Europe." *Atti del VI Congresso Internazionale delle Scienze Preistoriche e Protostoriche* I (Rome, 1962): 161–76.

Marinatos, Spyridon. *Excavations at Thera* I–VII. Athens, 1968–76.

Marshall, John. *Mohenjo-Daro and the Indus Civilization*. London, 1931.

Masson, V. M., and Sarianidi, V. I. *Central Asia: Turkmenia before the Achaemenids* [= *Ancient Peoples and Places* 79]. New York, 1972.

Matson, Frederick R. "Egyptian Blue." In *Persepolis* II [= *OIP* 69], edited by Erich F. Schmidt, pp. 133–35. Chicago, 1957.

Matz, F. "The Maturity of Minoan Civilization." *CAH*[3] 2:1, pp. 141–64.

Maxwell-Hyslop, K. R. "The Ur Jewellery." *Iraq* 22 (1960): 105–15.

Maxwell-Hyslop, K. R. *Western Asiatic Jewellery c. 3000–612 B.C.* London, 1971.

McCown, Donald E., Haines, Richard C., and Hansen, Donald P. *Nippur I: Temple of Enlil, Scribal Quarter and Soundings* [= *OIP* 78]. Chicago, 1967.

McKerrell, Hugh. "On the Origins of British Faience Beads and Some Aspects of the Wessex-Mycenae Relationship." *PPS* 38 (1972): 286–301.

Megaw, A. H. S. "British Archaeology Abroad, 1966." *Antiquity* 41 (1967): 126.

Megaw, J. V. S. "Across the North Sea: A Review." *Antiquity* 35 (1961):

45–52.

Mellaart, James. "Anatolian Trade with Europe and Anatolian Geography and Culture Provinces in the Late Bronze Age." *Anatolian Studies* 18 (1968): 187–202.

von Merhart, Gero. "Die Bernsteinschieber von Kakovatos." *Germania* 24 (1940): 99–102.

Merrillees, R. S. "Opium Trade in the Bronze Age Levant." *Antiquity* 36 (1962): 287–92.

Merrillees, R. S. "Reflections on the Late Bronze Age in Cyprus." *Opuscula Atheniensia* 6 (1965): 139–48.

Merrillees, R. S. *The Cypriote Bronze Age Pottery Found in Egypt* [= *SIMA* 18]. Lund, 1968.

Merrillees, R. S. "Review of Åström, L., *Arts and Crafts*." *PEQ* 100 (1968): 64–67.

Merrillees, R. S. "The Early History of Late Cypriote I." *Levant* 3 (1971): 56–79.

Merrillees, R. S. "Aegean Bronze Age Relations with Egypt." *AJA* 76 (1972): 281–94.

Merrillees, R. S. *Trade and Transcendence in the Bronze Age Levant* [= *SIMA* 39]. Göteborg, 1974.

Merrillees, R. S., and Winter, J. "Bronze Age Trade between the Aegean and Egypt: Minoan and Mycenaean Pottery from Egypt in the Brooklyn Museum." *Miscellanea Wilbouriana* 1 (1972): 101–33.

de Mertzenfeld, Christiane Decamps. *Inventaire Commenté des Ivoires Phéniciens et Apparentés Découverts dans le Proche-Orient*. Paris, 1954.

Meščaninov, I. I. "Kratkie svedenija o rabotah arheologičeskoj ėkspedicii v Nagornyj Karabah i Nahičevanskij kraj." *Soobščenija GAIMK* I (1926): 217–40.

du Mesnil du Buisson. *L'Ancienne Qatna*. Paris, 1928.

Michael, H. N., and Weinstein, G. A. "New Radiocarbon Dates from Akrotiri, Thera." *Temple University Aegean Symposium* 2 (1977): 27–30.

Milojčić, Vladimir. "Neue Bernsteinschieber aus Griechenland." *Germania* 33 (1955): 316–19.

Milojčić, Vladimir. "Zur Chronologie der jüngeren Stein- und Bronzezeit Südost- und Mitteleuropas." *Germania* 37 (1959): 65–84.

Monaco, Giorgio. "Scavi nella zona micenea di Jaliso (1935–1936)." *Clara Rhodos* 10 (1941): 45–178.

Money-Coutts, M. B. "The Cave of Trapeza: Miscellanea." *BSA* 36 (1935–36): 122–25.

Montet, Pierre. *Byblos et l'Égypte*. Paris, 1928.

Moorey, P. R. S. "Cemetery A at Kish: Grave Groups and Chronology." *Iraq* 32 (1970): 86–128.

de Morgan, J. "Observations sur les Couches Profondes de l'Acropole à Suse." *MDP* 13 (1912): 1–25.

de Mot, Jean. "Vases Égéens en Forme d'Animaux." *RA*, 1904, pp. 201–24.

Moucha, Václav. "Faience and Glassy Faience Beads in the Únětice Culture in Bohemia." *Epitymbion Roman Haken*, pp. 44–49. Prague, 1958.

Mughal, Mohammad Rafique. "The Early Harappan Period in the Greater Indus Valley and Northern Baluchistan (c. 3000–2400 B.C.)." Dissertation, University of Pennsylvania, 1970.

Mughal, Mohammad Rafique. "New Evidence of the Early Harappan Culture from Jalipur, Pakistan." *Archaeology* 27 (1974): 106–13.

Muhly, James David. "Review of A. L. Oppenheim, ed., *Glass and Glassmaking*." *JCS* 24 (1972): 178–82.

Muhly, James David. *Copper and Tin: The Distribution of Mineral Resources and the Nature of the Metals Trade in the Bronze Age* [= *Transactions of the Connecticut Academy of Arts and Sciences* 43]. Hamden, Conn., 1973.

Muhly, James David. *Supplement to Copper and Tin* [= *Transactions of the Connecticut Academy of Arts and Sciences* 46]. Hamden, Conn., 1976.

Müller, K. "Alt-Pylos II: Die Funde aus den Kuppelgräbern von Kakovatos." *AthMitt* 34 (1909): 269–328.

Murray, A. S., Smith, A. H., and Walters, H. B. *Excavations in Cyprus*. London, 1900.

Murray, Caroline, and Warren, Peter. "PO-NI-KI-JO Among the Dye-Plants of Minoan Crete." *Kadmos* 15 (1976): 40–60.

Myers, Bernard S., ed. *McGraw-Hill Dictionary of Art*. New York, 1969.

Mylonas, George E. *Ancient Mycenae: The Capital City of Agamemnon*. Princeton, 1957.

Mylonas, George E. *Grave Circle B of Mycenae* [= *SIMA* 7]. Lund, 1964.

Myres, John L. *Handbook of the Cesnola Collection of Antiquities from Cyprus*. New York, 1914.

de Navarro, J. M. "Prehistoric Routes between Northern Europe and Italy Defined by the Amber Trade." *Geographical Journal* 66 (1925): 481–507.

Naville, Edouard. *The Mound of the Jew and the City of Onas*. London, 1890.

Naville, Edouard. *The XIth Dynasty Temple at Deir el Bahari* III. London, 1913.

Neustupný, Evžen. "Absolute Chronology of the Neolithic and Aeneolithic Periods in Central and Southeastern Europe." *Slovenská Archeológia* 16 (1968): 19–56.

Newton, R. G., and Renfrew, Colin. "British Faience Beads Reconsidered." *Antiquity* 44 (1970): 199–206.

Nilsson, Martin P. *The Minoan-Mycenaean Religion and its Survival in Greek Religion*². Lund, 1950.

Noble, J. V. "The Technique of Egyptian Faience." *AJA* 72 (1968): 169.

Oates, David. "The Excavations at Tell al Rimah, 1964." *Iraq* 27 (1965): 62–80.

Oates, David. "The Excavations at Tell al Rimah, 1966." *Iraq* 29 (1967): 70–96.

Oppenheim, A. Leo. "The Cuneiform Texts." In *Glass and Glassmaking*, pp. 4–101. Corning, 1970.

Oppenheim, A. Leo. "Trade in the Ancient Near East." *V International Congress of Economic History*. Moscow, 1970, pp. 1–37.

Oppenheim, A. Leo. "Towards a History of Glass in the Ancient Near

East." *JAOS* 93 (1973): 259–66.

Oppenheim, A. Leo. "More Fragments with Instructions for Glassmaking." *JNES* 32 (1973): 188–93.

Oppenheim, A. Leo, Brill, Robert H., Barag, Dan, and von Saldern, Axel. *Glass and Glassmaking in Ancient Mesopotamia*. Corning, 1970.

von der Osten, Hans Henning. *The Alishar Hüyük: Seasons of 1930–32* I [= *OIP* 28]. Chicago, 1937.

Overbeck, John C., and McDonald, Christine K. "The Date of the Last Palace at Knossos." *AJA* 80 (1976): 155–64.

Özgüç, Tahsin. *Kültepe Kazısı Raporu*. Ankara, 1953.

Pace, Eric. "Some 'Gems' in Tut Tomb are Glass." *New York Times*, 21 July 1976, p. 36.

Palmer, Leonard R. *The Interpretation of Mycenaean Greek Texts*. Oxford, 1963.

Palmer, Leonard R. *Mycenaeans and Minoans: Aegean Prehistory in the Light of the Linear B Tablets*. London, 1965.

Palmer, Leonard R. *The Penultimate Palace of Knossos* [= *Incunabula Graeca* 33]. Rome, 1969.

Parker, Barbara. "Cylinder Seals from Tell al Rimah." *Iraq* 37 (1975): 21–38.

Parrot, André. "Les Fouilles de Mari." *Syria* 18 (1937): 54–84.

Parrot, André. *Les Temples d'Ishtarat et de Ninni-zaza*. Paris, 1967.

Parrot, André. "De la Méditerranée à l'Iran: Masques Énigmatiques." In *Ugaritica* VI, edited by C. F. A. Schaeffer, pp. 409–18. Paris, 1969.

Payne, Joan Crowfoot. "Lapis Lazuli in Early Egypt." *Iraq* 30 (1968): 58–61.

Peltenburg, Edgar J. "Some Early Developments of Vitreous Materials." *World Archaeology* 3 (1971): 6–12.

Peltenburg, Edgar J. "On the Classification of Faience Vases from Late Bronze Age Cyprus." *Praktikōn tou Prōtou Diethnous Kyprologikou Synedriou* (Nicosia, 1972): 129–36.

Peltenburg, Edgar J. "Appendix I: The Glazed Vases (including a polychrome rhyton) with analyses and technical notes by H. McKerrell." In *Excavations at Kition* I, edited by Vassos Karageorghis, pp. 105–44. Nicosia, 1974.

Peltenburg, Edgar J. "A Faience from Hala Sultan Tekke and Second Millennium B.C. Western Asiatic Pendants Depicting Females." In *Hala Sultan Tekke* 3 [= *SIMA* 45:3], edited by Paul Åström et al., pp. 177–200. Göteborg, 1977.

Pendlebury, J. D. S. *Aegyptiaca: a Catalogue of Egyptian Objects in the Aegean Area*. Cambridge, 1930.

Pendlebury, J. D. S. "Egypt and the Aegean in the Late Bronze Age." *JEA* 16 (1930): 75–92.

Pendlebury, J. D. S. *The City of Akhenaten, Part III: The Central City and Official Quarters*. London, 1951.

Pendlebury, J. D. S. "Egypt and the Aegean." In *Studies Presented to David Moore Robinson* I, edited by George E. Mylonas, pp. 184–97. St. Louis, 1951.

Pendlebury, J. D. S. *A Handbook to the Palace of Minos, Knossos*. London, 1954.

Pendlebury, J. D. S. *The Archaeology of Crete*. London, 1939.

Perkins, Ann Louise. *The Comparative Archaeology of Early Mesopotamia* [= *Studies in Ancient Oriental Civilization* 25]. Chicago, 1949.

Pernier, Luigi. *Il Palazzo Minoico di Festòs*. Rome, 1935.

Persson, Axel Waldemar. *The Royal Tombs at Dendra near Midea*. Lund, 1931.

Persson, Axel Waldemar. *New Tombs at Dendra near Midea*. Lund, 1942.

Persson, Axel Waldemar. *The Religion of Greece in Prehistoric Times* [= *Sather Classical Lectures* 17]. Los Angeles, 1942.

Petrie, W. M. Flinders. *Tell-el-Amarna*. London, 1894.

Petrie, W. M. Flinders. *The Royal Tombs of the First Dynasty*. London, 1900 and 1901.

Petrie, W. M. Flinders. *Researches in Sinai*. London, 1906.

Petrie, W. M. Flinders. *Arts and Crafts of Ancient Egypt*. Chicago, 1910.

Petrie, W. M. Flinders. *Prehistoric Egypt*. London, 1920.

Petrie, W. M. Flinders. *Tombs of the Courtiers and Oxyrhynkhos*. London, 1925.

Pettinato, Giovanni. "Il commercio con l'estero della Mesopotamia Meridionale nel 3. millennio av. Cr." *Mesopotamia* 7 (1972): 43–166.

Pichler, Hans, and Schiering, Wolfgang. "The Thera Eruption and Late Minoan I B Destructions on Crete." *Nature* 267 (1977): 819–22.

Piggott, Stuart. "Early Foreign Trade in East Africa." *Man* 48 (1948): 23–24.

Piggott, Stuart. *Prehistoric India*. Baltimore, 1961.

Piggott, Stuart. *Ancient Europe from the Beginnings of Agriculture to Classical Antiquity*. Chicago, 1965.

Piperno, Marcello, and Tosi, Maurizio. "The Graveyard of Shahr-i Sokhta, Iran." *Archaeology* 28 (1975): 186–97.

Platon, Nicholas. "Symbolē eis tēn spoudēn tēs Minōikēs toichographias: o krokosyllektēs pithēkos." *KrChr* 1 (1947): 505–24.

Platon, Nicholas. "Nouvelle Interprétation des Idoles-cloches du Minoen Moyen I." *RA* 31–32 (1948): 833–46.

Platon, Nicholas. *Crete*. Geneva, 1966.

Platon, Nicholas. *Zakros: The Discovery of a Lost Palace of Ancient Crete*. New York, 1971.

Pollitt, Jerome J. "The Explosion on Santorini (Thera) and its Place in the Aegean Bronze Age." In *Problems in Ancient History*, edited by Donald Kagan, pp. 135–45. New York, 1975.

Pomerance, Leon. "The Possible Role of Tomb Robbers and Viziers of the Eighteenth Dynasty in Confusing Minoan Chronology." *Temple University Aegean Symposium* 1 (1976): 1–2.

Popham, Mervyn R. "Two Cypriote Sherds from Crete." *BSA* 58 (1963): 89–93.

Popham, Mervyn R. "Sellopoulo Tombs 3 and 4, Two Late Minoan Graves near Knossos." *BSA* 69 (1974): 195–257.

Popham, Mervyn R. "Mycenaean-Minoan Relations between 1450

and 1400 B.C." *Bulletin of the Institute of Classical Studies* 23 (1976): 119–21.

Popovitch, Vladislav. "Une Civilisation Égeo-Orientale sur le Moyen Danube." *RA*, 1965, pp. 1–66.

Porada, Edith. *The Art of Ancient Iran*. New York, 1962.

Porada, Edith. "The Relative Chronology of Mesopotamia." In *COWA*, pp. 133–200.

Porada, Edith, and Wace, A. J. B. "A Faience Cylinder." *BSA* 52 (1957): 197–204.

Poulsen, Frederik. "Zur Zeitbestimmung der Enkomifunde." *JdI* 26 (1911): 215–48.

Poursat, Jean-Claude. *Les Ivoires Mycéniens: Essai sur la Formation d'un Art Mycénien*. Athens, 1977.

Poursat, Jean-Claude. *Catalogue des Ivories Mycéniens du Musée National d'Athènes*. Athens, 1977.

Pumpelly, Raphael. *Explorations in Turkestan*. Washington, 1908.

Quiring, Heinrich. "Die Herkunft des Bernsteins im Grabe des Tutanchamon (1358–1351)." *FuF* 28 (1954): 276–78.

Reade, J. E. "Tell Taya (1972–73): Summary Report." *Iraq* 35 (1973): 155–87.

Reed, Charles A. "Animal Domestication in the Prehistoric Near East." In *Prehistoric Agriculture*, edited by S. Struever, pp. 423–50. Garden City, N.Y., 1971.

Reisner, George A. *The Early Dynastic Cemetery of Naga-ed-der* I. Leipzig, 1908.

Reisner, George A. *Excavations at Kerma*, parts IV–V [= *Harvard African Studies* 6]. Cambridge, Mass., 1923.

Reisner, George A. "Stone Vessels Found in Crete and Babylonia." *Antiquity* 5 (1931): 200–12.

Renfrew, Colin. "Crete and the Cyclades before Rhadamanthus." *KrChr* 18 (1964): 107–41.

Renfrew, Colin. "Wessex without Mycenae." *BSA* 63 (1968): 277–85.

Renfrew, Colin. "Carbon 14 and the Prehistory of Europe." In *Old World Archaeology: Foundations of Civilization* (readings from *Scientific American*, pp. 201–9. San Francisco, 1972.

Renfrew, Colin. *The Emergence of Civilisation: The Cyclades and the Aegean in the 3rd Millennium B.C.* London, 1972.

Reuther, Oscar. *Die Innenstadt von Babylon* [= *WVDOG* 47]. Leipzig, 1926.

Revere, R. B. "No Man's Coast: Ports of Trade in the Eastern Mediterranean." In *Trade and Markets in the Early Empires*, edited by K. Polanyi, C. Arensburg, and H. Pearson, pp. 38–63. Glencoe, 1957.

Rhodes, Daniel. *Clay and Glazes for the Potter*. Philadelphia, 1973.

Riefstahl, Elizabeth. *Ancient Egyptian Glass and Glazes in the Brooklyn Museum* [= *Wilbour Monographs* 1]. Brooklyn, 1968.

Riefstahl, Elizabeth. "An Enigmatic Faience Figure." *Miscellanea Wilbouriana* 1 (1972): 137–43.

Rodenwaldt, Gerhart. *Tiryns II: die Fresken des Palastes*. Athens, 1912.

Rottländer, R. C. A. "On the Formation of Amber from *Pinus* Resin."

Archaeometry 12 (1970): 35–51.

Rutkowski, Bogdan. *Cult Places in the Aegean World* [= *Bibliotheca Antiqua* 10]. Warsaw, 1972.

Sackett, L. H., Popham, M. R., and Warren, P. M. "Excavations at Palaikastro VI." *BSA* 60 (1965): 248–315.

Sakellarakis, J. A. "Mycenaean Stone Vases." *SMEA* 17 (1976): 173–87.

Sakellarakis, J. A., and Kenna, V. E. G. *Iraklion Sammlung Metaxas* [= *Corpus der minoischen und mykenischen Siegel* 4]. Berlin, 1969.

Salonen, Armas. "Die Öfen der alten Mesopotamier." *Baghdader Mitteilungen* 3 (1964): 100–124.

Salonen, Armas. *Vögel und Vogelfang im alten Mesopotamien*. Helsinki, 1973.

Sandars, Nancy K. "Amber Spacer Beads Again." *Antiquity* 33 (1959): 292–95.

Sandars, Nancy K. "The First Aegean Swords and their Ancestry." *AJA* 65 (1961): 17–29.

Sandars, Nancy K. "Later Aegean Bronze Swords." *AJA* 67 (1963): 117–53.

Sapouna-Sakellarakis, Efi. *Cycladic Civilization and the Cycladic Collection of the National Archaeological Museum of Athens*. Athens, n.d.

Sarianidi, V. I. "The Lapis Lazuli Route in the Ancient East." *Archaeology* 24 (1971): 12–15.

Sarianidi, V. I. "North Afghanistan in the Bronze Period." *Afghanistan* 24 (1971): 26–39.

Sasson, Jack M. "Canaanite Maritime Involvement in the Second Millennium." *JAOS* 86 (1966): 126–38.

Schachermeyr, Fritz. *Die minoische Kultur des alten Kreta*. Stuttgart, 1964.

Schachermeyr, Fritz. *Ägäis und Orient*. Vienna, 1967.

Schaeffer, Claude F. A. *Les Fouilles de Minet-el-Beida et de Ras Shamra: Rapports*. Paris, 1929–37.

Schaeffer, Claude F. A. "Les Fouilles de Minet-el-Beida et de Ras Shamra —quatrième campagne." *Syria* 14 (1933): 93–127.

Schaeffer, Claude F. A. *Ugaritica* I–IV. Paris, 1939– 62.

Schaeffer, Claude F. A. *Missions en Chypre 1932–1935*. Paris, 1936.

Schaeffer, Claude F. A. *Stratigraphie Comparée et Chronologie de l'Asie Occidentale*. London, 1948.

Schaeffer, Claude F. A. *Enkomi-Alasia: Nouvelles Missions en Chypre 1946–1950*. Paris, 1952.

Schäfer, H. "Altes und Neues zur Kunst und Religion von Tell el-Amarna." *ZÄS* 55 (1918): 1–49.

Schmidt, Erich F. *The Alishar Hüyük: Seasons of 1928 and 1929* [= *OIP* 19]. Chicago, 1932.

Schmidt, Erich F. "Tepe Hissar: Excavations of 1931." *The Museum Journal* 23 (1933): 323–483.

Schmidt, Erich F. *Excavations at Tepe Hissar Damghan*. Philadelphia, 1937.

Schmidt, Hubert. *Heinrich Schliemann's Sammlung Trojanischer Altertümer*. Berlin, 1902.

Scholes, K. "The Cyclades in the Later Bronze Age." *BSA* 51 (1956): 9–40.

Schuler, F. "Ancient Glassmaking Techniques: The Molding Process."

Archaeology 12 (1959): 47–52; 116–22.

Schuler, F. "Ancient Glassmaking Techniques: The Egyptian Core Vessel Process." *Archaeology* 15 (1962): 32–37.

Schumacher, G. *Tell el-Mutesellim* I. Leipzig, 1908.

Schweitzer, Bernhard. "Hunde auf dem Dach: ein mykenisches Holzkästchen." *AthMitt* 55 (1930): 107–18.

Seager, Richard B. "Excavations on the Island of Mochlos, Crete, in 1908." *AJA* 13 (1909): 273–303.

Seager, Richard B. *Explorations in the Island of Mochlos*. Boston, 1912.

Sethe, Kurt. *Dramatische Texte zu Altaegyptischen Mysterienspielen*. Leipzig, 1928.

Shaw, Joseph W. *Minoan Architecture: Materials and Techniques* [= *ASAtene* 49]. Rome, 1973.

Shaw, Joseph W. "New Evidence for Aegean Roof Construction from Bronze Age Thera." *AJA* 81 (1977): 229–33.

Shaw, Maria C. "Ceiling Patterns from the Tomb of Hepzefa." *AJA* 74 (1970): 25–30.

Shear, T. Leslie. "The Mycenaean Tomb." *Hesperia* 9 (1940): 274–93.

Shear, T. Leslie. "Minoan Influence on the Mainland: Variations of Opinion since 1900." In *A Land Called Crete*, edited by P. W., Lehmann, pp. 47–65. Northampton, 1968.

Simpson, R. Hope. *A Gazetteer and Atlas of Mycenaean Sites* [= *University of London Institute of Classical Studies Bulletin Supplement* 16]. London, 1965.

Simpson, R. Hope, and Lazenby, J. F. "Notes from the Dodecanese." *BSA* 57 (1962): 154–75.

Sjöqvist, Erik. *Problems of the Late Cypriote Bronze Age*. Stockholm, 1940.

Smith, Ray Winfield. "Technological Research on Ancient Glass." *Archaeology* 11 (1958): 111–16.

Smith, William Stevenson. *Interconnections in the Ancient Near East*. New Haven, 1965.

Snodgrass, A. M. *Arms and Armour of the Greeks*. London, 1964.

Sparks, R. S. J., Sigurdsson, H., and Watkins, N. D. "The Thera Eruption and Late Minoan I B Destruction on Crete." *Nature* 271 (1978): 91.

Speiser, E. A. *Excavations at Tepe Gawra I: Levels I–VIII*. Philadelphia, 1935.

Starr, Chester G. "The Myth of the Minoan Thalassocracy." *Historia* 3 (1954–55): 282–91.

Starr, Richard F. S. *Nuzi*. Cambridge, Mass., 1939.

Steindorff, Georg. *Urkunden des ägyptischen Altertums*. Leipzig, 1903.

Stone, J. F. S., and Thomas, L. C. "The Use and Distribution of Faience in the Ancient East and Prehistoric Europe." *PPS* 22 (1956): 37–84.

Stubbings, Frank H. *Mycenaean Pottery from the Levant*. Cambridge, 1951.

Stubbings, Frank H. "The Rise of Mycenaean Civilization." *CAH*[3] 2:1, pp. 637–58.

Sulimirski, Tadeusz. "Faience Beads in the Polish Bronze Age." *Man* 48 (1948): 124.

Sulimirski, Tadeusz. *Corded Ware and Globular Amphorae North-East of*

the Carpathians. London, 1968.

Symeonoglou, Sarantis. *Kadmeia I: Mycenaean Finds from Thebes, Greece—Excavation at 14 Oedipus Street* [= *SIMA* 35]. Göteborg, 1973.

Tasić, Nikola. "The Problem of 'Mycenaean Influences' in the Middle Bronze Age Cultures in the Southeastern Part of the Carpathian Basin." *Balcanica* 4 (1973): 19–37.

Taylour, William D. "Mycenae 1968." *Antiquity* 43 (1969): 91–97.

Taylour, William D. "New Light on Mycenaean Religion." *Antiquity* 44 (1970): 270–80.

Thapar, B. K. "New Traits of the Indus Civilization at Kalibangan: An Appraisal." In *South Asian Archaeology*, edited by Norman Hammond, pp. 84–104. London, 1973.

Thapar, B. K. "Kalibangan: A Harappan Metropolis Beyond the Indus Valley." *Expedition* 17 (1975): 19–32.

Thapar, Romila. "A Possible Identification of Meluḫḫa, Dilmun and Makan." *JESHO* 18 (1975): 1–42.

Thomas, H. L. "The Archaeological Chronology of Northwestern Europe." In *COWA*, pp. 343–72.

Thomas, H. L. "The Archaeological Chronology of Northern Europe." In *COWA*, pp. 373–402.

Thomas, H. L. *Near Eastern, Mediterranean and European Chronology* [= *SIMA* 17]. Lund, 1967.

Thompson, R. Campbell, and Mallowan, M. E. L. "The British Museum Excavations at Nineveh 1931–32." *AAA* 20 (1933): 179–81.

Tobler, Arthur J. *Excavations at Tepe Gawra II: Levels IX-XX*. Philadelphia, 1950.

Točík, A. "Die Nitra-Gruppe." *Archeologické Rozhledy* 15 (1963): 716–74.

Todd, Joan M., Eickel, Marijean H., Beck, Curt W., and Macchiarulo, Angela. "Bronze and Iron Age Amber Artifacts in Croatia and Bosnia-Hercegovina." *Journal of Field Archaeology* 3 (1976): 313–27.

Tosi, Maurizio. "Excavations at Shahr-i Sokhta." *East and West* 19 (1969): 283–386.

Tosi, Maurizio, and Piperno, Marcello. "Lithic Technology behind the Ancient Lapis Lazuli Trade." *Expedition* 15 (1973): 15–23.

Tsountas, Chrestos. "Archaiotētes ek Mykēnōn." *EphArch*, 1887, pp. 156–72.

Tsountas, Chrestos. "Anaskaphai taphōn en Mykēnais." *EphArch*, 1888, pp. 121–79.

Tsountas, Chrestos. "Mētrai kai Ziphē ek Mykenōn." *EphArch*, 1897, pp. 99–127.

Tufnell, Olga. *Lachish IV and V: The Bronze Age*. Oxford, 1958.

Tufnell, Olga, Inge, Charles H., and Harding, Lankester. *Lachish II: The Fosse Temple*. Oxford, 1940.

Vats, Madho Sarup. *Excavations at Harappa*. Delhi, 1940.

Vercoutter, Jean. *Essai sur les Relations entre Égyptiens et Préhellènes* [= *L'Orient Ancien Illustré* 6]. Paris, 1954.

Vermeule, Emily T. *Greece in the Bronze Age*. Chicago, 1964.

Vermeule, Emily T. "Graffito on a Steatite Jewelry Mold from Mycenae."

Kadmos 5 (1966): 144–46.

Vermeule, Emily T. "A Mycenaean Jeweler's Mold." *BMFA* 65 (1967): 19–31.

Vermeule, Emily T. *The Art of the Shaft Graves of Mycenae* [= Lectures in Memory of Louise Taft Semple, Third Series]. Norman, Oklahoma, 1975.

Vitaliano, Charles J., and Dorothy B. "Volcanic Tephra on Crete." *AJA* 78 (1974): 19–24.

Vlassa, N. "Chronology of the Neolithic in Transylvania, in the Light of the Tartaria Settlement Stratigraphy." *Dacia* 7 (1963): 485–94.

Wace, A. J. B. et al. "Report of the School Excavations at Mycenae, 1921–1923." *BSA* 25 (1921–23): entire issue.

Wace, A. J. B. "Excavations at Mycenae: The Tholos Tombs." *BSA* 25 (1921–23): 283–402.

Wace, A. J. B. "The Curled Leaf Ornament." *BSA* 25 (1921–23): 397–402.

Wace, A. J. B. *Chamber Tombs at Mycenae* [= Archaeologia 82]. Oxford, 1932.

Wace, A. J. B. *Mycenae: An Archaeological History and Guide*. Princeton, 1949.

Wace, A. J. B. "Mycenae 1939–1953: Part I: Preliminary Report of the Excavations of 1953." *BSA* 49 (1954): 231–43.

Wace, A. J. B. "Mycenae 1939–1955: Part I: Preliminary Report on the Excavations of 1955." *BSA* 51 (1956): 103–22.

Wace, A. J. B. "Mycenae 1939–1956, 1957." *BSA* 52 (1957): 193–223.

Wace, A. J. B., and Blegen, C. W. "Pottery as Evidence for Trade and Colonization in the Aegean Bronze Age." *Klio* 32 (1939): 131–47.

Wace, A. J. B., and Thompson, M. S. *Prehistoric Thessaly*. Cambridge, 1912.

Wainwright, G. A. "Asiatic Keftiu." *AJA* 56 (1952): 196–208.

Walberg, Gisela. *Kamares: A Study of the Character of Palatial Middle Minoan Pottery* [= Boreas 8]. Uppsala, 1976.

Ward, William A. "Egypt and the East Mediterranean from Predynastic Times to the End of the Old Kingdom." *JESHO* 6 (1963): 1–57.

Ward, William A. *Egypt and the East Mediterranean World 2200–1900 B.C.* Beirut, 1971.

Warren, Peter. "The First Minoan Stone Vases and Early Minoan Chronology." *KrChr* 19 (1965): 7–43.

Warren, Peter. *Minoan Stone Vases*. Cambridge, 1969.

Watkins, N. D., Sparks, R. S. J., Sigurdsson, H., Huang, T. C., Federman, A., Carey, S., and Ninkovich, D. "Volume and Extent of the Minoan Tephra from Santorini Volcano." *Nature* 271 (1978): 122–26.

Watzinger, Carl. *Tell el-Mutesellim* II. Leipzig, 1929.

Wheeler, Mortimer. *The Indus Civilization*. Cambridge, 1968.

Whitehouse, David. "The Origins of Italian Maiolica." *Archaeology* 31 (1978): 42–49.

Williamson, William O. "The Scientific Challenge of Ancient Glazing Techniques." *Earth and Mineral Sciences* 44 (1974): 17, 21–22.

Woolley, C. Leonard. *Ur Excavations II: The Royal Cemetery*. London, 1934.

Woolley, C. Leonard. *Ur Excavations IV: The Early Periods.* London, 1955.

Woolley, C. Leonard. *Alalakh.* Oxford, 1955.

Wreszinski, Walter. *Der Papyrus Ebers.* Leipzig, 1913.

Wulff, H. C., Wulff, H. S., and Koch, L. "Egyptian Faience: A Possible Survival in Iran." *Archaeology* 21 (1968): 98–107.

Xanthoudides, Stephanos. *The Vaulted Tombs of Mesara.* Manchester, 1924.

Yalouris, Nicholas. "An Unreported Use for Some Mycenaean Glass Paste Beads." *Journal of Glass Studies* 10 (1968): 9–16.

Younger, John G. "Bronze Age Representations of Aegean Bull-Leaping." *AJA* 80 (1976): 125–37.

Zervos, C. *L'Art de la Crète Néolithique et Minoenne.* Paris, 1956.

Zeuner, Frederick E. *A History of Domesticated Animals.* London, 1963.

Index

'3t nbt, definition of, 14
'3t wdḥ, definition of, 14
Abu Hawām, faience from, 49, 54
Abydos, faience from, 33
Aegean: glass, 8; relations with Troy, 46; pottery, 157; trade with Europe, 164, 167, 168, 169, 170. *See also* Aegean islands; Crete. *See under individual sites*
Aegean islands: relations with Crete, 148, 150, 155; faience from, 148–52; paucity of faience from, 149. *See also* Akrotiri; Ialysos; Kythera; Melos; Thera
Aegeans: in Egyptian art, 35, 128, 161, 162
Africans: in Minoan art, 100, 101; in Town Mosaic, 100, 102, 115
Ajios Jakovos, faience from, 49
Akhera, faience from, 55
Akrotiri, 70, 80, 122; "Libya" fresco, 101, 107, 110, 111, 114; faience from, 149, 151, 152; date of destruction of, 151; ostrich egg rhyta from, 151, 152, 162. *See also* Thera
Alaca Hüyük, faience from, 29, 46
Alalakh, faience from, 48, 55
Alamgirpur, faience from, 32
Alishar Hüyük, faience from, 29, 46
Almas, faience from, 39
Altin-depe, faience from, 44
Amber: trade in, 39, 41, 165, 167–71, 174; jewelry, 40, 42, 168, 169; characteristics of, 165, 166; from Aegean, 166, 167, 169
Amulets, faience, 23, 31, 33, 45, 48
Anau, faience from, 30
Antelopes: in Aegean art, 91, 92
Anzaḫḫu, definition of, 17
Appliqués: of cockleshells, 62, 85; of rose leaves, 63; of figure-eight shields, 63, 96; of dolphins, 130, 132, 134, 136, 137; of figurines, 136
Arbon-Bleiche, faience from, 41
Arkhanes: house model from, 108; faience from, 116
Ashes, plant: and faience invention, 3; and NAGA, 16
Asine, faience from, 144
Assur, faience from, 46

Atheniou, ivory goblet from, 53
Azurite: relation to kyanos, 11

Babino, faience from, 40
Babylon, faience from, 45
Badari, faience from, 34
Bampur, faience from, 31
Baskets, faience, 62
Beads, faience: manufacture of, 2, 3; from Near East, 22, 23, 26–30 passim, 34, 43, 46, 48; crumb, 23; segmented, 23, 28, 29, 31, 40, 41, 42, 43, 44, 115, 116, 144, 171; "duck," 27, 28; spacer, 30; from Indus Valley, 32; from Egypt, 34, 48; from Cyprus, 34, 49, 54; Minoan, 34, 56, 115, 116, 117, 156; from Greece, 34, 142, 144, 145; from Europe, 39–43 passim, 171; bull's head, 49, 55, 145, 156; lantern, 55, 145, 156
—other materials, 3, 6, 22; spacer, 8, 168, 169
—*see also* Jewelry; Necklaces
Beadwork, faience, 37
Beakers, faience, 61. *See also* Chalices
Beard, faience, 27
Bees: in jewelry mold, 6
Beycesultan, faience from, 47
Blossom bowls: faience, 46, 51, 61; origin of, 51
Boats, Minoan, 57, 101, 102, 115
Bohemia, faience from, 41
Bone: beads, 42; inlays, 60; pomegranate models, 83. *See also* Ivory
Book of the Dead: and term for faience, 14
Borders, faience, 85, 94, 95, 96
Bowls, faience, 34, 51, 63. *See also* Blossom bowls
Bracelets, faience: manufacture of, 2; with craftsmen's marks, 60
Brackets, faience, 117, 144, 156
Brăiliţa, faience from, 39
Brittany, faience from, 41
Bronze foil: covering ostrich eggs, 132
Bulls: catching of, 53, 103; in Aegean sports, 79. *See also* Heads, of animals; Rhyta

199

27, 28, 36, 39, 41n184, 42, 50, 174; technical analysis of, 4, 42, 170, 171; prerequisites for production of, 4, 171, 173, 174; relation to glass paste, 5, 158; relation to glass, 6, 7, 8, 158; modern terminology for, 9, 10; Bronze Age terminology for, 10, 11, 12–17, 21; earliest, 22; relation to glazed steatite, 22, 23, 27; relation to lapis lazuli, 27, 32, 33, 158, 173; exploitation of characteristics of, 29, 35, 173; combined with other materials, 33, 34, 36, 79, 92, 94, 95, 96, 153; as imitation of other materials, 33, 34, 45, 49, 52, 66, 68, 69, 145, 148, 155, 173; as trinkets, 35, 39; relation to amber and tin, 165, 171, 172
—Aegean: earliest, 56, 59, 174; expansion of, 59; invention of polychrome, 59; characteristics of, 153, 155, 156, 173; decline of, 157, 158, 159, 162, 163; relation to other faience industries, 157, 170, 171, 172, 174
—workshops for: in Indus Valley, 31, 32; in Egypt, 36, 37; in Near East, 47; on Crete, 59, 60
—*see also* Craftsmen; Lapis lazuli; Metallurgy; Polychrome faience; Pyrotechnology
—*see under individual sites and areas; types of objects*
Figure-eight shields, 63, 78, 96; faience, 96, 141
Figurines, 3; manufacture of faience, 2; manufacture of glass, 7; faience animal, 23, 31, 32, 35, 36, 44, 46, 49, 54, 78, 79, 80, 81, 136, 137; faience human, 33, 35, 77, 78, 134, 136, 153; faience divine, 44, 46, 48. *See also* Snake handlers
Firing temperatures: of faience, 1; of glass paste, 5; of glass, 7
Flagpole supports: in Town Mosaic, 105
Flowers: manufacture of faience, 2; in jewelry molds, 5, 6; in Aegean faience, 63, 81, 83. *See also* Safflowers; Saffron; W₃d lilies
Flying fish, 80, 81, 137
Footstools, faience, 37
Foundation deposits, faience in, 23, 35
France, faience from, 41
Free-hand modeling: in faience manufacture, 2
Frit, definition of, 9
Fritted siliceous ware, definition of, 9
Fruit, faience, 35, 54, 81, 83
Fuente Alamo, faience from, 41
Furnaces, 7. *See also* Faience, workshops for; Firing temperatures; Kilns
Furniture inlays, 33, 92, 115; manufacture of faience, 2; in Linear B texts, 6, 10,

115; faience, 33, 45, 46, 85, 92, 95, 96, 115. *See also* Inlays
Fustat, faience from, 3

Gameboards: faience, 36, 142, 150, 156, 162; and "sacral" knots, 141. *See also* Draughtboards; Gamesmen; Playing pieces
Gamesmen, faience, 32, 46, 58. *See also* Draughtboards; Playing pieces
Garments, votive, 63, 86. *See also* Costume, Aegean
Geoy Tepe, faience from, 29, 43
Giza, faience from, 33
Glass: composition of, 6, 7; relation to faience, 6, 7, 8, 158; invention of, 6–7; manufacturing methods of, 7, 8; Bronze Age terminology for, 10, 16, 17, 21. *See also* Glass texts
Glass paste: composition of, 4, 5; Mycenaean, 5; relation to faience, 5, 8, 158; jewelry molds for, 6; Bronze Age terminology for, 10, 12–15 passim, 16, 17, 21; workshop sample of, 14
Glass texts: purpose of, 8; contents of, 8, 15, 16; and terms for faience, glass paste, and glass, 16–21
Glassy faience, definition of, 9, 10
Glassy frit, definition of, 9, 10
Glaze, definition of, 9
Glazed paste, definition of, 9
Glazed siliceous ware, definition of, 9
Glazing, 1, 3, 8, 13
Glyptic. *See* Seals
Goats: and kids, 91, 92; in Town Mosaic, 105
Gold: jewelry, manufacture of, 5, 6; trade of, 29, 36, 39, 158; relation to faience, 59, 105, 158; combined with faience, 60, 61; foil covering ostrich eggs, 132, 137
Gomel, faience from, 40
Gournia: 68n55, 76, 77, 122; faience from, 116
Gözlükule, faience from, 29
Great Britain, faience from, 42, 172, 174. *See also* Wessex
Gumla, faience from, 31, 32
Gum tragacanth: as binding agent, 2, 16

Hafit, faience from, 31
Haghia Triada, 77; faience from, 60, 98, 155
Hala Sultan Tekke, faience from, 55
Hama, faience from, 27
Handles, faience: for mirrors, 35; for metal tang, 29, 147. *See also* Swords
Harappa: faience from, 31, 32, 44; kilns for faience production at, 32

Harris Papyrus: and terms for faience, 12, 13

Hasanlu, faience from, 43

Headdresses, 5*n*32, 48

Heads, faience: of pins, 29, 31, 46; of humans, 44, 47; of animals, 45, 48, 54, 78, 80. *See also* Beads, faience; Rhyta

Hebrew, 15

Helmets, Aegean, 103, 125, 126

Hepzefa (governor of Kerma), 36. *See also* Kerma

Hittite, 15

Ḥmt, definition of, 15

Horses, faience, 47, 48

House façades, Town Mosaic: with ashlar and isodomic masonry, 107; with windows, 107, 108, 109, 110, 111; with cupolas, 107, 108, 109, 111; with doorways, 107, 113, 115; with half-timbering, 108, 111, 113; with beam ends, 109, 110, 111; with raised vertical section, 111, 113. *See also* Town Mosaic

Ḥrṣ, definition of, 15

Ḥsb n w3ḏ, definition of, 14

Ḥsbḏ: definition of, 13, 14; compounds of, 14

Hungarian Basin, faience from, 40

Ialysos, faience from, 148, 152

Idalion, faience from, 50, 51, 52

Iliad: and mentions of Kyanos, 11

Im, definition of, 13, 15

Immanakku, definition of, 14, 17

Imy-r ṯḥnt, definition of, 13

Imyt, definition of, 14, 15

Indus Valley, 34, 43; as center of faience production, 27, 30, 31, 32, 33; relation to Near East, 30, 31, 32, 33, 44. *See under individual sites*

Inlays, faience: manufacture of, 2; from Near East, 23, 29, 31, 36, 37, 44, 45, 46, 47, 54; from Aegean, 60, 85, 92, 94, 95, 96, 98, 99, 141, 142, 153. *See also* Draughtboards; Furniture inlays; Gameboards; House façades; Town Mosaic

Inru '$3w n wdh, definition of, 14

Iqni, definition of, 11

Irw ḥsbḏ, definition of, 14

Isin, faience from, 55

Ivory: in Mycenaean workshop, 5, 120; combined with glass paste, 6; in Levant, 47; combined with faience, 85, 92, 95. *See also* Bone

Izjum, faience from, 40

Jemdet Nasr, faience from, 26

Jericho, faience from, 49

Jersey, faience from, 41

Jewelry, faience: manufacture of, 2; design of, 5, 6, 39, 156, 158; in Harris Papyrus, 13; from Near East, 26, 30, 36, 37, 44, 45, 46; from Indus Valley, 31, 32

—glass paste: manufacture of, 6

—glass: manufacture of, 7

—*see under individual sites and types of objects*

Jug, faience, 156

Jutland, faience from, 43

Kalgūga, definition of, 21

Kali Limenes, faience from, 117

Kalû, definition of, 21

Kantir, faience from, 37

Karahüyük, faience from, 46

Keftiu: in Egyptian tomb paintings, 128, 161, 162; identification of, 161

Kerano-Munjan Valley, Badakhshan: as source of lapis lazuli, 5

Kerma, faience from, 35, 36

Kernoi, faience, 45

Khafaje, faience from, 26

Kilns: for faience manufacture, 31, 32, 36, 37, 47. *See also* Furnaces

Kish, faience from, 26, 29, 55

Kis-Zombor, faience from, 39

Kition, faience from, 50, 51, 53, 157

Knossos, 49, 63, 64, 76, 77, 79, 84, 94, 95; as center of faience production, 60, 95, 173, 174; frescoes from, 80, 88, 89, 104, 105, 137; coming of Mycenaeans to, 160, 161

—faience from: Vat Room deposit, 59, 77, 78, 92, 115, 153, 155; Kamares deposit, 59, 153; Loom-weight deposit, 60, 61, 99, 109; Throne Room, 60, 94; Royal Road, 60, 94, 98, 140, 141, 157; House of the Sacrificed Oxen, 61; Treasury of the Sanctuary Hall, 61; Temple Repository, 61, 62, 63, 70, 80, 81, 83, 84, 86, 88, 89, 91, 92, 94, 96, 115, 117, 123, 137, 140, 142; deposits of, in graves, 64, 85, 115, 116; Ivory Deposit, 78, 79; East Entrance, 78, 136; below Vestibule of the Hall of the Jewel Fresco, 79; Tomb of the Double Axes, 85, 125; unknown provenance, 98, 99

Kohl jars, faience, 35, 37, 48, 50

Koumasa, 77

Kourion, faience from, 52

KÙ.AN, definition of, 12

Kültepe, faience from, 46

Ku(wa)nnan, definition of, 11

Ku-wa-no: definition of, 10, 11; cognates of, 11, 12

Ku-wa-no-wo-ko-i, definition of, 10

Tell al-Wilayah, faience from, 30
Tell Arpachiyah, faience from, 22
Tell Billa, faience from, 55
Tell Brak, faience from, 23, 27
Tell el Fakhar, faience from, 46
Tell el Judeideh, faience from, 29
Tell el-Mutesellim, faience from, 49
Tell el Rimah, faience from, 45, 46, 55
Tell el Yahudiyeh, faience from, 12, 39
Tell Fara, faience from, 49
Tell Taya, faience from, 27, 29
Tell Ta'yinat, faience from, 29
Tepe Gawra, faience from, 22, 23
Tepe Giyan, faience from, 30, 44
Tepe Hissar, faience from, 26, 30
Tepe Sialk, faience from, 44
Tephra, collection of, 159, 160. *See also* Thera
Tersītu, definition of, 17, 21
Thebes (Egypt), faience from, 35
Thebes (Greece), jewelry workshop at, 5, 120
Theophrastos: and mentions of kyanos, 11
Thera, eruption of, 159, 160, 163. *See also* Akrotiri
Thnt: definitions of, 12, 13; compounds of, 13
Tiles, faience, 33, 35, 44
Tin: relation to faience, 42, 174; trade of, 120, 165, 169, 170
Tiryns, amber and gold from, 166, 167
Town Mosaic, 98; discussion of, 99, 100, 114, 115, 153, 155; depiction of humans, 100, 102, 103, 115; depiction of boats, 101, 115; depiction of scenery, 103, 104, 105; depiction of animals, 103, 105; depiction of columns, 105; depiction of house façades, 107–11, 113–15
Trade, 5; and faience distribution, 27, 29, 30, 31, 34, 35, 36, 39, 41, 42, 56, 57, 59, 148, 164, 165, 171, 172, 174; Aegean, 56, 57, 119–20, 163, 164, 167
Trapeza cave, faience from, 34, 56
Trees, faience, 23. *See also* Leaves
Trialeti, faience from, 43
Troy, faience from, 34, 46, 47
Tsoutsouros, faience from, 117
Turquoise: relation to faience, 3, 153, 173; Egyptian terminology for, 14

Tuzkû, definition of, 16
Tylissos, faience from, 92, 142, 155

Ú.BABBAR, definition of, 16, 17
Ugaritic, 15
Unĕtice group, faience from, 40
Uqnu: definition of, 11; compounds of, 12
Ur, faience from, 26, 29, 30, 45, 55
URUDU.HI.A nēḫu, definition of, 17, 21
Uruk, faience from, 26, 55
Usatovo, faience from, 40

Vapheio cists, 81, 103, 125
Varkiza, faience from, 144
Vasilike ware, 59
Vessels: glass, 7, 8; stone, 57, 120, 121, 122, 123, 126, 149, 155; metal, 155
—faience: manufacture of, 2; miniature; 26, 30, 31, 32, 61, 62, 63, 64, 153, 155, 156; from Near East, 27, 29, 30, 44, 45, 46, 47, 48, 49; from Egypt, 35, 36, 157; from Cyprus, 50, 51, 52, 53; from Aegean, 56, 60, 61, 149, 156, 162, 174
—*see under individual types*
Vinča, faience from, 39
Volos, 81
Vorobjovka, faience from, 40
Vounous, faience from, 34

W3d lilies, 81; faience, 115, 155
Weights, faience, 32
Wessex: faience from, 4, 42; chronology of, 42; relation to Aegean, 42, 168, 169, 170
Wigs, faience, 37
Workshops, 5, 11, 120, 162. *See also* Craftsmen; Faience, workshops for

X-ray fluorescence, 4

ZA.GÌN, definition of, 12
Zagindurû, definition of, 17, 21
Zakros, 64, 70; as center of faience production, 59, 60, 155, 174; faience from, 64, 65, 66, 68, 69, 78, 84, 85; tephra from, 159
Zapzagai, definition of, 15
Zukû, definition of, 16, 17, 21